Beyond
Modern Art

Carla Gottlieb was born in Cernăuți, Romania (annexed by the USSR during World War II), where she studied history. She wrote her doctoral dissertation on Romanian oil; its impact upon the history of Romania for Carolina University in Cernăuți. She came to the United States in 1945 and turned to the study of art history. She has taught this subject at Bryn Mawr, Sarah Lawrence, the New School, the University of Illinois, Carleton University (Ottawa), and chaired the art history department at Ripon College, Wisconsin. Ms. Gottlieb has contributed numerous articles to national and international professional journals. Among these are studies on Matisse, Picasso, and Duchamp as well as on the iconography and principles of modern art. She is coauthor of the book *The Meaning of Death*.

Beyond Modern Art

Carla Gottlieb

 A Dutton Paperback

E. P. DUTTON & CO., INC. | NEW YORK

First Edition

10 9 8 7 6 5 4 3 2 1

Published simultaneously in Canada by Clarke, Irwin &
Company Limited, Toronto and Vancouver.

ISBN 0-525-47370-X

Designed by Dorothea von Elbe

Contents

Acknowledgments ix

List of Illustrations xi

A Prelude with Chairs 1

I. Why Create? Why Art? 14

 1. Self-Discovery 17
 2. Scientific Curiosity 18
 3. Education in Sensibility 22
 4. The Factor X 25
 5. Interest in the Thing 27
 6. The Will to Inform and the Development of
 Human Consciousness 33

II. The Democratization of the Art Object 39

 1. Active Spectator Participation 40
 2. The Devaluation of Uniqueness 53
 3. The Spectacle as an Article of Mass Consumption 60

III. Developments in Content 69

 1. Nonobjective Symbolism 71
 2. The Mystic Presence: Voyages into the Absolute 80
 3. Mass Media Image: Banalized Celebrity and
 Celebrated Banality 89
 4. Confrontation with Energy, Pattern, and Matter 95
 5. The Thing, the Whole Thing, and Nothing But
 the Thing 103

6. The Rise of the Idea and the Malady of Form 115

IV. Uproar in Form 119

1. New Materials and New Tools Inspire New
 Techniques 120
2. Dialogue with a Limit: The Picture's Edge and
 the Sculpture's Boundary 124
3. The Monologue of Magnitude 136
4. Gravity in Harness 147
5. Soft Sculpture, Anti-Form, Solidified Shadow 158
6. Systemic Art: Reiteration, Multiplication,
 Permutation, Modularity 170

V. Storming the Barriers: The Aesthetics of the Merger 196

1. The Wounded Canvas, Combines, the Non-
 geometric Field 198
2. Environments, Light Situations, Space Sculpture,
 Sculpture as Causeway, Land Art 211
3. Lettrism, Happenings et Alia 254
4. Design in Movement 261
5. The Use of Sound 288
6. Physics as Tool 293

VI. The Desanctification of the Artist and the Desacralization
 of the Art Object 318

1. The Insane as Artist 320
2. The Machine as Artist 323
3. From Found to Discard Object, from Form to
 Function: The Battle Against the Essentials
 of Art 328
4. The Remythification of the Artist and the
 Remystification of the Art Object 333
5. Sense in Nonsense: Dada Rediviva 345

6. The Foul Object: Sculpture from Fat 354

VII. The Disavowal of the Art Object 363

1. Demise: Erased and Burnt Offerings 364
2. Demotion: From End Product to By-Product
 in Conceptual Art 370
3. Repression: The Neutered Object 377

Attempt at a Trial Balance 387

Bibliography 405

Index 411

Acknowledgments

In preparing this book, I have benefited from the kind help of directors Dr. Harald Seiler, Hanover, Germany, and Dr. Paul Wember, Krefeld, Germany, who have shared with me their knowledge of El Lissitzky and Yves Klein; however, I, alone, am responsible for the interpretation of the facts. I am also beholden to Rudolf Arnheim for sympathetic encouragement and contributions to the bibliography on art and insanity. The artists have assisted by patiently answering questions. The Bauhaus-Archiv, Berlin, has clarified problems relating to László Moholy-Nagy. Yaacov Agam, Joseph Beuys, John Coplans, Janet Daley, Hans Haacke, Allan Kaprow, Ursula Meyer, Grégoire Müller, Calvin Tomkins; the galleries Françoise Mayer, Brussels, Pierre Matisse, New York, and René Block, Berlin; the Los Angeles County Museum of Art; Le Musée des Arts Décoratifs, Paris; The Museum of Modern Art, New York; The National Gallery of Canada, Ottawa, Ontario; The Pasadena Museum of Modern Art; Rutgers—The State University, New Brunswick, New Jersey; *Studio International,* London; The Tate Gallery, London; Verlagsgruppe Bertelsmann GmbH, Gütersloh; and the Wadsworth Atheneum, Hartford, Connecticut—all have graciously permitted me to quote from their publications. To Guy Brett, Mme. Rotraut Klein-Moquay, Mrs. Albert List, and Henk Peeters I owe the privilege of using their photographs and copyrighted material. Ursula Meyer donated precious time to help in unsnarling rough spots. Work was carried out in The Museum of Modern Art Library and the New York Public Library. Thus I incurred special debts of gratitude to Bernard Karpel, Inga Forslund, Joseph T. Rankin, and Donald F. Anderle. The willing help

of other staff members of the two libraries facilitated my task. Finally I should like to thank especially my editor and his assistant for the help that greatly improved my text.

CARLA GOTTLIEB

List of Illustrations

Jackson Pollock at work on a painting 19

Man Ray: *Object to Be Destroyed* 42

Groupe de Recherche d'Art Visuel: *Labyrinth No. 1*. Plan 49

Groupe de Recherche d'Art Visuel: *Labyrinth No. 3*. Plan 51

Niki de Saint-Phalle *et alia: She—The Cathedral*. Drawing 63

Niki de Saint-Phalle *et alia: She—The Cathedral*. Installation 63

Louise Nevelson: *Homage to 6,000,000 No. I* 76–77

Barnett Newman: *Vir Heroicus Sublimis* 82–83

Josef Navrátil: *The Pie* 92

Anthony Caro: *LXXII* 102

Marcel Duchamp: *L.H.O.O.Q.* 104

Francis Picabia: *Self Portrait* 106

Cornelis Norbertus Gijsbrechts.: *Trompe l'oeil* 109

Jasper Johns: *White Target* 110

Günter Uecker: *Ocean* 123

Clyfford Still: *1951-D* 127

Frank Stella: *Sangre de Cristo* 129

Larry Poons: *Northeast Grave* 131

Morris Louis: *Alpha Tau* 142–143

Jules Olitski: *Panger* 145

Pablo Picasso: *Swimming Woman* 149

Kenneth Snelson: *Easy K* (two views and plan of site) 156–157

Claes Oldenburg: *Giant Soft Fan—"Ghost" Version* 161

Robert Morris: *Untitled* 165

Yaacov Agam: *Moods* (six views) 169

Andy Warhol: *Triple Elvis* 175

Andy Warhol: *Elvis I and II* 176

Yayoi Kusama: *Phallic Sofa* on *Macaroni Carpet* 181

Sergio de Camargo: *Relief No. 246* 184

Victor Vasarely: *VP 119* 188

Sol LeWitt: *A 2 5 8* 191

Lucio Fontana: *Spatial Concept: Expectations* 201

Robert Rauschenberg: *Coexistence* 205

George Segal: *The Gas Station* 213

Lucas Samaras: *Corridor*. Ink drawing 216

Lucas Samaras: *Corridor*. Installation 217

Constantin Brancusi: *The Newborn* 218

Tony Smith: *Untitled*. Models for Expo '70 222

Tony Smith: *Untitled*. Models for "Art & Technology" exhibition 223

Tony Smith: *Untitled*. Installation for "Art & Technology"
 exhibition 225

Larry Bell: *Untitled* 228

El Lissitzky: *Abstract Gallery*. Rear corner 230

El Lissitzky: *Abstract Gallery*. Side wall 231

El Lissitzky: *Abstract Gallery*. Corner with Archipenko sculpture 233

Dan Flavin: Untitled (*To Jane and Brydon Smith*) 238

Donald Judd: *Untitled* 243

Carl Andre: *37 Pieces of Work* 245

Christo: *Valley Curtain*. Looking north 251

Christo: *Valley Curtain*. Close-up of south face 252

Josef Albers: *White Line Square XIII* 265

Bridget Riley: *Arrest III* 266

Jesús-Rafaël Soto: *Penetrable* 271

Julio Le Parc: *Double Form in Contortion* 280

Pol Bury: *Sphere upon a Cube* 285

László Moholy-Nagy: *Light-Space Modulator*. Construction scheme 296

László Moholy-Nagy: *Light-Space Modulator* 298

Nicholas Schoeffer: *Cybernetic Light Tower* 300

Yves Klein: Pneumatic Architecture. *Climatisation de l'espace* 304

Yves Klein: Pneumatic Architecture. *Air Architecture* 306

Yves Klein: Pneumatic Architecture. *Fire Wall* 307

Hans Haacke: *Skyline* (two views) 310–311

Jean Tinguely: *Meta-matic No. 17* 325

Piero Manzoni thumbprinting eggs 340

Piero Manzoni: *Egg* 341

Joseph Beuys: *Eurasia*. Fluxus Action 358

Joseph Beuys: *Eurasia*. Fluxus Concert 359

A Prelude with Chairs

Art is an activity of change, of disorienta-
tion and shift, of violent discontinuity and
mutability, of the willingness for confusion
even in the service of discovering new per-
ceptual modes.—Robert Morris, 1970

The words *contemporary art* contain an inflammatory note, for so
much in that art is controversial. Moreover, what one person sees
of it is like the tip of an iceberg. The facts are difficult to come by
—fragmentary and contradictory. But if the obstacles for a study
of today's art are great, so is the challenge—the burning desire to
understand our own time. What other period of art could help us
as much in this problem?

This is the reason for my writing a book on contemporary art,
a period I equate with the years 1945 to the present. The outbreak
of peace after World War II seems to be the moment when the

1

latest corner was turned. After it, artists looked at art with different eyes, seeing a great many new problems that pressed for other, divergent, solutions. Let me explain what I mean by an example.

In 1957, Robert Rauschenberg made two pictures almost—but not quite—identical, going to such extremes as copying the dripped paint. These he titled *Factum I* and *Factum II*.[1] In traditional art, duplication is commercially motivated because the idea of copying a painting is at odds with the standards of creativity. Picasso had broken that taboo and explained, in 1935, to his friend, the art critic, Christian Zervos: "I have a horror of copying myself. But when I am shown a portfolio of old drawings, for instance, I have no qualms about taking anything I want from them."[2] Picasso's problem was to prove his creative powers. His solution: to copy from a picture is no worse than to copy from nature, as long as the motif is translated by the artist into his own style. But you cannot copy yourself, because you cannot translate yourself into another style. Rauschenberg took a step beyond Picasso, however: he had no qualms about copying himself. The reason can only be that he was no longer concerned with proving his creative powers. Instead, his problem was the uniqueness of the work of art. Does uniqueness exist? What value does it have? What constitutes a series? What value is there in seriality? How much is accident in dripping paint? What is the role of chance and that of controlled chance in art? These are the questions his duplication poses.

One bird does not announce summer, but many birds do. Uniqueness was only one among the many new problems rearing their heads after 1945. In conjunction, they caused art to deviate from its course, and that warrants a fresh label. The problems that preoccupy contemporary artists and the solutions they offer will form the frame into which this study is fitted.

[1] Andrew Forge, *Rauschenberg* (New York: Harry N. Abrams, 1969), pp. 49, 48.
[2] Alfred H. Barr, Jr., *Picasso: Fifty Years of His Art* (New York: The Museum of Modern Art, 1946), p. 273.

The artist is the best judge of what the innate meaning of his works is, particularly on the contemporary scene where the art historian is hampered in his estimates by the lack of perspective. Therefore, I have taken the statements of our artists as points of departure for my analysis. Historically, contemporary art divides into two portions: from 1945 to 1960, the fairly stable reign of Abstract Expressionism, the last of the grand "isms" in art; and from 1960 to the present, a rapid succession of "als" and "ics" in an atmosphere of galvanic activity, which starts with the emergence of Pop(ular) art breaking the hold on art by the Abstract Expressionists, and then leads to the Conceptual art practiced today. In this period a whole series of new trends developed: New Realism, Op(tical) art, Kinetic art, Environmental art, Minimal art, Land art, and many more. A fair number of statements is available for the earlier part of our period (1945–1960), but it is overshadowed by the large amount of material existing for the later part (1960–1970); the division coincides with the coming-of-age of the first postwar generation and the emergence of Pop art. The quantitative inequality may have been fostered by a faster succession of styles and the commercialization of tape recorders. Also, Pop art bridged the gap between artist and critic. Whether the use of the tape recorder is the cause or the effect of this change in attitude, I do not know.

In deciding what to include and what to omit from the documentary evidence, I was guided by the following criteria. Those who are acknowledged leaders among the artists will speak to us with the greatest authority and their voices will carry farthest; consequently they have been first choices for inclusion when the material was sifted. Yet not every artist handles words as well as synthetic paints or foam rubber, photomontage or neon tubes. Besides, some remain silent by inclination; others have not had their statements published as yet. Hence only some of the artists I quote to illustrate my points are those with whom I discussed the vanguard movement. Morris Louis, for instance, did not speak to us in words. Furthermore, the opinions of different leading artists have been set

side by side so that variety may obtain and the picture may become broader in scope. But in some instances the same artist has been quoted again in preference to another even more important artist if the first man had expressed himself more lucidly on the point in question. Here again my choices favor the artist as writer, and not as artist. On the other hand, in the illustrations of the principles set forth in the statements, I have adopted the opposite method: less is more. I have studied comparatively few artists, but have described each fairly extensively. From a study in breadth, I have turned to a study in depth. That forced me to omit many excellent artists. It was small consolation that some of them, like Eva Hesse, could at least appear through their statements. Yet a string of names usually leads to confusion, whereas a detailed discussion of a few selected examples, by stressing important points, enables us to grasp the essentials of a problem. Then it is not difficult to apply the knowledge gained in one case to others.

Due to airplanes and television, everything that happens today happens on a global level, and only some regionalism survives. Consequently, contemporary art must be investigated on a global basis. Yet, of necessity, the critic dealing with current events knows the development in his own country more intimately than what is happening elsewhere. For that he is dependent upon publications, which already means preselection. Such preferential treatment was involuntary and unavoidable.

In accordance with the definition of the year 1945 as the moment when a rift occurred between what had been and what was to be, only those artists who have come to the fore since that date will be considered. Matisse, Archipenko, Chagall, Beckmann, Arp, Ernst, Gabo, Magritte, Moore, Calder, etc., will find no place in this survey, except through passing mention, although their contemporaries Vasarely, Albers, and Fontana will be part of it—simply because the contributions to art of the former antedate 1945, whereas those of the latter postdate it. On the other hand, men like Picasso, Brancusi, Duchamp, Picabia, Man Ray, Schwitters, Lissitzky, Moholy-Nagy, etc., will appear in the role of ancestors. For yesteryear's side issue has become the foundation upon which today's central issue is built.

Things seen out of context have no relief, no body; they are as substanceless as blankets of fog and as impossible to grasp. Therefore, wherever feasible, my discussion of a novel solution or novel idea will be placed within a historical context. A background provides insights into the nature of the image it sets off. By reviewing contemporary problems and solutions against the background of their predecessors in premodern and modern art, what is original will stand out. Change can be discerned only against identity. As defined by Henri Frankfort, change is the *dynamics* of a situation and identity is its *form*.[3] Form is *trans*formed by the dynamic factors. It will be my task to point out such transformations in contemporary art, noting what is traditional and what radical, what identity and what dynamics, in the new solutions.

For instance, take the use of empty chairs as an iconographic motif. The empty seat is a common image in traditional art. It connotes waiting for somebody's arrival. The familiar example of this kind is the empty throne of Christ awaiting His Final Coming at the Last Judgment, but the motif is by no means confined to Christian religion. In modern art, Vincent van Gogh's two chairs, his own ordinary one and the fancy, ornate piece of Paul Gauguin, are well known, as are Marc Chagall's numerous empty chairs, and René Magritte's groups of objects symbolizing the pleasures of life threatened by danger—a beautiful female torso, a musical instrument, an empty chair, etc.[4] They all convey the expectation that somebody will be using them. But, whereas the empty thrones of traditional art are a status symbol, the empty chairs of modern art are a symbol of relaxation. Indeed, for Henri Matisse, the chair

[3] Henri Frankfort, *The Birth of Civilization in the Near East* (Garden City, N.Y.: Doubleday and Co., 1956), pp. 2–3.

[4] Otto Demus, *Byzantine Mosaic Decoration* (London: Routledge & Kegan Paul Ltd., 1948), Figs. 37 top, 38. S. H. Hooke, *Middle Eastern Mythology* ([Baltimore]: Penguin Books, Inc., 1963), p. 159. J.-B. de la Faille, *The Works of Vincent van Gogh: His Paintings and Drawings*, rev. & enl. ed. (New York: Reynal & Co.; William Morrow & Co., c. 1970), p. 222, Figs. F.498, F.499. Franz Meyer, *Marc Chagall: Life and Work* (New York: Harry N. Abrams, 1963), Nos. 607, 633, 634. James Thrall Soby, *René Magritte* (New York: The Museum of Modern Art, 1965), pp. 26, 27, 29.

embodied relaxation par excellence. His ever-quoted goal was that his art be "like an armchair in which to rest from physical fatigue" (see p. 31).

Sculpture also presents us with empty seats—in the form of pieces of furniture for representational purposes. That is, the chair in sculpture belonged to the domain of the decorative or minor arts. From there it was rescued by Marcel Duchamp in 1913, and introduced into sculpture in a new form. Duchamp substituted the chair for a pedestal, the normal support of a piece of sculpture, in his Ready-made *Bicycle Wheel*.[5] Duchamp's chair is not empty; it fulfills its purpose and, for it, the waiting period is over: time has come to a standstill.

Here contemporary art enters the iconographic scene with Robert Rauschenberg. In 1960, Rauschenberg made an empty chair into a part of a painting by attaching one to a canvas that he called *Pilgrim*. This idea was so novel and carried out so discreetly that the chair was mistaken by visitors to the studio for a place to deposit their paraphernalia—an error they discovered with embarrassment when they wanted to view the work.[6] Rauschenberg usually justifies his choices either on formal grounds or as chance encounters that form autobiographical notes. With regard to the use of the chair, we learn from Andrew Forge, Rauschenberg's biographer: "The chair found its way into *Pilgrim* because, on a visit to a collector's apartment, chairs had to be moved in order to see the pictures. *Pilgrim* solves this particular problem." [7] Does it? If so, the problem is solved in a perverse way, because this chair can *not* be moved. Rauschenberg regarded the problem as inconsequential. But is this the whole or part of the story?

Following on Rauschenberg's heels, Andy Warhol discovered the

[5] Robert Lebel, *Marcel Duchamp,* new ed. (New York: Paragraphic Books, 1967), No. 110, cf. Pl. 85.

[6] Calvin Tomkins, *The Bride and the Bachelors,* enl. ed. (New York: The Viking Press, 1968), p. 227. *Pilgrim* is illustrated in Forge, *Rauschenberg* (1969), p. 152.

[7] Andrew Forge, *Rauschenberg* (New York: Harry N. Abrams, 1972), p. 19.

electric chair in 1964, and made it one of the motifs of his Disaster series. Most of the Disasters deal with car accidents, more or less portraying gore and twisted metal. Warhol's electric chair is shown empty. It is this emptiness, as well as the fifteenfold repetition of the motif in five rows of three, which gives *Lavender Disaster* its sinister air.[8] For whom are these empty chairs waiting? A criminal or an innocent victim caught up in a net of circumstantial evidence? Your neighbor or yourself?

Warhol's reiteration of the motif inspired a third development. A series of different chairs was created by Lucas Samaras in 1969/ 70, which he exhibited under the title of *Chair Transformation* at the Pace Gallery in New York. There are wooden chairs, paper chairs, wire mesh chairs, aluminum foil chairs, Cor-Ten steel chairs, and cut-paper chairs, adorned with pins, wool, cotton, acrylic material, plastered cloth, Formica, jewels, mirror plate, and plastic flowers. Some chairs are squarish, others rounded, some are simple, others overdecorated, some sponsor symmetry and order, others tangle and chaos, some are upright, others collapsed, some resemble human beings, others abstract shapes, some have sections missing or are split in the middle, others have adjuncts that are not found on any normal chair—two of the pieces bring to mind ruination and over-growth by moss or lianas. Yet, almost all have in common the fact that the seat is unusable, because it has either an uneven or a broken surface, or the legs do not support it properly.

Taking stock of these empty chairs in contemporary American art, it appears that each of the three represents a novel approach (to be studied in detail below): Rauschenberg's merger of two categories of art, painting and sculpture, into a Combine (see chap. 5, sec. 1), Warhol's reiteration of a motif, and Samaras' permutation of a motif (see chap. 4, sec. 6). These are only three cases out of many. It would be possible to write a history of evolution and revo-lution in contemporary art and, by discussion of the use of the chair, cover perhaps half the ground.

[8] John Coplans *et al.*, *Andy Warhol* (Greenwich, Conn.: New York Graphic Society, 1970), p. 113. For the car Disasters, *ibid.*, pp. 114–121.

In 1963, the year before Warhol evoked the specter of the electric chair, the German Günter Uecker from Düsseldorf, who "paints" with nails (see chap. 4, sec. 1; Fig. 13, p. 123), applied his color-cum-shadow material to some furniture, among which are also chairs. The nails partially cover the seat and one leg of a common wooden chair. Because some are driven in at an angle and are slightly bent, the nails look like bristles, and the chair resembles a hedgehog whose senses have picked up a danger signal that puts its defenses on the alert.[9]

Joseph Beuys, who formerly taught sculpture at the State Academy of Art in Düsseldorf, another German artist, made a furniture-sculpture as early as 1953 called *Table I*. He is less exclusive in his use of new materials than Uecker, but they are as novel in nature: a goodly number of his works contain fat (see chap. 6, sec. 6) and felt. In 1964, one year after Uecker's *Nail Chair,* he linked his fat sculpture to an ordinary wooden chair. The seat is covered with a layer of fat leaning against the backrest. Seen from the front, the fat looks wedge-shaped and has a smooth top; seen in profile, the backrest's inclination reveals that it is triangular and that the sides bulge.[10]

In the catalogue of *Chair Transformation* Samaras lists a long line of sources, headed by the personal note that his name in Greek means saddle-maker (the saddle is a seat). Among the formative influences he names are: van Gogh, Rauschenberg, the electric chair, Magritte, several thrones, Duchamp and—Kusama's chair. The Japanese artist, Yayoi Kusama, arrived on the West Coast in 1957, then settled in New York, and is now commuting between Japan and New York. Her special art form is proliferation: giant-sized nets without boundaries in painting, and overabundant growth in sculpture. Outstanding among the latter are her barnacled furniture

[9] *Günter Uecker* (Hanover: Kestner-Gesellschaft, Catalogue No. 3, 1972), pp. 100, 101.
[10] *Joseph Beuys: Werke aus der Sammlung Karl Ströher* (Basel: Kunstmuseum, 1969/70), Fig. 23. The *Table* is illustrated in *Sammlung Karl Ströher: Bildnerische Ausdrucksformen 1960–1970* (Darmstadt: Hessisches Landesmuseum, 1970), p. 48.

pieces, densely covered with a vegetation of banana shapes made of stuffed material, like Claes Oldenburg's Soft Sculpture (see chap. 4, sec. 5). Kusama dates her first piece of this kind to 1962. Among these works is also a commonplace wooden chair, with every quarter of an inch of its caned [?] seat overgrown. The shapes covering it fight with one another for living space, pushing their neighbors out of the way in good, traditional, jungle-law style.

What is common to non-American chairs in contemporary art? It appears that each of the three represents the use of a fresh artistic material (to be studied in detail below). Furthermore, all three exploit the chair, adorned with the new material, as a new type of sculpture. In Duchamp, the chair was shaped to form a pedestal; here it is the work itself. That discovery, taken over for American art by Samaras, is a merger of two art disciplines, sculpture and furniture (see chap. 5, sec. 2).

As to chairs in contemporary art in general, it appears that none, with the possible exception of Rauschenberg, where this point is intentionally made ambivalent, invites the onlooker to sit down. This feature separates contemporary from precontemporary chairs. Contemporary chairs are not meant for leisure; they suggest waiting in tense suspense. Depending upon the artist, this nonleisurely chair motif may be a rejection of Matisse's hedonistic goal for art, or a reference to the psychological unrest of troubled times, or many other things.

None of these comments on contemporary art could be made if a historical background were lacking; without it, the meaning of the empty chair as a motif in an individual artist, in a country, and in contemporary art as a whole, could easily be misunderstood.

A case of how want of historical perspective can arrest brilliant analysts midway in their presentation of a contemporary achievement is Jasper Johns and his contribution to thingness. He has been credited with the discovery of three traits. All three are fairly com-

mon in the art picture of past centuries, and can be found singly as well as together (see chap. 3, sec. 5, and Figs. 11, 12, pp. 109, 110). Consequently, they do not suffice to explain the emergence of the concept of objecthood in contemporary art. The catalyst has still to be named.

As the study of contemporary art profits from a historical perspective, it profits likewise from a chronological framework. Pinpointing the time of events is essential to the clarification of relationships. Consequently, the dates of the statements have been added in the text next to the names of the authors; in undated interviews, the date of publication has been given. This procedure led to headaches, because many statements seemed to be earlier than the date of publication, some by several years. How to indicate the several alternatives without a boring scientific apparatus? Even the dating of works presented difficulties, because the evidence was conflicting. That was the debit side of this labor. On the credit side, it happened to carry its own reward. All at once unexpected connections became evident, as could be seen in the story of the chair motif. The same bonus was received in several other cases. For instance, when discussing El Lissitzky's *Abstract Gallery* (1927–1928, reconstructed 1966; Fig. 36, p. 230) as a forerunner of Environments and Situations (Figs. 31–35, 37, pp. 213, 216, 217, 222, 223, 225, 228, 238), I had no idea there was a direct link between them. But, through the dates, it became clear that the English translation of Dorner's description of the room in his museum, distributed free to all interested parties in the United States by a friend of the former director, must have reached Allan Kaprow just before he originated Environments (see chap. 5, sec. 2).

Whereto, why, and how—these are the questions I shall attempt to answer. *Where Do We Come From? What Are We? Where Are We Going?* is the title of a painting by Paul Gauguin, now hanging in the Museum of Fine Arts, Boston. Disillusioned and sick, Gauguin posed these three questions about life six years before his death: what are man's origins, meaning, and aftermath. We are posing them about art, reversing their order, and adding a fourth: in which

direction is art heading, why is that direction being taken, what is the nature of its achievements, and to what extent do previous achievements color this nature. Although the artist, through his statements, will answer the questions where is art going and why has that particular direction been chosen, art history will answer those about where does art come from and what has it achieved.

I have focused on seven problems that occupy much space in the statements of the artists. Each of these has been handled in several ways, the most significant of which I have tried to survey. These seven are by no means all the problems that face artists today, but they are those most frequently discussed in their statements.

Chapter 1 will center on the problem of the urge to create art and discuss today's motivations for the will to form. The need to create is, of course, as old as art itself, perhaps older, and even the reasons for creating given by the artists may not all be new —although this cannnot be verified for lack of relevant material from traditional and modern art. But how is the urge to live creatively connected with other problems in our day and age? The difference between premodern, modern, and contemporary art may lie in this aspect of the problem.

Chapter 2 will focus on the problem of the gap between the artist and his public, and on the remedy proposed to heal that gap, namely, the democratization of the art object. This objective has been approached by three methods: greater involvement of the public, production of works at prices that can be afforded by a larger number of buyers, and the staging of public spectacles. Here it will be noted that the problem of closing the rift between the artist and his audience apparently moves European art in a direction different from that of American art.

The following three chapters will be devoted to changes in the approach to art. Chapter 3 will deal with the new iconology, which represents an extension of the term *content,* and its relationship to iconography. Iconography and iconology are the mechanical bases for establishing affiliations in art, and are therefore useful in the

study of material as yet too near to us to be sorted out by other means. Chapter 4 will investigate the problem of evolution as it is resolved through formal innovations, and chapter 5 will study the problem of revolution, accomplished by the union of two branches of art, and by that of art with other disciplines; such unions have changed the essence of art. These formal innovations and unions are startling departures from earlier art forms. They date mainly from the second part of the period. In fact, since the 1960s, the ever-present urge for renewal in art is so deeply felt that it has become an obsession, a passion for the new in the name of newness. I confess that I, too, am an addict. However, not everyone is. According to a statement made to me by Meyer Schapiro, the art historian, not all changes in style are voluntary decisions on the part of artists. Some are imposed upon them by the dictatorship of fashion; also, the artists do not always obey this dictatorship. Yet the statements do not touch upon this problem. Why? And why did the pace of change accelerate so much in the 1960s? What advantages does such a rapid and radical transformation have for art?

Chapter 6 will turn to the problem of voiding art of mythical elements, a necessity for the majority of contemporary artists, but not for all. The exorcism of myth took two paths: the desanctification of the artist and the desacralization of the art object. By some trick of fate, the first objective was best achieved when desanctification was not the mark of the attack: the concept of the artist's sacrosanctity was most effectively deflated when the work of the insane was elevated to art and when the output of machines was equated with it, while monkeys were shown as capable of painting pictures. The demotion of the art object, on the other hand, proceeded as programmed. Its weapons, the battle against the values vested in art by tradition, the mass production of nonsense objects, and the use of aesthetically repulsive objects, are a follow-up of what modern art had started and an intensification of what it had done tentatively.

Chapter 7 handles the inevitable outcome to which this "path of no return" (see p. 378) leads, if pursued to its logical end: the

actual disavowal of the art object. The tactics for achieving this goal pass from destruction to demotion, which is realized by neutering the works. At first blush, the trend from violence to indifference may seem a sign of the storm having blown over. To me it seems that indifference is more dangerous than hate.

When the art object becomes a *by-product* instead of being the end product, when the *will to inform* operates without the *will to form,* then art has reached a halt in its evolution. With it, this survey can close. The time has come to evaluate what has been gained and where we stand.

Why Create? Why Art?

An arrogant independence to create is my
only motivation.

—David Smith, 1957

Just to keep off the streets.

—Andy Warhol, 1967

"There is no profession . . . in which you may expect less happiness
and contentment than in painting. For a painter, before he can
attain even a moderate degree of perfection, has to submit to so
many drudgeries and toils, that they exceed human credibility. Nor,
after so much sweating, may he expect even a little applause unless
some wind of favorable fortune turns up to blow him into the
harbor. Wherefore it often happens that his life ends in misery and
want." This anguished cry comes from the Venetian painter Carlo
Ridolfi, who voiced it in his book about Venetian artists, *The Won-*

ders of Art (1648).[1] Even if his comprehensive proposition is qualified by the addition of: There is no profession "in the middle and higher echelons of man's work force" it still would suggest that the motive(s) inducing a person to pursue an unrewarding profession must indeed be strong: man must be propelled by an unconquerable need or indomitable wish. "An artist works of necessity," Picasso confided to Zervos in 1935.[2] What is it that forces one to enter a profession beset with difficulty, toil, and distress, and also lacking the assurance of adequate compensation?

Many of us concerned with art ponder this question, and many of these many are the artists themselves. The reasons lying behind the act of creation are frequently mentioned in their statements. It is difficult to select representative quotations when there exist too many nuances, when one declaration of faith subtly merges into another that belongs to a different faith. By "declaration of faith" I mean to which part of the psyche the necessity to create is credited by the artist and what he names as the purpose for his work.

The frequent speculations of the artist about why he creates seem not to be matched by an equal attention to this question by the scientist. I have looked in vain for a systematic survey of theories as a framework by which to discuss the contemporary status of the problem. In my layman's view, I came to the following conclusions. The artist may be impelled to create by instinctive reactions and/or rationally guided actions: impulse and/or will are the two prompters in the act of creation, working singly or in unison. On the whole, the two alternatives seem to correspond to unconscious urges and conscious drives, but the correspondence is not total. The urges as well as the drives can be a need or want for (*a*) playing games, (*b*) release from pressures, (*c*) the cult of beauty; and a want or need for (*d*) expression, (*e*) survival, (*f*) knowledge, (*g*) status in life (recognition, money). There is also (*h*) the great unknown.

[1] Quoted in *Artists on Art: From the XIV to the XX Century,* ed. Robert Goldwater and Marco Treves, rev. ed. (New York: Pantheon Books, 1947), p. 129.

[2] *Ibid.,* p. 241.

The first three aims seem to belong to the category of urges, except that (c), the cult of beauty, can be dictated by will, thus falling also into the category of drives to which letters d through g belong. Among the drives (d), expression, can be also an urge. The aims under the heading of urges have received more attention from the scientists and have been covered under the names of the play theory (Friedrich von Schiller, Johan Huizinga), the therapy theory (Sigmund Freud), the art for art's sake and will to form theories (Roger Fry and Alois Riegl), and the expression theory (Benedetto Croce).

The problem of why the artist creates has two roots: his goal and why, in preference to other possibilities, he selected art for attaining this goal. The statements of the artists tend to blur over this distinction. I believe three causes should be listed for his choice: either the artist is attracted to art by a mysterious force, similar to that which operates as sex appeal between living beings; or he is directed to art by circumstances, say by education; or he selects art himself, so to say in cold blood. Here one may then speak of an urge, a passive floating, and a drive. Note that it is impossible to separate the cult of beauty from sex appeal when "love of art" is given by the artist as the reason for his choice.

Furthermore, an artist can create for his fellowmen, for himself, or for both. Again the statements are not always precise in establishing this point. All these facts must be borne in mind in order to understand the crossings from one terrain into another and the resulting manifoldness of the material.

I have isolated six reasons for the impulse/will to create in the statements of contemporary artists as representative of their stand on this question: self-discovery, scientific curiosity, education in sensibility, the factor X, interest in the thing, and the will to inform. Before surveying these, a general condition that colors all man's aspirations should be noted: the existence of positive and negative approaches to life. Some artists affirm, others deny; some try to further, others to prevent; some are "for," others are "against." Claes Oldenburg was born in 1929 and Roy Lichtenstein in 1923,

which makes them contemporaries once they had reached their third decade. Both are classified as Pop artists; both work in New York. Yet, in the statement made when he was thirty-eight years old, Oldenburg has chosen to list the things he favors; Lichtenstein, however, has given preference to listing the things he disfavors, in a statement made when he was forty years old.[3] But the option between *pro* and *anti* is a human problem, not an artistic problem.

1. *Self-Discovery*

Painting is self-discovery.

—Jackson Pollock, 1956

Self-discovery presupposes self-expression. Self-expression is a want inherent in every human being because it serves as an affirmation of his existence. This want can be fulfilled in several ways, one of which is self-expression through art. According to his character, man may want to put the stress either on the expression of his emotions or his thoughts; both types are amply represented among artists —I need only refer to Vincent van Gogh and Auguste Rodin.

Self-expression through art can differ in how much is revealed of the artist's personality. "Every good painter paints what he is." [4] This continuation of Pollock's statement given above covers the fact that every work of art is an expression of the artist's ego. It is the lowest step in the scale of self-revelation. The expressionist artist, in intentionally instilling his emotions into his creative work and in externalizing them through distortions, violent color, or frightening subject matter, advances to a deeper level of personality disclosure; the same is true of the symbolist artist who intentionally reveals his thoughts through subject matter and title, through color

[3] In Gene R. Swenson, "What Is Pop Art?, I," *Art News,* LXII (November 1963), p. 25. For Oldenburg, see Barbara Rose, *Claes Oldenburg* (New York: The Museum of Modern Art, 1970), pp. 190–191.

[4] In Selden Rodman, *Conversations with Artists* (New York: Devin-Adair, 1957), p. 82.

and shape. Their work represents the second step in self-revelation through art. Abstract Expressionism and Neoplasticism do not take shelter behind a subject but depict their passions, respectively ideas, directly—so to say, in the raw and without a mediator. That is the third and highest step in the revelation of the artist's character through his work. Quite rightly, critics have termed the work of the Abstract Expressionists *gestural* and *autobiographical,* but the second word should be applied to Mondrian's work as well.

Pollock, as Abstract Expressionist, belongs to the group of painters who reveal their passions through their art. However, by stating that "painting is self-discovery," Pollock goes beyond posing self-expression as the goal of his work, as do the other Abstract Expressionists. He adds the further angle that painting is for him a successful search for self-knowledge: the painter's character is revealed not only to the spectators, but also to himself. Painting becomes a tool for the understanding of the self.

Hans Namuth's photograph of the artist as he is stopping in the act of painting in order to scrutinize what he has done (Fig. 1) seems to bear out the artist's assertion. The photograph reveals a deeper concern with the work of art than a weighing of its elements formally: Pollock is emotionally caught up in what he sees. It is possible to imagine him looking at his painting as if into a mirror that reflects his being. The Greek Narcissus was enraptured by the beauty of his face; the new Narcissus is enraptured by the vision of his soul laid bare.

2. *Scientific Curiosity*

It's curiosity which motivates me.

—Larry Poons, 1968

Self-discovery is part of the discovery of the world in general. Scientific curiosity is another facet of such a thirst for knowledge; but, instead of centering on the person of the artist, it focuses on

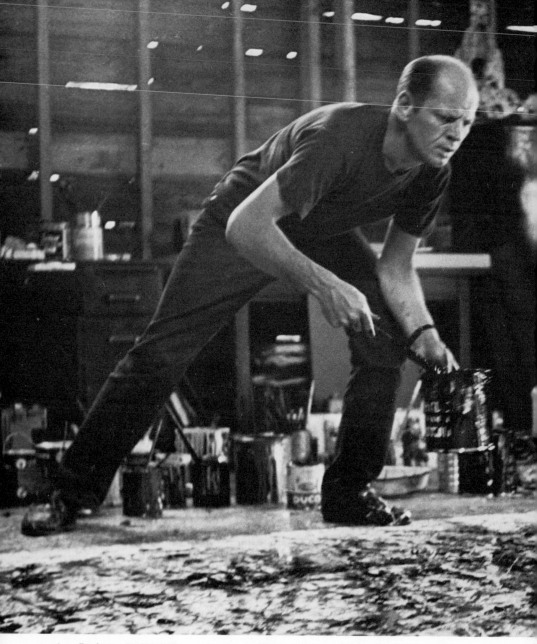

1. Jackson Pollock at work on a painting. Photograph: Hans Namuth, New York.

the work of art. The thirst for knowledge is, however, not so universal as the desire for self-expression—be it knowledge per se or knowledge as a prerequisite to a better understanding of the world around us. Many artists consciously reject the acquisition of knowledge as an inhibiting agent of their creative power, confining their studies to subjects closely related to their craft. Others feel differently. Rather than express their own egos, they try to capture the ego of the world in which they live. Thus Umberto Boccioni defined his aim as a Futurist in 1910 as follows: "We must draw inspiration from the tangible miracles of contemporary life." [5] Sometimes only a specific aspect of the contemporary scene may be chosen for expression in art, the one that is considered by the artist to contain its vital characteristics. To the Constructivist brothers Naum [Pevsner] Gabo and Antoine Pevsner, the essence of their times in 1920 was contained in the concepts of space and time. They noted in their *Realistic Manifesto:* "To realize our creative life in terms of space and time; such is the unique aim of our creative art." [6]

Similar to Gabo and Pevsner, Larry Poons is concerned with a specific side of the world: the curiosity that motivates him to create art is an interest in the laws of optics. Like space but unlike time, this is a subject that is inextricably part of his profession. As such, experimentation with and research into the laws of vision are nothing new to the world of art—I need only to refer to the Italian Renaissance, which produced Alberti, Brunelleschi, Leonardo, and Uccello, or to the nineteenth century, which produced the Impressionists, Cézanne, and the Divisionists. More important for us, Poons shares this involvement with experimentation and research with scores of contemporary artists who purposefully base their work upon scientific laws: all of Op art, much of Kinetic art, and many of the ventures into artificial lighting effects and sound (Figs. 41–43, 44–45, 47, pp. 265, 266, 271, 280, 285, 300). In fact, it is this body

[5] Goldwater-Treves, *Artists on Art,* p. 435.
[6] *Ibid.,* p. 454.

of relevant material that permits us to interpret Poons's elliptical statement the way I did above. The word *experiment* appears again and again in the writings of these artists: "My work is of an experimental nature," Richard Anuszkiewicz declared in 1963.[7] This proves the importance of experiment in Renaissance, modern, and contemporary art, but does not make experimentation and research into the laws of science an end in itself.

Enough instances exist, however, in which artists specifically state that experimentation is the true purpose of their art: "My aim is therefore experimental and pedagogic in the widest sense," Yvaral, co-founder with Le Parc, Agam, and others of the Groupe de Recherche d'Art Visuel and the son of Victor Vasarely, affirmed in 1965.[8] Moreover, some artists go even further and declare that only the *problems* connected with creating a work of art interest them, not the completed work itself. Thus Jim Dine said in an interview of 1963: "I am interested in the problem and not in solutions. . . . I paint about the problems of how to make a picture work, the problems of seeing, of making people aware without handing it to them on a silver platter." [9] And Poons in 1967: "What is important about painting is the contradictions of choices, decisions, believing in choice and allowing yourself to make choices." [10] The same approach exists in Europe, where Jan Dibbets, the Dutch exponent of Arte Povera, stated in 1969: "An oeuvre is less important than the research. . . . I'm more involved with the process than the finished work of art." [11] To speak in philosophical terms, the state of becoming in the creation of the work of art is more important to these artists than the final state of being.

[7] Dorothy C. Miller, *Americans 1963* (New York: The Museum of Modern Art, 1963), p. 6.

[8] In *Directions in Art: Theory and Aesthetics,* ed. Anthony Hill (London: Faber and Faber, 1968), p. 270.

[9] Swenson, "What Is Pop Art?, I," p. 61.

[10] Lucy R. Lippard, "Larry Poons: The Illusion of Disorder," *Art International,* IX/4 (April 1967), p. 22.

[11] *Art Povera,* ed. Germano Celant (New York: Praeger Publishers, 1969), p. 103.

Here is a significant step forward in the process of the devaluation of the art object, on which subject more will be said in the last chapter.

3. *Education in Sensibility*

I'm pleasing myself and educating others
to see.

—Josef Albers, 1960

Like self-discovery and scientific curiosity, education also has a part in knowledge. It may be defined as the spreading of knowledge to others. Its basis is the altruistic goal of giving to others what you yourself enjoy and feel to be vitally important in life. However, education is a two-edged sword. It demands great moral integrity from the educator who wields the power to form the mind. If misused, this instrument can hurt more than help.

When contemporary artists confide to us that the education of man through art is their aim, they can look back upon an impressive array of forerunners. Among these, several directions can be distinguished: the objective can be edification or spiritual instruction, moralization or instruction in ethics, spreading of knowledge or factual instruction, and spreading of sensitivity or sensory instruction. Spiritual, ethical, and factual instruction often go hand in hand in religious and historical art. As is known to all students of art history, edification through knowledge of the Bible was the principal aim of religious art in the Middle Ages: the decorations of churches served as the bible of the illiterate. Hopefully, this art form presupposes that its viewer will be inspired to ethical conduct. Jacques-Louis David, the artist of the French Revolution who excelled in historical subjects, frankly postulated morality and edification as the proper purposes of art. At the occasion of exhibiting his *Rape of the Sabine Women* (1799), he stated: "I could help the arts towards their true destiny, which is to serve morality and

elevate men's souls!" [12] Surprisingly, the identical intention, to rein-
force man's moral fiber, appears as the scope of art in a criticism
of the work of David's pupil, Jean-Auguste-Dominique Ingres, by
Odilon Redon, an admirer of Ingres's opposite number, Eugène
Delacroix. In his *Journal* Redon had the following to say in 1878:
"His works are not true art; for the value of art lies in its power
to increase our moral force or establish its heightening influence." [13]
It follows that the purpose for which an artist creates does not
necessarily shape the style in which this purpose is exposed. The
realist revolutionary, David, and the romanticizing symbolist, Redon,
see eye to eye in this respect.

As for the education in sensibility, it also antedates contemporary
art, being implicit in the 1929 statement of the Mexican muralist
Diego Rivera: "Only the work of art itself can raise the standard
of taste." [14] Contemporary art is interested only in this type of edu-
cation, in forming "aesthetically pre-educated beings who are mas-
ters of their own taste." [15]

Two means through which those who are insensitive to visual
form can be educated will be discussed in the next chapter: mul-
tiples and spectacles. To these two can be added a third agent—
Happenings (which will be studied later, chap. 5, sec. 3). In all
three, art speaks directly to the observer. Yet, indirect ways to
educate the audience in what is artistically relevant and negligible
are also employed by contemporary art, for example, articles and
lectures on aesthetic appreciation; in these cases a verbal explana-
tion accompanies the visual impact of the object.

Each artist has his preference for what means to use in the diffu-
sion of art education. In 1965 Vasarely mentioned the mass media
in this connection: "The idea of Art and the philosophy of the
artist will change through and through as an effect of the dialectical

[12] Goldwater-Treves, *Artists on Art,* p. 209.
[13] *Ibid.,* p. 359.
[14] *Ibid.,* p. 476.
[15] *Vasarely,* II, ed. Marcel Joray (Neuchâtel: Éditions du Griffon, 1970),
p. 197. Statement made in 1967.

machine, press, radio, television." [16] Julio Le Parc proposed "statements, manifestoes, declarations, public dialogues, exchange of ideas with other artists, etc," [17] in 1968, for the same purpose. He includes academic artists in the family of the formally blind.

Although not mentioned by Vasarely and Le Parc, films on art can be added to the list of pedagogic aids for education in sensitivity to art. Not so much those operating indirectly upon the spectator, like films showing a survey of Michelangelo's sculpture with commentary or panel discussions on art with artists, art historians, critics, and the general public as participants, but those that bring the viewer into live rapport with a work of art, like abstract films of from five to twenty minutes duration that consist of changes in color and shape as though the lens of the camera were recording a kinetic spectacle. Such shorts are regularly shown as an introduction to the feature films in the International Film Festival at New York, in museums, and in vanguard movie houses.

In this didactic program that the contemporary artist has mapped out for himself, he consciously relinquishes his traditional role as a detached creator for that of an involved crusader. He turns into "a kind of activator to draw people out from their dependence and passivity" [18] (Le Parc).

Spiritual-ethical-factual education through art is usually connected with the Establishment and/or government, that is, with forces outside the world of art. Religious art is ordinarily done on a commission basis. Historical art is mainly of the same kind: the setting up of monuments and statues in public places is always commissioned, history painting frequently. Both Jacques-Louis David and Diego Rivera were members of the governing party. At first blush, this deduction seems an unexpected result of the survey, but on second thought, the logicality of this position is seen. By portraying a man as a hero, villain, or victim, our vision is molded in a certain

[16] *Ibid.,* p. 194.
[17] "Demystifier l'art," *Opus International,* VIII (October 1968), p. 48.
[18] *Ibid.*

way. Art thus becomes a tool in the hands of those in power for influencing the masses.

On the other hand, you need not be a revolutionary in order to propose morality as the highest aim of art, as in the case of Redon; nor do all revolutionaries consider morality as the only aim of art, as is proven by Gustave Courbet. Here is yet another example of how art, as the expression of human behavior, confounds tidy sorting into pigeonholes. This is one of its major attractions in a world daily becoming more uniform.

Education in sensitivity is also connected with the Establishment and the state, as is evident in Nicholas Schoeffer's spectacles (Fig. 47, p. 300). Projects to educate the public on a large scale, and thus to change taste, necessitate outside financial backing since artists would rarely have sufficient funds. Such artists as did not avail themselves of the alliance with the Establishment or state would make no visible breach in the wall of artistic density.

What is the way out of this dilemma? Should the artist again chain himself to outside powers, as was the case until the nineteenth century? Or should he aim lower, contenting himself with the smaller gains he can achieve on his own? Moreover, is his role as a militant educator a free choice, or has he been manipulated into it by clever maneuvering? Only later generations will be able to see the issues in focus and judge the case.

4. *The Factor* X

> It [my art] meets needs of my own
> and I don't think I'm so peculiar a
> person as to have needs not shared
> by other people.

—Carl Andre, 1969

Andre does not specify what the needs are that have caused him to create art; nor does Warhol explain why professions other than

that of artist are not eligible to keep him off the streets. Neither do they identify the purpose of their work.

They may object to confiding in us. A series of psychologists and art historians consider the play instinct/desire in man as the root for his impulse/wish to create.[19] The play theory is not popular among artists. Obviously, not many adults will relish being likened to grown-up children who play games with the spectator. Even the high pontiff of games in art, Marcel Duchamp, did not dare to downgrade art to a game when he compared it to chess, but took instead the opposite route of upgrading the game to the level of art in his interview with the National Broadcasting Company in 1955: "I found some common points between chess and painting. When you play a game of chess, it is like designing something or constructing some mechanism of some kind by which you win or lose." [20] Another devotee of games in art, Jean Tinguely, wrote on the subject in 1959: "The relationship of art and play: to play is art—consequently I play. I play enraged." [21] Like Duchamp, Tinguely sidestepped the issue, likening play to art but not art to play.

Another possibility is that Andre and Warhol may not know the nature of their needs. The human mind blocks spying upon itself; when it functions creatively, it does not function analytically and vice versa. The need for self-expression, the desire for knowledge, and the wish to spread education have been coaxed into the open by analysts, but other needs, desires, and wishes are still hidden in the shadows of man's soul. These as yet anonymous urges I am calling the factor X.

Whatever factor X is, it exercises pressures that need to be relieved. This can be done by creative work. The healing power of art is utilized medically to detonate the neuroses and alleviate the

[19] For instance, Johan Huizinga, *Homo Ludens: A Study of the Play-Element in Culture* (Boston: Beacon Press, c. 1950).

[20] In *Wisdom: Conversations with the Elder Wise Men of Our Day,* ed. James Nelson (New York: W. W. Norton & Co., 1958), p. 97.

[21] *Kunst ist Revolte.* Düsseldorf 1959; reprinted in *Jean Tinguely* (Hanover: Kestner-Gesellschaft, Catalogue No. 2, 1972), unpaged.

psychoses of the mentally disturbed and ill.[22] Knowing this, man can travel the same road; without the aid of doctors, he can prescribe for himself, consciously or unconsciously, a retreat into the world of art as therapy against pressures. These pressures can be of a personal nature and they can be tied to disillusionments caused by modern life. Consequently, the work of art made for the purpose of easing the pressures of factor X is created either to help the individual or to help mankind. In both domains the artist can pursue either hedonistic or moral aims—or both. When Josef Albers links pleasure for himself to education for others in the statement quoted as the epigraph to the preceding section, he aims at serving his own self as well as at serving others. Barnett Newman's statement in 1947: "An artist paints so that he will have something to look at"[23] narrows the scope of art to his person through the use of the pronoun *he*. As is known from Newman's definition of his art in metaphysical terms (see chap. 3, sec. 2), he saw it as an instrument for the elevation of the spirit through a mystical experience. Carl Andre occupies a position in between the two. He works to satisfy his own personal needs, like Newman, but he is aware of the fact that other people share these needs, so that his art will affect also these others, as planned by Albers.

5. *Interest in the Thing*

I'm interested in the inscrutability and the
mysteriousness of the thing.

—Tony Smith, c. 1967

Words contain many shades of meaning, and it is not always possible to capture the correct one. The nearer to the now, the more difficult this task, because the ambiguities in the statements of the artists have had no time as yet to be resolved. Tony Smith states

[22] Francis Reitman, *Insanity, Art and Culture* (Bristol: J. Wright, 1954).
[23] In "The Ides of Art," *Tiger's Eye,* II (December 1947), p. 43.

that he is interested in the thing. Although this is not identical with making thingness *the* goal of art, it is a step toward making thingness *a* goal of it. The art historian Michael Fried offered the following explanation when, in his article "Art and Objecthood," he wrote in 1967 about the reifying pronouncements of the Minimalist artists (whom he prefers to call "literalists"): "Literalist art stakes everything on shape as a given property of objects, if not, indeed, as a kind of object in its own right. It aspires, not to defeat or suspend its own objecthood, but on the contrary to discover and project objecthood as such." [24] The projection of objecthood as such means that the basic physical properties of the object impose their laws upon the work of art instead of being subservient to it. The Minimalists use only primary, that is, pure shapes. The artist looks at such a shape, listens to what it has to say to him, and then forms his work accordingly. Thus the shape inspires the work; the physical world informs the aesthetic world.

As far as I can see, interest in the thing is an outgrowth of the concept of art for art's sake; Fried had already stated in his 1967 article that Minimal art "belongs rather to the history—almost the *natural* history— of sensibility." [25] In order to explain this assertion it is necessary to delve into the nature and history of this concept.

The artist who philosophizes that art should be created for art's sake alone must be motivated by love of art, a love that moves and fulfills him because he experiences art either as exalting his being or as stimulating his senses or as both. The spiritual experience may be tied to the idea of beauty and the sensual experience to that of *joy,* a term I selected in preference to the commonly used *pleasure* so that the pejorative note attaching to the latter may be avoided. As the driving force for the creation of art, both concepts can be traced back to Renaissance art. However, the objective of Renaissance art differs from that of later art, and the division lies in this facet of the problem. Until the nineteenth century, *fame* was the

[24] Michael Fried, "Art and Objecthood," *Minimal Art: A Critical Anthology,* ed. Gregory Battcock (New York: Dutton Paperbacks, 1968), p. 120.
[25] *Ibid.,* p. 117.

value for which artists strove; at that time, *form* took its place. In the Renaissance, art was one root of the motivation to create, in modern times, art is both roots.

A. THE DESIRE FOR FAME AND HONOR

I say this not to those who desire to gain
riches by their art but to those who desire
fame and honor.

—Leonardo da Vinci

Either by the accident of selective reading or by a historical fact, no artist writing on the reasons that induced artists to work comes to mind before Cennino Cennini in the fourteenth century. The Paduan painter's explanation is contained in his work *The Craftsman's Handbook*. Observing correctly that the problem has two roots, the goal of the artist and the reason that he selected art for attaining this goal, Cennini lists the following motivations:

It is the impulse of their refined dispositions that induces some young men to engage in this art, for which they feel a natural love. Their intellects enjoy drawing. . . . There are others who take up painting from poverty and the necessity of earning a living, combining the desire for profit with a sincere love of our art.[26]

Cennini's statement is incomplete in one point: some work for gain, but what induces others to work remains unspecified. Both turn to art impulsively because they love it or enjoy it.

The missing goal that counterbalances the working for material profit can be found in the writings of the great leaders of the Italian Renaissance, Leonardo da Vinci and Michelangelo Buonarroti; they clarify the poles of purpose as fame or gain. Leonardo in excerpts from his lost notebook spoke of the guild of painters in general (see

[26] Goldwater-Treves, *Artists on Art,* p. 22.

epigraph); Michelangelo in his sonnets refers to himself.[27] In the north, Albrecht Dürer saw the problem in a similar light.[28]

Before turning to another aim coupled by artists to love for art as a source of inspiration, an amusing solution to the problem of fame versus gain may be mentioned. It was proposed by Nicholas Hilliard, a painter and goldsmith at the court of Elizabeth I of England. Hilliard warned of the danger "that any should be taught the arte of painting saue gentelmen only," because no man using his art to earn his living could "performe any exact true & rare peece of worke." [29]

B. ART FOR ART'S SAKE

Do not be an art critic—paint.
There lies the salvation.

—Paul Cézanne, 1904

Art serves many masters, and the concept of art for art's sake can therefore serve as basis for diametrically opposed aims. The concept of sensual joy alone, when serving as the purpose of art, can range from sheer animal pleasure to purging man of his ills. When Thomas Couture asserts in his *Méthode et entretiens d'atelier* (1868) that the artist's "mission is to please and to charm," [30] Édouard Manet's teacher illustrates the hedonistic side of art. When Vincent van Gogh writes in a letter to his brother in 1888:

And in a picture I want to say something comforting as music is comforting. I want to paint men and women with that something of the eternal which the halo used to symbolize, and which we seek to give by the actual radiance and vibration of our coloring,[31]

[27] *Ibid.,* pp. 50, 55, 59, 60.
[28] *Ibid.,* pp. 80–81.
[29] *Ibid.,* p. 118.
[30] *Ibid.,* p. 244.
[31] *Ibid.,* p. 383.

he accentuates the curative side of art. Such distinctions must also have existed before the nineteenth century but, short of courting the attention of the Inquisition, an artist could not have dared to proclaim sensual pleasure as the content of his work; Paolo Veronese was summoned before their tribunal for a lesser offense.

Perhaps the best-known instance of an artist identifying his aim as making art that will serve as antidote to strain in man through the sensual pleasure it offers is Henri Matisse whose comparison of art with an armchair has been mentioned above. His statement won him notoriety at that time (1908) and merits to be quoted in full:

> What I dream of is an art of balance, of purity and of serenity, free from disturbing and engrossing subject matter, [an art] which would be for every mental worker, that is, for the businessman as well as for the man of letters, like a palliative, a mental soother, something similar to a good armchair that does away with the strain of his physical fatigues.[32]

Like van Gogh's motive, which it resembles, that of Matisse is altruistic: to soothe life's strains. But note that the comfort offered by van Gogh relies upon provoking emotion through hinting at God, whereas the détente offered by Matisse relies upon relaxing the mind through formal qualities. This juxtaposition shows again the intricacy of the situation with its constant shifts from one domain into the other, defying clear-cut classifications.

C. THE OBJECT AS OBJECTIVE

> As a thing, an object, it accedes [to] its
> logical self.

> —Eva Hesse, 1969

The goals of many contemporary artists seem merely variations on the concept of art for art's sake. This is, at any rate, how I inter-

[32] *La Grande Revue* (December 25, 1908), pp. 741–742.

pret such statements as: "The one assault on fine art is the ceaseless attempt to subserve it as a means to some other end or value" (Ad Reinhardt, 1962); [33] "The form then (Denver 39) is second (hand) to nothing" (Robert Rauschenberg, 1963); [34] and "I also want my painting to be so you can't *avoid* the fact that it's supposed to be entirely visual" (Frank Stella, 1964).[35] These attitudes prepared the road for the new orientation in the concept of art for art's sake, presented in the theory of the Minimalists, in which thingness substitutes for fame and form as the end for which their art is created.

The Minimalists amplify the meaning of thingness for them as follows. Don Judd wants his sculpture "to exist as a whole thing" [36] (1964), that is, sculpture should be self-referent and closed within itself, without stretching out an inviting hand to the spectator in the manner of Baroque art. Tony Smith is "interested in the thing, not in effects—pyramids are only geometry, not an effect," [37] that is, he is concerned solely with the object and its qualities, rejecting the retinal and haptic values so precious to the Impressionists.

Painting and sculpture are art, but they are things as well. Form is linked to the "art" part, thingness to the "thing" part; as motivations for the need and/or will to create both concepts are rooted in the work of art itself.

The following diagram traces the history of the concept of love of art as impetus to create through three different goals.

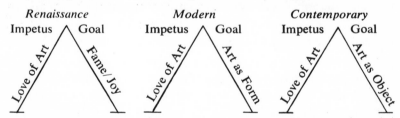

Renaissance		*Modern*		*Contemporary*	
Impetus	Goal	Impetus	Goal	Impetus	Goal
Love of Art	Fame/Joy	Love of Art	Art as Form	Love of Art	Art as Object

[33] "Art-as-Art," *Art International,* VI, No. 10 (December 1962), p. 37.

[34] "Note on Painting, October 31–November 2, 1963," *Pop Art Redefined,* ed. John Russell and Suzi Gablik (New York: Praeger Publishers, 1969), p. 101.

[35] Bruce Glaser, "Questions to Stella and Judd," *Minimal Art,* p. 158.

[36] *Ibid.,* p. 154.

[37] Samuel Wagstaff, "Talking with Tony Smith," *Minimal Art,* p. 385.

6. *The Will to Inform and the Development of Human Consciousness*

Sculpture has only then a value if it works
at the *development* of human consciousness.

—Joseph Beuys, 1964

By the 1970s, the wells had run dry; statements about the purposes of art are few and references are oblique. Perhaps the question had proved sterile. After all, at most, the answers had either uncovered personal, isolated motives or motives that were obvious. Most replies were off the point and unrevealing. Conceptualist artists (see chap. 7) declare that

> the aim of the artist would not be to instruct the viewer but to give him information. . . . The serial artist does not attempt to produce a beautiful or mysterious object but functions merely as a clerk cataloguing the result of his premise.[38]

Such statements omit saying what type of information is transmitted, and moreover, what the purpose of relaying it is.

Fortunately, some contemporary artists express these points clearly. They have taken up the cudgels for one of the oldest aims art has served: to influence current morality. This motivation had been stigmatized by the formalist schools, starting with the Impressionists. Yet it had never quite disappeared. The Dadaists and Surrealists openly criticized actions and institutions through their works. In the wake of World War II, Picasso, in 1945, defined the artist as "a political being, constantly alive to heart-rending, fiery or happy events, to which he responds in every way," and labeled painting "an instrument of war for attack and defense against the enemy." [39] Now the need to expose the inadequacies of society

[38] Sol LeWitt, "Serial Project No. 1, 1966"; reprinted in *Sol LeWitt* (The Hague: Gemeentemuseum, 1970), p. 54.
[39] Alfred H. Barr, Jr., *Picasso: Fifty Years of His Art* (New York: The Museum of Modern Art, 1946), pp. 247–248.

informs the Social Systems of Hans Haacke. It also informs the Aktionen of Joseph Beuys.

Haacke had explained his use of the word *system* in 1967:

> A system is most generally defined as a grouping of elements subject to a common plan and purpose. These elements or components interact so as to arrive at a joint goal. To separate the elements would be to destroy the system.[40]

His Social Systems followed after earlier systems (see chap. 5, sec. 6) at the beginning of 1969. They are inquiries into the behavior of groups of people, based either on questionnaires or on public documents. The results are recorded statistically and analytically. They highlight the shortcomings of the present organization of society. They do not draw conclusions; it is not necessary because anyone can do this for himself. Two such systems will be studied in chapter 7, section 3.

Haacke believes in the educative value of his systems in making society more humane, but only on a very limited scale. The artist by himself has no power to influence important issues decisively: "Information presented at the right time and in the right place can be potentially very powerful," he said in an interview with Jeanne Siegel in 1970/71.

> It can affect the general social fabric. Such things go beyond established high culture as it has been perpetrated by a taste-directed art industry. Of course I don't believe that artists really wield any significant power. At best, one can focus attention. But every little bit helps. In concert with other people's activities outside the art scene, maybe the social climate of society can be changed.[41]

Beuys's view of the artist's influence upon developing human consciousness seems more optimistic, but he doubts that everybody

[40] From an unpublished manuscript; German translation in Edward F. Fry, *Hans Haacke: Werkmonographie* (Cologne: Verlag M. DuMont Schauberg, 1972), p. 32.

[41] Jeanne Siegel, "An Interview with Hans Haacke," *Arts Magazine,* XLV, No. 7 (May 1971), p. 21.

could be reached. He believes in the malleability of man's character, which he sees as a plastic material like clay—or fat. Comparable to the plastic events in sculpting, "the development of human consciousness is itself already a plastic event." [42] For Beuys, to develop human consciousness is more precious than to develop creativity.

> One day most art students must recognize that they do not qualify as artists. But, if they become a locksmith or housewife or, as far as I am concerned, a utilitarian graphic artist, the time of their study must *(soll)* not have gone to waste. This is what I mean, when I say it is for me more important to know that somebody has learned with me how to educate his children in a better way, and less important to know that somebody has become a great artist.

However, although Beuys credits man with the potential for learning, he is not blind to the fact that not everybody can be taught: "My ideas can neither be realized through force nor deafness in face of those who cannot sympathize with these ideas on the basis of their long, [different] ideational (*weltanschaulich*) development." [43]

Few human beings possess Beuys's power to distance himself from his work and to evaluate priorities with such admirable clarity of vision.

In a survey made by two psychologists based on twenty-three interviews, nine of scientists and fourteen of artists, the following motivations are listed as the significant impulses behind creating: self-expression, release, escape from boredom and despondency, the calming of nervous tension, the desire to find an answer to the question Who am I, and the wish to make a relevant contribution

[42] "Plastik und Zeichnung," *Kunst: Magazin für moderne Malerei—Grafik —Plastik* (Mainz), V (December 1964); reprinted in *Joseph Beuys: Werke aus der Sammlung Karl Ströher* (Basel: Kunstmuseum, 1969/70) p. 13.

[43] Ernst Günter Engelhard "Ein grausames Wintermärchen," *Christ und Welt* (Stuttgart), XXI, No. 1 (January 3, 1969); reprinted in *Joseph Beuys: Werke,* p. 34.

to the world.[44] These findings are curiously similar and curiously dissimilar to ours.

Taking first the generalities, self-expression and release from pressures (to which calming of nervous tension belongs also) occur in both surveys; whereas, inversely, the play instinct and art for art's sake are ignored by both. Specifics like escape from boredom (which is some kind of pressure) is mentioned in both, but the interest in the thing (which is some kind of art for art's sake) is lacking in the survey of the psychologists; perhaps the interviewers were not familiar with this aspect of contemporary art and the omission is due to the form of questioning. Pollock's aim at self-discovery is paralleled by the query Who am I, asked of himself by a sculptor; and the great unknown, although not listed in the summary by the authors, is acknowledged by one writer who admitted: "Because, you know, that's a mystery to me . . . my own motivation." [45] On the other hand, scientific curiosity does not appear under the heading "motivation" but under "factors that facilitate and favor creativity," as a character trait of people interested in doing creative work; there it is listed together with open-mindedness, flexibility, and willingness to trust hunches.[46] Education is likewise missing but it may hide under the wish to make a significant contribution to the world.

One further interesting aspect of the study by the two psychologists is the proof of a cross-fertilization between art and science. For instance, accident, a catalyst for creativity promoted by the Dadaists and Surrealists, was claimed by one molecular chemist as the basis of a major discovery.[47] The sampling is too small and the approach of the psychologists too different from mine to permit further conclusions, such as whether self-discovery as an aim of creative persons is linked to art rather than to science.

After this glimpse of art as compared to science, we shall now

[44] *The Creative Experience,* ed. Stanley Rosner and Lawrence E. Abt (New York: Grossman Publishers, 1970), pp. 385–386.
[45] *Ibid.,* p. 148.
[46] *Ibid.,* p. 382.
[47] *Ibid.*

search for what art itself confesses through its choice of motivations.

The five reasons given by contemporary artists for their need and/or will to create have to be interpreted as the leading reasons for it, but not as the only ones; the necessity to create has many ramifications, as should by now have become clear. But deductions are based on leading causes. What is the common denominator of the five leading reasons in the things they omit as well as in those they stress?

My survey has been concerned strictly with the problem of *why* men create art, disregarding other questions linked to creativeness, such as the functioning of the creative process and the mysterious source of the power to create. These other questions are regularly discussed by psychologists but passed over in silence by artists. Yet artists must be haunted by them as much as the psychologists—if not more so. The explanation may lie in the very personal nature of these questions. In spite of his self-centeredness, Pollock was not ready to release his autobiography in full.

Three of the motivations listed by contemporary artists for their work—self-discovery, scientific curiosity, and education in sensitivity —are branches of the diffusion of knowledge. Bearing in mind the high esteem in which knowledge is held by science and the place scientific research occupies in contemporary life, there is nothing surprising in finding a parallel development in art. The fourth motivation, the cult of the object, is more puzzling. I am not sure that artists or, for that matter, art critics have been able to formulate this aim unambiguously. "The objects . . . as instruments for something," wrote Franz Erhard Walther in 1969.[48] As instruments for what? Even the art historian who has given us one of the best appraisals of the Minimalist striving for objecthood, Michael Fried, fails when he attempts to enlarge upon his initial discovery by writing, in 1967, that the "espousal of objecthood amounts to nothing other than a plea for a new genre of theatre." [49]

Thus we are left guessing whether the Minimalists' goal is to

[48] Celant, *Art Povera*, p. 174.
[49] Fried, "Art and Objecthood," *Minimal Art*, p. 125.

create any object, an aesthetic object, or an artistic object. A milk container can be an aesthetic object, but it is not an artistic object. To be aesthetic, an object must merely charm the eye. To be artistic, it also has to satisfy the mind, and that it can do only if it carries meaning for man. To remove pressures from us would fall under this heading. The milk container aims at satisfying bodily needs; Matisse's art aimed at satisfying spiritual needs. At what do the Minimalists aim? We shall return to this question in chapter 3, section 5.

The promotion of the object as a physical presence denotes a reaction against metaphysics in art. The Minimalists were supported in their research for a personal expression by Barnett Newman and his form of art; his work carries such overtones, as has been mentioned. By reacting against these, the Minimalists freed themselves from their tutor. The choice of a reaction in terms of the material, on the other hand, is in harmony with the expansion of the exact sciences after World War II.

The fifth motivation, to develop human consciousness through art, is a rejection of the overemphasis on form that started with Impressionism and produced a "mindless" art that was arrested at gratification of the senses. By itself, the use of art for moral education is almost as old as art itself. But the turn it has taken today, a repression of form—in some artists an almost total repression of form—in favor of information is probably the most radical feature of contemporary art. The will to inform has swallowed the will to form.

II

The Democratization of the Art Object

The process of the democratization of the art object has by now begun.

—Victor Vasarely, 1965

The democratization of the art object is a remedy for bridging the rift between the artist and his public. Who in the world of art has not heard of that rift which, supposedly, opened some hundred and fifty years ago? More likely, a gap was present throughout the centuries, but it passed unnoticed until it affected the artist. When a new social class, untrained in visual experiences, replaced the former rulers, who had for generations been taught to read the language of art, the nonunderstanding became a question of survival. Since some artists catered to the taste of the public, a dichotomy in types of art developed, official and avant-garde. This state of affairs placed

great hardships upon the artist remaining true to his convictions: it deprived him of spiritual and physical aid in his work—of encouragement through lack of recognition and of financial means through want of patrons. Lately, art has tried to cure this evil by training the public's eye.

The attempt to achieve "a breakthrough in the Art—General Public contradiction" [1] was launched by contemporary European artists. They turned to three different methods for reaching the audience.

1. *Active Spectator Participation*

The spectator is drawn into an
active participation.

—Yvaral, 1965

One method consists in having the spectator participate actively in the spectacle presented to him. Spectator participation has always existed in art: by looking at a work, you share an experience with the person who has made it; this is as true of the Renaissance as it is of today. What is new in the relationship between spectator and spectacle in contemporary art is either that, without our presence, the spectacle lives only as a potential and not as an actual fact or that the artist goes out of his way to provoke the spectator's interest in art. Thus the accent is placed upon the words *active* and *activate,* and either the viewer is made an integral part of the visual experience offered by the artist, or he is enticed into noticing it.

Forerunners of today's principle of active spectator participation can be found among the Dadaists. In April 1920, Jean Arp, Johannes Theodor Baargeld, and Max Ernst opened a show in Cologne they called "Dada Early Spring" ("Dada-Vorfrühling"). True to the Dada spirit, the site chosen was the closed-in courtyard of a

[1] Groupe de Recherche d'Art Visuel, Paris 1966; reprinted in *Julio Le Parc* (New York: Howard Wise Gallery, 1967), unpaged.

Bierkeller in the center of Cologne, which could be reached only by going through the men's room. The visitors to the exhibition thus fell into two categories: art devotees, arriving by design, and beer fans, dropping in by accident after attending to nature. Once in the courtyard, the audience was greeted by a young girl, dressed in white as though for first communion, who recited obscene poems. Thus provoked, the visitors were then given the opportunity of letting off steam. Among the works on view was an object by Dadamax Ernst, in very hard wood, to which a hatchet was chained, inviting the viewers to hack it to pieces. No one did, however, although the fury of the public, both art lovers and beer drinkers, reached a dangerous level, and other works, demanding less of an effort to destroy, were smashed. They called the police who closed the exhibition—until it was discovered that the item arousing the ire of the complainants was an etching by Albrecht Dürer (subject unrecorded). The exhibition was reopened under the name "Dada Wins." [2]

Unlike Ernst's object, Man Ray's *Object to Be Destroyed,* made in Paris in 1923, is an unplanned Dadaist contribution to active spectator participation. When the 1936 exhibition of "Fantastic Art, Dada, Surrealism" was shown at The Museum of Modern Art, New York, it contained an ink drawing of this piece (Fig. 2), then belonging to the father of Dadaism, the Romanian poet Tristan Tzara, which, in a notation on the back, advised how to proceed with the destruction: "Cut out the eye from a photograph of one who has been loved but is not seen anymore. Attach the eye to the pendulum of a metronome and regulate the weight to suit the tempo desired. With a hammer well-aimed, try to destroy the whole with a single blow." These instructions were, however, addressed to himself and not to the spectator. As the artist tells in his autobiography written in 1963: "I really intended to destroy it one day, but before

[2] Georges Hugnet, "The Dada Spirit in Painting," *The Dada Painters and Poets: An Anthology,* ed. Robert Motherwell (New York: Wittenborn, Schultz, 1951), p. 159 (translated from *Cahiers d'Art,* 1932–1934); Hans Richter, *Dada: Art and Anti-Art* (New York: McGraw-Hill Book Co., 1965?), p. 162.

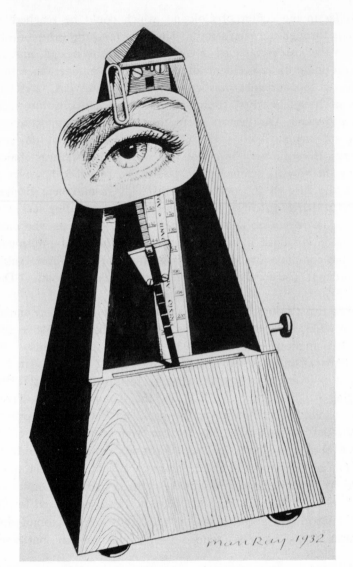

2. Man Ray: *Object to Be Destroyed*. 1932. Ink drawing. 11½″ x 7¾″. Mr. and Mrs. Morton G. Neuman, Chicago. Photograph: The Museum of Modern Art, New York.

witnesses or an audience in the course of a lecture." [3] In other words, the *Object to Be Destroyed* was not intended as bait for the spectator, but as a demonstration by the artist, a ritual execution. But Man [Ray] proposed and God disposed: unintentionally "Dadaman" was successful where Dadamax had failed. In 1957, the *Object to Be Destroyed* was shown in a retrospective of early Dada work in Paris. One day this exhibition was invaded by a group of Beaux-Arts students who distributed leaflets to protest against this type of art. Then they dismantled the exhibition by placing all items on the floor—all, except the *Object to Be Destroyed* and another Man Ray exhibit. The latter was recovered, riddled by bullets and marked by footprints; the *Object to Be Destroyed* disappeared. With the insurance money he collected, Man Ray made a second version of the lost piece, retitling it *Indestructible Object*.

In passing it may be noted that, a few years later, another descendant of the Dadaist "invitation to destroy" was honored by spectators: Jim Dine's *Hatchet with Two Palettes No. 2* (1963), a canvas and a plank to which a hatchet is chained. Spectators used one on the other in the exhibition "For Eyes and Ears" held at the Cordier and Ekstrom Gallery, New York, in 1964. [4]

The difference between the Dada exercises in active spectator participation and the efforts of contemporary artists is that the goal of the first was not to incite us to try our hand at creative work so that a bond of empathy be formed between art and viewer, on which fertile ground sensitivity to art can grow to maturity: the Dadaist objective was to combat apathy and provoke us to wrath. Hence it was of no consequence who wielded the ax. The Dadaists worked through destruction; contemporary art works through construction.

Forerunners to active spectator participation in this positive sense can be cited also. El Lissitzky's *Abstract Gallery* (executed in

[3] Man Ray, *Self Portrait* (Boston: Little, Brown, 1963), p. 389. The subsequent story of the object is told on pp. 389–392.

[4] Nicolas and Elena Calas, *Icons and Images of the Sixties* (New York: Dutton Paperbacks, 1971), p. 92.

two examples in 1926 and 1927–1928 in Germany) is the most relevant influence. It exhibited the pictures in shallow cases with movable covers that could be pushed aside by the viewer, who thus arranged his own exhibition (Fig. 36b, p. 231). Active spectator participation is only one of the pioneering ideas it embodied (as will be shown later). In the United States, Louise Nevelson's 1945 exhibition, "The Circus," at the Norlyst Gallery, New York, used the principle of active spectator participation in a positive sense. In it, circus posters on the walls formed the environment for (*a*) the artist's wooden sculptures of animals, *The Menagerie,* (*b*) the public (considered an integral part of the exhibition), *The Crowd Outside,* and (*c*) a sculpture, *The Clown Is the Center of His World.* Children visiting the exhibition were encouraged to play with the animals as with blocks.[5] Nevelson confined spectator participation to children. However, what disqualifies her invitation to participation as true active spectator participation in art is not so much this fact as that her education is achieved through touching *her* works instead of creating art oneself. Lissitzky's education in art was more advanced. Although it did not lead to the creation of individual works either, it did not exclude creativity altogether: art exhibits were composed.

True active spectator participation surfaced in Europe at about the same time Man Ray's *Object to Be Destroyed* was lost. True active spectator participation was put forward as an artistic principle by the Groupe de Recherche d'Art Visuel (GRAV), an association of artists organized in Paris in 1960 and disbanded eight years later. But the idea had been practiced previously by members of GRAV. It spread to other artists all over the world. Several simple and effective means to woo the viewer were devised.

He might be drawn into active participation by an offer to *manipulate* the work. This thought goes back to the Israeli artist Yaacov Agam, a founding member of GRAV who, in 1952, pre-

[5] Dorothy G. Seckler, "The Artist Speaks: Louise Nevelson," *Art in America,* LV (January–February 1967), p. 41.

sented boards upon which a predetermined unchangeable number of detachable units were inserted by means of pointed pegs, permitting the spectator to rearrange them at will, but neither to add one nor to subtract one. In traditional art, the artist would make several separate versions of an image; now the versions can be done within one frame and by anybody. Agam considers this type of work a fuller aesthetic experience because "an idea appears closer, more expressive to us, if we can grasp its multiple aspects." [6] The reason for arresting the number of elements is to forestall the viewer from arriving at a bad gestalt. The artist's task is to find shapes that will hold together, no matter what way they might be disposed by the spectator. It may be noted that the artist is thus the invisible guide or instructor of the viewer. Agam called these works *transformable paintings*. For reasons unknown, he abandoned this type of work the next year, starting another experiment in spectator involvement. However, although dissatisfied with the first approach in painting, the artist has continued to use it in sculpture (see Fig. 23, p. 169). New Yorkers are familiar with an example of such sculpture, since his *Three Times Three Interplay* (1970–1971) faces them on the terrace of the Juilliard School of Music at Lincoln Center.

The new type of painting to which Agam turned in 1953 rules out handling by the viewer and substitutes the viewer's *walking* for it. The spectator's pacing from right to left in front of the picture, or vice versa, brings the image to life; it shifts in composition like a series of motion-picture stills. That is, looked at from a position at the left, the picture presents a different formal configuration from that seen when one is standing at the right end. Quite properly, Agam named these works *metamorphical paintings*. The cinematographic transformations that the picture undergoes when the spectator moves catch his eye and engage his attention, involving him in the picture. This mental involvement cannot be separated from the physical involvement with which it interacts.

[6] *Yaacov Agam*, ed. Marcel Joray (Neuchâtel: Éditions du Griffon, 1962), p. 60. Examples of transformable paintings are shown in Figs. 9, 10.

Likewise, the manipulation of the transformable paintings cannot be separated from the search for a new form in their composition.

Yet, unlike what happens in the transformable paintings, active spectator participation has taken a step backward with metamorphical paintings. The initiative is taken out of the observer's hands; from creator he is demoted to cooperator.

Why was the education of the spectator through the trial-and-error method in painting shelved by Agam once he had discovered it? Didn't we measure up to the responsibility placed upon us? Was the artist unable to control the results properly? Was he unwilling to abdicate his status of singularity—a genius among ordinary beings? Whatever the reason for this volte-face, active spectator participation is a by-product rather than the objective in metamorphical paintings. The main issue is to introduce a new element into art, kineticism, and, on this basis, create a different art form. This problem belongs to another chapter of contemporary art.

Any kind of movement, virtual or true as in Agam and Tinguely (Figs. 23f, 50, pp. 169, 325), will attract the eye, arouse interest, and hence activate spectator participation. Whether or not the involvement of the viewer is the primary or the secondary goal of the artist must be studied from case to case. The same is true of the surprise element, another means to court attention. However, when the two devices, movement and the unexpected, are combined for the specific purpose of coaxing the viewer into cooperation with the artist, they inevitably succeed: they fortify one another to form a quasi obstacle in the path of the passerby. This thought of involving us by *obstructing* our route was also used to advantage by the Groupe de Recherche d'Art Visuel in an art exhibition they staged in Paris on April 19, 1966, called "A Day in the Street" ("Une Journée dans la rue").[7] Unfamiliar objects were placed upon streets

[7] Pierre Restany, "Quand l'Art descend dans la rue," *Arts et loisirs,* No. 31 (April 27–May 3, 1966), pp. 16–17; Groupe de Recherche d'Art Visuel, *Opus International,* I (April 1967), pp. 38–45.

well known without these ornaments. These forcibly caught the eye of the passerby.

If the friendly opposition is to be believed, the gods frowned upon the venture: it was a wet Tuesday—the proverbial April showers. Yet, there must have been sufficient breaks in the rain, because the photographs do not record it. GRAV had positioned its exhibits at strategic points along the habitual daily routes of Parisians and non-Parisians: the Chatelet, Champs-Élysées, Opéra, Tuileries Gardens, Saint-Germain-des-Prés, Montparnasse, and the rue des Rennes in the Latin Quarter. From eight o'clock in the morning until midnight the artists moved from position to position at two-hourly intervals, always being there where the densest crowd could be expected at this particular moment. They tried to reach one and all of the population: working class and leisure class. office worker and housewife, student and visitor. Eight o'clock at the Chatelet: Too early for critics and photographers; the happenings remained unrecorded. Ten o'clock at the Champs-Élysées: The visitor was introduced to art. Foreigners and provincials sight-seeing in the famous avenue were invited to construct a man-sized sculpture from a group of Plexiglas units. Parisians were also welcome to try their hand at it. Noontime at the Opéra: A round pavilion was set up on a landing of the steps. It consisted of a slender, metallic column supporting a disk-shaped metallic roof from whose periphery a curtain of nylon thread was suspended. Within, a charming Parisian girl in a striped outfit was a spectacle geared to the fastidious taste of the elite who frequent this fashionable site. Two o'clock in the Tuileries Gardens: Here a kaleidoscope with trick reflections, and a gleaming square sheet, whose center was cut into a spiral that could be pulled out to form a capricious frame for a living sculpture, were installed to gladden the children playing in the park. Adults also enjoyed these experiences. Four o'clock at Saint-Germain-des-Prés: Appeal to the churchgoer and student body with manipulable works; a relief with moveable units for the first; eyeglasses that elongated familiar objects into Giacometti-like figures and buildings, and sandals mounted

on spirals or with platform soles (not yet known as "platforms"), for the second. Six o'clock at Montparnasse: In front of the Café de la Coupole, the well-known Parisian artists' haunt, wooden blocks with uneven bottoms were laid out, which presented a challenge for testing your power in keeping your equilibrium. The users wobbled insecurely on the mobile slabs. Eight o'clock at the rue des Rennes: Juggling with balls in the night was offered to the eternally young, that is, to those ever-open to new experiences. A photograph recorded two men successfully balancing a giant sphere with the help of two closed umbrellas. At each of these sites questionnaires were handed out to gauge the public's reactions. To judge by their expressions most spectators were delighted, some puzzled.

The special value of this approach is that it compels the uninterested as well as the interested to pay attention. Therefore this method thrusts art into the view of the uninvolved. Even when the obstructing object is displayed in a museum, it may bring itself to the attention of the unconcerned visitor because it may stand in the way to his favorite gallery. GRAV had also inaugurated an indoor program of blocking the passage of the viewer in order to stimulate him to an active participation in art. In fact, bringing art to the streets postdates the indoor attempts that used for their purpose a series of connecting rooms, called by GRAV *Labyrinth*.

Labyrinth No. 1 (Fig. 3a) was shown in the Third Biennial of Paris in 1963. It was only one of a number of collective presentations in this exhibition, whose main characteristic was the prevalence of communal workshops. What one critic, Jean-Jacques Lévêque, called "poetic sites" were created by these groups coming from many different countries. Lévêque compared their achievements to those of Charles Le Brun who organized the royal festivities with the help of a group of artists in the reign of Louis XIV. But Le Brun was the head of a workshop, not a member of a team. In viewing a poetic site, "one does no longer look at a work, one must enter within it," Lévêque wrote, "you should not read it with

3a. Groupe de Recherche d'Art Visuel: *Labyrinth No. 1*. Plan. 3ième Biennale de Paris, 1963. Approx. 8′ x 70′ x 10′. Musée Municipal de l'Art Moderne de la Ville de Paris.

the intellect, instead you are impregnated by it." [8] By stepping into the room, the spectator exposes himself to its aura, which he is forced to absorb. GRAV called this phenomenon creating "a situation."

Labyrinth No. 1 consisted of a sequence of seven rooms, totaling approximately seventy feet in length (21 m.), each room about ten feet wide (3.14 m.), and approximately eight feet high (2.5 m.). Most rooms were preceded by a corridor, cut off from their sides, which prepared for the new experience. Three rooms had a niche-like space inserted in their middles. Through the corridors, the niches, and the disposition of the doors, the course of the viewer was laid out in a meander. That was not a must, however. In 1965, a different type of labyrinth was shown at the Contemporaries Gallery in New York: *Labyrinth No. 3* was arranged in a U-shape (Fig. 3b).[9] Be this as it may, in each room certain types of objects created the specific situation to which the attuned viewer responded.

Several modes of thought intersect in the presentation of such labyrinths: the prescribed route, the integration of architecture and artworks, the surprise element, the collective effort, the beguiling of the spectator, and the presentation of a spectacle. Not all of these ideas were new at that time, but the combination was. When these ideas reappear in the works of other artists, they recombine differently and further ideas are present, displacing the accent from active spectator participation to some other aspect, as shall be seen below.

The United States was introduced to active spectator participa-

[8] Pierre Cabanne, Raymond Charmet, Jean-Jacques Lévêque, Michel Ragon, and André Parinaud, "La 3ième Biennale de Paris, une porte ouverte sur autre chose?: une critique," *Les Arts,* No. 930 (October 2–8, 1963), p. 10. The use of the word *impregnated* may come from Yves Klein, see p. 87.

[9] The description of the *Labyrinth* can be found in the exhibition catalogue of the Paris Biennial, 1963, pp. 164–168. The exhibition at the Contemporaries Gallery is reviewed by J. G[rosberg], "In the Galleries: Groupe de Recherche d'Art Visuel," *Arts Magazine,* XXXIX (April 1965), p. 61, and by M. B., "Reviews & Previews: Groupe de Recherche d'Art Visuel de Paris," *Art News,* LXIV (April 1965), pp. 19–20.

swinging balls
with reflections

discs to spin

faceted
mirror

reflected
discs

GAMES ROOM

water bath
with varying
reflections

balls on
springs

meshes in
movement

unlevel
passage

swinging balls

reflecting
walls

view onto
passage

virtual images in
a truncated pyramid

visual
aggression

view through
hexagon

mesh sphere
and projection

partition
reflecting mobile

light wall

opening

string in
periodic
undulation

lights on
springs

blue signal

transformations
through
transparencies

sources of
variable light

visual
acceleration

visual acceleration
wall

luminous signal
in movement

transformations through transparencies

3b. Groupe de Recherche d'Art Visuel: *Labyrinth No. 3*. Plan. Con-
temporaries Galley, New York, 1965. From *Image,* 1966.

tion in a particularly successful way through Robert Rauschenberg's witty *Black Market* (1961), now in the Ludwig Collection, Aachen and Cologne.[10] The viewers are facing a panel containing a One Way traffic sign, under which hangs a series of "mailboxes"; a "strongbox," which can be opened and closed by anybody, stands on the floor below these. As suggested by the title, we are invited to conclude transactions. We can place orders in the mail drop, or effect the exchange of goods by taking an object from the box on the pavement. If anything is taken out of it, the value must be replaced in merchandise or money. The other party to this business is unknown. Through active spectator participation *Black Market* is in constant transformation; it is impossible to guess what the viewers will find when they see it the next time.

The brilliance of this invention seems to have had a dampening effect on American use of the concept of active spectator participation. When it appeared in the following years with Claes Oldenburg and the leaders of Minimal art, Robert Morris and Donald Judd (Figs. 21, 22, 38, pp. 161, 165, 243), it took forms different from the European one. Oldenburg's use of foam rubber for soft sculpture and Morris' rope constructions and felt works *force the exhibitor* to make a choice of form for the object when he sets it up, as well as inviting the viewer to reshape it when he sees it. More on these works in chapter 4, section 5.

The other American form of active participation was an invitation to creation, in the vein of Agam. It was inaugurated by Morris in 1965, when he started making several series of identical, solid, geometric shapes that could be regrouped at will into a sequence or a scattered arrangement, a continuous piece or a broken-up group, a unit in which all pieces are identically posed or some are reversed, and an isocephalous or a tiered group. Two years later, in 1967, Morris applied the same principle to series of box-shaped units and series of partitions, that is, hollow and two-dimensional works. He also created transformable pieces composed of segments,

[10] Andrew Forge, *Rauschenberg* (New York: Harry N. Abrams, 1969), p. 80.

mainly wedge-shaped, which added another choice for the regrouping in that these pieces could be arranged as open-ended or closed units. Morris discovered the wedge-shaped form through "the very mundane matter of having to deal with sculpture that's large, because you'd have to make a research to get it through the door." [11] These works solicit the active participation of the *owner* rather than that of the general public, because the pieces are too heavy to be shifted around by the casual gallery or museum viewer.

The solutions discussed for coaxing the spectator (or owner) into taking note of art—invitation to creation, handling, involvement by motion, attraction by the unexpected, provocation by obstruction (coercion through the nature of the materials)—do not exhaust the problem; but they suffice to illustrate it. The reader will experience more pleasure in uncovering other methods by himself than in finding them listed here.

2. *The Devaluation of Uniqueness*

> The question of the uniqueness of
> the work of art . . . has been raised.
>
> —Victor Vasarely, 1964

Another way to heal the estrangement between the artist and the general public is to educate the latter's sensibilities by making good art objects available to larger groups of the population through serial production.

The idea of serializing artworks is not new: in the form of bronze casts in sculpture and prints in graphics, it has existed for a long time. Moreover, there have been famous painters who did not shy away from copying themselves—El Greco, Chardin, or Daumier, for instance. We also know of factories that executed works accord-

[11] From a conversation recorded by the BBC in New York in 1967; reprinted in Michael Compton and David Sylvester, *Robert Morris* (London: The Tate Gallery, 1971), p. 14, ill. pp. 68, 70–79. The parallel development in Donald Judd cannot be discussed for lack of a catalogue.

ing to the designs of the workshop head, the same way that Victor Vasarely and Andy Warhol operate today. What is new in contemporary art is not the multiplication of a masterpiece, but the devaluation of the concept of uniqueness. Peter Paul Rubens, when he sold a work, always specified whether it had been done by himself or by members of his studio, and charged accordingly. He delegated execution as an expedient, because he had no time to do everything himself. When Warhol, all of whose paintings in 1967 were copied from his one original by his assistants, "like a factory would do," [12] states: "I think somebody should be able to do all my paintings for me," [13] he expresses a *wish* for what had been a necessary evil to Rubens. "The masterpiece is no longer the concentration of all the qualities into *one* final object but the creation of a *point-of-departure-prototype,* having specific qualities, perfectible in the progressive numbers," we are informed by Vasarely in 1964.[14] In a more radical approach, the appreciation of uniqueness is declared a prejudice linked to overcherished ownership, which prejudice the multiple can help to overcome because: "To own a work of art is less likely to turn into an obsession (*aliénant*) if a hundred persons possess the same work." Thus multiples are contributing "to desacralizing the unique work, to remove from it its character of fetish-object and of pretext for speculation." [15]

The term *multiples* distinguishes contemporary serial works produced by contemporary industrial and commercial techniques from serial works produced by traditional methods.[16] The word goes

[12] *Cahiers du Cinéma,* English ed., X (May 1967), p. 40.
[13] Gene R. Swenson, "What Is Pop Art?, I," *Art News,* LXII (November 1963), p. 26.
[14] *Vasarely,* I, ed. Marcel Joray (Neuchâtel: Éditions du Griffon, 1965), p. 36.
[15] Groupe de Recherche d'Art Visuel, "Multiples," *Julio Le Parc,* (Paris: Galerie Denise René, 1966), unpaged.
[16] On this subject see: *Ars multiplicata: Vervielfältigte Kunst* (Cologne: Wallraf-Richartz Museum, 1968); *3 →∞ : New Multiple Art* (London: Whitechapel Art Gallery, 1970/71); John L. Tancock, *Multiples: The First Decade* (Philadelphia: Philadelphia Museum of Art, 1971); *Technics and Creativity: Gemini G.E.L.* (New York: The Museum of Modern Art, 1971).

back to Denise René, the Parisian gallery owner in whom Vasarely, the Groupe de Recherche d'Art Visuel, Constructivist artists, and Kinetic artists found a patron. In 1966 Mme. René invented it to designate the new type of serial works produced by her artists. Yet, the history of multiples antedates that year.

The groundwork for the development of multiples was laid by two groups: William Morris and the Bauhaus, on the one hand, he blurred the distinction between art and artifact, the Bauhaus furthermore crusading for bringing art to the masses through factory production; Marcel Duchamp and Man Ray, on the other hand, who thumbed their noses at the high seriousness of art. The contribution of the first two can be summed up in the creation of an atmosphere conducive to the production of multiples. The contribution of the second two went further: they made the first quasi-multiples, duplicates, and multiples.

Duchamp started the development in 1916 by duplicating his *Bicycle Wheel* (1913). Since then, he has happily multiplied most of his Readymades. Man Ray's first duplicate was his *Lampshade,* sent to the first exhibition of the Société Anonyme in 1920. Accidentally, the paper of the lampshade was torn apart and thrown away by the museum's janitor, who mistook it for wrapping paper. When Katherine Dreier, one of the founders of the Société Anonyme, and Man Ray discovered the mishap on the morning of the day before the exhibition was due to open, the artist immediately went to a tinsmith, traced a pattern on a sheet of metal, and had him cut out the design. Then he twisted the metal into the form of the lost paper shade, and painted it with flat white paint. After the exhibition, the metal lampshade was bought by Ms. Dreier. But Man Ray "duplicated it a dozen times for other exhibitions. I have no compunction about this—an important book or musical score is not destroyed by burning it," he tells us.[17] He also duplicated other works that visitors destroyed, by accident or design, as has been seen.

[17] Man Ray, *Self Portrait,* p. 97.

Although not strictly speaking multiples but rather alternate versions, Duchamp's *Nude Descending a Staircase No. 3* (1916), and László Moholy-Nagy's five pieces of enamelware (1922), have a bearing upon the history of the new art form. Both were created by untraditional methods—methods to be legitimized for the production of multiples in times to come. Through the *Nude,* Duchamp took a swipe at the autograph in painting. His patron, Walter Arensberg, expressed a wish to possess the famous picture shown in the famous Armory Show of 1913, but he was unable to buy it. Duchamp obliged him with a copy of the work in the good old-fashioned artist-customer tradition; but the execution of the copy bore the signature of Duchamp's sharp wit. He took a photograph of the picture, colored this base in steel-blue and gray, and inscribed this piece "Marcel Duchamp (Fils) 1912 1916." [18] Arensberg had his substitute.

Once the principle of depersonalization of the masterpiece had been posed and accepted, it could be carried to extremes. This was done by Moholy (who disliked being called Moholy-Nagy). He created a series of works by remote control, even before he became a member of the Bauhaus. He ordered, by telephone, from a sign factory, the execution of five paintings in porcelain enamel, pinpointing the positions of the shapes in the field, and their colors, by reference to a squared graph paper, and the factory's color chart. "He [the man in the sign factory] took down the dictated shapes in the correct position. (It was like playing chess by correspondence.) One of the pictures was delivered in three different sizes, so that I could study the subtle differences in the colour relations caused by the enlargement and reduction." [19]

In spite of the fact that the road for the creation of multiples had been prepared in the 1920s, it was not until several decades later, after World War II, that multiples got under way seriously. Even

[18] Robert Lebel, *Marcel Duchamp,* new ed. (New York: Paragraphic Books, 1967), p. 39, Pl. 52, No. 89.
[19] László Moholy-Nagy, *The New Vision and Abstract of an Artist,* 3rd rev. ed. (New York: Wittenborn & Co., 1946), p. 73.

then the start was a slow one. The first systematic attempt was made by Daniel Spoerri, a multifaceted person active in the theatre, dance, literature, and art. In 1959, Spoerri created the Multiplication d'Art Transformable (MAT). Studying the possibilities of the new medium, he concluded that some works lend themselves to reproduction, others to multiplication. To the first category belong works that are based on personal handwriting. To the second category belong works that incorporate movement, virtual or true, released by the spectator or by a motor: because such works have more than one face, they would not be weakened by duplication. Spoerri therefore approached Denise René, the dealer who promoted Kinetic art. She refused her cooperation, feeling that the market was not yet ready for this experiment; the public had to accept the new kind of art before it would sell in multiples. Her judgment proved correct. MAT did not move. Moreover, the egalitarian principle that every work should cost the same proved inapplicable: the old guard sold (Albers, Duchamp, Man Ray, Vasarely), the newcomers did not (Agam, Bury, Gerstner, Mack, Munari, Soto, Tinguely, etc.).

Spoerri's experiment was revived in 1964 by the gallery Der Spiegel in Cologne, in collaboration with the artist Karl Gerstner. Since then, multiples have established themselves firmly in the art market, and even set off as a chain reaction the opening of special galleries, such as the Multiples Inc. art gallery, New York. Particularly, the most recent years saw a number of exhibitions devoted to this theme: Cologne in 1968, London in 1970/71, Philadelphia and New York in 1971. The catalogues accompanying the exhibitions offer a good picture of the broad range in names and styles that are represented in multiples today. They also provide space for venting opinions on the advantages and disadvantages of multiples. Those in favor claim three points: (*a*) The uniqueness of the work of art encourages speculation, which profits only dealer and collector; multiples will free art from commercialism. (*b*) Multiplication will bring aesthetic enjoyment to the masses. (*c*) Art must reflect its own time; our civilization is based upon mass production.

I find these arguments defective in logic and so does Janet Daley who has voiced her objections in the catalogue of the London 1970/71 exhibition, "3 → ∞ : New Multiple Art." Much that I shall say comes from her article. Interestingly, the Groupe de Recherche d'Art Visuel, whose artists are inspired by socialist ideals, also considers multiples a mixed blessing. Noting the disadvantages and predicting the undesirable side effects of the new medium, they advocate temporary use as a stopgap only.[20] Here are the objections.

(1) Far from removing art from the orbit of speculators, multiples have put the work of art as a commercial object within the reach of more art dealers, thus tightening the stranglehold upon the artist. The cure for the problem is not to do away with uniqueness, which has little to do with the problem, but to do away with the commercial structure of transactions, which created the problem in the first place and nourishes it. Expose the commercial spirit for what it is, and, hopefully, it will be checked.

(2) Perhaps the only success multiples achieved is to have democratized art. But the value of this success is questionable. Bad as well as good art can be reproduced or multiplied; moreover, prices for multiples of established artists soared to levels that made them inaccessible to the public at large. So the democratization of art through multiples helped little in providing good art.

(3) The assumption that mass production is the governing factor in our civilization, or even one of them, remains to be proven. The assumption that art must express mass production by using its *method of operation* is certainly false. By doing this, art endangers what constitutes its essence: symbolic language. Art should *mirror the spirit* of mass production, not use its techniques. That does not mean mechanical processes should be tabooed; one extreme is as false as the other when posited as a rule. Technology can be used by art, but with due caution. It should be the means of art, not its goal.

The arguments against mass production brought by Ms. Daley are

[20] Groupe de Recherche d'Art Visuel, "Multiples," unpaged.

numerous, but they may be summed up in her posing and answering the question: what is the influence of mass production upon man? I can find no better way to drive home the truths she exposes than by letting her speak for herself:

> Have our ways of perceiving and appreciating been systematically altered by mass-produced throw-away goods? Are there values (concerned with the validity of personal vision and individual commitment) which the artist should seek to perpetuate in the face of a growing trend toward depersonalization? . . . If dehumanization and lack of faith in the individual consciousnesss is (or will be) the prevailing cultural condition, then artists should be the last to jump gleefully on the bandwagon. Our need for them in their traditional role as unique visionaries is more urgent than ever. What must be considered is this: mass produced art with its rejection of the artist in his role as visionary in preference to the supposedly less elitist (because more mundane) one of designer, obliterates the distinction between art and interior decoration. When artists are nothing more than decorators, they are, virtually by definition, tame, acquiescent handmaidens of the social status quo. Banished forever is their capacity to transcend (and rebel against) the moral expectations and limitations of the world which they inhabit and interpret. Society gains a plethora of new ornaments and loses a potential fifth column.[21]

Ms. Daley differentiates between art and artifact, visionary artist and decorator. To anyone in sympathy with her point of view, it is obvious what she means. However, there are those who do not share her feelings. For them, a clarification is necessary. And here I find myself caught, appreciating her wisdom in abstaining from an elaboration. For it is difficult to define the difference without recourse to metaphysics. Arthur Miller has the following to say on the subject: "By whatever means it is accomplished the prime business of a play is to arouse the passions of its audience so that by the route of passion may be opened up new relationships between a man and men, and between man and Man."[22] In other

[21] Janet Daley, "Anti-multiples," $3 \to \infty$: New Multiple Art, pp. 3–4.
[22] Arthur Miller, "On the Audience," Playbill Magazine, IX, No. 12 (December 19, 1972), p. 21.

words, if the work grips you, it is art. It may be added; if it pleases you, then it is an artifact. But what happens if the passions aroused are of the wrong kind? Let us approach the problem from another angle.

What is the purpose or usefulness of art for man? I see two aspects: to bewitch the senses and to educate the mind. The enthrallment of the senses is produced by the shapes, the colors, and their combination into a design. If a work stops at enchantment of the senses, it is an artifact. Artifacts can be beautiful, indifferent, or ugly. The education of the mind is effected through three means: by telling us something about mankind through the choice of form and content; by yielding documentary knowledge; or by elevating the spirit through new visions, through the transformation of the commonplace into a fairy tale. All of these can set off the electric shock that shakes the viewer to the foundations of his being in a really great work, because understanding, knowledge, and visions enlarge the being. If a work educates man, then it is art, not an artifact.

3. *The Spectacle as an Article of Mass Consumption*

> . . . works . . . become . . . an article of
> mass consumption, a spectacle.

—Nicholas Schoeffer, 1963

Every work of art is a spectacle, because it is a visual experience, a feast for the eyes. More specifically, Meyer Schapiro used the word *spectacle* in connection with the themes of Édouard Manet, Edgar Degas, and the Impressionists: their theatrical scenes, cabaret shows, circus performances, ballets, and races, perhaps also landscapes.[23] In Schoeffer, the meaning of the word is not taken from the vocabulary of the visual arts, but from that of art in general. By *spectacle,* in his sense, is meant a composite show, addressing

[23] From class lectures at Columbia University, 1952.

itself to several senses at once through the inclusion of sounds, and taking place in time through the changing sequence of visual images. Moreover, the visual effects need not be confined to line, shape, and color; fireworks of artificial light, ballets, television shows, and so on can be introduced. From an object of contemplation, the work of art is transformed into a kinetic show. On the other hand, the spectacle can also consist of one single element, say a hologram produced by laser beams. Thus the range of the spectacle is very broad and varied in contemporary art.

When is an exhibition a spectacle? The dividing lines have become fluid. It is neither length nor diversity that is decisive, but the quality of being something notable—spectacular. The labyrinth of the Paris Biennial invited the public to active participation. As some people responded, they transformed the exhibition into a spectacle, for themselves and for the watchers. The same is true of Niki de Saint-Phalle's *hon—en katedral* (*She—a Cathedral*), executed in collaboration with her husband Jean Tinguely, the Swedish artist Per-Olof Ultvedt, and five young assistants at the Moderna Museet, Stockholm, in 1966, at the invitation of the museum's director, Pontus Hultén.[24]

Unlike the preexhibition planning that went into *Labyrinth No. 1,* the team of Saint-Phalle, Tinguely, *et alia,* worked at that time with ad hoc decisions. *She* was conceived, constructed, displayed, and destroyed, except for the head, at Stockholm; the head was sent to the Old Prison of the city. The destruction was part of the program, a gesture against the tradition that a thing of beauty is a joy forever. However, this approach to an exhibition was also an adjustment to the fact that there were no funds for the transportation of works of art.

She was one of Ms. de Saint-Phalle's overblown female figures, so unaccountably charming through their special brand of vulgarity. This one, subtitled *a Cathedral* was hollow inside. (Is this a veiled attack on the Catholic religion, which considers the Virgin Mary to be a symbol of the Church?) A giant eighty-two feet long, thirty

[24] *hon—en historia* (Stockholm: Moderna Museet, 1966).

feet wide, twenty feet (or three stories) high, and weighing six tons, the figure was lying on its back on the floor of the museum's entrance hall, filling it almost to capacity (Fig. 4a). Construction took forty days.

First, a skeleton of steel tubes was set up, connected by chicken wire, and the whole was covered with glue-impregnated linens that were painted in patterns of bright colors; Claes Oldenburg referred to *She*'s costume as a "bathing suit."[25] Second, the interior was shaped into an intricate system of humorous displays by Tinguely and Ultvedt. What made the figure so irresistibly funny was the incompatibility of its parts: they were taken from three different realms, age-old mythical symbols for love and sex being placed next to simulations of human organs in the form of machines, both hobnobbing with the attractions of today's Fun City.[26] Knees drawn up and thighs spread apart as though she were about to give birth, *She—a Cathedral* challenged the spectator to laugh at the overdose of psychoanalysis fed to us by too zealous and too serious-minded Freudians; to laugh at the mysteries of religion, which misled so many into obscurantism and fanaticism; and to laugh at man's vain pursuit of pleasure in darkened bars and lovers' nooks, at his gullibility in accepting shams and fakes as the genuine articles.

The access to the figure's body was through its genitals, dubbed by Tinguely the "portal of life"; it was reached by a flight of steps (Fig. 4b). Admission was regulated by a traffic light. While waiting for green to flash on, the viewer could read, on the left leg, the famous admonition of the Order of the Garter: "Honi soit qui mal y pense." Both steps and doors are well-known Freudian symbols, and the device of the order could be reinterpreted as a Duchampesque pun on the American endearment "honey," meaning darling, which here would be particularly appropriate as a diminutive of Hon—Hon-Honi equaling Charles-Charlie phonetically. Such a pun, "Beloved be the one who has evil thoughts," daringly reverses the meaning of the motto.

[25] *Ibid.*, p. 167.
[26] Ulf Linde, "A Giant among Women," *ibid.*, p. 140.

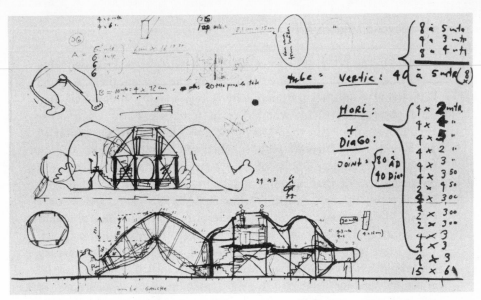

4a. Niki de Saint-Phalle *et alia: She—The Cathedral.* 1966. Drawing.
From the exhibition catalogue.

4b. Niki de Saint-Phalle *et alia: She—The Cathedral.* Installation in
Moderna Museet, Stockholm. Linen, steel tubes, wire. 20′ x 80′ x 30′.
Photograph: Hans Hammarskiold/Tio, Stockholm.

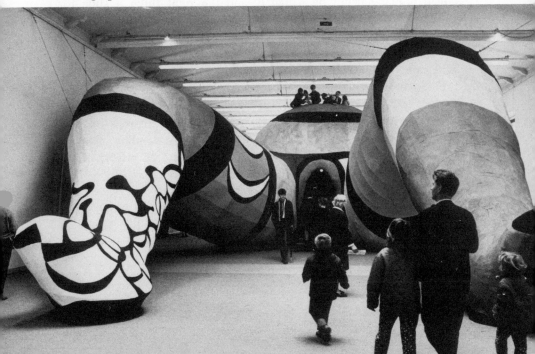

Once in the body, the visitor was faced with the task of switching from one level of experience to another and yet another. A pond with living goldfish surmounted by a big, moving mill wheel had been placed where the womb lies in a female body, as another Freudian symbol. But the *Man in a Chair* (located in the center of *She*'s body) by Ultvedt, who watched the motion of the sea on television while a number of arms caressed him, reasserted her physicality, since that motion mimicked her heartbeat. Another construction by the same artist, fashioned as a *Broken Clavicle,* was situated in the head and reminded one of a Vanity because a mouse was gnawing at the bones; with it the viewer faced tradition in art. Then there was a pokey Coca-Cola and milk bar in one breast, connected by a chute for garbage disposal with Tinguely's bottle-crushing machine, the two together assuming the appearance of man's digestive tract. The guests in the soft-drink bar had the further pleasure of eavesdropping on lovers seated on the love seat, which was located in the left leg and reached through a tunnel. Unknown to the lovers, their retreat was bugged so that their whispers were broadcast in the breast bar. The other breast contained a planetarium by Tinguely and the right thigh a slide for children, while a gallery *Piennalen* exhibited fake pictures in one toe; its name was explained by the critics as a barb directed against the Biennial of Venice, which had just barred Tinguely from participation. Belonging also to Fun City, one arm housed a special twelve-seat minicinema that featured an early Garbo movie—*Luffar-Petter* (1922). Into the navel was built a restaurant with a skyview from a terrace, overlooking the "landscape" of the figure's body as well as that seen from the museum's doors. A vending machine selling lottery tickets with drawings of the artists as prizes, and a telephone, were also hidden in the complex body.

Tinguely's comparison of the giant figure to a bit of Noah's ark, some portion of *Gulliver's Travels,* and a piece of the Tower of Babel [27] aptly sums up what *She* had to offer to her visitors: an

[27] *hon—en historia,* p. 154.

amazing variety of things, similar to the Ark; the experience that the Lilliputians had in climbing over Gulliver's body; and a curious mixture of sounds composed of an unbearable din from the crushing of glass and clanking of machines, heard in conjunction with music by Bach and with human voices amplified by microphones, a sort of Babel of noise. Other writers have drawn attention to the similarity between *She* and the Venus of Willendorf seen in supine position, between *She* and the Statue of Liberty, and between *She* and the egg-bodied figure containing other figures in Hieronymus Bosch's *Garden of Earthly Delights.*

She was a great success. By the time the show was dismantled, seventy thousand persons had visited it. This public acclaim was well deserved. No description can convey the figure's monumentality— quite apart from its size—the joyful gaudiness of its coloring, and the strength of its shapes: the three red mounds, stomach and breasts, their redness pointed up by the harlequinesque head, trunk, and legs, their swollen sizes dwarfing the tiny, insignificant, balloon-shaped head; the unevenly angled legs forming converging walls that led to the green portal; and, climaxing all, the horseshoe shape of this portal, rising above its stepped pedestal. Looking at it, the domed shape into which it gave access truly resembled a small circular church. It is regrettable that *She* was destroyed. Something so vital as this work is a loss for art.

The spectacle can be staged in a hall or displayed in the open. In the latter case, the work of art is lifted out of its shrine in order to be placed in the middle of the city's main square. For the problem of educating the public, the spectacle in the street is of greater interest than the one in a museum, because it reaches out to the uninvolved, as has been mentioned.

In his *Spatiodynamic and Cybernetic Tower* (1961), Nicholas Schoeffer has given the town of Liège a means of displaying spectacles publicly. This tower, set up in the park La Boverie on the bank of the Meuse next to the Palace of Congress, captures the life of the city—its changes in light and noise. Directed by these, the

tower's electronic brain issues orders that release musical sequences and rotate mirrors to reflect colored spotlights. This happens uninterruptedly, but on holidays the tower mounts special luminodynamic audiovisual spectacles that are built upon music by Henri Pousseur and poems by Jean Seaux. These are projected upon a screen set up behind the glass façade of the Palace of Congress.[28] Schoeffer was supposed to place a similar tower in a suburb of Paris, as part of a project for the Ministry of the Defense. The model was first exhibited in 1963 (Fig. 47, p. 300), but construction has not yet started for lack of funds.[29]

Such towers are visible at great distances. It seems to me that they are meant to replace, on the one hand, the civic monuments to heroes and, on the other hand, the community centers, that is, cathedral and town hall. Through their locations, the shows performed by towers become part of man's natural environment. As a result, the spectacle is transformed into an article for mass consumption, joining the mass media in that respect. This development was acknowledged by Vasarely when he stated in 1965: "Psychic needs . . . become consumption goods, like transistors, television sets or cars."[30] Like other mass media, art acquires the power to influence man. Since the visual experiences of a spectacle are shared by all the inhabitants of a city, Schoeffer hopes that this new scope of art will reestablish "a lost brotherhood with the community of men."[31]

Obviously such projects require technical knowledge and financing beyond the means of the individual artist. Consequently, "the

[28] Red Gadney, "Aspects of Kinetic Art and Motion," *Four Essays on Kinetic Art* (St. Albans, Great Britain: Motion Books, 1966), pp. 32–33.

[29] Nic[h]olas Schoeffer, "Tour lumière cybernétique: projet pour le quartier de la défense à Paris," *Art International*, XII, No. 1 (January 1968), pp. 24–25; Frank Popper, "Nicholas Schoeffer: The Creative Idea and the Direct Effect," *ibid.*, pp. 28, 30.

[30] *Vasarely*, II, ed. Marcel Joray (Neuchâtel: Éditions du Griffon, 1970), p. 197.

[31] "The Three Stages of Dynamic Sculpture," *Nicolas Schöffer*, eds. Guy Habasque and Jacques Ménétrier (Neuchâtel: Éditions du Griffon, 1963), p. 140.

collaboration of engineers, builders, electronicians, architects, writers, reporters, public relations specialists, photographers, motion picture directors, radio and television technicians, etc. is essential to him"; while "big industry is assuming more and more the role of art patron, providing a fruitful collaboration." [32] It may be added that the State is thus once again a patron of vanguard art, since it was the French Government that commissioned the *Tour lumière et cybernétique* of Paris (Fig. 47).

Another type of public spectacle is the exhibition of works of art arranged by a group on the streets of a city. New York has several such shows yearly. The Parisian "A Day in the Street" exhibition was mentioned above; it had been planned for two years, from 1964 to 1966. Its participants, García Rossi, Le Parc, Morellet, Sobrino, Stein, and Yvaral, expressed their aim as follows in a statement: "The life of large cities could be bombarded in a massive fashion —not by active bombs—but by new situations which solicit a participation and a response of the inhabitants." These artists did not think that their "attempt will suffice to break the routine of a day in the Parisian week," but they hoped that "it will help them to enter into contact with an unforeseen public." [33]

The solution of European artists to draw nearer to their public by a democratization of the art object, in order to educate their fellowmen in art, is so simple that one wonders why it took one hundred and fifty years to discover. The reason may be that the efficacy of this method is in doubt: official art can tread the same path and miseducate the public. This would set the score back to where it started from. Moreover, there is the danger that the untrained spectator may confuse his love of games and admiration of technology with his enjoyment of art. The staging of a spectacle is not art per se; the spectacle must also be an aesthetic experience. It is necessary that the optional compositions and obstructing ob-

[32] *Ibid.,* p. 133.
[33] Groupe de Recherche d'Art Visuel in *Opus International* (1967), p. 42.

jects, the moving patterns and moving constructions, the Eve of Stockholm and her guts, Notre Dame de la Défense and her open-air production be beautiful in themselves. The spectacle must not only be notable, but also noteworthy.

Perhaps the questionable success of the idea that the public can be artistically guided, through the democratization of the art object, accounts for the negative and shaded reaction to it by American artists. They accept multiples unreservedly, but perhaps merely as a successor to prints and not as a weapon to debunk uniqueness. They use active spectator participation but halfheartedly, perverting its meaning by limiting it to the owner. They bypass spectacles in the grand manner; when such spectacles are staged in the United States, they are usually European imports, moreover, the best known are not public spectacles.

For instance, Tinguely's *Homage to New York* (1960), arranged in the garden of The Museum of Modern Art, admitted only a number of selected individuals as witnesses to the self-destruction of his machine, and they did not participate actively in it. Therefore *Homage to New York* is more in the nature of a Happening than of a spectacle, and a mono-Happening at that, because it happened only once. As for open-air spectacles, art exhibitions in the streets are a permanent feature of the American art scene. However, these shows are not group manifestations like "A Day in the Street"; they are open to members of diverse artistic persuasions, and they do not promote a specific theme. Their keynote is individuality not teamwork. Schoeffer's towers, on the other hand, have not been installed in the United States; instead, the old-fashioned stage performances and concerts still hold sway in Central Park and Lincoln Center's Damrosch Park, modernized by the admixture of the droning jets overhead.

Developments in Content

Where would you focus to determine content?—paraphrased from Jasper Johns, 1964

In 1964, Jasper Johns noted in an interview: "What it is—subject matter, then—is simply determined by what you're willing to say it is. What it means is simply a question of what you're willing to let it do." [1] The artist correctly saw that something was boiling in art, but he incorrectly diagnosed the substance as subject matter, that is, primary or factual meaning. Generally speaking, the themes used by contemporary art are heirs to those of their predecessors. The revolution was centered in content, that is, intrinsic meaning. [2]

[1] Gene R. Swenson, "What Is Pop Art?, II," *Art News,* LXII (February 1964), p. 66.
[2] For these expressions, see Erwin Panofsky, "Iconography and Iconology: An Introduction to the Study of Renaissance Art," *Meaning in the Visual Arts* (Garden City, N.Y.: Doubleday & Co., 1955), pp. 28–31.

To wit, the nonleisurely chair, an old theme with a new content.

Content, like motivation, seems to be conditioned to a greater extent by the artist's personality than by the environment in which he lives, which is the opposite of what seems to be true of subject matter. On the whole, all the exponents of a certain trend tend to use the same thematic material so that there is little crisscrossing among different groups in that respect. Consequently, subject matter is a good criterion for evaluating the impact of a civilization upon its art, as well as for establishing an artist's affiliation. Towering a head above the "ists," are the solitaries whose work resists assignment—very often because the content of their work is different. As a result, content can likewise serve for classification, although more in appraising quality than style.

This situation still exists today. It is still possible to group artists together according to their subject matter, for instance, the Abstract Expressionists, the Pop artists, the New Realists, the Kineticists, the Primary-Structure sculptors, the Earthworkers, the Lettrists, the Tech. artists, the Neo-Surrealists, the Neo-Dadaists, etc., etc.; and it is still possible to discern dissimilar types of subject matter linked to similar content in artists belonging to different currents, for instance, the criticism of contemporary values is couched in Pop vocabulary by Robert Indiana and in Neo-Dadaist language by Jean Tinguely. The uniformization of the world and the heterogeneity of the uniformized global civilization have merely widened the scene: instead of the same content or subject matter recurring in Spain and the Low Countries, they recur in Japan and Brazil.

However, classifications according to style, that is, according to subject matter, no longer are satisfactory. Content had always been the essential component, although perhaps not "the only significant element in art," as asserted by Wassily Kandinsky in an article written for an exhibition at Stockholm in 1916.[3] But in contemporary art content outdistanced subject matter further, challenging it as the proper basis for classification.

[3] "On the Artist," ed. Ellen H. Johnson and Gösta Oldenburg, *Artforum,* IX, No. 7 (March 1973), p. 78.

In contemporary art the boundaries of content have been extended beyond recognition; the artists have not only explored virgin territory in the old world of experience, but also discovered new artistic worlds as well. *Abrogated* may be a better word than *extended* to define what has happened to the former boundaries, since all restrictions are now banned. In the words of Johns (with content substituted for subject matter), what content is depends on what the artist is willing to say it is and on what the audience is willing to let it do. What this is, over and above what was said and accepted as possible to be done before, will be studied in this chapter.

We shall analyze, first, nonobjective excursions into the symbolist and transcendentalist territories of the old world of experience, and discuss the divorce of content from subject matter in the Pop artists. Then, we shall investigate the excursions of other artists into virgin worlds where energy, pattern, and matter become the content of art, and where the object has been made subject as well as content. Finally, we shall survey content that has become self-sufficient, that is, the abandonment of significant form as its mode of presentation.

1. *Nonobjective Symbolism*

In back of all of my work is the Image
and the Symbol.

—Louise Nevelson, 1956

Some critics have defined symbolic construction as a thing that is present referring to one that is absent, and included all representational art in this category.[4] Such a widely inclusive use of the word *symbol* leads to confusion in art. The word *image* can, and should, replace *symbol* in this context. The latter term should be reserved to indicate a visible image referring to an (invisible) concept. It is in this restrictive sense that symbol is used here.

[4] For instance, Michael Kirby, *The Art of Time: Essays on the Avant-Garde* (New York: Dutton Paperbacks, 1969), p. 47.

Symbolism flourished in Christian art and Surrealism, but it can be traced back through the centuries to ancient times; in fact, it must be as old as art itself. Traditional symbolism employed *figurative* images to translate religious or dogmatic ideas, posit moral or ethical issues, and express metaphysical or philosophical truths. Contemporary art opened a new road for the translation of symbolic thinking into visual terms by employing *nonobjective* images. Of necessity, these are confined to conveying universal concepts.

At first glance, the reading of nonobjective symbolism seems to present an insurmountable difficulty. How can the observer guess that such an image is a reference to something beyond itself? Moreover, even if he detects the symbolic nature of the image, how can he hope to interpret the symbolic message correctly? The answers to these questions are simpler than could be expected: somebody tells the spectator the facts. Unless somebody tells him the facts, the spectator will also more often than not miss the symbolic content of figurative images; that is, he will neither recognize them as symbols nor be able to read their meaning. He will see a laver instead of a reference to death and rebirth in baptism;[5] he will see a bent and broken watch instead of a reference to Einstein's theory of relativity (bent) and to time standing still in eternity (broken).[6] In Christian symbolism, the Church Fathers, followed by other writers past and present, interpret the images for the audience. In Surrealist symbolism, Freud, Surrealist poets, and the artist through his title, followed by other writers, help the public to understand the images. In nonobjective symbolism, the *artist* by word of mouth, by title, and by image gives the public its clue. Traditional symbol-

[5] For instance, in the Master of Flémalle's *Mérode Annunciation,* c. 1425–1430, The Cloisters, New York; see Carla Gottlieb, " 'Respiciens per fenestras': The Symbolism of the 'Mérode Altarpiece,' " *Oud Holland,* LXXXV (1970), p. 67, Figs. 1–8.

[6] As in Salvador Dali's *The Persistence of Memory* (1931), The Museum of Modern Art, New York; see Carla Gottlieb, "Modern Art and Death," *The Meaning of Death,* ed. Herman Feifel (New York: McGraw-Hill Book Co., 1959), pp. 163–164, Fig. 3.

ism originated in literature and is interpreted for us first by writers; contemporary symbolism originated in art and is interpreted for us first by artists.

The observer is further helped in understanding the meaning of nonobjective symbols by the fact that only universal concepts such as life and death, youth and old age, eternity and time, good and evil, etc., are used. These concepts have the advantage of being accessible to everyone. Since they do not presuppose a specialized knowledge, they remain accessible even after the passage of time, which tends to bury the key to deciphering religious symbols and allegories. Small wonder that universal concepts have been symbolized at all times, alongside specialized concepts. With the ebbing of Christian symbolism in the eighteenth century, these archetypal symbols became prominent.

Three steps can be detected in the relationship between the image and the archetypal symbol in modern and contemporary art. In the nineteenth century, a figurative image served as a metaphor: winter and ruin symbolized death.[7] In the first half of the twentieth century, a figurative image was reduced to a near abstraction so that it might signify an aspiration rather than portray an action: a bird abbreviated to its essence symbolized the concept of flight,[8] a new-born child abbreviated to an egg symbolized the concept of life (Fig. 33, p. 218), and a couple with prominent sexual attributes symbolized the attraction between male and female.[9] In the second half of the twentieth century, an abstract image was composed independent of, and unrelated to, the symbolization, which was later

[7] See Caspar David Friedrich, *Monastery Graveyard under Snow* (1819), National-Galerie, Berlin; Gottlieb, "Modern Art and Death," pp. 174–175, Fig. 11.

[8] See Brancusi's Birds; Carola Giedion-Welcker, *Constantin Brancusi* (Basel: Benno Schwabe, 1958), Figs, 60–64.

[9] See Pollock, *Male and Female* (1942), Lloyd collection, Haverford, Pennsylvania; Bryan Robertson, *Jackson Pollock* (New York: Harry N. Abrams, 1960), Fig. 99.

connected to it by the title given to the work.[10] However, the symbolic content expressed in the title need not be an afterthought. It could have been present from the inception of the work. That is, the symbolic thinking of the artist could have influenced his formal vocabulary, so that the work progressed toward a formal goal attuned to his symbolic content. It is with the third type of symbolization, postdating World War II, that we are concerned here.

Louise Nevelson's works (cf. Fig. 5, pp. 76–77) are symbols, according to the artist. Asked in 1964 by her then dealer, Colette Roberts, the director of the Grand Central Moderns Gallery, why she used the word *cathedral* for her works, Ms. Nevelson replied: "Why not? It's a symbol." [11] Yet neither the black color nor the wall shape, neither the compartmentation nor the found objects in the boxes of *Sky Cathedral* (one of the works in the exhibition "Moon Garden + One" at the Grand Central Moderns in 1958 and now in The Museum of Modern Art, New York) [12] and not even its material, wood, have any *immediate* connection with the words *sky* and *cathedral*. Such words evoke first and foremost this-worldly visions of a desired, unreachable goal and of a majestic church, and otherworldly visions of the abode awaiting the eternally blessed. Only when the artist's statements are studied does her intention in using the above title become clear. She tells us that her Sky Cathedrals are "man's temple to man." [13] Since the first word, *man,* in this sentence stands for the artist herself in the context, what specifically she identifies with in her work must be studied. Another statement in the 1964 interview reveals that specific identification: "I really deal with shadow and space. I think those are the two important

[10] Cf. the explanations of David Smith, published in Elaine de Kooning, "David Smith Makes a Sculpture," *Art News,* L, No. 5 (September 1951), p. 40. Anticipated by Paul Klee; Werner Haftmann, *Paul Klee: Wege bildnerischen Denkens* (Munich: Prestel Verlag, 1950), p. 108.

[11] Colette Roberts, *Nevelson* (Paris: Éditions Georges Fall, c. 1964), p. 24.

[12] Illustrated in John Gordon, *Louise Nevelson* (New York: Whitney Museum of American Art, 1967), p. 24.

[13] "One Woman's World," *Time,* LXXI, No. 5 (February 3, 1958), p. 58.

things in my work and for me because I identify with the shadow." [14]
Shadowy space is a basic element of a cathedral and of a Nevelson
"shadow box." It is an aesthetic element in their designs. The word
cathedral in her titles refers therefore to the shadows that play hide-
and-seek over the walls that hold space captive—concealing here,
revealing there, a treasure trove of objects.

But are Nevelson's cathedrals temples of spiritual exaltation or
burial grounds of man? Does her assembled nocturne symbolize
peace through contemplation of the beautiful or the great naught?
Do we face the "midnight-bloom" or the "Queen of black black,"
to use two images penned by Nevelson in a poem of 1961? [15] Both
interpretations are possible, as well as others. For the reading of
cathedral as a reference to the end of days can be legitimized by a
study of another Nevelson work, consisting of similar elements.

Homage to 6,000,000 No. I (completed in 1964; Fig. 5), in the
collection of Brown University, is a monument to the six million
Jews killed during the Hitler regime in Germany. In this work the
wooden shadow boxes reappear assembled into a black wall panel
filled with black objects. The only major difference between *Sky
Cathedral* and *Homage* is the curved shape of the latter and its
partitioning into two sections. However, as signaled by the title, in
Homage the shadowy spaces are not there to enrapture our senses.
The work has become a columbarium, and the compartments re-
cesses for the deposition of the remains. The House of God has
turned into a cemetery, and the spectator's emotion changes from
awe to grief. More than one reading is again possible, however, for
a similar curved wall in The Detroit Institute of Arts is entitled
Homage to the World (1966).[16] Thus, *Homage to 6,000,000 No. I*
can also be interpreted as a reminder that peace comes with night.

The possibility of alternate readings for the symbolism in Nevel-
son's works reveals that interpretations of the symbolic content of

[14] Gordon, *Louise Nevelson* (1967), p. 11 (from the tapes of Colette
Roberts).
[15] *Art News,* LX (September 1961), p. 12.
[16] Illustrated in Gordon, *Louise Nevelson* (1967), p. 54.

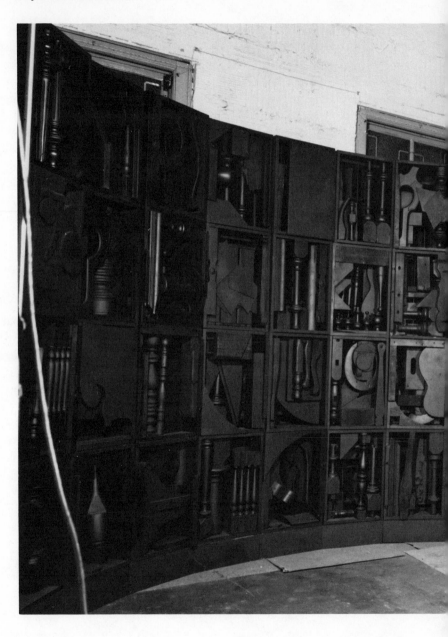

5. Louise Nevelson: *Homage to 6,000,000 No. I.* 1964. Wood. 108″ x 216″. Collection Brown University, Providence, Rhode Island; gift of the Albert List Family Collection.

nonobjective art can differ from one individual to the other. This can happen because no specific authority regulates symbolism today. What exactly is meant by the image is intentionally left indefinite by the artist, so that the link between title and work, image and idea, becomes a personal discovery by each spectator. Since this discovery is predicated upon a world of personal experiences, the solution will be subjective.

Not every contemporary work of art that has a title carrying symbolic overtones has been intended as a symbolic message by its author. David Smith is a case in point. Starting out as a "representational" symbolist, Smith made his *Cathedral* in 1950, fashioning descriptively the main elements of such a building, which he saw as a "symbol of power—the state, the church or any other individual's private mansion built at the expense of others."[17] A few years later when he made his series of ten Tank Totems (1952–60),[18] Smith had left symbolism behind but not as yet its verbal vocabulary. Turning to the artist for enlightenment of what the word *totem* means to him, it is found that he linked it to the existence of certain sets of behavior in society, totem referring to the permissible actions, taboo to the forbidden. "A totem is a 'yes,' a taboo is a 'no,' " he told Thomas B. Hess in 1964.[19] For a socially oriented individual like David Smith, the word *totem* thus possessed an emotional appeal. As for *tank,* it refers to Smith's use in these sculptures of circular concave disks manufactured as ends for steel drums that hold liquids; the artist ordered these from a catalogue. The Tank Totems recall ritual totem poles only very vaguely, mainly in their upright orientation. For Smith this title was merely a designation for an object selected, as far as totem is concerned, on the basis of a personal preference for a word. Similarly, a proper name

[17] E. de Kooning, "David Smith Makes a Sculpture," p. 40.
[18] Edward F. Fry, *David Smith* (New York: The Solomon R. Guggenheim Foundation, 1969), p. 97, cf. item No. 55.
[19] "The Secret Letter," *David Smith* (New York: Marlborough-Gerson Gallery, 1964), unpaged.

is a designation for a human being, selected on the basis of a personal liking. Totem need as little bring to mind a mystical bond as Deborah does a bee.

Other titles chosen by David Smith for his works confirm this assumption. During the 1950s, the titles are often carry-overs from symbolism, but voided of it (*Timeless Clock,* 1957); during the 1960s, the titles are mainly descriptive, either references to the component elements of the work (*Cubi,* 1961–65) or to its shape (*Three Planes,* 1960–61). Or Smith's titles may be dedications to someone dear to the artist (*History of Leroy Borton,* 1956, named for his forging assistant; *Bec-Dida Day,* 1963, named for his two daughters Rebecca and Candida).

However, the artist's cavalier treatment of the symbolic content of his titles does not preclude the viewer from having his thoughts run on a symbolic track, should he be so inclined. To some people the word *tank* may suggest a prison cell, to others an instrument of war. They may link the title Tank Totem to the fact that tanks, that is, bad prisons, and/or material for the conduct of wars, are totems in our society, that is, institutions considered permissible. To some people *Timeless Clock* may signify eternity, to others the sloppy workmanship prevalent in the manufacture of goods today.

It follows that contemporary symbolism has three characteristics: the use of nonobjective images whose links to the symbolization are not immediately apparent, but whose meaning can be deciphered through the titles; the intellectual appeal of the visual image that functions as a stimulus in searching for a relationship with the title, the carrier of the symbolic meaning; and the subjective character of the interpretation. The second trait is shared by all symbolic images in art; they all taunt the imagination to find their meaning, yet, in traditional art, titles may not be of help in this task. The third trait is shared by all twentieth-century symbolic art; to wit, the manifold readings offered for Surrealist paintings. But the first trait is unparalleled in earlier works; it is a find of contemporary art.

2. *The Mystic Presence: Voyages into the Absolute*

The artist tries to wrest truth from the
void.

—Barnett Newman, c. 1943–45

I want to create works which will be
spirit and mind.

—Yves Klein, c. 1960

In 1955, the art critic Clement Greenberg noted a difference in
the works of the Abstract Expressionist group, distinguishing Clyf-
ford Still, Barnett Newman, and Mark Rothko from Jackson Pol-
lock, Willem de Kooning, and Franz Kline [20] (cf. Figs. 14 and 6
with Fig. 1, pp. 127, 82–83, 19). In 1962, he defined the difference
more precisely: "The picture no longer divided itself into shapes, but
rather into zones and areas and fields of color." [21] He also observed
that this effect was not fully realized in Still. Greenberg's discovery
served to baptize the section Still-Newman-Rothko, and their fol-
lowers, who have been referred to since then as *color-field painters*.
The name indicates that their works stand or fall through the han-
dling of sheets of color (Figs. 6, 14). Since artistic form is intri-
cately linked to thought and emotion, these artists obviously wished
to convey something different from the Pollock-de Kooning-Kline
section. What it is can be gathered from Rothko's and Newman's
statements.

In 1949, Rothko wrote: "The progression of a painter's work,
as it travels in time from point to point, will be toward clarity:
toward the elimination of all obstacles between the painter and the
idea, and between the idea and the observer." [22] The word *idea* has
no clear-cut meaning in Rothko because the artist neither capitalized

[20] " 'American Type' Painting," *Partisan Review,* XXII, No. 2 (Spring 1955),
pp. 179–196.
[21] "After Abstract Expressionism," *Art International,* VI, No. 8 (October
1962), p. 27.
[22] *Tiger's Eye,* IX (October 1949), p. 114.

it nor did he elaborate. Nevertheless, anyone sensitive to art, when looking at one of Rothko's incandescent paintings, understands what Idea meant to him and feels what he wanted to communicate to his audience.

Each color field in a Rothko painting is only slightly differentiated, and its impact upon the viewer is almost unrelieved. The specific hue in his composition counts for little. Its interchangeability with other hues in another painting may be compared to that of a saint's likeness in religious paintings. In both it is the overall atmosphere of the picture that reaches out to the viewer, not a specific color or face. Invisible fingers seem to touch his being. Such an experience is always connected with mysticism.

Strictly speaking, the presentation of the Idea in a work of art belongs in the category of symbolism. Yet, like the severance of psychology from philosophy, the realization of mysticism seems better served if treated separately from symbolism in art.

Many religious works are considered by believers to house a mystic presence; this is as true of Catholic altarpieces as of fetishes. Another sort of mysterious presence in a work of art is experienced by spectators when they become deeply touched on seeing it. The Parthenon and Hagia Sophia, Michelangelo's Rondanini *Pietà,* and Picasso's *Guernica* come immediately to mind. If the presence of God is felt in the altarpieces and fetishes, the power of a human creator suffuses the great masterpieces. Communication with a presence defying explanation in Grünewald's Isenheim *Crucifixion* and Leonardo's *Mona Lisa* is facilitated by seeing a recognizable image. The works of Rothko endeavor to create the same experience without such assistance. This is the consequential point.

Barnett Newman's aim in art (recorded c. 1943–45) has a different slant. Faced with "the chaos of the blank picture plane" and with "the chaos of form" he created out of these an "expression of his attitude toward the mystery of life and death." He wished "to dig into metaphysical secrets . . . [to create] a religious art which through symbols will catch the basic truth of life which is

its sense of tragedy." [23] The use of the word *dig* jars with *metaphysical*. Like the substitution of *secrets* for *truths,* it suggests that Newman tried to deemphasize the mystical overtones in his confession and make his search earthbound. He did not succeed in this attempt.

Unlike Rothko, Newman did not rely upon the sensuous nature of paint for communicating a metaphysical truth. "Art is an expression of the mind first and whatever sensuous elements are involved are incidental to that expression," he wrote in some early notes.[24] Avoiding this materialistic bypath, he went directly to metaphysics;

[23] Thomas B. Hess, *Barnett Newman,* (New York: The Museum of Modern Art, 1971), pp. 38, 51.
[24] *Ibid.,* p. 39.

6. Barnett Newman: *Vir Heroicus Sublimis*. 1950/51. Oil on canvas.
7' 11⅜" x 17' 9¼". The Museum of Modern Art, New York.

when he found his style in 1948, his starting point became infinite
space signified by a vast expanse of canvas. Because the canvas is
so big that the viewer cannot encompass its boundaries—for in-
stance, *Vir Heroicus Sublimis* (1950/51; Fig. 6) in The Museum
of Modern Art, New York, measures seven feet and eleven and
three quarters inches by seventeen feet and nine and a half inches
—the viewer experiences the same sensation he has when overlook-
ing the panorama of a landscape: the boundaries of the visual field
are unstable, melting at their edges and suggesting continuity beyond
what the eye sees. "Anyone standing in front of my paintings must

feel the vertical dome-like vaults encompass him to awaken an awareness of his being alive in the sensation of complete space," Newman stated in an interview with Dorothy Seckler in 1962.[25] The effect of infinite space was a conscious endeavor.

These enormous canvas surfaces are monotonously covered by a thin layer of paint. While Rothko's paintings are calling out to the spectator, Newman's pictures keep silent. Flame is replaced with barrenness. However, over Newman's neutral field run narrow bands. The artist called them *"zips."* They have the effect of lightning. They assert themselves as alien forces in the barren field (Fig. 6, pp. 82–83).

Newman called his first zip painting *Onement I* (1948). With it he arrived at his own unique expression. Hess has told the story of how the artist suddenly discovered this new road on a magic day. It was so new he needed time to adjust to it:

> On his birthday, January 29, 1948, he prepared a small canvas with a surface of cadmium red dark, and fixed a piece of tape down the center. [The artist's method for keeping his motifs separate from the background.] Then he quickly smeared a coat of cadmium red light over the tape, to test the color. He looked at the picture for a long time. Indeed he studied it for some eight months. He had finished questioning.[26]

Hess calls the work an "interrupted painting" and points out that it needed a tremendous act of will to leave it alone.[27]

To Hess, the word *onement* recalls harmony and wholeness, but it could also refer to the single zip. This zip, which splits the pictorial field in two, Hess interprets as a symbol of the creative act: God divided the light from the darkness, the waters from the waters, the dry land from the waters; the artist divided the pictorial field. But Newman rejected this reading. From him, Hess elucidated that the title *Onement* is a reference to the Jewish Day of At-Onement,

[25] "Frontiers of Space," *Art in America,* L (Summer 1962), p. 86.
[26] Hess, *Barnett Newman,* p. 51.
[27] *Ibid.,* p. 65.

which, according to the Cabala, is the moment for meditation on rebirth.[28]

Abraham, a painting dated to the next year and, like *Onement I,* in The Museum of Modern Art, New York, is a black-on-black canvas: one shiny, fairly broad zip running down a vertical matte field seven feet long. This painting is a memorial to Newman's father, Abraham, who died on June 30, 1947, and, as explained by Newman to Hess, it commemorates the "sadness of the father" who sacrifices himself for his son. One wonders whether this should not read "the father who sacrifices his son." Newman's father lost his fortune in the 1929 crash, and the artist had to take a hand in straightening out the family finances instead of following his calling. This was necessitated by the fact that, unlike the majority of those affected, Abraham Newman refused to declare himself bankrupt. Hess furthermore connects *Abraham* to Barnett Newman's profession because, according to the Cabala, the Patriarch was the first artist on earth.[29]

Newman's most acclaimed and most influential painting, *Vir Heroicus Sublimis* (Fig. 6, pp. 82–83), overwhelms through sheer size and the rightness of the divisions. Over a horizontal cadmium field run five slender zips, the first and fourth red, the second white, the third purple, and the last yellow-brown. This last one is very near the right end of the canvas and the extreme narrowness of this ultimate field is counterbalanced at the left by the sharply contrasting white against the red of the second zip. This white zip and the purple zip divide the painting into a triptych with a broad center panel, but that underlying structure is overshadowed by the three additional zips and has to be searched out by the viewer. The apparent simplicity and inherent complexity of the painting do not prepare the spectator for the reason it was titled *Vir Heroicus Sublimis:* a reference to Harry Truman who dared to fire General MacArthur from command during the Korean War. When Newman heard this news on the radio, April 11, 1951, it struck him as a heroic deed. The

[28] *Ibid.,* pp. 53, 56.
[29] *Ibid.,* p. 61.

number 18 used in the painting's length dimension symbolizes life to Newman. In Hebrew this number is written with the letters *heth* and *yud,* which together spell *hai,* that is, *life* in Hebrew.[30]

It is evident that Newman's symbols belong in a different category from Louise Nevelson's symbols. The latter took hers from the world of art—a cathedral, a cenotaph, a monument; her symbols relate to worldly problems—the praise of beauty, emotions of anguish, sentiments of joy. Newman's pictures deal with the unknown—life, death, rebirth, creative power, and courage; his symbols, space and zips, have cosmic connotations.

With the Frenchman Yves Klein, the question where he stood in regard to the titles for his symbolism does not arise. Like Newman, Yves (this is how he preferred to be called) attempted to state a metaphysical truth through his art. But in Yves this truth is not shaded by subjective momentary experiences, as it is in Newman. Yves did not adulterate what he had to say. Stipulating, around 1960, that the spectator should "experience spirit without explanation, without a vocabulary," he reduced his presentation of this experience to a uniformly applied blue, which he called the "great COLOR" or the "Immaterial Blue." He spoke through color because for him "color is saturated with the cosmic sensitivity," and through blue, because, as the symbol of infinity, blue favors "the voyage of human sensitivity in the cosmic sensitivity. . . ."[31] Yves denies us all help in establishing a rapport with his work.

The reduction to a monochrome was not enough for Klein, however, and he took the final drastic step—exhibiting empty space at the Galerie Iris Clert, Paris, in 1958. As he put it: "Pictures are merely the 'ashes' of art. The authentic quality of a picture, its 'being' itself, once created, is found beyond the visible." For Yves, an immaterial intangible reality had a greater power than a visible

[30] *Ibid.,* pp. 69, 81.
[31] "The Monochrome Adventure," *Yves Klein,* ed. Kynaston McShine (New York: The Jewish Museum, 1967), pp. 28, 35.

image. To create such a reality, the painter had first to impregnate his being from the "KOSMOS," and then, by his sheer presence, he impregnated the exhibition space. Yves quotes the newspapers as reporting that forty percent of the visitors to his exhibition "The Pictorial Material Sensibility in the State of Prime Matter" ("La Sensibilité picturale matérielle à l'état de matière première), popularly known as "The Void" ("Le Vide"), experienced a mystical presence "seized by the intense climate which reigned, terrible in the apparent void, of the exhibition hall." [32]

The story of this exhibition has been recorded by Klein himself [33] and several other writers. His exhibitions the year before at the Iris Clert and Colette Allendy galleries, Paris, had not satisfied him. This time he was determined to make it right, and hence prepared the event in thorough fashion. The Iris Clert Gallery, then located on the Left Bank at 3, rue des Beaux-Arts, was small in size, having only sixty-five square feet (20 m.²). The artist emptied it of furniture except for one showcase fixed in the rear wall, and then painted the walls, the glass of the street door and window, and the case white. By this act, he purified the space of all earlier exhibitions and created the space of the new one. While the inside of the gallery was all in white, the outside was colored in ultramarine. The gallery's door and window plates were given a blue coating on the exterior, and the artist also planned a blue illumination of the obelisk on the Place de la Concorde, but this portion of the plan did not work out. He closed the entrance to the gallery. Instead, access was through the door of the building, ritualized for the occasion by an ultramarine canopy and the presence of two republican guards in official dress, who were stationed at the two sides as though at the entrance to the presidential Palais de l'Élysée. Thirty-five hundred invitations printed in blue on white paper were sent out, three thousand to Parisians, but only two posters and some inconspicuous announcements in *Arts* and *Combat* informed the general public

[32] *Le Dépassement de la problématique de l'art* (La Louvière, Belgium: Éditions de Montbliart, 1959), pp. 3, 11.
[33] *Ibid.,* pp. 4–13.

of the event. The opening was scheduled for April 28, from nine o'clock at night through midnight. It was attended by two thousand guests who were received in the corridor of the building, which was approximately one hundred feet square (32 m.2), and were served a blue cocktail, prepared by the bar of the Coupole from gin and Cointreau, dyed with methylene blue. From the corridor, they proceeded in groups of ten to the gallery through a door covered by a blue hanging. Inside they were permitted from two to three minutes of meditation.

The crowd of visitors created a sensation in the night. Alerted, the police and fire departments arrived on the scene to investigate, dispersing temporarily the crowd in the street. The moment they were gone, people returned, again blocking passage in the rue des Beaux-Arts. The exhibition proved to be such a success that it had to be extended from the one week planned through two weeks— over two hundred persons visited it daily. Alas, those who did not avail themselves of the opportunity had no second chance to see "The Void" through the eye of the camera: the recording photographer shot with an empty box.[34] Lucky coincidence? Unfortunate absentmindedness? Yves sold two (immaterial) paintings from the show, each for two pounds (one kilogram) of gold.

When described in the cold light of day, the enemy of mystical ecstasies, "The Void" sounds like a fraud, and the visitors appear mainly as sensation seekers. This is not at all the case. Many came because they were sincerely interested in Klein's work. The guest book registers the acclaim of Albert Camus, "with the void, full powers." [35] Moreover, the influence Yves exercised over the Nice Group (Arman, Martial Raysse), Group Zero in Düsseldorf (Heinz Mack, Otto Piene), Piero Manzoni (see chap. 7, sec. 3), and Group N in Italy, as well as group Nul in Holland (Henk Peeters, Armando, Her de Vries) would, by itself, vouch for the authenticity of Yves the Monochrome's work. And yet, the phenomenon Klein needs an

[34] From a letter from Iris Clert to the author, October 22, 1971.
[35] Pierre Descargues, "Yves Klein," *Yves Klein,* (1967), p. 22.

explanation. It proves that a goodly portion of the intelligentsia, bourgeois middle class and bohemians alike, are missing the religious values of which our life has been so relentlessly denuded, at an ever increasing pace, since the Renaissance.

3. *Mass Media Image: Banalized Celebrity and Celebrated Banality*

[Pop art is] the use of commercial
art as subject matter in painting.

—Roy Lichtenstein, 1963

Content and subject matter are two entities in art: content is informed by symbolism, subject matter by the story. Yet, it is not always possible to keep them apart. If the same subject is shown by one artist with one end in view, while another aims at another end, then the work will undergo a change in content. A nude can be Aphrodite, Eve, or a model—signifying love and beauty, lust and sin, or art and fulfillment. Intent forms the subject. It is with this facet of a work of art, the influence of meaning on iconography, that the present section will deal. It will also deal with the liberation of content from subject matter.

Like the miniskirt, Pop art was born in England, but English Pop was not forceful enough to impose itself beyond the British Isles in the 1950s. Perhaps this was due to the fact that the American Dream, its subject matter, was an import on which foreigners could not speak authoritatively. New York, the focus for all those who strive for or against this dream, was the right place to discuss it through art. The first New York exhibition of Pop art as a group manifestation, "New Forms, New Media I," opened at the Martha Jackson Gallery in October 1960 without provoking much comment. But it was followed by a series of one-man shows, a second group show at Martha Jackson, "Environments, Situations, Places" in September 1961, and the stamp of official approval in the inclusion of Pop artists in the exhibition "The Art of Assemblage"

shown at The Museum of Modern Art during October and November of the same year. With that, the door had been opened to Pop.

The reaction to it was two-faced. The sigh of relief was almost audible among one section of the public: ten years of suffering through the exposure to Abstract Expressionism had come to an end! Since the triumph of that art, you could not even relieve your frustration by asking: "But what does it mean?"—that is, unless you did not mind branding yourself as uneducated, insensitive, and philistine. Here, finally, was an art form that could be grasped instantly by young and old, highbrow and lowbrow, farmer and office worker, millionaire and pauper. For it depicted subjects with which everyone was familiar, and depicted them in a simple legible way.[36] The other section of the public, the ardent fans of Abstract Expressionism, were dismayed and disgusted, however. Most found it beneath their dignity to express themselves on the subject; those who spoke out used words like *kitsch* and *vulgarity*.[37]

Both sides were wrong and both were right. In the heat of excitement, it was overlooked that Pop art only seems simple. Even the champions of Pop art, although seeing its formal complexity, read its content at surface level. This error is encouraged by the statements of the Pop artists. Yet, even though Warhol denies being involved in the problems of our life, how can the painting, or, for that matter, the viewing, of a car wreck, of an electric chair, be "uncomplicated by intellectual responsibility"? How can it be "divorced from story-telling or social content"?[38] Pop art is generally differentiated from Dada today in that Dada is considered to have been involved, and Pop is thought of as uninvolved. Yet in 1922 Tristan Tzara, head of the Dadaists, claimed in his "Lecture on

[36] Dorothy G. Seckler, "Folklore of the Banal," *Art in America,* L, No. 4 (Winter 1962), pp. 56–61; Gene R. Swenson, "New American 'Sign Painters,'" *Art News,* LXI, No. 5 (September 1962), pp. 44–47, 60–62.

[37] Greenberg, "After Abstract Expressionism," p. 32; Max Kozloff, "'Pop' Culture, Metaphysical Disgust and the New Vulgarians," *Art International,* VI, No. 2 (March 1962), pp. 34–36.

[38] Lucy R. Lippard *et al., Pop Art* (New York: Praeger Publishers, 1966), pp. 78, 84–85.

Dada": Dada "is rather the return to a quasi-Buddhist religion of indifference." [39] Nobody takes this assertion seriously; why, then, accept Warhol's statement at face value? On the other side of the fence, the detractors of Pop art overlooked that a Pop painting is not a poster nor is a Pop object a car. Perhaps the most important contribution of Pop art is that it has dispelled some of the fog that envelops the distinction between art and industrial design, which was originated by Morris and the Bauhaus.

The subject matter of Pop art has been described as banal, commonplace, and anonymous—all of which define the character of its thematic material only partly. Banalities had formed the subject matter of Jan Steen's and Adriaen van Ostade's tavern scenes in the seventeenth century, and of Honoré Daumier's and Karl Spitzweg's lower-middle-class scenes in the nineteenth century; commonplace objects devoid of charm (newspapers, drinking glasses, etc.) appear in some Cubist still lifes. What could be more anonymous than the discards Schwitters used for his collages? Even the fact that Pop art often centers on one motif, portrayed in close-up, has forerunners—compare Josef Navrátil's picture *The Pie* (c. 1855-60; Fig. 7) in the Modern Gallery of Prague with the pies of the Pop artists, and Picasso's famous painted bronze *Glass of Absinth* (1914),[40] with Pop hamburgers, ice-cream cones, and other foodstuffs. The apparel and furniture of Pop art are foreshadowed in van Gogh's shoes and chairs of the 1880s, the washstands in Duchamp's *Fountain* (1917),[41] and the toothpastes in Stuart Davis' *Odol* (1924).[42] True, the serialized repetition of the same motif found in some of these Pop works has no precedent, but that is a *mode of composition* (to be discussed later), and composition does not affect the theme of a work of art. On another level it has been

[39] Tristan Tzara, *Lampisteries précédés de sept manifestes Dada* ([Paris]: J. J. Pauvert, 1963), p. 136.

[40] Alfred H. Barr, Jr., *Picasso: Fifty Years of His Art* (New York: The Museum of Modern Art, 1946), p. 90.

[41] Robert Lebel, *Marcel Duchamp,* new ed. (New York: Paragraphic Books, 1967), p. 40, Pl. 80, No. 132.

[42] Lippard, *Pop Art,* Fig. 4.

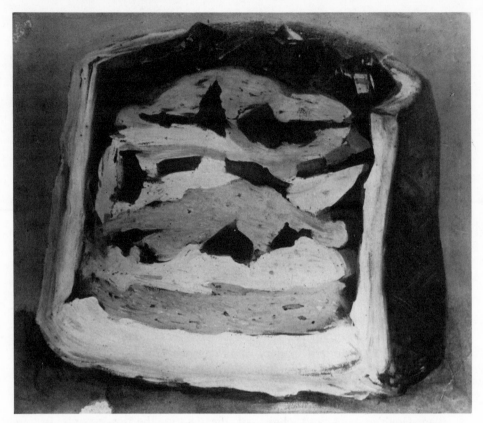

7. Josef Navrátil: *The Pie*. c. 1855–1860. Oil on canvas. 7¾″ x 9″.
Modern Gallery, Prague.

noted that Pop art celebrates the American way of life. Here again,
there are numerous precedents for Americana: the Ashcan School,
the Immaculates, and the Regionalists. What then is new in the
iconography of Pop art?

I believe Roy Lichtenstein has answered the question in pointing
to the use of motifs borrowed from commercial art, although images
used in the mass media may perhaps be a better definition. The
mass media use indiscriminately famous and commonplace sub-
jects. This is precisely what Pop art does.

The word *pop* (ular) implies that a motif will be recognized instantly by the vast majority of people. As phrased by Robert Indiana in 1963: [43] "Pop is Instant Art . . . Its comprehension can be as immediate as a Crucifixion." However, such an image need not necessarily be neutral, insignificant, or commonplace: it can be a political figure like Warhol's *Jackie Kennedy,* a Hollywood idol like his *Elvis* (Figs. 24a, 24b, pp. 175, 176), a national emblem like the flags taken over from Jasper Johns and Frank Stella, a symbol of recurring present-day disasters like Warhol's car wrecks and Lichtenstein's *Drowning Girl* (1963), in the Wright Collection, Seattle,[44] a status symbol like Richard Hamilton's and Tom Wesselmann's *Cars,* a sex symbol like Wesselmann's and Rosenquist's nudes, a political comment like Robert Indiana's emblematic road signs and Ronald Kitaj's *Murder of Rosa Luxemburg* (1960),[45] a comment on our habits like Edward Kienholz's references to intercourse in cars, as well as an ordinary food product like Warhol's Campbell soup cans and Oldenburg's edibles, a garment like Dine's and Oldenburg's pants and ties, a mechanical gadget like Oldenburg's fans (Fig. 21, p. 161), telephones, and toasters, a plumbing fixture like his bathtubs, etc., etc. Portions of contemporary fetishes are also admissible, provocatively hot legs or lips (James Rosenquist, Joe Tilson) as well as coolly efficient machine parts (Oldenburg). Every type of image qualifies, provided *it is an article of mass consumption,* and thus well known to the public at large. In its own way, each image is a celebrity and each is banal, because in the process of becoming a product salable to the crowd, the anonymous is put on a par with the famous.

Every type of image qualifies—apparently save one. Its absence, or scarcity, is all the more pointed because it is part of the American Dream. The fetish fabrication of Pop art stops short at baseball.

[43] Gene R. Swenson, "What Is Pop Art?, I," *Art News,* LXII (November 1963), p. 27.

[44] Diane Waldman, *Roy Lichtenstein* (New York: Harry N. Abrams, 1971), Fig. 52.

[45] Lippard, *Pop Art,* Fig. 40.

Even the substitute sport shows of football, handball, boxing, wrestling, ice hockey, etc., barely seem to have been touched. The only early reference to these sports appears to be a photograph, from 1963, of the British Pop artist Hamilton by Betsy Smith, in which he is dressed up as a spaceman-fullback.[46] When sports are referred to in American Pop art, they are mainly the pastimes of the leisure class: golf, table tennis, and driving; the portrayal of the bicycle seems restricted to England.[47] The sign Hands Off is usually attached to national emblems, like the flag; in Pop art the national entertainment rated this sign, turning the iconoclasts into iconodules. This unmotivated abstention provokes mutinous thoughts in the nonbeliever, suggesting to him that the Pop artists were after all vulnerable in the matter of the American way of life: like the public, they were subject to idolatry.

Let me say a few words about the reason for the choice of commercial subject matter by the Pop artists. The motifs were not selected to promote the commonplace, as was the case with Ostade, or to prove that everything can be made into art, as was the case with Schwitters, but to deflate art of the emotionality with which it had been oversaturated by Abstract Expressionism: the "Popsters . . . abandoned the Temple for the street," Indiana explained in 1963, and "who could be nostalgic about canned spaghetti?" asked Rosenquist in 1964.[48] There is too much excitement around in life; art should slow down man's pace by using boring things: "I like boring things," Warhol confided to us in 1968.[49] Because they are so well known, these images tend to fade into their environments: "They're both things which are seen and looked at, not examined, said Johns in 1965." [50]

Here lies the crux of Pop iconography. The dull subjects leave the artist indifferent. Consequently the subjects are interchangeable,

[46] John Russell and Suzi Gablik, *Pop Art Redefined* (New York: Praeger Publishers, 1969), p. 38.
[47] Lippard, *Pop Art,* Fig. 126.
[48] Swenson, "What Is Pop Art?, I," p. 27; *ibid.,* "II," p. 41.
[49] *Andy Warhol* (Stockholm: Moderna Museet, 1968), unpaged.
[50] Walter Hopps, "Jasper Johns," *Artforum,* III, No. 6 (March 1965), p. 34.

like styles in Picasso: Elvis Presley can substitute for the Borden cow, Jackie Kennedy, a flower, a car crash, soup cans, or the electric chair—and vice versa. Like style for Picasso, the subject for Popsters has lost its weight. This permits them to present their material impartially and to let the public judge its import, as is done by good reporters. It explains why critics believe that Pop artists do not exhibit intellectual responsibility. Pop art merely reports.

But, as the individual piece in a puzzle does not yield a picture, likewise the individual Pop subject does not disclose what the Popsters are reporting. By working concurrently in manners belonging to different stylistic periods, Picasso voided style of its link to historic time, establishing a new type of "style"; Pop art voided iconography of its link to content, establishing a new type of "iconography." The new iconographic type is a *plurality* composed of diversified individual pieces, which, each by itself, carries a different meaning from that of the whole and from that of its partners. That is the revolution brought by Pop to art.

4. *Confrontation with Energy, Pattern, and Matter*

The modern artist . . . is expressing an
inner world . . . the energy, the motion
and other inner forces.

—Jackson Pollock, 1950

My main interest has been to make what
is popularly called decorative painting
truly viable in unequivocal abstract
terms.

—Frank Stella, 1969

Much of the sculpture that I'm doing
might get to be about fluidity or
something of this sort.

—Anthony Caro, 1966

The point at which uncharted regions of experiences have to be crossed has been reached. It is inappropriate to do this with traditional terms that are linked to notions that do not fit today's art. However, no purpose is served by substituting other terms that would also be ambiguous. Art history constantly relies upon words like *abstract art, nonobjective art, reality,* although they are imprecise. Yet, with good will on the part of the reader, their meaning is readily grasped. What I shall try to do is to point out facts and their significance. The labels I shall use—subject matter, content, etc.—are incidental in that study.

Actually the notions of subject matter and content have needed definition for some time—to be precise, since abstract art came on the scene. It was soon evident that a great variety existed in types of abstraction, which made it impossible to encompass all of abstract art in one category; but that this variety derived from subject matter as well as content was not made clear. Our problem is how to separate these two realms in abstract art. It can be done on the basis of how they are differentiated in figurative art.

The subject matter of traditional art is usually obvious; only the reading of its content may present difficulties. The subject of Emanuel Leutze's *Washington Crossing the Delaware* (1851), in The Metropolitan Museum, and of Larry Rivers' *Washington Crossing the Delaware* (1953), in The Museum of Modern Art, New York, is a battle scene, but the content of one is a glorification of history and that of the other is ridicule of the event.[51] Gilbert Stuart's *Washington* glorifies history like Leutze's picture, but his subject is a portrait. In appraising abstract art, the viewer may encounter obstacles in the recognition of subject matter as well as content. Guided by his sensitivity to art, he may well succeed on his own. Otherwise, he can help himself by scanning the statements of the artists.

Studying Wassily Kandinsky's pre–World War I abstractions, and

[51] Eugen Neuhaus, *The History and Ideals of American Art* (Stanford, Calif.: Stanford University Press, 1931) [p. 134]; Sam Hunter, *Larry Rivers* (New York: Harry N. Abrams, 1970), Pl. 44.

Jackson Pollock's abstractions within the framework used for figurative art, it is found that, as subject matter, both are the revelation of a man's inner world, but the content of one *inscape* is a lyrical dream and that of the other a mimetic outburst. Kandinsky confesses the following in his autobiography, written in 1913: "This Moscow, in the totality of its outer and inner life, I consider the font of my artistic aspirations. It is my pictorial tuning fork." Earlier in the same text he says: "It was the hour when dusk is falling. I returned home with my paint box from sketching, still dreamy and immersed in the completed work. . . ." [52] Pollock's interpretation of his painting as reflecting an inner world of energy and other forces, quoted above as an epigraph, is backed up by his friend Willem de Kooning. "The pictures done since the Women, they're emotions, most of them. Most of them are landscapes and highways and sensations of that, outside the city, with the feeling of going to the city or coming from it," the artist explained to an interviewer in 1963.[53] Emotions and sensations belong to man's inner world; coming and going to his motor activity.

Two years after Pollock's statement, the critic Harold Rosenberg discussed Abstract Expressionism in an article, "The American Action Painters," establishing two generic names that express this aspect of the group's work. Quoting as an epigraph a sentence from the poet-friend of the Cubists, Guillaume Apollinaire: "Pure (*blanc*), I gesture among the solitudes," Rosenberg noted that, before Abstract Expressionism, the canvas had been a space in which to reproduce or express an object; now it was an arena in which to act: instead of pictures, the painters produced events.[54] The title of his essay supplied the name Action Painting and his epigraph that of Gestural Painting, names since used by writers as substitutes for the phrase Abstract Expressionism. With these terms,

[52] Wassily Kandinsky, *Rückblick 1901–1913,* ed. Ludwig Grote (Baden-Baden: W. Klein, 1955), pp. 34, 21.

[53] "Content Is a Glimpse . . . ," *Location,* I, No. 1 (Spring 1963), p. 47.

[54] Harold Rosenberg, "The American Action Painters," *New York Painting and Sculpture: 1940–1970,* ed. Henry Geldzahler (New York: E. P. Dutton & Co., Inc., 1969), p. 342.

Rosenberg had put his finger on what distinguishes Pollock's, de Kooning's, and Kline's art from that of Kandinsky, namely: the act of painting, the gesture of the painter in wielding his instrument, is consciously chosen as a vehicle of expression.

However, what Rosenberg's followers, when employing the terms Action Painting and Gestural Painting, failed to take into account is that these two terms define one aspect of the group, whereas Abstract Expressionism defines another; consequently the designations are not mutually exclusive. Rosenberg's error lies in not specifying that he speaks of the content of the works, and in not stating that their subject matter is the inscape. Consequently he left himself open to attacks. Quoting his "What was to go on the canvas was not a picture but an event," his critics pointed out that this is not true.[55] They were right in that a canvas can only be an image, not an event; but this image can *signify* an event, which, in this case, is to make a record of yourself in paint by motor activity. It is possible that Rosenberg borrowed the name Action Painting from a quotation by Tristan Tzara that ran: "It is as action that what is commonly called art will, henceforth, have to be considered." [56] Tzara's observation proves the deficiency of Rosenberg's analysis from the opposite angle: in disregarding the subject matter of Abstract Expressionism in his analysis, he also left himself open to the criticism that all painting is action, as noted by Tzara. Yet, although every painting is produced by action, not every such action produces an epic inscape; nor does every painting signify action as a portrait of the self.

Now to Frank Stella. After the Gestural Painting of the Abstract Expressionists had opened a door to new vistas, Stella could explore content and subject matter further.

When Stella stated that he wished "to make what is popularly

[55] Leo Steinberg, *Other Criteria: Confrontations with Twentieth-Century Art* (New York: Oxford University Press, 1972), p. 61.

[56] Lucy R. Lippard, *Dadas on Art* (Englewood Cliffs, N.J.: Prentice-Hall, Inc., 1971), p. 7.

called decorative painting" (see epigraph), his qualification "popularly called" provides the clue that the artist did not think of his painting as decoration in the pejorative sense in which this word is often used to indicate, say, wallpaper. To differentiate between work of that type and Stella's work, I am substituting the term *visual* when referring to the patterns in the latter. What is the difference between decorative patterns and visual patterns, both chosen as the sole ornamentation of an object by an artist?

Decorative patterns have been used since prehistoric times to embellish vases, and, later, as a prominent feature in Islamic art. Their basic trait is the absence of a beginning and an end, making them expansible ad infinitum. More important, they are confined either to crafts or to architecture, and *subordinated to their supports* [57]—vase or wall. On the contrary, visual patterns, which can be either expansible or self-contained, function autonomously, that is, they *instigate the shape* that the work of art will take, the support accommodating itself to their a priori existence (see chap. 5, sec. 1).

The emergence of visual patterns was prepared by the Symbolists who, at the end of the nineteenth century, stressed the importance of formal elements. Thus, when Maurice Denis pronounced in 1890 that a painting is first and foremost a flat surface covered by colors that are assembled in a specific order, and only secondarily a warhorse, a nude woman, or a certain anecdote, he pointed out that formal values count in painting, and that the story cannot exist as art without them; he did not think of form as detached from figuration as it appears in abstract art, however. Hence it is not astonishing that, initially, the pictures of the Abstract Expressionists, Concretists, and Tachists were dismissed as mere decoration: "like a panel for a wallpaper" (Aldous Huxley); "a pleasant design for a necktie" (Theodore Green).[58] That had not been the intention of these painters, whose works carry messages for the spectator: they

[57] The word *support* is used to designate the object supporting the decoration, and translates F. Adama van Scheltema's expression *Träger*, in *Die altnordische Kunst*, 2d ed. (Berlin: Mauritius-Verlag, 1924).

[58] "A Life Round Table on Modern Art," *Life* (October 11, 1948), p. 42.

externalize the "sentiment of beauty" (Lucio Fontana, 1946 [59]), embody an "idea" (Rothko, 1949); translate the artist's "emotion," "feelings" (Franz Kline, 1957) and "experiences" (*idem,* 1960),[60] and function as "signs" (Jesús-Rafaël Soto).[61] Consequently these pictures have an iconography *and* iconology, being bipolar in this respect, like figurative art. These works are not decoration. Yet neither are they visual patterns because image and support function separately. Some are inscapes, others signs; some convey auto-biographical data, others metaphysical truths.

Only when a "pattern [was] imposed upon a field" by Stella (1969),[62] only then did visual patterns enter painting. The composition of the pattern, dominating the support and thus freed from its interference, asserts itself as form in its own right (Fig. 15, p. 129).

Stella's statement makes it clear that visual patterns are the content of his art. Visual patterns may also be its subject matter, and this fusion of the two realms may constitute the crux of Stella's contribution. However, it can be argued that the titles of his paintings designate his themes, which then would be portraits, city- and landscapes, flags, etc. Time will clarify this problem.

The inscapes of Abstract Expressionist painting and the signs of Constructivist painting are duplicated in Abstract Expressionist and Constructivist sculpture, and so is their gestural and metaphysical content.[63] But the sculptors did not go beyond what the painters had done. Stella's visual patterns, on the other hand, have a counterpart on the other side of the Atlantic in the sculpture of the English-

[59] *Manifesto bianco,* Buenos Aires 1946; English translation in Michel Tapié, *Fontana* (New York: Harry N. Abrams, 1962), unpaged.

[60] Selden Rodman, *Conversations with Artists* (New York: Devin-Adair, 1957) pp. 106, 109–110; Katharine Kuh, *The Artist's Voice* (New York: Harper and Row, 1962), p. 144.

[61] Jean Clay, "Soto," *Signals* (London), I, No. 10 (November–December 1965), p. 9.

[62] William S. Rubin, *Frank Stella* (New York: The Museum of Modern Art, 1970), p. 47.

[63] Theodore Roszak and Charles Biederman, Herbert Ferber and Richard Lippold, are cases in point.

man Anthony Caro, who translated the problem into tactile terms (Fig. 8, p. 102) instead of merely copying the pictorial findings, as did the Abstract Expressionist and Constructivist sculptors.

What the field is to painting, matter is to sculpture: to a painting that denies sovereignty to its support corresponds a sculpture that "denies its corporeality." [64] By that Caro meant an abstract work without "reference to art history," yet also not "amorphous." To be amorphous is to be formless, but since art without form does not exist, it may be assumed that Caro used the word in a figurative sense, to signify meaninglessness. Excluding the references to art history, that is, imagistic and gestural content as it is found in representational art and Abstract Expressionism, he selects his content from the properties of matter, such as extension, fluidity, etc.

Matter has many properties, some common to all materials, and others found only in specific kinds. Caro works mainly in steel. The early pieces of the years from 1960 to 1967 concentrate on the basic properties of matter: extension, demonstrated horizontally and vertically by rods and bands; and separation, total and partial, illustrated by plates and screens.[65] In 1968, the artist turned to more sophisticated statements on the qualities of matter, such as elasticity, tensile strength, flexibility, resistance, gravity, etc.

Caro's *LXXII* (1968; Fig. 8) is a three-sided construction, precariously balanced upon a block. Its shape recalls a sling. The top, formed by a straight rod, resembles a cord stretched to capacity. It is drawn apart by two unequal arms, the left a hyperbolic curve, the right a reversed ogee. Focusing on the stretched rod, the viewer experiences elasticity and resistance. If, however, he concentrates on the arms, he notices the pull of gravity: the piece seems to topple from its base, and the left side has already collapsed, turning from an ogee into a single curve, thus withdrawing the support necessary to keep the ogee side of the fork intact.

This three-sided center piece is decorated at the left and the right

[64] Andrew Forge, "Anthony Caro Interviewed," *Studio International,* CLXXI, No. 873 (January 1966), p. 7.

[65] Examples in *Anthony Caro* (London: Hayward Gallery, 1969).

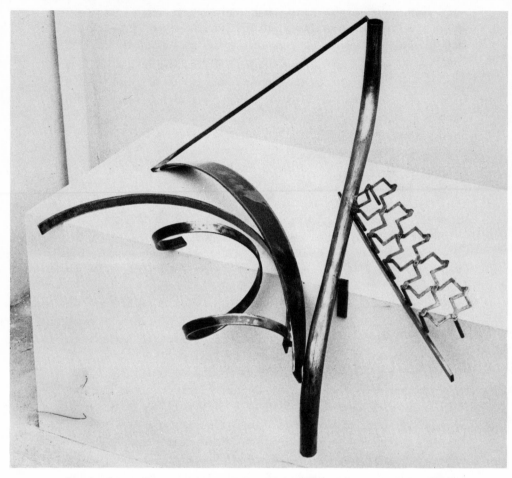

8. Anthony Caro: *LXXII*. 1968. Steel. 37″ x 48″ x 32″. Collection of
S. M. Caro, London.

with a flourish and a pattern; a loosely and irregularly spiraling
steel band is attached to its left side, and a deformed grid, a cross-
breed between a meander and a zigzag, lies to its right. The spiral
externalizes extension and flexibility; the grid partial separation and
opposition to bending.

Matter, the content of Caro's art—and perhaps also its subject— is not the same as the object, which is matter shaped into specific and predictable forms. To this aspect of contemporary art, the object as its content, but also as its subject, we turn next.

5. *The Thing, the Whole Thing, and Nothing But the Thing*

The thing as a whole, its quality as
a whole, is what is interesting.

—Donald Judd, 1965

Much has been made of thingness since Michael Fried pointed out in 1967 that this concept is a goal of "literalist" art. As an artistic expression, reism synthesizes two other modes of approach: the use of banal objects as themes and the use of banal objects as vehicles of meaning. Immediately Duchamp's Readymades, Picabia's Object-Portraits, and Pop art spring to mind (Figs. 9, 10, 21, pp. 104, 106, 161). Yet none of these professes thingness. How do they differ from Minimalist art?

Duchamp's Readymades are not a homogeneous group, as has been pointed out by Robert Lebel in his catalogue of the artist's works. The *Bicycle Wheel* (1913), mentioned above, with which the series started, is a *true Readymade*. The bearded and mustachioed Mona Lisa, entitled *L.H.O.O.Q.* (1919; the title reads phonetically in French: "Elle a chaud au cul": "She has hot pants," "Her arse is itching"; Fig. 9), is a *corrected Readymade*.[66] In it, a masterpiece has been altered and thus invested with a new identity whose meaning is given in the title. Through the reference of the wheel and stool to a work of art and support, the *Bicycle Wheel* functions like an allegory in reverse. An allegory is a moralizing image in which

[66] Besides true and corrected Readymades, Lebel lists reciprocal, assisted, and naturally corrected ones. "Use a Rembrandt as an Ironing Board" (c. 1911–1915) is an example of a reciprocal Readymade (Lebel, *Marcel Duchamp*, p. 35). For the other two categories, see chaps. 5, sec. 5 and 6, sec. 4.

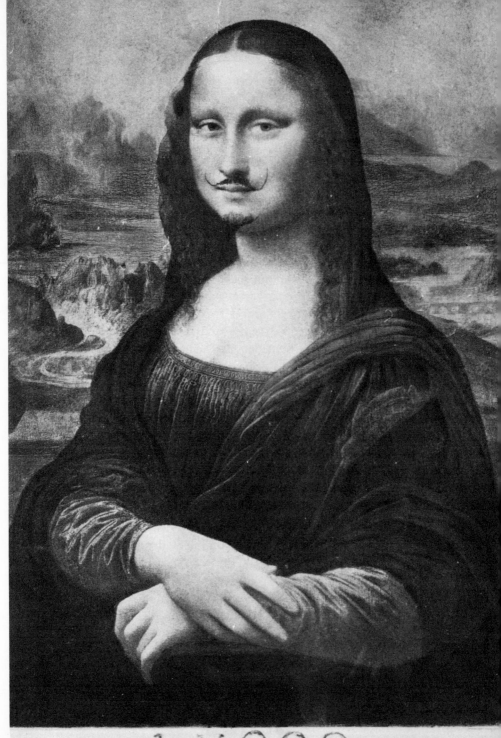

L.H.O.O.Q.

a fictional figure stands for a reality. In Duchamp's *Bicycle Wheel,* a reality, the chair and the wheel, stand for fiction=art. *L.H.O.O.Q.,* on the other hand, resembles an emblem whose definition, as given by the inventor of emblems, Andrea Alciati (1492–1550), is: a picture, its meaning clarified in a caption and a motto, teaches us a moral lesson.[67] Duchamp has reorganized Alciati's system by condensing caption and motto into one reference, and leaving our recollection of the original picture and title to function as the second reference. In both *Bicycle Wheel* and *L.H.O.O.Q.* the lesson is taught through a comparison between actuality and implication, whereas the appeal of the works consists in the conflict created between the original and the revision, the first and the second levels of meaning.

Francis Picabia's Object-Portraits, published in the 1915 Summer issue of Stieglitz's review *291,* are somewhat different in nature from the Readymades. They are symbols. As the cross signifies Christ the Crucified, and as the three intertwined circles signify the identity and indissoluble unity of the Three Persons of the Trinity, likewise Picabia's picture of a disjointed camera headed "IDÉAL" represents Stieglitz the photographer, an idealist fighting against a materialist culture, and an automobile horn (see chap. 6, sec. 5) headed "CANTER" stands for Picabia, the man who pours out an endless stream of stock phrases (Fig. 10, p. 106). The Object-Portraits are known as *mechanical symbols.* This designation derives from the artist's explanation to the *New York Tribune* in 1915 that he had chosen machines to expose human characteristics because the machine is "perhaps the very soul" of human life, besides being "the form which appears most brilliantly plastic and fraught with symbolism." [68]

Although the objects in Duchamp and Picabia are the carriers of messages concerning art, the Readymades and Object-Por-

[67] For an example, see Carla Gottlieb, "An Emblematic Source for Velázquez' 'Surrender of Breda,'" *Gazette des Beaux-Arts,* 6 ser., LXVII (1966), Fig. 5.

[68] "French Artists Spur on an American Art," *New York Tribune* (October 24, 1915), sec. IV, p. 2.

9. Marcel Duchamp: *L.H.O.O.Q.* 1919. Corrected Readymade, print and pencil. 7½ " x 5". Private collection, Paris.

CANTER

F. Picabia
Juillet 1915
New York

LE SAINT DES SAINTS
C'EST DE MOI QU'IL S'AGIT DANS CE PORTRAIT

10. Francis Picabia: *Self Portrait*. 1915. Ink drawing(?). 17⅛ " x 11¼ ". From *291*, Summer 1915.

traits are ideologically unrelated to the profession of objecthood because *the use of banal things is incidental to their purposes.* Duchamp's goal was to test the critic's power to distinguish art from non-art. Picabia's aim was to question the validity of the traditional way of viewing things by likeness; for that, he substituted the referential attribute. Both artists selected banal objects as their means of expression solely because they lived in the twentieth century, which rejects motifs loaded with sentimental and romantic overtones, such as human figures, animals, landscapes, or flowers. Because they were not concerned with the object itself, Duchamp and Picabia could jettison its integrity by subjecting a textbook to decomposition (see below, chap. 6, sec. 4), and by presenting the camera disjointed.

Like Duchamp and Picabia, Pop artists invested banal objects with symbolic significance. Yet, in spite of the fact that they selected these images for their iconography, that is, as banal objects, Pop artists are not thing-centered, like the Minimalists. Their symbolism focused on *the use made of these objects.* The concept of objecthood presupposes that the message be about *values resident in the object itself,* for instance: "The magnification of this single most important sculpture value—shape. . . ." The quotation comes from an article on sculpture by Robert Morris, written in 1966.[69] Likewise, Michael Fried saw the profession of objecthood as vested in shape.[70] As for Caro, he is not a thing-centered Minimalist because he externalizes *values resident in the material.*

It is still difficult to interpret fully the development toward thingness as the content of art because insufficient time has passed to clarify the terms in which this trend is discussed by the artists: language is ambiguous, and words are sorely in need of definition Thus, when Jasper Johns says of his paintings in 1964: "Some of them I have thought of as facts, or at any rate there has been some

[69] "Notes on Sculpture, Part I," *Minimal Art,* ed. Gregory Battcock (New York: Dutton Paperbacks, 1968), p. 228.
[70] "Art and Objecthood," *ibid.,* p. 120.

attempt to say that a thing has a certain nature," [71] and when he declared in 1965 that what interests him "is the particular object encountered at any moment. . . . the one object which is being examined is what's important," [72] these statements seem to promote objectivity and the specific over the general, not objecthood. They refer to restraint from emotionality and to the use of the object as image in art.

Here a distinction must be made between sculpture in the round and painting. In sculpture in the round, every image is an object. In painting, which has a pictorial field established a priori, only images that coincide with the field can assume the character of physical objects, cf. Jasper Johns's *White Target* (1957; Fig. 12, p. 110). However, a "literal *presentation,* in which the image or shape is coextensive with the whole field . . ." alone, does not suffice to establish this character, as has been assumed. Nor is Johns the first artist who "took the background out of painting and isolated the thing" or the first whose "work was looked at rather than into." [73] Painting had done this before.

Images coextensive with the field go back to ancient art provided that low relief is included; that inclusion seems justifiable in view of the fact that Johns's painting has a very marked relief character. Even in easel painting, the image coextensive with the field reaches far back into history, being ubiquitous in representations of windows, doors, paintings, tabletops, etc. As for pictures to be looked at rather than into, all trompe-l'oeil representations of walls, doors, tabletops, letter racks, etc., are of this type. The *Trompe l'oeil* (c. 1670) by

[71] Swenson, "What Is Pop Art?, II," p. 43.

[72] Hopps, "Jasper Johns," p. 35.

[73] Barbara Rose, *Claes Oldenburg* (New York: The Museum of Modern Art, 1970), p. 128; Robert Morris, "Notes on Sculpture, Part IV: Beyond Objects," *Artforum,* VII, No. 8 (April 1969), p. 50. The difference between painting and sculpture in respect to the relationship of image to object has been discussed in my lectures at the New School for Social Research, New York (1956–1960), in connection with the promotion of the motif to theme in modern art. For the flag as a self-sufficient unit, see my article " 'The Pregnant Woman,' 'The Flag,' 'The Eye': Three New Themes in Twentieth Century Art," *The Journal of Aesthetics and Art Criticism,* XXI (1962), p. 180.

11. Cornelis Norbertus Gijsbrechts.: *Trompe l'oeil.* c. 1670. Oil on canvas. 26" x 34". Royal Museum of Fine Arts, Copenhagen.

the Dutch master Cornelis Norbertus Gijsbrechts., painter to the court at Copenhagen where the picture is currently, portrays the back of a framed painting on which a label with the number 36 is affixed by seal (Fig. 11); Gijsbrechts. has taken the background out of painting and isolated the thing; his painting is made to be looked at rather than into; and it is coextensive with the field. However, neither this picture nor any others of this type is experienced as a physical object. Johns's flags owe their quality of physical objects to three factors: the coexistence of the image with the field,[74] the representation of a solid object, and the physical presence of the paint crust that transforms the painting into low relief. Johns's

[74] The image need not be *one* object, however; cf. *Three Flags,* illustrated in Max Kozloff, *Jasper Johns* (New York: Harry N. Abrams, 1969?), Pl. 20.

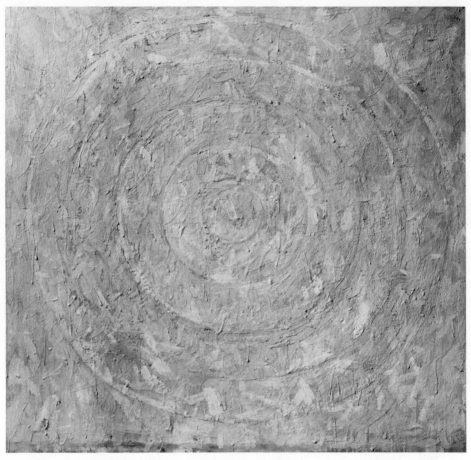

12. Jasper Johns: *White Target*. 1957. Oil wax on canvas. 30″ x 30″.
Whitney Museum of American Art, New York.

radical discovery is that, in conjunction, these three aspects add up
to a slab (Fig. 12).

Johns came to the use of objects through Duchamp's Readymades.
He went beyond Duchamp, however, in that he spotted the difference
between sculpture and painting as it relates to object character.
Through transferring Duchamp's discovery to another branch of
art, he carved out his own niche in the exploration of the object.

He also used this discovery to demonstrate a different concept. He painted flags and targets between 1955 and 1960/61 to serve him as a means for playing upon the words *thing* and *picture,* a variant on the traditional dichotomy of reality and illusion. By making his image either coincide with a real object or contain additional material—one flag or three flags, a target or a target plus other things—he suggests that the two words, *thing* and *picture,* cannot be separated meaningfully. As he explained to Walter Hopps in an interview in 1965: "If the painting is an object then the object can be a painting." [75] The question: Is this art or an object? becomes superfluous. In 1960, Johns illustrated the same point in sculpture. Casting two Ballantine ale cans in bronze, one hollow and the other solid, he then overpainted the bronze to reproduce the cans illusionistically.[76] But the question "Is this work a sculpture or an object?" had been raised five years before by Robert Rauschenberg with his *Bed* (1955).[77] Rauschenberg had audaciously hung upon a wall the frame of an actual bed with its bedding saturated in paint, as a contemporary equivalent of a Renaissance Luca della Robbia majolica. Such philosophical speculations are foreign to Minimal art.

Stella's flag *Die Fahne hoch* ("The Banner High"; 1959) [78] was inspired by the flags of Johns, whose dichotomy of art and object he accepted. However, Stella translated into paint not only the flag's characteristic stripes, like Johns, but also its two-dimensionality. But no illusion was sought: the flag is rendered in unrealistic black and white, declaring it art. The painting's existence as an object is underscored by the use of a deep stretcher, standing out from the wall and casting a perceptible shadow. Stella also furnished the painting with a title communicating a particular message, which message he divorced from the representation. *Die Fahne hoch* is a

[75] Hopps, "Jasper Johns," pp. 35, 36.
[76] Kozloff, *Jasper Johns,* Pl. 80.
[77] Andrew Forge, *Rauschenberg* (New York: Harry N. Abrams, 1969), p. 180.
[78] Rubin, *Frank Stella,* illustrated on p. 19.

line from the text of the *Horst Wessel Song*. But Stella's picture *Jill,* done in the same year and also with black-and-white pinstripes (arranged, however, in diamonds instead of right angles), refers to a young lady who was in the habit of frequenting deviate clubs.[79] Hence no connection exists between the black bands and the specific song or person referred to in the title. It is as if two trains ran parallel to one another on two separate tracks.

In his Black paintings, Stella had not been aiming more at object-hood than Johns; in fact, this by-product was unwelcome. When the artist noticed where he was headed, he quickly took off at a tangent, "correcting" his work correspondingly. There could be some question whether the shape of the canvas had an influence on the pattern in the pinstripe canvases. This question is eliminated for good in the Aluminum series of 1960, where the pattern generates the shape of the support.[80] The dominance of pattern over support is even more emphatically asserted in Stella's Portrait series of 1963, done in a metallic purple on canvases that are shaped as triangular, pentagonal, hexagonal, octagonal, rhomboidal, or trapezoidal bands.[81] Stella may have used Picabia's Object-Portraits as a source, for each canvas is named after a friend. Yet the connection between shape and personality is obscure. Take, for instance, the triangle and the trapezium, portraits of the dealers Leo Castelli and Ileana Sonnabend, his wife at that time. As pointed out by William Rubin,[82] if the Castelli triangle is placed so that the Sonnabend trapezium is its support, then a larger triangular unity is formed. This may be a reference to one person sustaining another, morally or financially. If so, the image is anticipated in medieval church sculpture where four prophets of the Old Testament, Isaiah, Ezekiel, Daniel, and Jeremiah, carry on their shoulders the four Evangelists; [83] and it is anticipated in modern art, in Marc Chagall's *The Birthday* (1915)

[79] *Ibid.,* p. 45.
[80] *Ibid.,* illustrations are on pp. 49, 51, 52, 57, etc.
[81] *Ibid.,* illustrations on pp. 83–88.
[82] *Ibid.,* p. 82.
[83] Émile Mâle, *The Gothic Image: Religious Art in France of the Thirteenth Century* (New York: Harper & Brothers, 1958), p. 9, Fig. 7.

in The Museum of Modern Art, New York, where the artist's wife Bella supports her husband's body on her head, like a bridal veil floating in the wind.[84] Stella's coupled portraits could also be an allusion to the subordinate position of woman in marriage: she has to submit to man's will. The trapezoidal shape below is swallowed within a triangle, the shape of her partner, above her. Be this as it may, only formal relationships are spelled out in the image of support and supported, of trunk and head, of incompleteness and self-containment. The characters of the couple remain vague. Thus the shapes of the Portrait series have as little overt connection with the sitters as the black stripes with the *Horst Wessel Song* and Lady Jill. Duchamp denatured the object, renaturing it differently. Through the new identity that he bestowed upon the object, he poked fun at the artist and the work of art—a negative approach. Stella did not denature an existing object; he formed a new one— his approach is positive. But both artists violated the integrity of the object. By shaping his canvas according to a pattern dictated by his fancy, Stella proved that it is the canvas as a patterned object, and not the object itself, that stands at the root of his art.

Al Held's position toward the object and objecthood combines those of Johns and Stella. As he himself explained in 1966, he tries "to make each individual form exist by itself." He further stated that he aims "to paint into a form the feeling of its actuality so that it is not just a pattern or a form, so that a circle, for example, would be specifically that particular circle in that particular context rather than a generalization of all circles." [85] Held promotes the specific, like Johns, but he uses motifs not objects to this end, and "motif-hood" or "shapehood" is the content of his works.

Although painting seems to have failed so far in equating an object denuded of gestural content with the pictorial field—targets

[84] Franz Meyer, *Marc Chagall: Life and Work* (New York: Harry N. Abrams, 1963), p. 259.

[85] Bruce Glaser, "The New Abstraction," *Art International,* X, No. 2 (February 1966), p. 43.

and flags are riddled with emotional overtones, doors and windows are spiced with symbolism—sculpture has succeeded in making the object *as object* its content. Perhaps the three-dimensional character of sculpture has contributed its share to the object attaining the full status of thingness in art. This achievement is due to the Minimalists.

When the Minimalists entered the scene, they found several stepping-stones for reaching their philosophy of art. First, there was the motif of the banal object, manipulated by the artist as allegory, emblem (Duchamp), or symbol (Picabia, Pop art). Second, there was the dichotomy object/art (Johns). Third, there was the focus on formal and material properties of the object: pattern (Stella), or shape (Held), and extension, resilience, etc. (Caro). Fourth, perhaps there was also the Kantian expression of the "thing in itself," picked up from Dadaist writing,[86] where it was used as a slogan rather than for its meaning. Taking a thread here and a strand there, the Minimalists wove them into their own peculiar fabric, based upon the use of primary structures.

Primary structures, or Specific Objects as they are called by Donald Judd, substitute a class for an individual object. This had also been done before, to wit, Constantin Brancusi who portrayed the essence of the species to which his image belonged. The novel element in the work of the Minimalists is that now the character of the object is shown in its actual physical form, whereas Brancusi or, for that matter, Piet Mondrian externalized that character by an abstraction. Carl Andre's *37 Pieces of Work* (1969; Fig. 39, p. 245) is composed of a great number of different metal squares; both the material, metal, and the individual shapes, squares, do not refer to anything beyond themselves. Likewise Judd's *Untitled* (1969; Fig. 38, p. 243), which is composed of four "boxes" in anodized aluminum with Plexiglas; again both the material, anodized aluminum with Plexiglas, and the individual shapes, open-sided containers, have no area

[86] For instance, Jean Arp, "Notes from a Dada Diary," *The Dada Painters and Poets: An Anthology,* ed. Robert Motherwell (New York: Wittenborn, Schultz, 1951), p. 222.

of reference beyond their own specific physical properties. In Brancusi, *The Newborn* (Fig. 33, p. 218) is shown as an abstraction personifying birth from the egg. In Mondrian, the ocean is shown as an abstraction personifying the motion of the waves.[87] The Minimalists show a slab or cube as a slab or cube personifying a slab or cube. The object as object is the subject and the content of the work. A thing is a thing is a thing.

Minimal art is prone to a hazard, namely its susceptibility to duplication. The simpler the form, the better the realization of Minimal aims. The simpler the form, the easier to copy. This hazard is countered by what could have been another hazard, but was turned from a liability into an asset by the Minimalists: the difficulty of renewing oneself within the system. The simpler the form, the greater the artistic realization, but also the harder to vary the statement. Hence easy to copy, but difficult to imitate. If the Minimalists were trapped by their own prerequisite, so were the copyists who could only either duplicate or produce inferior work. Judd, Andre, Morris, LeWitt, etc., each found his own way out of the Minimalist dilemma. Some succeeded in inventing new shapes for Specific Objects (Judd, Fig. 38, p. 243); others varied the compositions (Andre, Fig. 39, p. 245); some resorted to non-Minimalist work (Morris, Fig. 22, p. 165), and others succeeded in finding a primary structure capable of evolution (LeWitt, Fig. 28, p. 191).

6. *The Rise of the Idea and the Malady of Form*

The idea becomes a machine that makes
the art.

—Sol LeWitt, 1967

All art that has a claim to being art presents an idea, conveys information, or communicates with the viewer. Therefore, an idea is

[87] Hans L. C. Jaffé, *Piet Mondrian* (New York: Harry N. Abrams, 1970), Figs. 48–50, Pl. p. 117.

always the motor that produces art. What Sol LeWitt wanted to express in the above-quoted comment is the switch from an indirect to a direct mode of presentation. Before, the idea was hidden behind the image, which covered it up and dressed it up. Now, the idea is shown in the nude, overtly and directly; it substitutes for the image. This permits great latitude in "iconography." Iconography had developed in long drawn-out stages from religious to historical art; to genre, still life, landscape; to inscapes; to the object. All these are now available for use, and the artist is free to select at his pleasure. Hence, a bewildering variety of artwork is produced from the angle of iconography. But the point is: iconography is no longer important. We no longer deal with art as a structure of iconographic motifs and sensual matter, but as a strategical tool.

The strategy consists in devising the means to stimulate thought into analyzing something. An address to the mind had been part of art before, but it had been the onlooker's choice whether or not he wished to respond. The good work of art existed independently of his reaction; now it exists solely through his response. The viewer who does not analyze the work does not bring it to life.

Since the realm of ideas is infinite and the presentation can assume as many forms as there are artists, how can it be possible to describe, even inadequately, these millions of agents of production under a myriad of forms? In LeWitt, it is the composition of art in visual terms that the viewer is invited to study. Other artists turn to social problems (see Hans Haacke, discussed in the first chapter). Or metaphysical notions are held up for inspection by making invisible art (see chap. 7, sec. 3). The viewer's powers of deduction can be taxed on linguistic, artistic, philosophical, scientific, and many other levels. Punning, metaphors, visual patterns, scientific data, all alike are his playing grounds. Good and bad had been dependent upon the artistic powers of the creator in the old-fashioned *hardware* art, that is, art that had as a goal the fashioning of an object. In *software* art, the *producer* of the *artwork* needs to be intellectually alert, instead of sensitive to quality in form.

The artists contend that form is not important, a crutch that

should be discarded, leaving the idea walking on its own two feet. In theory, they are right, in practice, wrong. Charisma does not make a leader morally good, but it makes a leader. Without it, a man may be good, but he will never find followers. Form is the charisma of art; without it, the artist will not captivate his public. His voice will speak, but it will not be heard.

Here I leave the survey of the idea as the content of art unaccompanied by form. After Conceptual art has been studied, the revolution in content that followed the usurpation by the idea of the place given formerly to the image will be better understood.

The review of content in contemporary art brings to light an interesting fact: the role played in it by form. On the one side, traditional content is innovated through the use of form: symbols are traditional content but, clothed in nonobjective garb, they are something new. This trend continues a line developed in modern art. The same recourse to form as agent for the new can already be detected in Monet, Cézanne, Seurat, and others whose subject matter—landscapes, genre scenes, portraits, nudes—is traditional, while their form—comma stroke, dab, point—is new. The development culminated in Picasso who, in Cubism, invented a new language for traditional subject matter.[88] On the other side, form was promoted to serve as the content of contemporary art under the guise of patterns (Stella), shape (Held), and Specific Objects (Minimalists). Then, when the influence of form in art had reached its apex, a reaction set in with Conceptual art, and form was reduced to zero level (for details, see chap. 7, sec. 3).

Another point to be deduced from a study of content in contemporary art is the intermediary position between past and present of the Abstract Expressionist and Pop artists. Like Janus, they look with one face—content—forward and with the other—subject matter

[88] See Carla Gottlieb, "Picasso's 'Girl Before a Mirror,'" *Journal of Aesthetics and Art Criticism,* XXIV (1966), p. 509.

—backward. Not so Stella and the Minimalists, even though Stella gives his paintings personal names and names of cities, they are not portraits or cityscapes in the accepted sense. As for the Minimalists, their use of objects as subjects is again different in nature from the use of objects for carrying messages. Stella and the Minimalists look only in one direction: forward.

The final point to be made about form concerns the building of a new road for art by the Conceptualists. By eliminating form, they have cut the thread connecting them with their predecessors.

IV

Uproar in Form

A change is demanded in the very essence
and in the form.

—Lucio Fontana, 1946

The demand for renewal in art is ever present. But since the 1960s, the pressures have increased tenfold. Today they are so intense that this need has become a clamor for the new rather than a claim for renewal—the new equated with progress. For progress today is identical with technology, and it is through technology that the most revolutionary and startling innovations in form could be brought about. New territory was opened to content, but the uproar in form by far exceeds the level of change in content.

Interviews with contemporary artists touch, without fail, upon their formal innovations, a conclusive proof that this facet of their art is important to them and/or their interviewers, as well as to the art community at large. This interest is not new; it can be traced back to the nineteenth century, when the working methods of Pissarro and Sisley, etc., formed the subject of descriptions and interviews.[1]

[1] Georges Lecomte, *Exposition Camille Pissarro* (Paris: Galerie Durand-Ruel, 1892), p. 8. Adolphe Tavernier, "Sisley," *L'Art français* (March 18, 1893).

1. *New Materials and New Tools Inspire New Techniques*

The creator of today . . . with new tools . . .
will invent new techniques.

—Victor Vasarely, 1964

Technical advances have always had repercussions in art: the discoveries of the potter's wheel and the lost-wax process are instances in point. But the extraordinary development of technology in the twentieth century has brought onto the market a supply of synthetic materials, as substitutes for paints and stones, unheard of within such a short period of time, and created new tools like the oxyacetylene torch, which could be borrowed for work in art. These new materials and new tools incited artists to discover a series of new working methods, which they described, often by exposing their reasons for their particular choices. For instance, the "drip" method, based upon the use of artificial, fluid, fast-drying paint, discovered by Hans Hofmann in 1940, popularized and described by Pollock; [2] the "soak-and-stain" method, based upon the use of unsized canvas, discovered by Rothko about 1948, carried on by Pollock and Helen Frankenthaler, from whom Morris Louis took it over in 1954, exploiting its potentialities further; [3] and the welding of metal in sculpture, perhaps first used by Julio Gonzalez in 1931/32, introduced to the United States by David Smith in 1933. [4]

At the same time, new visual effects were sought in old as well as new materials, and their why and how were also discussed by the artists. Thus George Segal confessed in 1964 that his plaster figures (Fig. 31, p. 213) carry "special connotations of disembodied spirit,

[2] Sam Hunter, *American Art of the 20th Century* (New York: Harry N. Abrams, 1972?), pp. 190, 194. "My Painting," reprinted in Bryan Robertson, *Jackson Pollock* (New York: Harry N. Abrams, 1960), p. 194. Hunter's important book reached me too late for taking his findings into account.

[3] Hunter, *ibid.,* pp. 211, 320–321.

[4] *Ibid.,* p. 241. Hunter's statements correct former appraisals of who should be credited with these innovations.

inseparable from the fleshy corporeal details." [5] And Stella explained in 1969: "The aluminum surface had a quality of repelling the eye in the sense that you couldn't penetrate it very well." [6]

The new materials were of two kinds. New *technological* discoveries, such as plastics and synthetic rubber, etc., which through their special properties permitted new types of works to be done with new effects, like soft sculpture in foam rubber, etc. (Figs. 21, 25, pp. 161, 181) or styrofoam, and transparent structures in Plexiglas, fiberglass, or coated glass (Fig. 35, p. 228). New *artistic* discoveries using materials that existed before but had never been thought of as suitable for artworks, like cotton wool, nails (Fig. 13, p. 123), felt (Fig. 22, p. 165), rope, the human body, eggs (Fig. 51, pp. 340, 341), bread, fire (Fig. 48c, p. 307), light (Figs. 37, 47, pp. 238, 300), etc. Perhaps their invasions into the sacrosanct domain of oil and stone were caused or facilitated by the intrusion of the technological materials. These artistic discoveries can be aesthetic in nature —Schoeffer's *Cybernetic Light Tower* (Fig. 47)—or symbolic— Beuys's fat sculpture (see chap. 6, sec. 6)—or both—Klein's fire paintings (Fig. 48c), Manzoni's eggs (Fig. 51).

Several of these innovations merit special discussions because they have uprooted many traditional ideas on art and presented us with new visual experiences. They will be described below. Therefore suffice it here to analyze only one instance. I have chosen to discuss the exploitation of a material new in art, that is not a new technological discovery, but a new artistic find. How new dimensions can be conquered for art by the use of the nail as a compositional element has been brilliantly demonstrated by Günter Uecker (see Fig. 13, p. 123).

Uecker had joined Otto Piene and Heinz Mack as one of the leaders of Group Zero around 1962. This group, active in Düsseldorf from 1957 to 1966, was named after the moment of takeoff in

[5] Henry Geldzahler, "An Interview with George Segal," *Artforum,* III, No. 2 (November 1964), p. 29.

[6] William S. Rubin, *Frank Stella* (New York: The Museum of Modern Art, 1970), p. 60.

space exploration because its members proposed to take off into unexplored space in art. Uecker did just that when he exploited the potentialities of the nail as an artistic medium. Starting out in 1957 with nails embedded into the paint surface to give it variety and texture, a method used by Schwitters and Pollock, Uecker transformed the nail into a structural element for relief sculpture in 1959 by driving it into a wooden panel. He had discovered his own road.

He succeeded in finding a variety of ways how to use his awkward material. In one example his nails are set out loosely like a checkerboard; in the second they are arranged more densely like a field of wheat; and in a third they are deployed in group formation like troops in a parade. In one type the nails produce diverse configurations through their varied degrees of compactness, such as geometric figures, human bodies, or landscape motifs; in another type rhythm is accented, either as circular, or as spiral, or as reiterative, or as syncopated, etc.

Besides utilizing traditional methods of composition for his nail works, Uecker also developed methods based upon the specific properties of the nail itself. Sometimes his nails are stuck in vertically; sometimes they are inserted at an acute angle, to relate obliquely to the plane of the panel; and sometimes they are threaded through the canvas like needles, to lie parallel beneath its surface with only the heads visible, or they are pushed through from the back with the points facing us. Often their bodies are cut so that a gradation in height is obtained. Color may be added to their heads and bodies, or only to a portion of them. As three-dimensional objects, nails throw shadows that, in their effects, depend upon the density factor and the time of day. Thus all kinds of patterns and motions, vibrations and configurations, in color and light are created by Uecker.

Uecker's mastery over the medium is evident in his relief *Ocean* (1970; Fig. 13). In it, long lines run over the surface vertically because the nails are spaced nearer one another in this direction than across the work. The lines are slightly irregular suggesting the ripple of the waves on a quiet summer day. Over the center of the

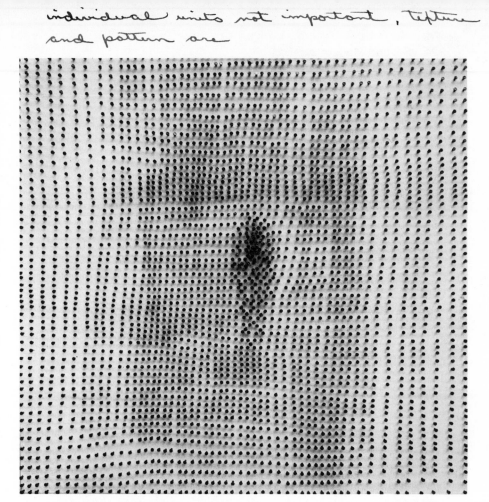

13. Günter Uecker: *Ocean.* 1970. Nails on canvas on wood. 59″ x 59″ x 6″. Artist's collection, Düsseldorf.

field lies a large pale shadow, and in the center of this shadow is a stronger concentration of darkness in the shape of an almond. One can visualize a cloud reflected in the water, or the wind caressing the ocean, or a boat creating a disturbance in the pattern of the waves around it.

In addition to relief surfaces like *Ocean,* the artist also built three-dimensional objects with his nails. He studded a cube with nails on

five sides, spiked a sphere with them, and structured a space drawing from them. He covered tables and chairs with them, the nails cascading down from the tabletops and chair seats, slithering over one leg and/or rearing up over a post in the backrest. He made a pillow out of nails, also floor mats and dancing mannequins. He structured environments from nail pieces and, by the use of electricity, turned nails into incandescent candles. He used small and large nails, and even monumentalized the nail by shaping it in heroic size.[7]

Who before Uecker could have thought of a nail as an instrument to embody different moods? Yet, by placing a few, isolated, tiny nails on large steps, the artist made them look lost and forlorn. His giant dark nails protruding from the underside of a huge table are frightening, like shark's teeth, transforming the object into a medieval portcullis. The hedgehog table and chair, the nail pillow for a couch, and nail mats for a floor look absurd. A colossal over-life-sized nail, carried by the artist like a spear, is threatening the passersby. The candle nails are beautiful and frightening at the same time, like lightning. And *Ocean* is serene. Uecker thinks of his art as expressive of spiritual values. His favorite color, white, is for him the equivalent of a prayer.[8]

Enough has been said to prove that a new material in art has given birth to new visual experiences, adding a new repertory— but is it a new repertory in painting or in sculpture?

2. *Dialogue with a Limit: The Picture's Edge and the Sculpture's Boundary*

To be stopped by a frame's edge
was intolerable.

—Clyfford Still, 1963

[7] For illustrations of Uecker's work, see *Günter Uecker* (Hanover: Kestner-Gesellschaft, 1972, Catalogue No. 3).

[8] *Ibid.,* p. 39.

My things . . . begin in the world.

—Carl Andre, 1970

Aside from descriptions dealing with the new working methods and the visual effects of new materials, the statements of the artists plumb the new modes of composition, and they are given an equally large amount of space: technical and formal sides balance one another in significance in contemporary art.

For instance, the expression *nonrelational* painting. It appears in Stella, who employs it to define the difference between the "new painting" and Cubist composition, because Cubism had been discussed in terms of "relations between straight lines and curves . . ." by Albert Gleizes and Jean Metzinger in 1913.[9] Following their interpretation, Stella posited in 1964 that in European geometric art: "You do something in one corner and you balance it with something in the other corner. Now the 'new painting' is being characterized as symmetrical. Ken Noland has put things in the center and I'll use a symmetrical pattern, but we use symmetry in a different way. It's nonrelational." [10] The nonrelational symmetry of the new American art was named "anaxial" symmetry by Carl Andrė in 1970. [11] In it, structural regularity is substituted for balance as the principle ordering the composition (Fig. 15, p. 129). The term *holistic,* on the other hand, deriving from the Greek word *hólos* (complete, whole) and used to designate the theory that the world is composed of wholes, that is, irreducible elements, appears in Judd's statements; compare the epigraph above the discussion of objecthood. Judd's work offers examples of what he meant by it: something as plain as possible, to avoid having parts that necessitate balancing (Fig. 38, p. 243).

Nonrelational and holistic compositions are solutions to the prob-

[9] Albert Gleizes and Jean Metzinger, *Cubism* (London: T. Fisher Unwin, 1913), p. 33.
[10] Bruce Glaser, "Questions to Stella and Judd," *Minimal Art,* p. 149.
[11] Phyllis Tuchman, "An Interview with Carl Andre," *Artforum,* VIII, No. 10 (June 1970), p. 57.

lem of the edge in painting and the boundary in sculpture. These two problems developed as two logical sequels to the elimination of the frame and the pedestal by Mondrian and Arp in the first decades of this century. Arp, though he reversed himself on the subject in his later years, had denounced these "unnecessary crutches" of art plainly in the *Almanach Dada* of 1917, and had again mocked them in 1948. "Even in my childhood, the pedestal enabling a statue to stand, the frame enclosing the picture like a window, were for me occasions for merriment and mischief, moving me to all sorts of tricks," he wrote, relating how he painted blue sky on a window pane *under* the houses seen through it, making them float in midair, how he sawed a hole in the wooden wall of a shack, framing a "picture" of a landscape with men and cattle, how he took up the stance of a bashful nymph upon an empty pedestal.[12]

With the disappearance of the frame, the edge became noticeable. When Jules Olitski in 1967 spoke "of painting as possessed by a structure—i.e. shape and size, support and edge,"[13] he showed an awareness of this element. However, an edge does not possess the same binding power as a frame or line; it is merely a termination. This is acknowledged in Ellsworth Kelly's statement in 1964: "In my work, it is impossible to separate the edges from the mass and color."[14] It is also implicit in Albers who stated in 1962 that he felt it necessary to "always keep a white margin" because he wanted his "pictures to have a beginning and an end."[15] It is this ambiguity of the edge, compared to the frame, the fact that the edge can be seen as an end, as well as a part of a shape, that permitted new solutions in composition to evolve. The frame allowed only two readings of the image it surrounded: the image is complete or incomplete. The

[12] "I Became More and More Removed from Aesthetics," *Arp on Arp: Poems, Essays, Memories,* ed. Marcel Jean (New York: The Viking Press, 1972), pp. 237–238.

[13] "Painting in Color," *Artforum,* V, No. 5 (January 1967), p. 20.

[14] Henry Geldzahler, "Interview with Ellsworth Kelly, *Art International,* VIII, No. 1 (January 1964), p. 47.

[15] Katharine Kuh, *The Artist's Voice* (New York: Harper and Row Publishers, 1962), p. 20.

edge allows three: the image continues beyond the field, it equates with the field, or it does either one. These three approaches are exemplified in the works of Clyfford Still, Frank Stella, and Larry Poons.

14. Clyfford Still: *1951-D*. 1951. Oil on canvas. 117″ x 105″. Marlborough-Gerson Gallery, New York.

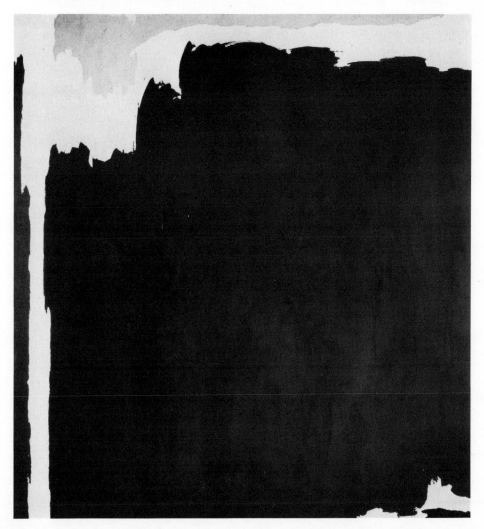

A painting was a living thing for Still, and any restriction of liberty was a violation of self-determination. To him a fence transformed a field into a prison. Hence the edge had to be ignored so that "a Euclidian prison . . . be annihilated, its authoritarian implications repudiated without dissolving one's individual integrity and idea in material and manners." [16] The love of the disciplines of freedom guided Still's mind and hand when he took the decision away from an a priori established field and handed it over to the image.

The artist's method of overcoming the boundaries of the picture so that the image is not fenced in by them can be studied in *1951–D* (Fig. 14). Still covered the canvas with a limited number of similarly constructed shapes in different colors, some small, others large; he brought these right up to the edge where they were cut off by it, thus terminating in clean straight lines; whereas he gave his color areas jagged outlines on the sides not bordering on the edge. The sizes and colors are kept far apart to create tension. The small forms are generally placed on the periphery of the canvas, the large ones extend over its center and occupy two thirds of its surface. Due to the jaggedness of the inner lines, the outer sides look incomplete in contrast. If Still's pictures had frames, his shapes would be seen as sliced in two, an effect familiar to us from the paintings of Edgar Degas, Henri de Toulouse-Lautrec, and Pierre Bonnard. Without a frame, the eye experiences them as though they continued beyond the edge of the field into the surrounding void. The edge of the canvas is not strong enough to check their outward drive.

It is impossible to visualize Frank Stella's shaped paintings with frames, and it even needs an effort to place one mentally around the early rectangular pictures of the Black series, the so-called Pinstripes. Stella's works are strongly self-sufficient, in the sense of Greek metopes. His motifs seem neither to pass beyond the edge of the pictorial field, like Still's, nor to be restricted by it, like Pollock's, whose painting sinks away at the edges of the canvas as the tide recedes from the shores of the ocean (see Fig. 1, p. 19).

[16] Ti-Grace Sharpless, *Clyfford Still* (Philadelphia: Institute of Contemporary Art, University of Pennsylvania, 1963), unpaged.

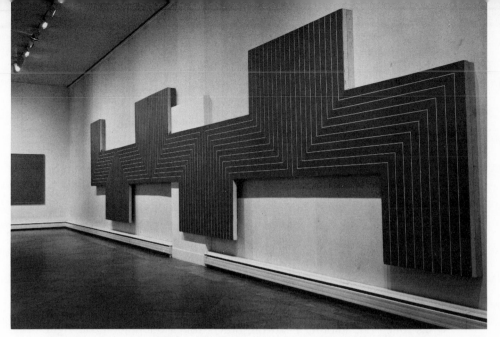

15. Frank Stella: *Sangre de Cristo*. 1967. Metallic powder in polymer emulsion. 10' x 42'. Installation *Plus by Minus: Today's ½ Century*, Albright-Knox Art Gallery, Buffalo, 1968. Collection of Dr. Charles W. Hendrickson, Orange, California.

Stella's motifs coincide with the edge, illustrating the meaning of holistic composition as can be seen in *Sangre de Cristo* (1967; Fig. 15). The impression of wholeness is underlined by the deep stretchers the artist uses, which detach the pictures from the wall in the form of slabs.

This is true even of the early paintings in the Black series. Practically, it would be possible to add to or to subtract from their pinstripe pattern at will, yet the viewer has the distinct impression that the image would resist these attempts. Perhaps it is a question of a hidden law of visual harmony, like that regulating proportions in the golden section, a law for stripes that demands that a certain type be linked to a certain size for best effect as a pattern.

By making his image reach to the edge in full strength, Stella hoped to make the painting look larger. "Spanning the entire surface produces an effect of scale—the painting is more on the surface, there is less depth," he stated in 1969. "And the picture seems

bigger because it does not recede in certain ways or fade at the edge." [17]

The pictures done by Larry Poons between 1962 and 1968 offer a third solution to the problem of the edge (since abandoned for different experiments). For him, "the edges define but don't confine the painting." [18] As can be seen in *Northeast Grave* (1964) in the Hirshhorn Collection at the Smithsonian Institution (Fig. 16), Poons based his picture upon an open field strewn with one serial element: small, elongated ovals (during 1962/63 it was the dot). In *Northeast Grave* the field is a rich, deep red and the ovals are given six colors: two reds, two greens, and two blues, each pair composed of one bright and one grayed tone. The units are positioned with a scientifically calculated randomness within a nonexistent but recognizable grid system in what may be called ordered disorder. Some ovals touch one another head on, others touch one another at right angles, and yet others are separate. Series, clusters, and solitaries can be distinguished. The intense color contrast between field and figure stimulates afterimages. (When this was pointed out to the artist, he was provoked to paint in shadows around his ovals, and even to sham afterimages by painting some units in complementary colors.) Despite their point-to-point differences, the egg-shaped units coalesce into a pattern, a checkerboard, which is—and is not—there. Poons knows exactly where to draw the line so that neither the minimal nor the maximal deviations from alignment and regularity interfere with the possibility of recognizing the underlying grid. In this structured irregularity resides the power of the work. Poons came to art from music and, although the artist denies that his work has anything to do with this discipline, the effects are similar: both hypnotize the audience, transporting it into an inactive awareness that lies between consciousness and dream. This state of half-awareness favors the ambivalence of the edge at which Poons aims.

Is it or isn't it a boundary? For Poons's ovals and their framework,

[17] Rubin, *Frank Stella*, p. 39.
[18] Lucy R. Lippard, "Larry Poons: The Illusion of Disorder," *Art International*, IX, No. 4 (April 1967), p. 24.

16. Larry Poons: *Northeast Grave*. 1964. Liquitex. 90" x 80". Hirsh-horn Collection, Smithsonian Institution, Washington, D.C.

the grid, do not stop short at or pass over the boundaries of the canvas, like Stella's patterns or Still's shapes, neither do they taper off at this point, like the Abstract Expressionist allover design from which Poons has drawn for his work. They are equally strong and dense at the periphery and center of the artist's pictures. They run straight up to the edge, where some are even halved by it. Hence, contrary to the Abstract Expressionist canvas, which is closed off toward the environment, Poons's design is open-ended. The edge

provides a temporary halt over which the viewer can step. Poons thought of his type of composition as "space relationship. . . . I'm trying to open up the space of the canvas and make a painting with a space that explodes instead of going into the painting."[19]

The difference between the compositions of Still, Stella, and Poons resides in the fact that Still's image is a fragment, Stella's a whole, and Poons's a segment; the first is incomplete, the second complete, and the third complete as well as incomplete (Figs. 14–16, pp. 127, 129, 131). The segment is a unit belonging to a larger entity; as a unit, it is complete, but as a part of a larger whole it is incomplete.[20] Consequently, the segment is ambiguous in visual structure. Poons has maintained that "the responsibility of not knowing . . . is one of the most important aspects of making art. . . . I believe in ambiguity." [21] Logically, the fragment in abstract art encourages a free motion of the glance (Still), the wholeness of the unit promotes scale (Stella), and the segment leads to ambivalence in vision (Poons).

When linking the frame to the pedestal in his mockery, Arp did not find it necessary to point out what the connection between the two is: that both isolate the real world of the viewer from the imaginary world of art. In painting and in sculpture two opposite trends exist concerning such separation: for and against, *segregationism and integrationism.* Frans Hals, in painting, is one of the integrationists when he makes his sitters extend their hands through the picture frame into the space of the spectator. The trompe-l'oeil

[19] *Ibid.*

[20] For the difference between fragment and segment, see Rudolf Arnheim, *Art and Visual Perception: A Psychology of the Creative Eye* (Berkeley, Calif.: University of California Press, 1954), p. 81; the segment is experienced as a "visual amputation."

[21] Lippard, "Larry Poons," p. 22.

paintings in which things are hung upon a wall [22] are other examples of integrationist works—to quote only a few cases.

Sculpture likewise has its segregationists and integrationists; Robert Morris is mistaken if he sees the "dialogue with a limit" as a problem of painting alone.[23] The question whether to make the work of art self-contained or to have it reach out beyond itself has preoccupied both branches of art equally.

Corresponding to painting's disregard of the frame as a limit, sculpture disposed of the pedestal. This solution for merging the work of art with the real world was adopted by some masters of the fifteenth century who placed their figures directly on the floors of churches; and by Auguste Rodin in the nineteenth century who, in his project for *The Burghers of Calais* (which was aborted by the officials of Calais), positioned his figures on the stones of the square in front of the town hall so that the crowd could rub elbows with them.[24] Rodin's example was followed by several artists, such as Aristide Maillol and Matisse, but sporadically. Arp transferred the idea to the nonobjective realm.[25]

A second integrationist solution, more congenial to twentieth-century art, was discovered by Brancusi. On the one hand, he made sculpture reach the ground; on the other hand, he made it reach beyond itself. Retaining the pedestal, the Romanian master converted it into a part of his sculpture by developing it from a nondescript, indifferent *plat*form into a *plastic* form whose shape, like

[22] For instance, Jacopo de'Barbari, *The Dead Partridge,* Munich (1504), or Wallerand Vaillant, *Trompe l'oeil: Letters,* Dresden (1658); illustrated in Charles Sterling, *Still Life Painting from Antiquity to the Present Time* (New York: Universe Books, 1959), Figs. 11, 34.

[23] "Notes on Sculpture. Part I," *Minimal Art,* p. 223. Morris is also mistaken if he states that illusionism exists in painting but not in sculpture (*ibid.*). Perhaps this is true for a sculptor, but for the average person illusionism is equally effective—or ineffective—in both media.

[24] *On Art and Artists,* ed. Paul Gsell (New York: Philosophical Library, 1957), p. 103.

[25] For examples by Matisse and Maillol, see Albert E. Elsen, *The Sculpture of Henri Matisse* (New York: Harry N. Abrams, 1972?), p. 61. For Arp, see Carola Giedion-Welcker, *Hans Arp* (New York: Harry N. Abrams, 1957), illustrations on pp. 52, 53, No. 23.

that of the figure above it, was inspired by the material he used.[26] (It has been consistently overlooked by writers that Brancusi treated wood differently from stone.) Then he borrowed the gleaming surfaces of metal and polished his pieces so highly that they reflect the room and the viewer, overcoming their spatial separateness (Fig. 33, p. 218); if Larry Poons's picture-space explodes, Brancusi's sculpture-space sucks us in. Brancusi's mirror surfaces added a new dimension to art—and not only to sculpture since mirrors became part of paintings or collages as well, starting in 1912.[27] Both discoveries, the base in plastic form and the insertion of mirrors into a work of art, inspired a long succession of disciples, and disciples of disciples, some of which will be discussed below in connection with Environments and space sculpture (Figs. 32, 35, 37, 38, pp. 216, 217, 228, 238, 243).

However, one of the disciples went beyond the master: Robert Rauschenberg, who adapted the Brancusi principle to painting. In 1952, the artist did a series of White paintings whose shiny surfaces served like waxed floors in capturing vague reflections of the environment. Unlike the metal surfaces of Brancusi's sculpture, which distort the images because they are curved, the White paintings show the silhouette correctly but in a vague manner, as though the image were veiled. These pictures function like delicate, hypersensitive plants that react at the slightest provocation. That is how the artist thinks of them rather than as passive objects. "One could almost look at the painting," he wrote, "and see how many people there were in the room, by the number of shadows cast, or what time of day it was, like a very limited kind of clock." [28]

The third integrationist solution owes a debt to Brancusi and Duchamp. By using a chair as support for the *Bicycle Wheel* (see

[26] Examples in Carola Giedion-Welcker, *Constantin Brancusi* (Basel: Benno Schwabe, 1958).

[27] The first example seems to be the mirror embodied by Juan Gris in his *The Lavabo* (1912; Noailles collection, France); illustrated in Guy Habasque, *Cubism* (Geneva: Albert Skira, c. 1959), p. 67.

[28] Andrew Forge, *Rauschenberg* (New York: Harry N. Abrams, 1972), p. 18.

introduction), Duchamp had applied to the Readymade Brancusi's idea that support and supported should be treated as an entity and therefore both should be sculpted. If Duchamp could develop the base into *a* piece of sculpture, why not continue in this direction and isolate it as *the* piece of sculpture? This is the premise from which Beuys, Uecker, Kusama (Fig. 25, p. 181), Samaras, etc., started when transforming furniture into sculpture. Taking off at a different angle, the Minimalists reinstated the pre-Brancusi form of the pedestal, but raised this cube, rectangle, or platform, traditionally considered a base for sculpture, to sculpture in its own right. Thus Specific Objects took over where Brancusi had left off (Fig. 38, p. 243). A fourth solution, the invisible pedestal of airborne sculpture (Fig. 49, pp. 310, 311), will be discussed in chapter 5.

Once the concept of placing the sculpture directly on the ground had been accepted as normal, the next step was to take advantage of the new situation. The experiments again moved in the two directions of segregation from, or fusion with, the setting. This time, however, it was not a question of isolation from or union with the observer. Object was wedded to object, or divorced from object, rather than space—thus excluding man.

A case in point is the work of Carl Andre who is grounding his objects in the preexisting formation of their sites (Fig. 39, p. 245). For him "the place" is the determining factor of the form his work will assume: "My things are conceived in the world," [29] he said in 1970. Since the location generates the work of art, the two become one.

Another integrationist solution hangs the objects from the ceiling like lighting fixtures. But the resemblance stops with the method of suspension. These works are usually in the form of slabs (cf. Morris' *Cloud* [30] of 1962); they seem a less successful diversion in art. Not every step forward is aesthetically an advance. Nonetheless, every

[29] Tuchman, "An Interview with Carl Andre," p. 55.
[30] Michael Compton and David Sylvester, *Robert Morris* (London: The Tate Gallery, 1971), illustrated on p. 34.

experiment should be welcomed, because it may inspire other steps forward that may turn into advances.

So far only integrationist attempts have been surveyed in sculpture. An interesting example of a segregationist solution without pedestal is Morris' equilateral slab *Corner Piece* (1964) in the collection of Count Giuseppe Panza.[31] The effect of this object, destined to be placed in the room's corner, depends upon its strongly separatist, holist form. Leaning against the wall with its point fitted into the angle that it touches, it jars with that angle because of the upright surface it erects in front of it. It jars with the cubical space of the room through its quickly running slopes and backward inclination. In short, it affects the viewer like a splinter in the eye. Morris' work thus contains integrationist objects as well as segregationist objects, but the hostile types are much more successful than the friendly ones. What a psychoanalyst would make of this fact can be easily puzzled out.

3. *The Monologue of Magnitude*

> I think the presence of a large
> painting is quite different from
> that of a small one.
>
> —Franz Kline, 1960

Size and scale, that is, the awareness of size, have always played a role in art. Size is linked to the nature of the work, in that the important image preempts more space than the trivial. Scale is dependent upon the artist's power to make the viewer experience size as monumentality. A survey of the changes these two aspects underwent in contemporary art has to note this difference as a frame of reference. When studying size, the problem facing us is man's evaluation of things as significant or insignificant. When studying scale, the problem we are dealing with is the artist's discovery of

[31] *Ibid.,* illustrated on p. 38.

methods to make his work look monumental—such as Stella's solution, just discussed, which consists in spanning the whole canvas surface with the visual pattern (Fig. 15, p. 129).

Until the time of Courbet, religious, allegorical, and historical subjects were considered meaningful and were represented in large formats, whereas genre and still life were considered trivia and were given small ones. Courbet thought differently. Grounded by his grandfather in the ideals of the French Revolution, one of which is the principle of equality, he rejected this hierarchy as outdated. When the grandson portrayed the burial of the old revolutionary in 1849, he used the heroic dimensions of ten by twenty feet, accorded previously to kings. To him, the death of the old fighter for freedom seemed as momentous for mankind as *The Story of Marie de Médicis,* painted by Rubens in similar dimensions, which he could admire in the nationalized royal collection. This audacity provoked a good deal of unfavorable comment in art circles. Undaunted by it, Courbet went even further in this direction and painted an allegory about himself, his *Atelier* (1855), in the same giant proportions. By this deed, he declared that, as an artist, he was entitled to royal status. Now even his supporters, like Champfleury, dissociated themselves from his course. Courbet was accused of overbearance and vaingloriousness. His example found no immediate imitators in easel painting.[32] The artist's enormous memorials to self-made individuals remained unique until the period after World War II.

At that time Courbet's idea that the great painter can rightfully claim the same attention as Christ or a ruler was adopted by American artists. The first to use Courbet's precedent were the Abstract Expressionists who externalized their emotions and feelings in canvases of uncommon size. However, although they were aware of using large surfaces, they could not define what size did for their art formally. When asked the reason for this choice, they justified it on emotional rather than rational grounds, such as that they "enjoy

[32] Murals, panoramas, dioramas should be excluded from the argument because their sizes are dictated a priori by the wall spaces, and by their functions; of course, murals can be traced back to ancient painting.

working big . . . felt at ease" in such size (Pollock, 1950), wanted "to be very intimate and human" (Rothko, 1951), felt that "there's an excitement about the larger areas" (Kline, 1960), or found it "a defiant position. . . . you are not going to bow to the sales angle" (David Smith).[33]

Since then sizes have steadily increased on this side of the Atlantic (see Figs. 6, 15, 17, pp. 82–83, 129, 143), influencing European and and South American art. And, aided by the critic,[34] later artists have discoursed on the artistic advantages of large size, giving these as reasons for following the lead of the Abstract Expressionists. For George Rickey, the choice of large formats is linked to scale: "The actual area of the canvas and the height and width of the sculpture become the scale." [35] The same connection between magnitude and scale was made by Al Held in 1968: "When the forms are large enough, they cease to have form, only scale." [36] But how can size become scale, which is the measuring of one element through *comparison* with another?

Scale is introduced into art through size when a work is exhibited in a confined space; this keeps the spectator from stepping back far enough to take in the whole piece at one glance (Fig. 15, p. 129). As a result, he is forced to let his eyes travel over the surface.[37] Due to

[33] William Wright, "An Interview with Jackson Pollock"; reprinted in Francis V. O'Connor, *Jackson Pollock* (New York: The Museum of Modern Art, 1967), p. 81. *Readings in American Art since 1900: A Documentary Survey,* ed. Barbara Rose (New York: Praeger Publishers, 1968), p. 160. Kuh, *The Artist's Voice,* p. 152. Thomas B. Hess, "The Secret Letter," *David Smith* (New York: Marlborough-Gerson Gallery, 1964), unpaged.

[34] Eugene C. Goossen, "The Big Canvas," *Art International,* II, No. 8 (November 1958), pp. 45–47.

[35] "The Morphology of Movement: A Study of Kinetic Art," *The Nature and Art of Motion,* ed. Gyorgy Kepes (New York: George Brazille⁻, c. 1965), p. 106.

[36] Eleanor Green, *Al Held* (San Francisco, Calif.: San Francisco Museum of Art, 1968), p. 7.

[37] Although critics have noticed the connection between the spectator's closeness to the work of art and the experience of scale (Goossen, "The Big Canvas," p. 45; Rickey, "The Morphology of Movement," p. 106; Morris, "Notes on Sculpture," p. 233; Rubin, *Frank Stella,* p. 40), they have failed to explain this phenomenon.

the instinctive reaction to which he is conditioned—a case of active spectator participation antedating the posing of this principle by the Groupe de Recherche d'Art Visuel in Europe—an awareness of bigness is born in the viewer, followed by the wish to evaluate this bigness. The measuring can be done against an external agent, such as our body, as noted by Rothko in 1951: "To paint a small picture is to place yourself outside your experience, to look upon an experience as a stereopticon view or with a reducing glass. However, you paint the larger picture, you are in it." And clarified by Kline in 1960: "I think you confront yourself much more with a big canvas. I don't know exactly why." [38] Or, a detail of the work itself can be measured against the total field, as pointed out by William Rubin: "Large Abstract Expressionist pictures contain numerous very small markings or local changes of color and value which are played off against the dimensions of the larger compositional units and the size of the canvas itself." The same thought was expressed by Stella in 1969, when he stated: "The development of a more accurate consciousness of the size and scale of both fields and their interior units . . . let me . . . make more extreme paintings, in the sense of larger fields." [39]

Although this assumption cannot be proven, it is probable that the notion of scale, a formal principle, entered into the use of size by the Abstract Expressionists, and defiance of conventions, an emotional dictate, played a similar role in the use of size by later artists.

The magnitude of contemporary works has brought in its wake certain formal developments, in painting as well as sculpture. But each medium reacted in its own way. Since painting was in advance of sculpture at the time when magnitude became a component of easel painting and room sculpture, the response of painting to magnitude will be discussed first.

[38] *Readings in American Art since 1900*, p. 160. Kuh, *The Artist's Voice*, p. 152.
[39] Rubin, *Frank Stella*, pp. 39–40.

Because a picture has an a priori established field, the positioning of the image within this field as well as the relationship of void to solid within that image are formative devices in painting. When the pictures assumed heroic sizes, this latter property of painting led to two new visual experiences: either the viewer was faced with an unprecedented plenitude of impressions or with sameness of colossal dimension.

The multiplicity of impressions in the new art has been noted by art historians and critics in connection with the allover design of Pollock but, I believe, without explaining why it becomes part of the spectator's aesthetic experience. The connection to magnitude was not made. It was not stressed that, because the dichotomy between the total effect and the place-to-place inspection has greater latitude in Pollock and de Kooning than it does in normal-sized canvases, it does not develop into the overcrowded business of *horror vacui*. The effects of a heroic-sized sameness have been studied in connection with the single-image painting of Rothko, Newman, and Morris Louis (Figs. 6, 17, pp. 82–83, 143). I see the work of Rothko as a dialogue, hence sameness is not an absolute order in it. In his painting there is a question-and-answer situation, instigated by colors that provoke one another. Here we shall analyze the effects of the colossal sameness as a monologue of the field, ignoring the question addressed to it by other pictorial elements. This monologue can take three forms: the field is a monotone color presence, as in Newman; the field is an empty canvas presence, as in Louis; and the field is an atmospheric sprinkled-color presence, as in Olitski.

Newman's *Vir Heroicus Sublimis* of (1950/51; Fig. 6, pp. 82–83) has been analyzed above from the point of view of its two component elements: color field and zips. The electric zips create shock waves; but the color field is so gigantic that it is not perceptibly shaken by them. Only a few ripples are caused, right next to the zips, in response to the current. These ripples cannot reach far into the stillness. In principle, the color field remains undisturbed, a quiet solitude of vast proportions. The viewer is confronted with the universe and he is alone in it. He must be careful not to get lost.

Louis also operates with two component elements mixed in telling disproportion, with all the available space handed to the field. Instead of zips he has repeat motifs, and instead of a color field a blank canvas surface. Take his *Alpha Tau* (1961), for instance, from his Unfurled series in the City Art Museum of Saint Louis (Fig. 17). This work measures eight and a half feet by nineteen and a half feet. Of this surface, less than a quarter is occupied by image, the remainder is empty. The whole center is blank, and at each side are writhing, parallel ribbons of color, running diagonally out of the field. It is as if the giant empty portion of the center has attacked and put to flight the color formations at the left and right. What is significant in that phenomenon is that *emptiness* has acquired the power to conquer *image*. I here differentiate—perhaps arbitrarily—between emptiness and void. By *void,* I understand an emptiness experienced as filled with space. Because air moves and can expand, such voids can push in art. That is a well-known phenomenon experienced in cupolas and arches. But the central area in Louis is not experienced as space. Rather, as white becomes color under certain conditions, here naught becomes weight. The best analogy I can think of in another discipline is the weight of the pause in the music of John Cage which is more fraught with meaning than the tones.

Olitski's achievement is difficult to discuss without a color reproduction because his forte is color, as has been noted by Michael Fried.[40] Fried links Olitski to Jan van Eyck and Vermeer on the grounds that the works of all three painters demand a prolonged scrutiny of each detail. This is true, but the reason for the prolonged scrutiny is, once, a mode of composition (Jan van Eyck), and, once, an approach to the rendering of light (Vermeer, Olitski). Therefore, only Vermeer's art is related to that of Olitski, particularly as his mode of composition is just the opposite from that of Jan van Eyck.

The polar modes of composition in art are either to alert our

[40] *Three American Painters: Kenneth Noland, Jules Olitski, Frank Stella* (Cambridge, Mass.: Fogg Art Museum, 1965), p. 34

faculties through the image or to put them to sleep. We may speak of provocative and hypnotic compositions. Scrutiny of detail belongs to the first type and Jan van Eyck should be paired with Pollock. In Jan and Jackson, the eye travels restlessly over the surface, constantly discovering new motifs. Olitski, on the other hand, should be classified together with Rembrandt, Emil Nolde, and Rothko, as using hypnotic composition. In them, the epic mood is replaced by lyricism. Their painting is "a structure born of the flow of color feeling"; [41] Olitski's definition for his work, given in 1967, suits the work of the other three artists as well. The viewer becomes immersed in the picture because color casts a spell over him.

[41] Olitski, "Painting in Color," p. 20.

17. Morris Louis: *Alpha Tau*. 1961. Acrylic on canvas. 102″ x 234″.
City Art Museum of Saint Louis, Saint Louis, Missouri; gift of the
Shoenberg Foundation.

Olitski's link with Vermeer, in whom neither the wandering of
the glance and the exploitation of minutiae nor the stillness of con-
templation are exclusively accented, resides in the use of *colored
light*. This effect is also present in the night pieces of Vermeer's
contemporary Aert van der Neer,[42] earlier in Pintoricchio, and,
nearer to the time of Olitski, in the Impressionists, the Divisionists,

[42] Hans Kauffmann, "Die Farbenkunst des Aert van der Neer," *Festschrift
für Adolph Goldschmidt zum 60. Geburtstag* (Leipzig: E.A. Seemann, 1923),
pp. 107, 109.

the Nabis, etc. In Olitski it is not certain whether his light is colored or his color is filled with light; one opts for the latter because he is a nonobjective artist.

Going hand in hand with this power to deemotionalize and unburden color by light is Olitski's impeccable choice of startling, unheard-of color combinations, a faculty he shares with Matisse.

Olitski's web of atmospheric color extends over almost the whole field, except for a narrow band in a different, solid tint that functions as a closing device or frame, see *Panger* (1969; Fig. 18). Between the years 1964 and 1973 this "frame" was further and further condensed or altogether eliminated except on one side. In the early paintings it still covered about one-fifteenth of the canvas; by 1972 it had been trimmed to one-sixtieth. Also, in the early paintings, motifs were placed on it—circles, ovals, and stripes; in the later paintings these disappear.

Olitski's huge field of vibrating color is not uniform in hue, however. It may range from green to either violet-blue or golden-yellow,[43] etc. The change from one hue to another takes place so gradually that it is nearly imperceptible, a type of color composition to be found also in Titian. We must bear in mind, however, that Titian's color is not atmospheric but rather a streaming, juicy, sensuous mass, whereas Olitski's color dots dissolve the surface-bound quality and the weight of color, dancing playfully over the ground; yet both artists have continuity in passing from green through neutrals to blue, and even pink, tints. This continuity—flow in Titian, and dance in Olitski—is achieved by making the transitions harmonious and many-stepped. One color passes unnoticed into another, changed by minute modulations. That eliminates all drama, as it is found in the color oppositions of Rubens, and all tension, as it is found in the color disharmonies of Rothko. The tiny variations are overlooked unless the surface is closely scrutinized. The

[43] *Rexus* (1966) and *Green Goes Around* (1967) are cases in point; see, *Jules Olitski* (Boston: Museum of Fine Arts, 1973), No. 26, not illustrated; *Jules Olitski, Recent Painting* (Philadelphia: Institute of Contemporary Art, University of Pennsylvania, 1969), unpaged.

18. Jules Olitski: *Panger*. 1969. Acrylic emulsion on canvas. 106″ x 73″.
Photograph: Knoedler Contemporary Art, New York.

viewer is not induced to do this because he is swept away by the rapid motion of the dance in Olitski (and flow of the stream in Titian). There is only the marveling at how green could have become pink—and a never-ending delight for the eye in confronting this infinite variety. Then at the edge there is the full stop, resembling a streaming pennant that decorates a field. Its plain color supports the colors in the web, some working with it and others against it, according to whether they are in harmony or discord. The sliver of solid color also offers a resting place for the eye at the end of the road. But what a weird kind of resting place! Instead of fading out, the picture builds up to a climax at this point. First the spectator is startled by the sliver's otherness in hue and texture; then he savors its beauty. A pick-me-up is offered, not a bench for tired feet.

In the 1970s Olitski substituted for the web either a scintillating surface or a pockmarked surface animated by slightly raised ground, reminiscent of Yves Klein's planetary reliefs. Through this change Olitski's monologue with magnitude has lost its resonance. It remains to be seen where this change will lead. At present no gain is as yet evident to offset the loss.

Magnitude affects the *internal* space of easel painting; in room sculpture it affects the *external* space. If room sculpture assumes colossal proportions, then the room becomes either its niche or its container, depending upon whether the sculpture is placed against the wall or in the center of the room. This subserviency of the setting to the work of art is evident in Nevelson's *Homage to 6,000,000 No. I* (1964) and Oldenburg's *Giant Soft Fan* (1967; Figs. 5, 21, pp. 76–77, 161). Sometimes a piece of contemporary sculpture is specifically constructed to fit into a niche or container, as in traditional art.[44] But, whereas in traditional art sculpture was always harmoniously integrated with its setting, contemporary art uses both relationships—harmony and discord. The latter approach can again be seen in Nevelson's *Homage,* which is purposefully

[44] E.g., Ronald Bladen's *The X,* done for the exhibition hall of the Corcoran Gallery of Art in 1967; shown in "Scale as Content" (1967/68).

curved to stand away from the wall. It was also described above in Morris' *Corner Piece.*

Through magnitude, quasi-Environments are formed. These should be differentiated from the true Environments to be studied in the next chapter, because the sculpture is fitted into an already existing room, whereas in true Environments the setting is created together with the sculpture.

4. *Gravity in Harness*

Paintings liberated from the earth's
force of attraction.

—Yaacov Agam, 1962

There was neither above nor below,
neither right nor left (*Seiten*).

—Kenneth Snelson, 1971

The wish to escape the burden of his body must have haunted man before he was man; nothing else could have induced him to stand up and walk on his hind legs, which action contributed to the evolutionary changes that made him man. The next step was to soar into the air. What adult has forgotten the elation he felt as a child when the swing gathered momentum? What adult does not remember the elation when the earth fell away beneath him and Leonardo's dream became a reality? With such thoughts in mind it is understandable that the liberation from gravity should have become a problem for art.

This problem has two sides. Liberation from the pull of gravity can be achieved by technical means. That is the case in the work of Pol Bury and Hans Haacke. In the first (see Fig. 45, p. 285), spheres placed on oblique or level surfaces roll down or around, only to stop short at the edge. In the second (see Fig. 49, pp. 310, 311), balloons float or levitate in airflows or the air. In these works,

motion is controlled by electromagnets, drafts of air, etc. However, neither such simple nor more complicated technical feats need art-historical guidance for their appreciation. They are too obvious. We are interested here in the use of (*a*) virtual gravity to assert the autonomous status of the work of art, and (*b*) actual gravity to help in shaping it. Both are discoveries of painting, a medium with a two-dimensional physical existence. But the first was translated later also into the three-dimensional medium of sculpture.

The experience of liberation from gravity must not be confused with the representation in art of suspended gravity or levitation. The latter has been employed by traditional artists for two purposes: to identify a figure as a supranatural apparition, and to suggest motion by portraying draperies fluttering horizontally behind a figure. Thus the suspension of gravity served illustrative purposes in traditional art. Contemporary art is interested in quite a different matter: to prove the autonomy of the art object. It is for this reason that it tries to negate the power of gravity over the work of art, putting it on a par with a living being. This fact is clearly expressed in Pol Bury's statement in 1966: "When he wishes to bring to life things that are inert, the sculptor immediately feels Gravity sinking down with all its weight into the scale-pan." [45]

The artist's challenge to gravity seems to date from the development of engineering during the nineteenth century. In traditional works of art, shape and color in painting and mass in sculpture were located in the lower halves, placing the weight or accent in the portion nearer to the ground. When the Impressionists and Rodin did away with this prerequisite, the work of art looked reversible in regard to which half should be placed above.[46] This illusion

[45] "Le Petit Commencement," quoted from the English translation in *Pol Bury* (Berkeley, Calif.: University Art Museum, 1970), p. 22.

[46] Carla Gottlieb, "Harmony and Discord in the Visual Arts," *Proceedings of the IV International Congress on Aesthetics, Athens 1960,* ed. P. A. Michelis (Athens: Édition du Comité Héllénique d'Organisation, 1962), pp. 63–64. There exist a few earlier "reversible" pictures, e.g., Caravaggio's *Narcissus* (c. 1600), illustrated in Roger Hinks, *Michelangelo Merisi da Caravaggio: His Life—His Legend—His Works* (New York: The Beechhurst Press, 1953), Pl. 35.

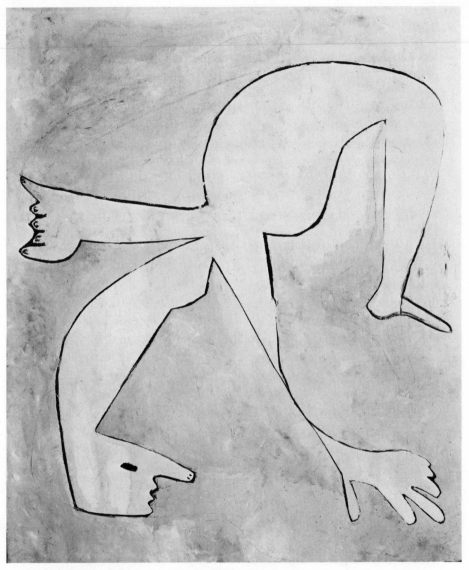

19. Pablo Picasso: *Swimming Woman*. 1929. Oil on canvas. 63⅞″ x
51⅛″. Present owner unknown. Photograph: The Museum of Modern
Art, New York.

became a fact through Picasso who, in addition, widened the concept of the reversibility of the upper and lower halves by making *any side* interchangeable with the other three. In 1929 he created a painting, *Swimming Woman* (Fig. 19), which can be hung with any side at the top.[47] Two artists greatly influenced by Picasso in their beginnings, Arshile Gorky and Jackson Pollock, were less radical in this respect. Gorky was in the habit of reversing his canvas when he painted the second half, and he saw no reason to object to his work being hung upside down in his San Francisco retrospective of 1941, a fact brought to light and proven by Rubin in 1963.[48] Pollock's larger surfaces led him to "work from all four sides" (1947–48 [49]). In spite of this difference in technique, in the pictures of both artists the tops are only interchangeable with the bottoms and the right sides only with the left sides.

The final step in this development seems to have been taken by Jasper Johns in his *White Target* (1957; Fig. 12, p. 110), now in the Whitney Museum of American Art, New York. In it, each of the four sides can be substituted for the other three, not only in the hanging, as in Picasso, but also in the image: the painting is composed of four identical, or almost identical, portions. A target is a symmetrical object whose efficiency in serving as a target depends upon the accuracy of its construction. Johns's *White Target* is not perfect in this respect, but the small deviations are easily discounted in a work of art. They take the edge off the painful feeling of sameness that such quadruplication is apt to generate. Johns's four-sided composition in symmetry was soon adopted by Robert Indiana, Frank Stella, and a score of other artists. Indiana accented the decorative, heraldic-emblematic side of such a design. Stella developed its mesmerizing effect, a sort of contamination of the viewer

[47] Alfred H. Barr, Jr., *Picasso. Fifty Years of His Art* (New York: The Museum of Modern Art, 1946), p. 164.

[48] William Rubin, "Arshile Gorky, Surrealism, and the New American Painting," *New York Painting and Sculpture: 1940–1970*, ed. Henry Geldzahler (New York: E.P. Dutton and Co., Inc., 1969), p. 379, n. 4.

[49] "My Painting," Robertson, *Jackson Pollock*, p. 194.

by the image, whose disease, extreme rigidity, is transmitted to him by empathy.

As a further development from such quadrilateral or circular compositions, biaxial paintings could now also be hung any odd way. According to Clement Greenberg, this was the approach of Morris Louis. Writing about the artist for his posthumous exhibition at the Norman MacKenzie Art Gallery, Regina, Canada, in 1963, Greenberg said: "The decision as to which side of a portable painting is top, bottom, left or right is not irrevocable, and Louis . . . felt that if a painting of his was good enough it would stand up no matter how it was hung." [50]

In all of these examples, commencing with the Impressionists, the picture is freed from the pull of the earth and floats in its own space. However, the statements of the Impressionists and Rodin do not discuss their new way of distributing weight, whereas Pollock was not concerned with the link between his composition and the negation of gravity; in the above-quoted statement he brought his method of working from all four sides back to "the method of the Indian sand painters of the West," [51] thus formulating its historical connection, not its artistic meaning. That side of the problem, the relationship between composition and gravity, was stated by Agam: "Until now paintings have been built 'like houses,' their entire stability determined by gravity." [52] He considers works that can be shifted around a center, that is, turned upside down or right to left, to be richer in expressive value. It should be noted that a work of art, by following its own law of gravity, becomes self-centered, which separates it from its environment as effectively as if it were surrounded by a frame or placed on a pedestal.

Gravity plays a role not only in Pollock's mode of composition but also in his technical method. By dripping and flipping fluid paint onto the canvas, he harnessed gravity to assist him in the formation

[50] Quoted by Michael Fried, *Morris Louis* (New York: Harry N. Abrams, 1971?), p. 36.

[51] "My Painting," Robertson, *Jackson Pollock,* p. 194.

[52] *Yaacov Agam,* ed. Marcel Joray (Neuchâtel: Éditions du Griffon, 1962), p. 10.

of the image. More specifically, the pull of gravity served him in introducing formations into his picture that look accidental although they are regulated. As Pollock noted, in the film made of him by Hans Namuth and Paul Falkenberg in 1951, he could control the flow of paint so that there was no accident in its distribution.[53] But flipping can be controlled only up to a certain point. Be this as it may, the swirling rhythms of the streams and rivulets, the knots and constrictions of the web, the puddles hurled over the surface do not seem calculated in Pollock, or in any other nonobjective artist using his method.

Like Pollock, Morris Louis also enlisted the pull of gravity as a helper in the construction of his image, besides using it to make his painting self-centered. But Louis did not bind gravity to violence. In the Veils of 1954 to 1960, the series with which Louis found his specific mode of expression, gravity followed its natural course and hence is obvious. Louis' biographer, Michael Fried, even reconstructed the artist's working process on this ground. He suggested that Louis, in making the Veils, poured thinned Magna on a canvas partly stapled to a support, with the result that "the paint ran from top to bottom" enabling him "by tilting the scaffolding and manipulating the canvas itself . . . to control the flow of pigment across its surface." [54] The experience of gravity is encouraged by two devices in Louis: greater density at the point of origin or end of the route; and blank surfaces above the point of origin, alongside the route, or below its end.

Once attention is directed to the use of gravity in Louis' work, it is apparent that his pictures divide into groups on this basis, each group handling the problem of where and how the bands of color pull differently. In the Veils, the pull is downward. A multilayered curtain of color formed of overlapping variegated sheets is suspended in front of us and spreads in pools at the bottom. In the split Veils, there is a pull and a counterpull as the central monolith gravitates toward the earth while the flank slabs strive upward. In the Florals,

[53] Robertson, *Jackson Pollock,* p. 194.
[54] Fried, *Morris Louis,* p. 27.

executed about the same time as the Veils, the pull of gravity is centrifugal. Adapting Fried's factual explanation of a visual phenomenon to this case, the image of the Florals seems formed by placing dabs of paint in the center of the canvas and, with each successive dab, rotating the canvas slightly so that the paint could run down. The Unfurleds, commenced in 1960 (see Fig. 17, p. 143), defy gravity. The bands of paint have become narrow and wavy. Fried called them rivulets. They seem to move slowly over the canvas surface, broadening slightly as they flow from the bottom toward the sides and sometimes separating into two arms, or uniting with other rivulets of paint, or both, so that islands or lakes are formed in between. However, they flow *upward*. The canvas is a *man-made* map, not a translation of nature, upon which the rivulets are shown running in northeasterly and northwesterly directions. The experience of seeing colored rivulets rising vertically, against the pull of gravity, gives to the Unfurleds their unrivaled position in Louis' work. Finally the Stripes, executed between 1961 and 1962—at first glance, they seem to return to the overt statement of gravity found in the Veils: instead of sheets of fluctuating color, a group of juxtaposed bands is suspended in front of us. However, although each of the other series finds a prototype in nature that would explain the workings of gravity—a curtain pulling down, petals pulling centrifugally, geysers rising vertically—the Stripes do not have such a prototype and, as stripes, cannot stand upright. Gravity is negated.

At about the same time at which Pollock worked on his painting "from all four sides," Kenneth Snelson, a twenty-one-year-old ex-GI from a small town in Oregon, started on the road that was eventually to lead him to the inventions of tensegrity and how to represent the orbiting of the electrons around the nucleus of the atom. Tensegrity is the principle of continuous tension–discontinuous compression that permits the suspension of objects in space (Fig. 20, p. 156). Through it, Snelson could make works that have their centers of gravity within themselves, like Picasso's *Swimming Woman*, Pollock's abstractions, and Johns's *White Target* (cf. Fig. 20 with Figs.

19, 1, 12, pp. 149, 19, 110). Snelson's invention was popularized through his friend, Buckminster Fuller, who adapted it to his architecture, publishing an article on it in 1951 and naming it tensegrity in 1955.

Snelson met Fuller at Black Mountain College, where he had enrolled to study with Josef Albers in 1948. In that year Robert Rauschenberg and Willem de Kooning were also present. After returning home, Snelson built his first Structure. As described by Grégoire Müller, the artist and art critic, in the catalogue of Snelson's exhibition at Hanover, Germany, in 1971, Snelson commenced with a mobile.

> In a 1948 piece, he was playing with the well known toy of the little man oscillating on top of a narrow support: he sophisticatedly extended it by piling little men on top of each other's head and ended up with a sculpture which had the appearance of a mobile by Calder . . . with the major difference being that his mobile was not suspended, but supported. The analysis of this piece led him to the conclusion that two combined forces were holding it together: the force of the support and the force of gravity. In other words, the tension of gravity was compressing the support, thus creating a stabilized balance. The next logical step was to replace this tension by the actual tension of a cable, which he did in 1949 with a piece called X P i e c e. Free from gravity, this piece has no spatial orientation; it can be placed on any of its sides, it can be suspended or even leaned against a wall: it is a structurally closed system.[55]

Recognition was slow to come to Snelson, and it took an oblique path. His work was first exhibited in a group show at the March Gallery, New York, in 1958, and then as an adjunct to the Buckminster Fuller exhibition at The Museum of Modern Art, New York, the next year. In 1962, he showed in the "Twentieth Century Engineering" exhibition at the same museum. But the year after, in 1963, he had his first one-man show at Pratt Institute, New York. From here on, his road ran smoothly. The reason for Snelson's uphill fight in art is his affinity for the disciplines of architecture and

[55] "Kenneth Snelson's Position Is Unique," *Kenneth Snelson* (Hanover: Kunstverein, 1971), p. 20.

engineering: his sculpture is no longer clear-cut sculpture. In this respect he is part of a general trend in contemporary art, to pull down the barriers between the disciplines and renew art through mergers with other fields, a trend so extensive that all of chapter 5 will be devoted to it. When the barricades fell down, Snelson's Structures were admitted to art.

Snelson's works are composed of a number of short-length aluminum tubes interconnected by steel cables and organized into self-contained units. The tubes can be identical in diameters and proportions, or vary. One-, two-, or multi-unit Structures exist. In the last two, one type of unit holds another type of unit in place; it could not stand by itself. Formally, the Structures are based on a motif in the shape of an X, on scale, and on tension: tubes cross tubes, and tubes cross wires; cablelike tubes are measured against ropelike tubes and against threadlike wires; the pull of the tubes and the counterpull of the wires, tension and compression, transform the static structure into a field of active energy, ready to shatter the precarious balance at any moment.

Perhaps due to the nature of the discipline of sculpture, Snelson's development reversed that described above for painting. His early pieces from 1948 or 1949 onward are nondirectional and can be rotated like the Picasso and Johns, their quarters either divergent like the first or identical like the second. In 1963, Snelson started to design one-directional towers. These bring the formal experience discovered by Gustave Eiffel for the Paris World Fair of 1889 up to date. Seen from the outside, they are a cathedral spire detached from its support, drawn out in length, and perforated. Seen from the inside and looking up at the point, they are a tangle of crossing lines with an orderly spider's net design as center. Compared to the Eiffel Tower, Snelson's towers intensify the sensation of airiness through perforation, to which they add the experience of levitation. In 1967, Snelson designed a cantilever structure for the Los Angeles County Museum. Attached at one end to a wall, this work stretches out into space horizontally, like the arm of a crane. In 1970, Snelson turned toward floor cantilevers, that is, pieces that do not touch

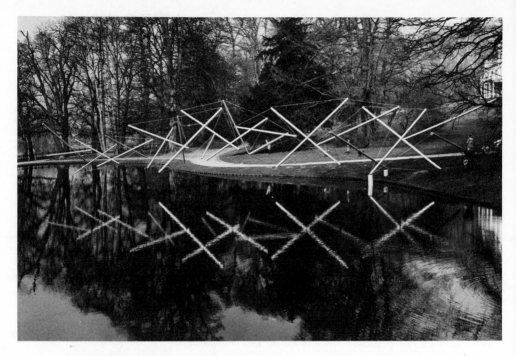

20. Kenneth Snelson: *Easy K*. 1971. Two views and plan of site by Mr. D. van Golberdinge, Chief Curator, Gemeentemuseum, Arnhem. Aluminum and stainless steel. 16′ x 100′ x 20′. Installation *Manifestations*, Arnhem, Holland, 1971. Artist's collection, New York.

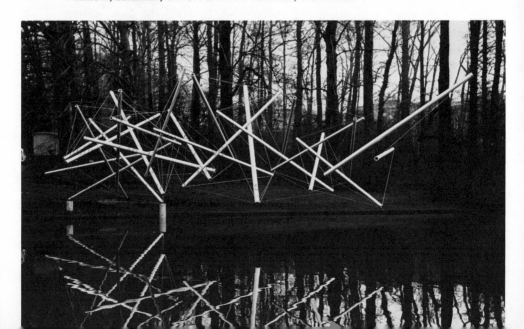

the ground with the full extension of their bodies. Obviously such structures presuppose a horizontal expansion.

Easy K (1971; Figs. 20a, 20b) is one hundred feet long, eighteen feet high, and twenty feet wide. Seen here in the summer group exhibition at Park Sonsbeek, Arnhem (Holland), of that year, it stands next to a small pond, which some tubes overhang at one end, where the units are lower and lighter (Fig. 20c). The outer-most tube at this end runs parallel to the ground—the only one to do so—emphasizing the termination and underscoring the levitation (Fig. 20a, left). The work looks like the skeleton of a prehistoric bird or mythological dragon that has alighted on the ground near water and is bending down for a drink. Figure 20b is a closer view and shows *Easy K* looked at from "the front," or almost from the front. The tube running parallel to the ground is here seen at the right and pointing toward the spectator; the spine pattern of a series of repeats, stretching out horizontally in the long side view, has disappeared. Crossings and compactness dominate: the upward thrust

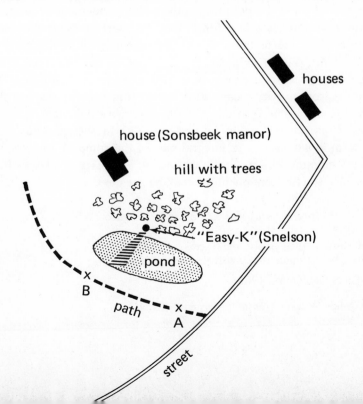

of the poles is felt intensely, and the tubes look like containers for projectiles that are to be launched into space. I believe *Easy K* can probably not be positioned in more than one way, that is, it cannot stand up like a tower, not even with the lighter end in the air. But this seems to be merely the technical problem of distributing the weight in a proper balance, so it could be taken care of in another work.

In 1971, Snelson discovered yet another application for his tensegrity Structures: works to be hung on walls. These line-drawing reliefs are composed of bamboo sticks and rope, as well as metal tubes and wire.

One important aspect of Snelson's Structures has still to be mentioned. I have left it for the end, because it can be found in the rotatory, cantilever, and wall pieces alike. The works are all capable of endless extension, a principle going back to Brancusi's *Endless Column* for the park at Târgu Jiu, Romania, set up in 1937.[56] Some permit additions only at one end, for instance, the towers at the base, the reliefs at the periphery; others can be added to at all ends. However, not all extended forms may be satisfactory aesthetically. Up to a point, the potential for endless extension is also present in Johns's *White Target* (Fig. 12, p. 110), but the identification of this image with a real object through its title excludes its being limitless.

To Snelson, gravity means little except that it is an element that he had to overcome in order to form organisms complete in themselves. Contrariwise gravity is given its due in soft sculpture and anti-form in which it is an integral part of the composition. Yet not all soft-sculpture objects and anti-form objects exploit gravity fully or as an aesthetic component, as shall be seen next.

5. *Soft Sculpture, Anti-Form, Solidified Shadow*

To translate the eye into the fingers. . . .
That's why I make things soft that are hard.

—Claes Oldenburg, 1966

[56] Giedion-Welcker, *Constantin Brancusi,* Pl. 95*.

Sometimes a direct manipulation of a
given material without the use of any
tool is made. In these cases considera-
tions of gravity become as important
as those of space.

—Robert Morris, 1968

It is a form and its shadow.

—Yaacov Agam, 1971

In *The Art of Sculpture,* Herbert Read has argued that palpability
is essential for the appreciation of sculpture and criticized Gian-
lorenzo Bernini's *Ecstasy of Saint Theresa* on the grounds that it
has too many excrescences that, by the decomposition of the surface,
destroy the object's mass.[57] His argument reminds us of the fact that
the British philosopher was a great friend of Henry Moore, who
stated in 1937: "Since the Gothic, European sculpture has been
overgrown with moss, weeds—all sorts of surface excrescences which
completely concealed shape. It has been Brancusi's special mission
to get rid of this undergrowth, and to make us once again more
shape-conscious." [58] Yet, the *Saint Theresa* has palpability of a sort:
it is prickly, thorny. Prickliness may be a quality disagreeable to
the touch—in a sense paralleling ugliness, which is disagreeable to
sight. Still, prickliness is a tactile property and, like ugliness, its ex-
perience in art should not be confused with its experience in reality.

Soft sculpture (see Fig. 21, p. 161) is a step further away from
Read's specifications for this medium, and one wonders what the
philosopher thought of this new development. Soft sculpture has
mass, but does it possess palpability? It yields to the touch, impairing
palpability and complicating our apprehension of its shape. This is
what Oldenburg meant, in 1964, when he said he wishes "to trans-
late the eye into the fingers," explaining that, instead of tactility,

[57] Herbert Read, *The Art of Sculpture* (New York: Pantheon Books,
1956), pp. 74–75, 83.
[58] John Russell, *Henry Moore* (New York: G.P. Putnam's Sons, 1968),
p. 43.

"the dynamic element here is flaccidity . . . that is the tendency of a hard material to be soft, not look soft." [59] Oldenburg is the artist who discovered foam rubber as a material for sculpture. He presented this discovery to the public in the show "The Store," held at the Green Gallery, New York, in 1962.

Oldenburg's *Giant Soft Fan—"Ghost" Version* (1967; Fig. 21) in the Museum of Fine Arts, Houston, is made of foam rubber covered with canvas painted white with Liquitex; some wood and metal are also used. The work is ten feet high. Material as well as size and color play a role in its aesthetic effect. Foam rubber is resilient, that is, it puts up a resistance to manipulation. It lacks the hardness of stone and bronze as well as the limpness of cloth. The *Fan* sags, its parts droop—still it has some will of its own, due to the material from which it is made. It looks tired, worn out, but not lifeless. However, it does not look like the electric fan that was used to fight the summer's heat before air conditioning became a run-of-the-mill item in houses and offices—at least not at first glance. The giant size and flopping stance obscure its identity with a specific object. Only when the work is studied, only then the stand and its switch, the propellers and their screen, the cord and plug are distinguished, so that a fan can be recognized as the work's prototype. The discrepancy between the image of a busily whirring electric fan and this sad, beaten replica is charmingly piquant, a gigantic joke on the viewers who can appreciate such finesse. The white color adds to the "ghost" effect of this version.

Oldenburg likes to repeat his works in different colors and materials and also to present them from different viewpoints: from inside and from outside, as a fragment (seen from very near) or as a whole (seen from far away).[60] The *Fan* belongs to the series done in black and white, both soft; other works appear in both soft and hard versions. According to the dates, the white *"Ghost" Fan* of Houston

[59] "Extracts from the Studio Notes [1962–64]," *Artforum*, IV, No. 5 (January 1966), p. 33. On the importance of the exhibition "The Store" for soft sculpture, see Barbara Rose, *Claes Oldenburg* (New York: The Museum of Modern Art, 1970), p. 91.

[60] *Ibid.*, p. 128.

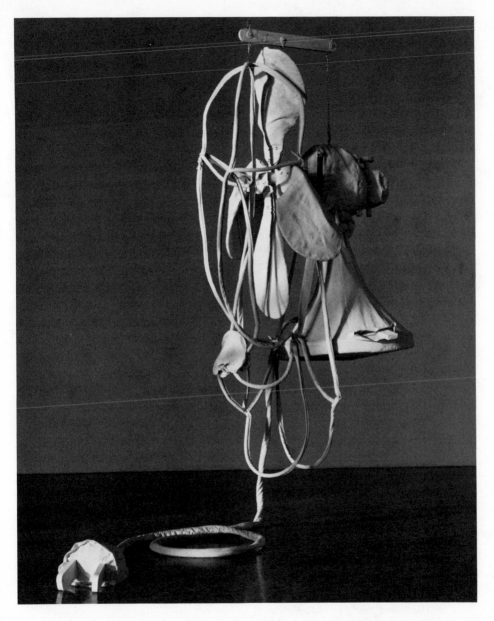

21. Claes Oldenburg: *Giant Soft Fan—"Ghost" Version*. 1967. Canvas,
wood, foam rubber. 73″ x 96″ x 54½″. Museum of Fine Arts, Houston.

was started after the black fan, which is in the Sidney Janis Collection of The Museum of Modern Art, New York, for which vinyl and plastic tubing are used instead of canvas, etc.[61] I find the black version more powerful but lacking the funny side of the Houston monster.

As documented by his *Notebooks* and recorded by his biographers, Oldenburg sees several Freudian images in each of his works. Actually the artist provokes these associations himself by intentionally tailoring the formal appearances of his works to multiple readings. As noted by Barbara Haskell, each work has three associative constants: one with anthropomorphism, one with eroticism, and one with absurdity.[62] The *Fan* looks like a human body, and the cord can be made to look like intestines. The switch looks like a mouth with outstretched tongue and, to someone with a vivid imagination, the constellation of three hanging blades may bring to mind the male genitals, whereas the two projections of the switch may remind him of female breasts. A soft fan is incongruous, a contradiction in terms, and hence absurd. As for the associative variables, Oldenburg has listed a set of seven for the *Fan* in his *Notebooks* (1967): (*a*) The blades resemble a banana with its skin peeled back. (*b*) The screen in front of the propellers resembles the spiked halo of the Statue of Liberty. (*c*) The scope of the fan reminds one of the pleasant southwest breeze enjoyed by Lower Manhattan. (*d*) The nature of the fan reminds one of "Motorized America, the chopper." (*e*) The name, fan, reminds Oldenburg of Satan, because in Swedish the word *fan* means Satan. (*f*) The pairing of a black with a white version is in line with the superstition that two angels accompany man, standing either for death and life or for day and night or for right and left. (*g*) The motion of the blades recalls that of windmill flails.[63] In addition, Oldenburg invites his viewers to form their own associations as part of the enjoyment of his works.

[61] Illustrated, *ibid.,* p. 134.
[62] *Object into Monument,* ed. Barbara Haskell (Pasadena, Calif.: Pasadena Art Museum, 1971), pp. 8–10
[63] *Ibid.,* p. 52.

In 1963, the year Oldenburg made his first foam rubber sculpture Robert Morris made his first rope construction. His felt pieces were started in 1967.[64] Although Morris' rope and felt objects are known as anti-form and the appellation soft sculpture is reserved for Oldenburg's foam rubber works, Morris has gone further than Oldenburg in making sculpture nontactile. His pieces flee the touch. A blind person could not visualize such objects fully.

As listed by Morris, the characteristics of nonrigid sculpture are: direct manipulation of material without the use of manufactured tools; considerations of gravity as important as those of space; the forms not planned in advance; organization deemphasized; chance and indeterminacy accepted; disengagement from preconceived, enduring forms.[65] Through the title of the article in which he discussed this approach, Morris coined the expression *anti-form*—whence the name for his rope and felt objects. Applied to art, the term *anti-form* is self-contradictory. Art without form is not art. *Anti-rigid form, labile shape,* or *transformable shape* expresses the formal situation Morris has created.

Rope is used commonly in some tribal art and this may be how contemporary art happened upon it. If so, our artists departed widely from their source of inspiration. In tribal art as, for that matter, in Beuys the rope is an adjunct arranged in an orderly manner. Perhaps contemporary American art borrowed its approach to the rope from Duchamp's decoration for the "First Papers of Surrealism," an exhibition he organized with André Breton at the Reid Mansion in New York, in 1942. For it, Duchamp crisscrossed the gallery space with sixteen miles of white string, producing a maze as setting for the show. Contemporary rope pieces are also arranged in a tangle of strands, so that armature and work are one. That is, except in Morris. His rope pieces are simple, one-strand constructions. Their power resides in his handling of gravity.

[64] Cf. *Untitled* (1963; wood and rope), illustrated in Compton and Sylvester, *Robert Morris,* p. 67. On the first felt pieces, done at Aspen, Colorado, *ibid.,* p. 105.

[65] "Anti Form," *Artforum,* VI, No. 8 (April 1968), p. 35.

Gravity is an essential component of nonrigid sculpture. It lends itself to different approaches, as a comparison between Oldenburg and Morris reveals. Oldenburg coaxes gravity to become a hand-maiden to his work; gravitation under the aspect of sagging form gives his foam-rubber sculpture a physiognomic expression. I am referring to the impression of tired disillusionment they convey. They look humbled. Morris does not tamper with gravity. The viewer does not experience a yielding of the object, but the attraction of the earth. The straight fall of the single strand of rope, which then coils as it comes to rest on the ground, externalizes that attraction. Through this effect, Morris' rope pieces depend upon gravity for their existence as art, which is not the case in Oldenburg, in whose work gravity is merely an added spice. In the felt pieces, gravity is handled more prosaically by Morris. It exists, but not in a way different from that in which it would exist in a non-art object. Consequently gravity loses its aesthetic function in them. The appeal of Morris' felt pieces is built upon other factors.

Morris' *Untitled* (1967–68; Fig. 22 background), in the collection of Philip Johnson, consists of a piece of felt cut into strips. One end—or is it the middle? the original form is obliterated by the shredding—is suspended from a nail driven into the wall. It cascades softly to the floor where the felt expands—or is arranged to expand—like a waterfall. Within this waterfall occur loops, plain stretches of band, twistings, and corner pieces. By corner pieces, I mean the place where the bands connect with one another. For the felt seems cut in the way the children in Europe cut paper. A large sheet is first folded and refolded many times in a certain fashion, and then cut in a specific manner. When it is unfolded and an object is put into its center, it expands and functions like a shopping net. Fairly heavy objects could be placed in this paper net; this is its attraction. But if the folding or cutting has been done wrongly, then the sheet of paper falls apart into disconnected pieces and the object drops to the floor.

In Morris' felt version of this trick, several visual experiences are notable. The allover effect of a scattered mass reminds us of Abstract

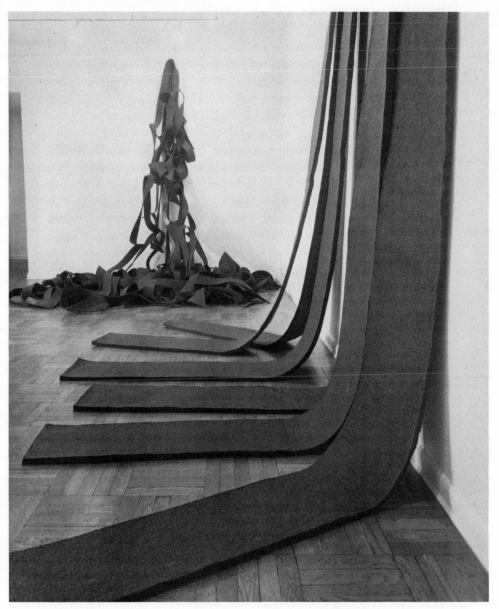

22. Robert Morris: *Untitled* (rear wall). 1967–1968. Black felt. ⅜"
thick. Installation Leo Castelli Gallery, New York, 1968.

Expressionist art: it has the same apparent lack of composition. The texture of felt is of course different from the texture of other materials used in sculpture, but that is not an important point. Linked to the scattered composition is a potential for change not present in Abstract Expressionist art. The felt can be hung at whatever height is desired or else spread out directly upon the floor. The pattern the piece will assume depends on the placement. Morris' soft sculpture is transformable sculpture, like Agam's (Fig. 23, p. 169). But, as argued by Michael Compton and David Sylvester, there is a certain resistance to accident: "The felts impose firm restrictions on what one can do with them," and, although I would not go so far as to assert, with them, that "one has the strange feeling that one isn't looking at something pliable which has just assumed its present shape but at something carved in stone which has always had its present shape," Compton and Sylvester are certainly right in that: "With Morris's felts it's not the softness of the material that one is conscious of but the planes and the edges of the ribbons." [66] The effect of stiffness and the resistance to accident are due to the material, felt, which is not pliable.

Another distinct visual experience in Morris, not present in Oldenburg, is heaviness. The felt piece looks ponderous enough to satisfy Read who would, however, reject it as sculpture because it lacks integral mass. Unlike stone, which seems heavy but springy, the felt piece seems heavy and inert. Through its springiness, stone is experienced as anthropomorphic. Like man, stone seems to have the capability of motion, it seems to be able to rise from a supine position. Through its ponderousness, the felt piece impresses the viewer as an orderly tangle despite the randomness of the fall. He thinks that the collapsed mass could be reconstructed into a square at will. In this case the material seems again to be the reason for this impression.

As in much sculpture, the felt piece offers an alternation of voids and solids, but there is neither interaction between them nor do

[66] *Robert Morris*, p. 11.

the voids turn into negative shapes. They remain part of the back-
ground, foil not companion to the object. The overlappings, on the
other hand, a visual experience adopted from painting, are as richly
exploited as in the sister art.

Even a discussion of only two nonrigid sculpture pieces makes it
evident that this newly opened branch of "sculpture" has a wide
range of possibilities. Oldenburg's flaccid-looking objects, which
resist change, are very different from Morris' rigid-looking ribbons,
which are subject to it. Man has probably never before started out
on a new road in art with such diversified equipment; usually only
one course is run, which later spreads out. Here there is immediately
a parting of the ways.

When I speak of *solidified shadow,* this does not refer to the
experiments in painting of Matisse and the Cubists, who objectified
shadow as a flat, bounded shape that exists as materially as the
object casting the shadow.[67] Rather, my remarks deal with the trans-
ference of this artistic discovery to the medium of sculpture. In
sculpture, solidified shadow presents a novel solution to the problem
of the support.

Frame and pedestal had become redundant with the advent of
abstract art; not being liable to confusion with reality, abstract art
did not need a separation from reality. But, whereas painting was
quick to rid itself of the frame, sculpture tackled the problem of
the pedestal in many different fashions, the solutions to which have
been outlined above, in section 2 of this chapter. Unfortunately, the
Abstract Expressionist sculptors ignored the problem—with discour-
aging results. In an overwhelming number, their works are stuck
upon a rod fixed to the base, resembling insects impaled upon a pin
by a botanist.

Agam, whom we discussed above in chapter 2, section 1, in con-
nection with transformable paintings, followed Brancusi's lead in
that he also integrated the support with the sculpture. Yet, in his

[67] Pointed out in Matisse by Meyer Schapiro in class lectures at Columbia
University, 1952.

work there is no difference between support and object: one is a mirror image or shadow of the other. "They interchange like the figure 8. They intercommunicate with one another," was his comment in 1971 on this type of Siamese twins. Agam links the two parts at right angles to each other so that "the beginning and the end meet." [68] This permits the displaying of the sculpture not only in an L-shaped or corner position, supported upon a body (Figs. 23a, 23c, 23d), but also in a ∧ or gable-shaped position, supported upon legs (Figs. 23e, 23f). It stretches the range of transformation so that the gestalt of the sculpture is unbelievably varied.

Moods (1969; Figs. 23a–23f) is a golden brass sculpture. It consists of nine units, identical in shape but graded progressively in size. Each unit is formed of two half circles meeting at right angles to one another. The artist's description of this work is as follows:

> It beats like a heart, it desires like a human being, it changes like a mood. It may expand or contract, shrink, double itself or accumulate its elements in different shapes like flames, boats, gates. It is a form and its shadow; it is the one and the space in the many, it is mood.[69]

Figures 23a–23f give six views of how this piece can be set up, with the sections arranged according to size. Variant *a,* in the top row at left, divides the nine pieces into three threes, placing the first or smallest trio and third or largest trio to one side, the second or intermediate trio to the other. A neat gatelike construction with circular "ramparts" or "walks" is erected. In flagrant opposition to this architectural design, variant *b,* at its right, looks like a snail house. Here the units are spread apart from one another and rotated around their axes. Variant *c,* in the central row at left, places the units close together, as the gate, but it rotates each slightly clockwise against its outer neighbor. A hoodlike formation results, which is slightly crooked. Variant *d,* at its right, spreads the units slightly

[68] *Yaacov Agam: Transformables* (New York: Galerie Denise René, 1971), unpaged.
[69] *Ibid.*

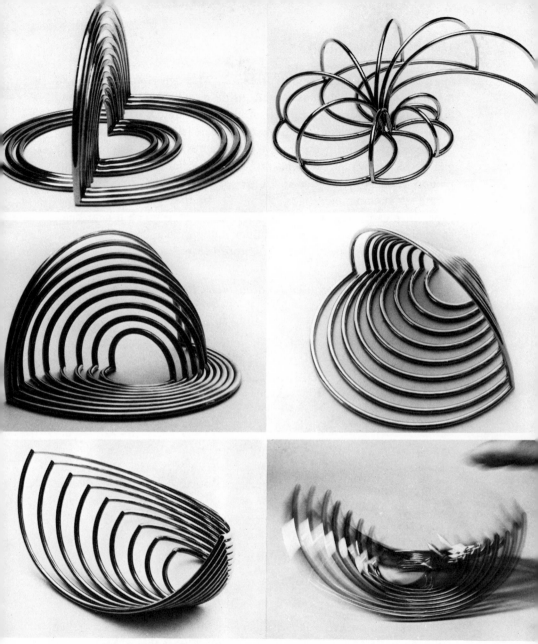

23. Yaacov Agam: *Moods* (six views). 1969. Golden brass. 4¼″ x
3¼″. Photograph: Galerie Denise René, Paris and New York.

apart and places them without rotation. Through the distancing of the sections, the "hood" is turned inside out, brought forward, and this formation looks like a colossal gaping mouth. Variants *e* and *f,* in the lowest row, stand the units upon their legs. They are set close to one another, turning into a formation resembling the hull of a galley ship of which only the prow and oars are seen. These oars remind one also of a ribcage. In *Moods,* the position upon the legs permits a rocking motion of the work, so that yet another visual experience can be enjoyed (Fig. 23f). It is not so much a heartbeat, as defined by Agam, as a pendulum motion, like that of a clock. More about this aspect of the sculpture below.

6. *Systemic Art: Reiteration, Multiplication, Permutation, Modularity*

You do the same thing. . . . over and over again.

—Andy Warhol, 1963

If I repeat the same element again and
again on the painted surface, I shall
take away its importance, and finally
make it disappear.

—Jesús-Rafaël Soto, 1965

The flickering of rhythmed (*sic*) networks
and permuted structures . . . provide us
with wild joys.

—Victor Vasarely, 1965

I . . . had an opportunity to design . . . based . . .
on modular organization.

—Tony Smith, 1967

The expression *Systemic* art was coined by the art critic Lawrence Alloway in 1966 for an exhibition at the Guggenheim Museum in New York to define the approach of a group of artists "who work

in runs, groups, or periods." [70] The next year an exhibition, "Art in Series," at Finch College, New York, followed by an exhibition, "Serial Imagery," at The Pasadena Art Museum in 1968, gave rise to definitions of that term. Alloway uses it "to refer to the internal parts of a work when they are seen in uninterrupted succession." [71] Mel Bochner, an artist who participated in the Finch College exhibition, sees seriality as a working method. On the other hand, Coplans, who organized the exhibition at Pasadena, differentiates between "serial syntax" and "modular structure, that is of a micro-order." [72] In other words, because the expressions *Systemic art* and *Serial art* can be employed in different ways and the meanings overlap, the critics have felt impelled to start with definitions of their positions. However, no consensus has been arrived at. I have no choice therefore but to define my own viewpoint. On the whole it corresponds to the position taken by Coplans, but I find Alloway's term *Systemic* better qualified than *Serial* to cover the developments in contemporary art. Since serial comprises systemic, I start with the word *Serial* and its relationship to art.

The word *series* has to be used differently in art from science. In art its laws are dictated by the visual experience as well as by physical facts. Since similarity and dissimilarity are strongly felt, three identical motifs seen in succession, perhaps even two, become a series. This is evident in Andy Warhol's *Elvis I and II* (1964; Fig. 24b, p. 176), in the Art Gallery of Ontario at Toronto. But, the duplication of a human figure will be experienced more strongly as seriality than that of a soup can; and if two shoes are seen, no duplication is felt because shoes come in pairs.

Serialization can be applied in two manners to art: as a repetition of a work and as a repetition of a motif (under which word I

[70] "Systemic Painting," *Minimal Art,* p. 56.

[71] Lawrence Alloway, "Serial Forms," *American Sculpture of the Sixties,* ed. Maurice Tuchman (Los Angeles: Los Angeles County Museum of Art, 1967), p. 14.

[72] Mel Bochner, "Serial Art, Systems, Solipsism," *Minimal Art,* pp. 92–102; John Coplans, *Serial Imagery* (Pasadena, Calif.: Pasadena Museum of Art, 1968), p. 9.

include a unit in sculpture). Serialization as the repetition of a work in the sense of duplicates in painting or sculpture, multiples in prints and bronzes, versions and variants of a work of art, etc., should be excluded from Serial art because the units of the series are not supposed to be seen together. Technically they are a series but they never formed a series visually. This is true of Leonardo's versions of the *Madonna of the Rocks* in the Louvre and London, Raphael's variations on the theme Madonna and Child, and Chardin's duplicates of his works. As formulated by Coplans in 1968: "To paint in series, however, is not necessarily to be Serial. Neither the number of works nor the similarity of theme in a given series determines whether a painting or sculpture is Serial." [73] Monet's variations on the theme of haystacks and Albers' variations on the theme of Homage to the Square, on the other hand, were meant to complement one another as a series rather than form duplicates. What binds Monet's series to Albers' series and differentiates these series from Leonardo's, Raphael's, and Chardin's series is their intent. Whereas Leonardo, Raphael, and Chardin painted their repeats because they liked the picture, or the public liked it and demanded a repetition, Monet and Albers painted their repeats because they were not satisfied with their efforts, having found that they had not exhausted the potentialities of the subject. Yet, if Albers' work qualifies for inclusion in this chapter, it is not on the grounds that he painted a series of similar pictures, but because each member of the series is constructed according to a system, the special form serialization has taken in contemporary art.

Serialization as the repetition of a motif poses two questions. Does it include motifs identical in shape if they are different in size, such as Johns's circles or Agam's complex curves (Figs. 12, 23, pp. 110, 169)? What about motifs identical in size but different in internal structure, like Warhol's assemblage of sixteen different shots of *Jackie* (1964),[74] and Nevelson's shadow boxes (Fig. 5, pp. 76–77)?

[73] *Ibid.*, pp. 10–11.
[74] Illustrated in John Coplans *et al., Andy Warhol* (Greenwich, Conn.: New York Graphic Society, 1970), p. 101.

The laws of visual perception dictate that variations that do not affect the gestalt should be disregarded, and variations that together yield a new gestalt obstructing the experience of serialization should be honored. Consequently Agam's curves and Warhol's shots of Jackie will be seen as serialization, while Jasper Johns's *White Target* and Nevelson's *Homage* will be seen as a target and a wall panel rather than as assemblages of circles and boxes.

The serial rendering of a motif is quite common in art and goes back to prehistory. Such a rendering is based on addition, consequently the additive side of the organization will come to the fore in the composition; *additive* is the term Paul Frankl created to contrast the design of Romanesque churches with that of Gothic ones.[75] Additive organization leads to rhythm. Serialization in art uses rhythm to tie the composition together and to introduce a directional drive.

Systemic art differs from Serial art in that its units are not only interdependent but also interact according to some order. Here the question is: what type of order? In a scientific survey only those theorems whose construction can be proven to be based upon mathematical formulas would be included. Since the average viewer (and average artist) is not in a position to know all the rules to the full extent of their complexity, his qualifications for distinguishing what is Systemic become lax. Any variation done according to a scheme can be accepted. Thus Warhol's serialization of flowers shows variations in color, and his serialization of the electric chair shows variations in value. Who can assert with certainty whether or not they fit mathematical formulas? Only a computer, not a normal human being. But it is not worthwhile to find out as long as these variations impress us as orderly deviations from a norm. Again, it should be the visual experience rather than the scientific fact per se that should govern our classification.

The rightness of this decision is borne out by the fact that, even when using mathematical laws, the aim of the artists is rarely to

[75] Paul Frankl, *Die Entwicklungsphasen der neueren Baukunst* (Leipzig: B.G. Teubner, 1914).

make these laws evident. More often they try to disrupt them. The mathematical formulas are covered up so that the viewer is either not aware of them or has to figure them out. For instance, who could see spontaneously what system Vasarely (Fig. 27, p. 188) uses for his permutations? Who could say spontaneously what module Albers (Fig. 41, p. 265) uses? Even if the quotient of progression is evident as in Sol LeWitt's modular works (Fig. 28, p. 191), who could write down the mathematical formula equivalent to them? In art, the mathematical rule is a secondary factor in the visual experience; a conceptual order is replaced by a visual puzzle. Good art is, after all, not the same as good science. Indeed, the contrary is true, since art operates with ambiguities and science with clarifications.

According to the system used, I have subdivided Systemic art into four categories: based on reiteration, multiplication, permutation, and modularity. In the first type, the artist arranges a group of units to form a set (Figs. 24, 38, pp. 175, 176, 243). In the second type, the artist makes an object composed of so many units that they can be counted only with difficulty, or not at all (Figs. 13, 25, 26, pp. 123, 181, 184). In the third type, the artist operates with changes in the character of the units (Fig. 27, p. 188). In the fourth type, the artist constructs his work upon the ratio of multiples to integer (Fig. 28, p. 191). The first three types have either identical, that is, standardized, units (Figs. 24, 38) or variables, that is, deviations from the standard unit (Figs. 25–27). The fourth type has modular units, that is, scaled to be multiples of a fixed unit, the module (Fig. 28). These four types will be discussed in turn.

If standardized units are arranged in reiteration, how can such a work be labeled Systemic art? Would it not be Serial art? I believe the distinction has to be made on visual grounds. If the primary aim of Serial art, to direct toward a goal and tie the composition together by rhythm, is perverted, then this is no longer Serial art in general, but a special variety of it.

Take, for instance, Andy Warhol's multiplications of Elvis Presley

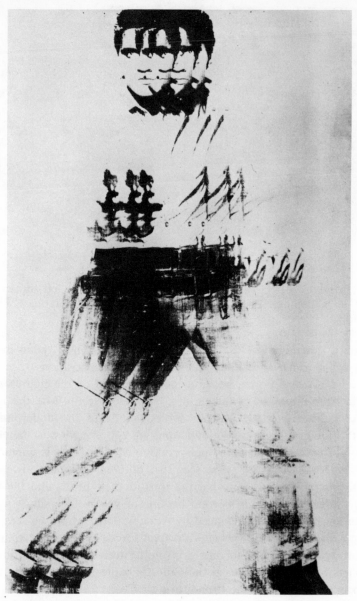

24a. Andy Warhol: *Triple Elvis*. 1962. Silk screen, enamel plus acrylic on canvas. 82′ x 42″. The Harry N. Abrams Family Collection. Photograph: Leo Castelli Gallery, New York.

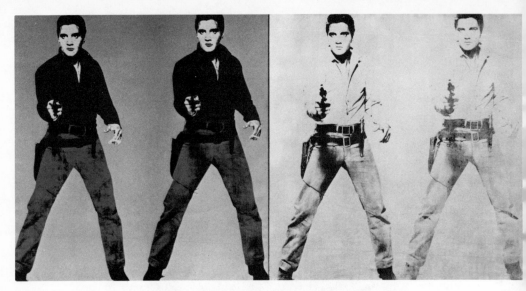

24b. Andy Warhol: *Elvis I and II*. 1964. Silk screen: left on acrylic, right on aluminum. Each 82″ x 82″. Art Gallery of Ontario, Toronto, Ontario.

pointing a handgun at us (Figs. 24a and 24b). The rhythm in the legs, arms, guns, and other repeats ties the compositions together, but it is not directional, because the orientation of the figures contradicts the direction of the repeats, and because, in 24a, the units are too close together. Rhythm serves mainly as the underpinning for the ludicrousness of the situation. In 24b the viewer somehow does not twice see the same person doubled (Fig. 24b is composed of two works), but he twice sees two different gunmen advancing upon him, so near to him that the tops of their heads and the toes of their feet are already beyond his line of vision. The shock wears off in an instant, to be replaced by recognition of whom he sees and how, which strikes the viewer with equal force: he faces the amusing absurdity of the one and only god of the teen-age congregation in duplicate. As incongruous is the Cubistic triple Elvis of Figure 24a, a cheeky imitation of the triune form of Christ.

In Warhol's Elvis series, spacing and color are used to modify the images. The compactness of the clustered duality or trinity is underlined by stringing out the figures in other dualities and

trinities (Figs. 24a and 24b). The equality of the "persons" in one version is contrasted in another by the juxtaposition of one strong and one pale motif, an image and its afterimage (not illustrated). The variants affect one another as one color or size affects another. But the *Variations on the Theme of Elvis Presley* do not build up to a system. Seen as an entity, an Elvis series borders on permutation, but does not quite make the grade. The viewer can exploit many visual experiences in such a spectacle. What he cannot do is feel a directional drive—whether he looks at one work or at a group of Warhol's Elvises.

A similar perversion of the directional drive can be noted in some of the Specific Objects of the Mimimalists. Rhythm can be enjoyed in them but it stops short of nowhere. It does not lead to a climax. Sometimes the elements are tied together so there is a path for the eye to follow; but they are identical, which confuses the directional drive.[76] At other times the pieces are separate; the artist challenges the spectator to make the connection, as in Judd's *Untitled* (Fig. 38, p. 243). Nobody who casts a second glance at one of Judd's groups of standardized units could resist that challenge.

These groups are an unforgettable experience. In their precision and purity of lines, in their infallible sense of composition, they remind us of Mondrian, in spite of being quite different from his work. Yet, it is the relation of piece to piece, not the piece itself, which carries the artistic message—Judd to the contrary. Al Held was right when he asserted "that there is no such thing as things that are not interrelated." [77] But I should like to go even further and state that, without a relationship of piece to piece, or part to part, some Minimal work would not exist as art. The novel element is the type of relationship, not the relationship itself. In the European tradition antedating Minimal art, the

[76] E.g., the I-beams in Morris' *Untitled* (1967), illustrated in Compton and Sylvester, *Robert Morris*, p. 97.

[77] Bruce Glaser, "The New Abstraction," *Art International*, X, No. 2 (February 1966), p. 43.

elements are bound together by a weighing that establishes eitnei equality or equivalence. In Minimal art, the sides are bound together by sameness, if one-unit pieces, and by sameness and rhythm, if Serial works. But the rhythm is open-ended and leads nowhere.

Judd's *Untitled* (1969; Fig. 38, p. 243) in the City Art Museum of Saint Louis consists of four anodized aluminum boxes, rectangular in shape, with two faces opposite one another open; the inside is sheathed with blue Plexiglas. Each box is four feet high, five feet wide, and five feet long, reaching to about a person's breast. The boxes can be set up in many ways, one of the cases of proprietor participation practiced by an American artist. In the Saint Louis museum they are disposed symmetrically in a serial unit with three narrow intervals, the open sides aligned. Whether we start from the right or the left, there is a bipartite rhythm composed of a box followed by space. Due to the bipolar symmetry, orientation is lacking in this arrangement; posed in front of the solid faces, the viewer looks from the right open end to the left open end, and back, in a pendulum motion that, however, is rhythmically articulated into object/space, long/short, solid/void.

Other options for the four boxes would be to run them in a zigzag, distance them progressively, alternate open and closed faces, form a cross, form a diagonal, alternate height with width so that the tops are not aligned, close up into a tunnel, arrange at random, etc. As the boxes stand in Figure 38, they yield a brilliant play of light-and-dark rectangles, formed by reflections in the Plexiglas interiors. This play would vary in other dispositions. However, considering all feasible options, the most perplexing in its effect upon the viewer is the arrangement in a series without deviation that was chosen by the Saint Louis museum. This is as true of the open-ended boxes as of the earlier, closed units.[78]

[78] For example, the unit of eight pieces, *Untitled* (1968). The drawing for it is reproduced in *Don Judd,* ed. William C. Agee (New York: Whitney Museum of American Art, 1968), p. 8.

One would think that a series of identical box-shaped units, set out at identical intervals, would be boring. Just the opposite happens to be the case. The arrangement has a special flavor, soothing and exciting at the same time.

An assemblage of standardized units, that is, motifs disposed above and below one another, to right and left of one another, produces an altogether different visual effect from the arrangement in a series studied in connection with reiteration. When the whole field is systematically covered with elements, the sensation of rhythm is replaced by an overall throbbing because the unit and, with it, the sequence are lost in the crowd. Instead of individual trees, forming an alley, there is a forest. Only the overall optical effect counts. Furthermore, all hierarchy is eliminated, not only of above and below, right and left, as in Pollock and Snelson, Gorky and Louis (Figs. 1, 20, 17, pp. 19, 156, 157, 143), but also of center and periphery. Jack Burnham speaks of "a field as a plenum of kinetic effects." [79] As in Johns, Snelson, etc., this field is extensible ad infinitum, but not all extensions will be aesthetically satisfactory.

Uecker's *Ocean* (1970) and Poons's *Northeast Grave* (1964; Figs. 13, 16, pp. 123, 131) are such kinetic fields. It may be objected that they do not belong in Systemic art. I am fortunate to be able to quote Uecker's statement of 1961 on this subject, as follows: "In the beginning I utilized strict serial rhythms—mathematical systems—which later dissolved themselves into a free rhythm." [80] Perhaps one should speak of fluid systematization in such cases. The organization by the use of wavy vertical lines and three tones in Uecker, and by the use of obliques forming a grid in Poons, is unmistakable, although the free rhythms of which Uecker speaks have done away with any formulas or mathematical systems that

[79] *Beyond Modern Sculpture* (New York: George Braziller, 1968), p. 254.
[80] *Günter Uecker, XXXV Biennale di Venezia,* ed. Dieter Honisch (Essen: [Museum Folkwang?], 1961), unpaged.

may or may not have been present originally in the compositions.

From Uecker we learned that the forest of units can be disposed evenly or grouped into formations which, in turn, can be abstract or representational. We also learned that the grouping is achieved by altering the consistency of the units—in color, density, or orientation; Uecker shades with his nails in the tradition of graphic art. Often the same artist will do both abstract and representational types. Also the type of unit used varies considerably from Uecker's nails to Kusama's stuffed fabric, from Poons's dots or ovals to Stella's lines, and many other materials and motifs. But neither the material nor the motif can serve as a stylistic criterion, because some artists use several types and several artists use the same type. From Poons we further learned that such a field, if it extends to the borders of the canvas, has the character of a segment.

What happens if such a kinetic field is spread over an object, that is, a three-dimensional sculpture is formed with it, can be seen in *Accumulation 1* (1963?) by Yayoi Kusama, renamed *Phallic Sofa* (Fig. 25) by the artist. Kusama, known to the world as The Polka Dot Girl, is connected with sex obsession, food obsession, compulsion furniture, the repetitive room, the macaroni vision, Dot Events, and Self-Obliteration Happenings (in which she and models in a setting of her works painted fluorescent polka dots over their nude bodies to the tune of rock and roll or frogs croaking, etc.). She came to the attention of the American public first in 1955 at the Brooklyn Museum's "Water Color International" show. In it, and subsequent United States shows, she was represented by paintings of intricate web patterns that copied the networks found in leaves, butterfly wings, etc. These net paintings grew and grew until one was thirty-three feet long. The critics called them Impressions or Zen Buddhism, which labels are disputed by the artist. She has described them as follows: "My net-paintings were very large canvases without composition—without beginning, end or center. The entire canvas would be occupied by monochromatic net. This endless repetition caused a kind of dizzy,

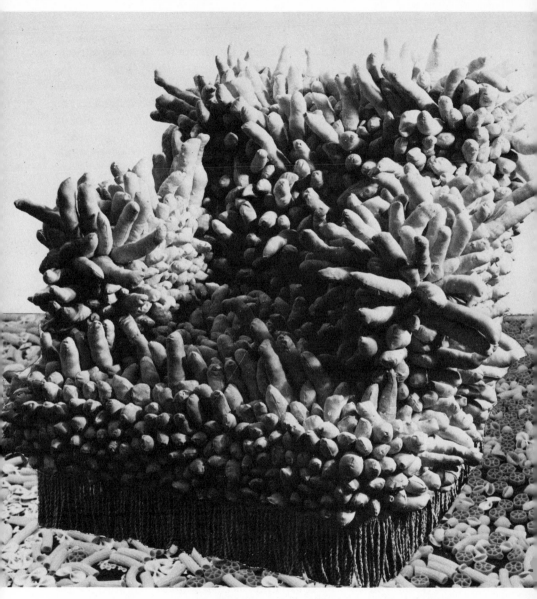

25. Yayoi Kusama: *Phallic Sofa* on *Macaroni Carpet* (1963?). Fabric. Artist's collection, New York and Tokyo.

empty, hypnotic feeling." [81] Kusama's description discloses an affinity in composition to Uecker, Poons, and Olitski (Figs. 13, 16, 18, pp. 123, 131, 145), but omits to mention that there were some imperfections within the giant net, arresting the eye's trajectory. In 1961, Kusama started on collages of postage stamps, airmail stickers, and dollar bills. And in 1962 or 1963, she discovered aggregation sculpture, of which *Phallic Sofa* is a sample. In 1963, she presented this discovery in an exhibition, "No Show," at the Gertrude Stein Gallery, New York. Commenting on it she said:

[My aggregation-sculpture] arises from a deep driving compulsion to realize in visible form the repetitive image inside of me. When this image is given freedom, it overflows the limits of time and space. People have said that presents an irresistible force . . . that goes by its own momentum once it has started.

Then she added: "I am deeply terrified by the obsessions crawling over my body, whether they come from within me or from outside. I fluctuate between feelings of reality and unreality." [82] However, in the 1966(?) release of the Castellane Gallery "Kusama Does It with Mirrors" for the "Floor Show" in which the gallery, sheathed in mirror plates, reflected and multiplied a vegetation of white phallic shapes decorated with polka dots (for such mirror rooms, see Samaras, chap. 5, sec. 2, below), Kusama revealed that she finds this terror pleasurable: "I, myself, delight in my obsessions. . . ." [83] *Phallic Sofa* is an instance of Kusama's obsessions with multiplication and sex.

Actually it is impossible to say whether the piece of furniture is a sofa, a settee, or an upholstered chair, because every quarter of an inch of its surface is densely overgrown with banana shapes from soft material. These fight with one another for access to the

[81] Gordon Brown, "Miss Yayoi Kusama," *De nieuwe Stijl* ([Amsterdam ?]: De Bezige Bij, 1965), p. 163.

[82] *Ibid.*, pp. 163–164.

[83] "Kusama Does It with Mirrors," press release of the Castellane Gallery, New York, [1966?].

light; the work is a morsel of jungle life, transplanted into the home. I prefer to call it a love seat, because the erotic dreams you will enjoy when sinking into the luscious arms stretching forth to welcome your body are painfully transparent.

The drive to proliferation of the shapes is so powerful that the viewer can visualize them encroaching upon the environment in spite of their being tied to a shape. This irrepressible vitality and assertion of the self are characteristics of all of Kusama's sculpture. In Uecker's furniture sculpture the growth is indicated by a trailing formation; in Kusama's it is an explosion.

The standardized unit in an assemblage can be disposed uniformly or altered. A common device for variation is the rotation of the unit. Another common device for variation is difference in size. Sergio de Camargo, a Brazilian artist who works in Paris, operates with these as a basis, adding a few other differences to achieve his effects. His standardized unit is a cylinder whose sections he cuts straight or slanted, whose shapes he makes circular or squarish, whose diameters and lengths fluctuate. He places his elements upon wooden panels, setting them at various angles and contrasting them either as group to group by density and by size, or as agglomerate to empty surface. The quiet empty stretches within or around the agglomerates he calls banks (*rives*) or borders (*orées*).[84] In his system he can produce combinations as varied as Uecker can with his nails. Formations of larger units looking like garlands detach themselves from a ground of smaller units. Bunches of cylinders rotated in several ways project from a bare ground, throwing shadows upon it. One configuration looks like a letter of some alphabet, another like a geometric figure. Sometimes the shape of the field influences the visual experience, as when a tall, narrow panel is covered with cylindrical units. As in Uecker, density of elements and time of day have their say in the experience of the light effects.[85]

[84] Jean Clay, *Sergio de Carmargo* (Zurich: Gimpel & Hanover Galerie, 1968), unpaged.
[85] Examples in Clay, *Sergio de Camargo* (1968).

26. Sergio de Camargo: *Relief No. 246.* 1969. Wood. 18½″ x 18½″.
Photograph: Gimpel & Weitzenhoffer, New York.

Camargo's *Relief No. 246* (1969; Fig. 26) is arranged as the op-
position of an agglomerate to a bare surface, the agglomerate set out
in the center of a square—a format that Camargo, like many other
modern and contemporary artists, favors. There are seven elements,
each a cylinder with one end cut as an approximately straight
section, while the other end is slanted at about forty-five degrees so

that the pieces look like portions of cones. The units are rotated in different directions, and vary in size and proportion. They are placed near one another, but without crowding. The arrangement is rooted in the image of a four-petaled flower with three intermediate leaves, but the similarity is intentionally destroyed by disorientation of the upper and lower "petals," which face inward with their rounded ends. Both agglomerate and ground are painted white.

Light is a vital component in the design. Although everything is coated with the same color, the way the cylinders are posed and the variations in size make some seem dark, others bright. For the individual pieces of the agglomerate throw shadows upon one another, and upon the background, that vary in strength, brightness, and density. The three-dimensional cluster has a strong bodily presence in spite of its evasive color, while the flat surface of the field tends to fade away into nonvisibility, camouflaged like a chameleon by the identity of color. The immaterial pale shadows contrast with the physicality of the cylinders and with the barrenness of the field, mediating between the two by their imaginative play. The dance of these phantoms changes as the viewer changes places, and so does the configuration of the agglomerate, which the spectator sees as a bird would see a field of grass: from above and from the side, from near and from far.

In his article "Tony Smith and Sol LeWitt: Mutations and Permutations," written in 1968,[86] John N. Chandler used these terms to describe the works of the two sculptors. Although not introduced in the title, the expression *modular* is applied to their art in the text. How do we differentiate between these expressions?

Permutation demands a transposition of units within a group with a change in their character. Permutation in art occupies a position between reiterative/multiplicative art and modular art. It differs from the first in that the gestalt of the unit is changed; it differs from the second in that the module need not be used for

[86] *Art International,* XII, No. 7 (September 1968), pp. 16–19.

the change. Moreover, if it is used to defy the spectator's power of grasping the mathematical substructure of the work, then the system should be classified as permutation rather than modularity. For, as mentioned above, art is ruled by visual, not mathematical, order. Josef Albers and Tony Smith are two instances in point.

In analyzing Albers' Homages to the Square (see Fig. 41, p. 265), Eugen Gomringer discovered that they are built upon a module equal to one-tenth of their length; the lines of the squares all coincide with divisions or multiplications of this module. Gomringer established four typical schemata in Albers' series, one for the four-unit type and three for the three-unit type.[87] Yet, because the squares are not centered upon one another so that the screened portions of the squares are unevenly proportioned, and because the colors do not fall into a system, Albers' steps in space, backward and forward, look like permutations rather than modular structures.

Tony Smith's use of the module is even less noticeable (see Fig. 34, pp. 222, 223, 225). His biographers inform us that he uses crystal modules as the basis for his sculpture, namely tetrahedrons and octahedrons; they also note that the structural patterns are hidden. "In analyzing Smith's work I have found it imperative to make models of his pieces; it is only by doing this that I have been able to detect their underlying structure," says Chandler, explaining that "these tetrahedra and octahedra are indiscernible in the finished work." [88]

On the broadest basis, permutation can be rooted either in the shock of a sudden deviation from the norm or in a fluid, regular transformation of one unit into another that is different in character. Victor Vasarely uses both types. In fact, he is the greatest wizard in the art of permutations. Starting with his training at the Mühely, the Hungarian Bauhaus, where exercises in permutation

[87] Eugen Gomringer, *Josef Albers. His Work as Contribution to Visual Articulation in the Twentieth Century* (New York: George Wittenborn, c. 1968), pp. 137, 139.

[88] Chandler, "Tony Smith and Sol LeWitt," p. 18.

formed part of the curriculum, he exploited every nook and cranny in that area of art. However, it was in Paris, where he moved in 1930 and where he has lived ever since, that he developed his innumerable imaginative variants in permutation. Intentional "faults" in the spacing of lines, or cubes dissenting from a family of circles, are seen alongside linear transpositions from a straight line to a curve, or from a circle to a square.[89] The deviations may be abrupt substitutions in color, shape, size, and orientation, or gradual changes of these that then reverse themselves with a resulting break in continuity there; a segment of the unit may be chipped off; the unit may be reversed from white to black, from concave to convex, from opaque to transparent. Binary permutations alternate with arithmetical and geometrical progressions, couplings in depth, swellings, and other things. The irregular deviations may be arranged to yield a figurative image like the famous *Harlequin* and *Chessboard* (both 1935) and *Zebras* (1932–42).[90] The same may happen to the regular permutations, as can be seen in the sack and balloon shapes of *VP 119* (1970–71; Fig. 27).

Vasarely's works look mathematically engendered, whatever the artist's source of inspiration be. The cunning way in which Vasarely achieves this result can be studied in *VP 119*. This painting consists of a vertical canvas in the proportion of 1:2 so that two squares are formed. The ground of the upper square is golden in color, that of the lower square, carmine. Both squares are filled with dots set in checkerboard formation, which are permuted in shape and color, but each square is filled in a different and often contradictory way. Due to the permutations, the checkerboard pattern decomposes into "frames" formed of dots and their variants. In the lower portion, there is an outer circular black frame of dots, followed by an olive frame in which only the four corner dots remain circular, while the other dots turn into ellipses set *at*

[89] For example, *Supernovae* (1959–61; The Tate Gallery), illustrated in *Vasarely*, I, ed. Marcel Joray (Neuchâtel; Éditions du Griffon, 1965), Fig. 160.

[90] *Ibid.*, Figs. 74, 77, 80.

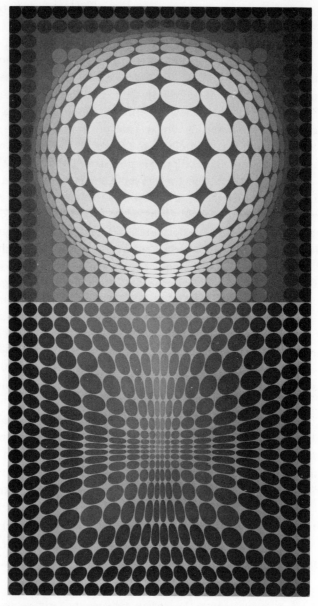

27. Victor Vasarely: *VP 119*. 1970/71. 102⅜" x 51³⁄₁₆". Acrylic on canvas. Photograph: Galerie Denise René, Paris.

right angles to the lines of the frame. These ellipses are slightly larger in size than the dots, the units becoming more and more drawn out in length as they approach the painting's two axes. There follows a khaki-colored frame of units similarly done, except that here the corner dots are already ovals. Then come two golden frames, graded from dark to light, and further increased in size as well as ellipsoidal deformation. After these frames the rhythm is broken: in the following five sets the frames decrease in size instead of increasing. What is more, they again become rounder until they are full circles in the innermost frame, which is no longer a "frame" but a unit of four small dots. The total effect is of a patterned surface being sucked forcefully into the depths by a powerful agent. The pull is intense.

In the upper square a different phenomenon takes place. Here the dots of the frames turn from gold into carmine and then pink, a reversal of the color permutation in the lower portion. Another difference is that the dots are identical in size and shape, except in the centers of the frames where they become ellipses drawn out *parallel to* the direction of the frame. These ellipses increase in number from four in the second frame to eight in the third frame and to twelve in the fourth frame. The break in the construction occurs here, rather than after the fifth row, as in the lower square. For the following six frames, the shapes start to increase in size and roundness, but with the smaller units now in the corners instead of in the centers, as below. The innermost frame is again composed of four identical dots, but spaced far apart and large in size. The effect in the upper square is of a balloon growing out of the patterned web, of a tautly spanned skin swelling until it is ready to burst. Although both squares permute from dark to light, the amount of brightness is much stronger in the lower portion, which draws toward yellow, than in the upper portion, which leads into pink.

The permutations in this painting are serial in nature. Due to the presence of a serial element, rhythm is inserted. In conjunction with permutation, rhythm can be either an acceleration or a decel-

eration. Moreover, depending on whether the spectator views the work of art in depth or looks at its surface, he either sees spatial planes increasing/decreasing or experiences growth/shrinkage. Artists can accentuate either one of these sensations.

In Albers the impression of planes in depth comes to the fore, (Fig. 41, p. 265), in Vasarely that of growth predominates (Fig. 27). The statements of the two artists prove these effects were purposefully sought by them. "In this way the subdivisions, which at first appear to be flat, become steps. The differentiated subdivisions are lifted from the plane into space," Albers explained when speaking of his series Homages to the Square.[91] "The small motif grows, becomes muscled, sharpened, is promoted and becomes form, taut, essential; a new being is born, concealing a whole world beneath its apparent simplicity," Vasarely told us in the same year.[92]

Modular art is visibly ordered by mathematics. But before it can be discussed, a point of semantics must be clarified.

The word *module,* a diminutive of the Latin word *modus,* is a small unit of measure that governs as scale the proportions of a work. In classical architecture, half the column's diameter at the base served as module. The module's size varied from building to building. Modular coordination in modern architecture, on the other hand, proposes the use of a predetermined standard size in the manufacture of the parts used in the construction of buildings to reduce the costs. Here the module is a known quantity.

Sol LeWitt refers to his objects composed of a regular lattice-work as modular. His projects he classifies as serial, which he defined as follows in 1966:

Serial compositions are multipart pieces with regulated changes. The differences between the parts are the subjects of the composition. If some parts remain constant it is to punctuate the changes. The entire

[91] Gomringer, *Josef Albers,* p. 137, who, in note 19 on p. 138, ascribes it to Albers' *Additional Notes to my "Homages,"* which text I was unable to locate.
[92] *Vasarely,* I, p. 33.

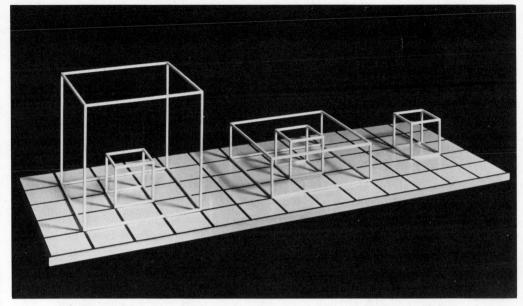

28. Sol LeWitt; *A 2 5 8*. 1968. Baked enamel on steel. 19¼ " x 81" x 32". Krannert Art Museum, University of Illinois, Champaign, Illinois.

work should contain subdivisions which could be autonomous but which comprise the whole.[93]

I would apply this definition to modular art on the basis of sentences two and four: the composition consists of a module and its offspring; the module remains autonomous so that the offspring can be measured against it. These conditions are fulfilled in LeWitt's *A 2 5 8* (Fig. 28). His latticework objects, on the other hand, and Judd's *Untitled* (Fig. 38, p. 243) I would disqualify as modular art because they consist only of the module, which is reiterated. And Stella's *Sangre de Cristo* as well as Agam's *Moods* (Figs. 15, 23, pp. 129, 169), although based on a regular mathematical increase in size of their elements, are not experienced as modular because the module is embedded in the units, appearing in these works only as a multiple of itself. As to Tony Smith, here

[93] "Serial Project No. 1, 1966," *Sol LeWitt* (The Hague: Gemeentemuseum, 1970), p. 54.

the modularity is even further hidden, since the module is so complex that it can only be dissociated with an effort from the whole with which it has been fused (Fig. 34, pp. 222, 223, 225).

The module in LeWitt's *A 2 5 8* (1968; Fig. 28) in the Krannert Art Museum, Champaign, Illinois, is a square of approximately six and one third inches. The work consists of a platform divided into thirteen by five such tiles, upon which stand five openwork structures, multiples of the module square but contrasting with it: whereas the tiles are solid and flat, the frames are space drawings and three-dimensional. Three of the five structures are cubes equaling the module multiplied by itself. They are set upon the second, fifth, and eleventh tiles, counting from the right. Then there is a framework in the shape of a block, equal in height to the module cube but triple its width, which is superimposed and centered upon the cube on tile five. It covers nine tiles, thus containing nine times the area of the module cube. Finally there is another cube sitting above the third module cube on tile eight. It again covers nine tiles like the block centered on tile five but, since it is a cube, it is twenty-seven times the size of the module cube.

It so happens that LeWitt's *A 2 5 8* is Systemic in three respects: it reiterates the small cube three times, permutes a square to a cube, and is based on a module. It is, furthermore, part of a series.

LeWitt has outlined for us the principles he follows in the creation of such works in "Serial Project No. 1, 1966." He uses the square and cube as syntax for his project because "a more complex form would be too interesting in itself and obstruct the meaning of the whole." [94] With such a module as a basis, he sets up certain premises and then calculates all the possible variations of his premises. In the series to which *A 2 5 8* belongs the premises are: use of a module; use of open and closed forms; use of cubes, tower shapes, and block shapes. There are four alternatives for the construction of the shapes in terms of open and closed form, and nine alternatives in terms of which motifs to use together. These

[94] *Ibid.*, pp. 54–55.

two sets the artist numbered respectively A–D and 1–9. In A all elements are open; in B the inner ones are closed and the outer ones open; in C the inner ones are open and the outer ones closed; in D all are closed. The combinations of motifs run as follows: Number 1 has no motif. Number 2 has a small cube the size of the module cube. Number 3 has a towerlike shape, triple the height of the module cube. Number 4 has a blocklike shape, triple the length and width of the module cube. Number 5 has the module cube set within such a block shape. Number 6 has the tower shape set within the block shape. Number 7 has a cube twenty-seven times the size of the module cube. Number 8 has a module cube set within the big cube. Number 9 has the tower shape set within the big cube. Our example has all elements open and uses numbers 2, 5, and 8: a module cube, a module cube within a block shape, and a module cube within a large cube. The same shapes occur in the variant at The Museum of Modern Art, New York, but this work follows the specifications set out in B, alternating inner solid cubes with outer openwork structures. The two sets of specifications are embodied in the titles of the works: *A 2 5 8* and *B 2 5 8*.

Thus *A 2 5 8* has compositional elements of different orders. These can be seen separately or together. If seen separately, each element can call up a mental image of its alternatives in the project —or at least of some of them. The number would depend on the mathematical proficiency of the viewer. But if all elements are enjoyed as a whole, then the list of alternatives the spectator can call up mentally will be severely restricted in proportion to its actual size. LeWitt advises us to read his work "in a linear or narrative manner (12345; ABBCCC; 123, 312, 231, 132, 213, 321) even though in its final form any of these sets would be operating simultaneously, making comprehension difficult." [95] This is necessary only if the viewer likes to proceed in an orderly fashion and if he wishes to exploit the maximum of alternatives in the project available to his mental ability. Otherwise he can read

[95] *Ibid.,* p. 54.

the work in cross section and his imagination can roam around freely among the alternatives.

LeWitt wants the viewer to enjoy his work only conceptually, as a cerebral exercise. But this limitation also limits the enjoyment of the work. Moreover, the lines between the conceptual and visual domains seem fluid. For instance, in studying LeWitt's works from the point of view of rhythm, it will be noticed that rhythm is experienced separately in the planar and geometric configurations. There is no bridge between the two for the eye to cross, although the three-dimensional shape is the square of the two-dimensional one. That seems to prove that there is only a rational link, but no visual one, between a square and a cube. But is the observation based on visual or conceptual data? I believe on both.

Reiteration, multiplication, permutation, and modularity seem to borrow their syntax from civic architecture: the street composed of a row of identical houses, the town composed of houses whose individuality is lost, the square that permutes the house block and interrupts the network of the streets, and the brick unit or steel frame that structures the building are their prototypes. From the four, multiplication, that is, composition with standardized units, strikes me as the most revolutionary discovery and the broadest in possibilities. Reiteration, permutation, and modularity, that is, repetition, motifs that seem to grow and shrink, and play with proportions, all three have been encountered also in traditional art, but the image composed of a host of identical motifs in an un-climaxed composition is apparently a new venture.

On the whole the uproar in form documents a revolt against tradition. Revolts against tradition are commonplaces in art, but this last one was of such gigantic proportions and of such a violent nature that it revolutionized art, overhauling completely and most successfully its outer appearance. "Nonartistic" materials were proven to be artistic, and nonrigid objects were made into art. The edge and the boundary were shown to be capable of uniting the

work of art with, and at the same time separating it from, its environment—quite unlike their predecessors, the frame and the pedestal, which offered only alternate solutions; since these alternate solutions were also open to the edge and boundary, they presented three choices to the artist. By giving the unmodulated area a colossal size, this area was made into a field of emptiness that affected the composition; earlier, emptiness could affect the composition only if visualized as space. Autonomy was wrested from the frame or pedestal and vested in the work of art itself. Finally, ambiguity as the foundation of art was questioned by the use of systems. Thus all the nos were declared yeses; all the bans were lifted; all the taboos were overridden and marked as childish prejudices.

V

Storming the Barriers:
The Aesthetics of the Merger

Luminodynamism . . . achieves a real syn-
thesis between sculpture, painting, cine-
matics and music.

—Nicholas Schoeffer, 1963

The changes in the outer appearance of the work of art were not
enough for the revolutionaries. They plunged deeper in their efforts
to eradicate tradition: the very nature of art was transformed by
them. In addition to new types of composition or new visual
experiences based on the use of new materials, we shall now see a
change in the essence of painting and sculpture. What traditionally
constituted the due and lawful form of these branches as separate
entities will be denied them, dismissed as yet another childish
prejudice. The boundaries between painting and sculpture, between
them and other fields of art, and between art and other fields of
human creativity were swept away. With an iron broom the stable
of art was cleared of the remaining cobwebs that had accumulated
during the past. Obviously the changes in the appearance and the

transformations in the nature of art cannot always be separated cleanly. It was often difficult to decide where a certain development belongs, because its roots may lie in a change of appearance but its crown reach into the realm of mutation, of change in essence. Quasi Environments leading to Environments are such a case.

In a study of the new field of action that was given to art through the challenge to the nature of its disciplines, two sides have to be distinguished: the creative idea and the technical execution. The first always remains the prerogative of the artist. He decides what to bring together and in what manner. But since such schemes spanning different disciplines are apt to involve theoretical and practical knowledge for which specialists would be needed, scientists and/or technicians, the degree to which the technical side is done by the artist may vary. Some pride themselves on keeping their ideas well within the limits of their own capacity so that they can execute them unaided. Happenings are based on this maxim (see Fig. 52, pp. 358, 359). Others accept cooperation to a limited degree, as sculptors and printmakers have accepted technical help in the past. Environments are based on this maxim (Figs. 31, 32, 34, 35, 43, pp. 213, 216, 217, 222, 223, 225, 228, 271). Still other artists confine themselves to presenting the idea and leave the transference of this idea into an object as well as the execution of this object to the specialists; here scientists as well as technicians are engaged in helping the artist. Spectacles are based on this maxim (Fig. 47, p. 300). Their authors have acknowledged the necessity of collaboration: "In order to achieve his objectives, the artist of today cannot work alone," we were told by Schoeffer in 1963, "he must abandon his ivory tower, associate himself with various disciplines, such as music, the plastic arts, literature, choreography, etc., work in a team with other artists and technicians who can contribute their knowledge in various realms." [1] The same rule of conduct was adopted by Victor

[1] "The Three Stages of Dynamic Sculpture." In Guy Habasque and Jacques Ménétrier, eds. *Nicolas Schöffer* (Neuchâtel: Éditions du Griffon, 1963), p. 133.

Vasarely in 1968: "I began to think about building a machine in collaboration with electronics specialists." [2]

Whatever the artist's decision about the degree of collaboration, he is helped in his task of synthesizing art with other domains by the fact that, like the Renaissance man, he is active in several domains at once: painting, sculpture, and architecture (Newman, Agam), art and poetry (Uecker), art and dance (Morris), art and film (Warhol, Kaprow), etc. Moreover, like his Renaissance proto-type, the contemporary *homo universalis* has some familiarity with the vast realm of science as well (Rockne Krebs). How else could he know what to select for use in his art?

In planning the divisions of this chapter, I have been guided by the type of discipline with which painting and sculpture have been amalgamated, specifically by its degree of relationship to them. Starting with those nearest to art, I have ended with those having the least in common with it. There are six sections: the first will deal with the synthesis of painting and sculpture; the second with the synthesis of art and architecture; the third with the synthesis of fine art and verbal art (literature, theatre); the fourth with the synthesis of fine art and motion art (film, dance); the fifth with the synthesis of art and music; and the sixth with the synthesis of art and science.

1. *The Wounded Canvas, Combines, the Nongeometric Field*

... not painting, not sculpture ...

—Eva Hesse, 1969

In the mergers to be studied, that of painting and sculpture has the most closely related members. However, contemporary art is not the first to wed these cousins. Their alliance can be traced back into prehistory, since relief is a mixture of painting and sculp-

[2] *Vasarely*, II, ed. Marcel Joray (Neuchâtel: Éditions du Griffon, 1970), p. 198.

ture. This assertion is correct, and yet it may misrepresent the facts because it is not known whether painting preceded relief in the history of man. It may be that painting is a derivative of relief. The reasons for the emergence of relief are unknown, but it can be conjectured that it served to decorate architecture. Perhaps relief is actually a mixture of architecture and sculpture, and not of sculpture and painting. Relief has been classified as sculpture during the Renaissance because it has tactility, and as painting in the twentieth century because it composes on the surface.[3]

Pastel is another union between cousins, a mixture of painting and drawing. Edgar Degas' pastels are sometimes classified as painting, sometimes as drawing. The reasons that pastel was used as a medium vary throughout the centuries. In the case of Degas, it was the quickened interest in immediacy, spontaneity, informality, and the unfinished.

Relief and pastel marry two branches of art. More recently art was married to non-art objects by the Cubists. They pasted bits of papers into their paintings, creating collage in 1908, and commingled manufactured objects with pieces they shaped themselves, creating Constructions in 1912.[4] Collage and Constructions aimed at proving the ambiguity of the concepts of illusion and reality.

With one exception, none of the artists synthesizing two branches of art, or art and manufactured objects, seems to have aimed at eliminating the boundaries between the arts, or between the arts and non-art objects. The exception is Kurt Schwitters. His Merz works are purposefully directed at fusing pictorial and plastic values. This is proven by a statement of 1920: "I drove nails into

[3] Daniel-Henry Kahnweiler, *Juan Gris: His Life and Work* (London: Lund Humphries, 1947), p. 46. Robert Morris, "Notes on Sculpture, Part I," *Minimal Art: A Critical Anthology,* ed. Gregory Battcock (New York: Dutton Paperbacks, 1968), p. 224.

[4] The earliest Collage seems to be Picasso's ink drawing *The Bathers* (The Solomon R. Guggenheim Museum, New York), illustrated in Harriet Janis and Rudi Blesh, *Collage: Personalities, Concepts, Techniques* (Philadelphia: Chilton Company Book Division, 1962), pp. 9, 12, 17–19; Fig. 6. The earliest Construction is Picasso's *Guitar* (1912), illustrated in Alfred H. Barr, Jr., *Picasso, Fifty Years of His Art* (New York: The Museum of Modern Art, 1946), p. 86.

pictures in such a way as to produce a plastic relief aside from the pictorial quality of the painting. I did this in order to efface the boundaries between the arts." [5]

This, then, is the basis from which contemporary art launched its attacks upon the division between two-dimensional and three-dimensional forms, between elements fashioned by the artist and manufactured elements. Three artists are in evidence: Lucio Fontana and his broken canvas surfaces, Robert Rauschenberg and his Combines, and Frank Stella and his shaped canvases.

Fontana belongs to an older generation of artists, like Josef Albers and Barnett Newman. Born in Argentina in 1899, but educated at the Brera Gallery, Milan, Italy, he divided his activities between these two countries. His specific artistic expression he named *spazialismo* ("spatialism"), stipulating as his axiom that art must transcend the limitations imposed upon it by tradition. In painting, this axiom led him to the perforation of his canvases. In fact, his holes and slashes have punctured and rent once and for all the traditional concept that a canvas surface has to be solid and whole. This innovation dates from 1949 when Fontana pierced the surface of a monochrome canvas with holes, creating an image that has been likened to a galaxy of stars or the Milky Way.[6] In 1951, Fontana started to enrich the composition of these works with blotches and splashes of paint, and the year after, he added glass stones to the texture of the picture. Moonscapes were thus created. The slashes came nine years after the holes, in 1958. Except for the earliest examples, the backs of the cuts are covered by black gauze so that the effect is controlled by the artist. These works Fontana titled Attese ("Expectations").

The *Concetto Spaziale: Attese* ("Spatial Concept: Expectations," 1960; Fig. 29) in the Ludwig Collection, Aachen and Cologne, belongs in this category. In discussing it, several aspects have to be sepa-

[5] "Merz," *The Dada Painters and Poets: An Anthology,* ed. Robert Motherwell (New York: Wittenborn, Schultz, 1951), p. 62.

[6] Guido Ballo, *Fontana* (New York: Praeger Publishers, 1971), p. 157.

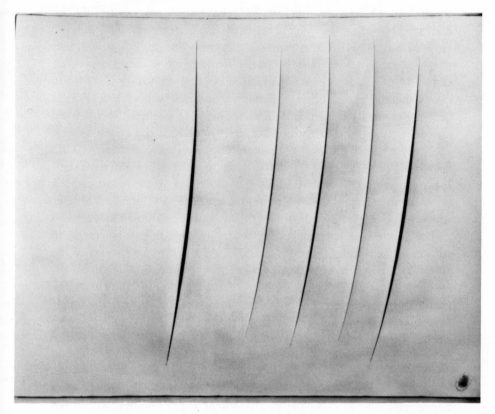

29. Lucio Fontana: *Spatial Concept: Expectations*. 1960. Oil on canvas.
31½" x 39⅜". Ludwig collection, Wallraf-Richartz-Museum, Cologne.

rated: the artist's aim, the work's artistic merit, and the position
artist and work occupy in relation to other achievements in art.

First, the artist's aim. Fontana wanted to create an art that was
neither painting nor sculpture: "It is further demanded that paint-
ing, sculpture, poetry and music be superseded," he wrote in 1946.[7]
Ideologically, he belongs together with Newman, who broke

[7] *Manifesto bianco,* Buenos Aires, 1946; English translation in Michel
Tapié, *Fontana* (New York: Harry N. Abrams, 1962), unpaged.

through in 1948, a year before Fontana's discovery of the pierced canvas. This community of ideas between Newman and Fontana is suggested by the twofold reasons they give for their innovations: they are new aesthetic experiences embodying metaphysical concepts. In 1965, Fontana explained his scope as follows: "I have not attempted to decorate a surface, but, on the contrary, I have tried to break its dimensional limitations." He wanted "to open up space, create a new dimension for art, tie in with the cosmos, as it endlessly expands beyond the confining plane of the picture." [8] I do not think that Fontana's pictures fuse visually with the surrounding space, as he wished. Had he succeeded, he would have created an early instance of quasi Environments. But this intention illuminates his relationship to Brancusi. In a way, Fontana's lacerated canvases are the pictorial counterpart of the mirror surfaces in Brancusi's sculpture (Fig. 33, p. 218). As the latter disposed of the traditional concept of sculpture as a self-contained, unchangeable, static work, so the former disposed of the traditional concept of the canvas surface as a self-contained, unbroken field, with its image formed by paint (Fig. 29). The last-named point has not yet come up for discussion.

Second, the artist's achievement. What he substituted for painted shapes should become clear in a moment. The slashes in Figure 29 open five vertical slightly curving slots in a horizontal field. They are spaced off-center to the right, four at regular intervals and the fifth, at the left, twice as far away from its neighbor as the others. One beat has been skipped. This last slash is also the broadest and longest opening. It forms the strongest accent. Numbering 1 to 5 from left to right, next in width comes the slash at right, number 5, and then number 3. Thus 1, 3, and 5 are read together as against 2 and 4. Each slash is also individualized by its length, by where it starts and where it stops, and by its direction. In sum, the slashes articulate the surface of the canvas as effectively as shapes, forming a gestalt. The image is completed by a tiny motif

[8] "Symposium Artecasa," *Lucio Fontana: The Spatial Concept of Art* (Minneapolis, Minn.: Walker Art Center, 1966), unpaged.

in the lower right corner: a blob of paint housing the artist's finger-print as signature. The composition looks disciplined in patent contrast to the elements upon which it is based: neither violence in execution, nor violation of the canvas surface, is felt.

Third, the position of the pierced canvas as a formal discovery. The meaning of this discovery need neither correspond to the artist's aim nor be confined to it. Fontana's aim was to create a new art form by introducing real space into a painting. Hence he united painting with an extra-artistic medium, like the Cubists, except that he was using nature whereas they used a manufactured object. However, real space had always been a part of art in sculpture, where it is known as a *void*. Reading the story of voids in sculpture will clarify the position of Fontana's holes and tears in the canvas surface.

Voids in sculpture appear between the arms and trunk, between the legs, and between drapery or objects and the figure. Many such voids remain unobtrusive, fading into the space of the setting. However, at least as far back as the Italian Renaissance, voids had asserted themselves as formal powers and were seen by the observer as negative shapes. This development reached its peak in the second decade of the twentieth century in the work of Alexander Archipenko, who pierced the body of his figure by fashioning its head as a hole.[9] In the 1930s the hole in sculpture conquered fresh territory when Henry Moore started to shape its boundaries like hills and dales. As I have shown elsewhere,[10] Moore's formal invention is connected with the trend toward equalization of parts in modern art: Manet deemphasized the face of his figures, thus equalizing face and body; contrariwise Moore articulated the trunk of his figures, the least sensitive portion of the body, thus giving it equal status with

[9] E.g., Archipenko's *Woman Combing Her Hair* (1915; The Museum of Modern Art, New York), illustrated in Andrew C. Ritchie, *Sculpture of the Twentieth Century* (New York: The Museum of Modern Art, 1952), p. 138. Donatello's *David* (c. 1430–1432; Bargello, Florence) illustrates the Renaissance void through the arrow-shaped form between the arm with the sword and the body.

[10] Carla Gottlieb, " 'The Pregnant Woman,' 'The Flag,' 'The Eye': Three New Themes in Twentieth Century Art," *Journal of Aesthetics and Art Criticism,* XXI (Winter 1962), p. 178.

the shaped head. Fontana took over Moore's use of holes for the animation of plain surfaces, transferring this device from sculpture to painting.

In 1953 a different enterprise for stepping out of the restrictive atmosphere imposed upon art on the ground that each branch should remain self-contained, that is, bound to its own specific medium, was undertaken by Robert Rauschenberg, the discoverer of Combines. The word *combine* is familiar to every farmer in an industrialized country as a harvesting machine that cuts, threshes, and cleans grain in one continuous action. Rauschenberg comes from Texas, which is grain country, and he likes double-talk. His Combines are works of art combining painted canvases with three-dimensional objects. Are they also a reference to contemporary art harvesting the crop, peeling off the superfluous husk, and isolating the kernels?

Rauschenberg's Combines marry painting to manufactured objects, like Cubist Constructions. But they differ from these works in one major aspect: they do not create a new medium by blending the component elements of the old ones. Relief and pastel fuse the media: Collage and Constructions amalgamate them, but Combines mingle painting and sculpture *without loss of identity*. However, many of Rauschenberg's Combines include also Collage and Constructions. Furthermore, the artist does Combine-paintings and Combine-sculpture. Technically as well as visually his Combines are greatly varied and full of surprises.[11]

Coexistence (1961; Fig. 30) in the Leo Castelli collection, New York, is a Combine because what appears to be an oval wrought-iron ornament, the upper of a man's rubber boot, and a broken grille have been included nontransmuted in the work. Together with them Rauschenberg uses Constructivist elements. These are disposed upon a vertical canvas to form a scarecrow figure that carries a kind of scale upon its shoulders; the arrangement could also be taken for a semaphore signal in the Go Ahead position. The semaphore consists

[11] Examples in Andrew Forge, *Rauschenberg* (New York: Harry N. Abrams, 1969).

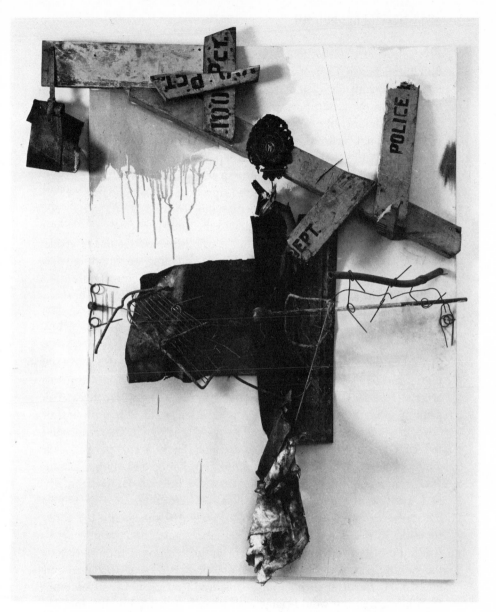

30. Robert Rauschenberg: *Coexistence*. 1961. Combine painting. 60″ x
42″. Photograph: Leo Castelli Gallery, New York.

of a yellow crosspiece, five yellow broken boards, a broader, thinner, unpainted board projecting beyond the canvas surface at the upper left corner, and the rubber vamp, caked with dirt, which hangs free in space from its strap, suspended horizontally from a nail in the projecting board, like a lamp identifying a house of ill repute in bygone days. The yellow pieces once served the police department as a barrier to hold off the public. The letters *NYPD* are incised upside down (by the artist?) upon the crosspiece, while the words *POLICE DEPT. 100 PCT* appear distributed upon the broken boards, which are nailed to the crosspiece or to one another, one board jutting out toward the spectator, at right angles to the canvas surface.

The scarecrow is placed with its "head" in the center of the crosspiece. The head is actually an oval figurative frame surrounding what turns out to be a magical relic: a tooth lies in the center upon a gold trefoil within a row of red "pearls," of which some are broken. Around the pearls runs a twelve-edged star design. The amulet is mounted upon a staff so that it can be stuck into a soft material or a hole. The "body" of the scarecrow consists of a vertical sheet of metal, rusted and bent, forming the trunk; a horizontal sheet of metal, kin to it, forming the right, winglike arm; and a roll of metal, attached to the bottom of the vertical sheet, the taillike legs. The grille is affixed to the arm. With it goes a length of wire with eleven "eyeglass" motifs projecting at right angles at irregular intervals from the wire length (for this motif, see center left), a rod painted red, white, yellow, and blue with a shimmering knob, and rubber tubing (see center right). All these elements are interwoven horizontally and fixed to the canvas at the sides. At left, there is also a tiny piece of green sponge. The particolored rod, the tubes, and the wires function like a human left arm, human fingers, and paintbrushes, while the broad horizontal sheet and the grille upon it remind one of the painter's palette, as it is held in self-portraits of Cézanne and Picasso. However, if such an image inspired Rauschenberg's Combine, then his scarecrow would paint with its left "hand." Finally, there is a piece of dirty sackcloth as a support under the metal sheet.

The canvas to which this Combine is affixed has its own abstract

design. The upper half is painted in white, with the brushstrokes, in circular rhythms, strongly in evidence. The lower portion is yellow-white, but no strokes are seen; it seems stained either with color or dirt. The overall coloristic effect is one of brightness, except for the upper left corner under the projecting board. This area is covered with an ugly khaki color that runs down in streaks. A few isolated drippings also spot the canvas surface elsewhere on this side. Like all of Rauschenberg's works, *Coexistence* is a strong abstract design.

But it is also a challenge to the imagination. On one level, a variety of things from our throwaway culture have found a new home, in which they live in harmony—coexist. On another level, a portion of a boot or rubber hose giving the Go Ahead signal coexists with a scarecrow scaring off intruders from an area closed by a police barricade; in this zone a grille coexists with a tooth enshrined for voodoo practices. It has often been asserted that Rauschenberg's work is linked to Surrealist art; but his images are more personalized. One has to know a lot about Rauschenberg in order to decipher them, above and beyond the obvious. What is more, his Combines are not frightening like Surrealist works. They are amusing because of the weird way they look. But they could not scare anyone. That thin rubber hose could not hurt a human being, and it is dripping khaki blood.

The viewer also cannot experience fear because his whole being is filled with another emotion: frustration. He never knows what is a found object, or what is manufactured. For instance, the amulet, if amulet it originally was. The viewer has the impression that the tooth in it has replaced some other relic. But how much the artist took over, how much he adjusted, is anybody's guess. Contrariwise, the spectator believes that the eyeglass motif is not Rauschenberg's invention, but again we are not sure. Then the caking of the objects and canvas with dirt and paint. The boot and sackcloth seem to owe their texture and coloring to natural causes. In the end, it does not matter, except that knowing the answers would help to penetrate correctly into the meaning of the work. And even this does not matter greatly when we are looking at a Rauschenberg. Let each

of us interpret *Coexistence* in our own way through our private fantasy world.

The third effort at a synthesis of painting and sculpture is owed to Frank Stella, who transformed the picture into a painted relief by deepening the stretcher and shaping the support for the canvas.

According to Thomas Hess, the deepened stretcher is a gift to art from Barnett Newman, who was the first to use it for his *The Wild* (1950).[12] I believe the deeper stretcher can be linked to the absence of a frame and to large-sized canvases; the absence of a frame made it necessary to have the picture stand out farther from the wall, and the greater weight necessitated a stronger support. The shaped canvas, on the other hand, was discovered by Ellsworth Kelly in Paris in 1953.[13] However, it was only when Stella in 1960, then only twenty-four years old, explored the formal values of a shaped canvas and combined that with the deepened stretcher that the picture came to the fore as a slab. It became a kind of painted metope placed upon a room's wall in the manner of the Greek friezes displayed in museums.

Shaped supports are common in the minor arts, for instance, vases, ritual objects, etc., and they occur even in panel painting under the form of the crucifix. These works differ from the shaping of the support in contemporary art, as practiced by Stella, in the following: in traditional art, the shaped support established the pictorial field a priori, and the image was adapted to this form; in contemporary art, the image dictates the form of the support, which is cut to conform to the structure of the image.

The relationship between the image and the support shaped after that image was developed by Stella in several subtle ways, and not in all of these does the support have an abnormal form. Yet, the differences between these various types are less consequential

[12] Thomas B. Hess, *Barnett Newman* (New York: The Museum of Modern Art, 1971), p. 73.
[13] Hunter, *American Art of the 20th Century,* p. 324.

than their common ground. Most remarkable in this respect is the fact that even when the image is a rectangle or square, somehow the support retains its separate gestalt.[14] Consequently the viewer has the impression of a reciprocity between the image and the support, not of a subordination of the latter to the former. This is why Michael Fried could read the structure of the painting as acknowledging the support.[15] Actually the two acknowledge *one another.* This interdependent independence between the structure of the image and the form of the support is particularly evident in the Irregular Polygon and Protractor series of 1966 to 1968 because of the peculiar shapes of their supports.[16] They are irregular polygons upon which geometric patterns are painted, designed to profit by the irregularities of the support which they follow, resolving them into geometry. In other words, the painted geometric shape decomposes the polygon of the support into its constituent elements, exposing its hidden order.

The dichotomy between the image and the support as well as the secret ties between the two can also be explored in *Sangre de Cristo* (1967; Fig. 15, p. 129). Its pattern and its support have different gestalten and move differently. The support is a long horizontal panel with short arms placed alternately above and below, somehow like a regularized tree trunk in a horizontal position with its branches extending vertically. In the image, the horizontal portion is covered with horizontal stripes and the vertical arms with vertical stripes, the two series of lines meeting at right angles. This results in wedge-shaped units that interrupt the continuity of the horizontal crosspiece, biting into its flesh. The wedges override the horizontal configuration of the support, substituting themselves for it. The eye glides over the support, but zigzags over the image. Moreover, the first and last arms are only half the width of the others, so that

<hr/>

[14] As in *Die Fahne hoch* (1959) or *Sabine Pass* (1961), illustrated in William S. Rubin, *Frank Stella* (New York: The Museum of Modern Art, 1970), pp. 19, 75.

[15] Quoted *ibid.,* p. 59.

[16] Illustrated *ibid.,* between pp. 110 and 146.

the wedges are replaced by right angles. This difference in experience dissociates them from the intermediate arms and integrates them as end parts with the horizontal beam. But, instead of contributing to its horizontality, these ends reinforce the up-and-down motion. On the other hand, if half of the second arm is covered up, then the pattern can be experienced as a zigzag, beginning and ending with a vertical.

Stella defined his pictures, in 1969, as "architectonic in the sense of building—of making buildings." They are organized in architectural terms: "I enjoy and find it more fruitful to think about many organizational or spatial concepts in architectural terms, because when you think about them strictly in design terms, they become flat and very boring problems." Yet he thinks his "painting remains a distinctly pictorial experience—it's not finally an architectural one." [17] A pictorial experience coordinated by architectonic means —this makes Stella's work a potent type of mural decoration. Interest in architecture is the reason that he developed his painted-relief slabs resembling metopes. My referring to his slabs as metopes indicates that I feel he has succeeded very well in his aim. It also indicates that, in my opinion, his works are most effective if seen in a serial composition as if they were metopes. The serial composition can be either an assemblage of related works, as in his Portraits,[18] or a reiteration of a motif in one work as in his *Sangre de Cristo* (Fig. 15, p. 129). In both cases, the wall is structured in such a way that the existence of space is brought to the notice of the viewer. The decisive outline of the slabs carves a shape out of the void, that is, it makes the space captured within its silhouette stand out as a negative shape. To do this, more than two sides of the void must be bordered by sharp, clean lines, which demands the use of several works, that is, a "frieze," or of one work with a meandering outline. It is in this sense that Stella's slabs can be classified as painted relief; the wall is the flat background and

[17] *Ibid.*, p. 46.
[18] Illustrated *ibid.*, pp. 83–88.

the slabs are the figures placed upon it. Stella's works are on the borderline of art married to architecture.

There are other contemporary experiments that synthesize painting and sculpture, for instance *cutouts,* that is, silhouettes cut from board, metal, etc., and set up like sculpture.[19] But these works have not caused a breakthrough in art so far. On the contrary, Fontana's destruction of the canvas as a surface and Stella's slab formations have charted new courses. Fontana's disregard for the even, neat, painted field reappears in the rippled canvas surfaces formed of crumpled folds, which are drenched in kaolin to stiffen them into landscapes, into similes of sand, soil, or rock formations.[20] Stella's slabs served as a basis for slablike canvases with blank fronts but with color around the corners on the canvas sides for effects in which color, transmitted by reflection, appears and disappears as the eye adjusts to the color waves; the painted slab, offspring of painting and sculpture, is here married to motion art (see chap. 5, sec. 4).

2. Environments, Light Situations, Space Sculpture, Sculpture as Causeway, Land Art

I have learned anything is possible.

—Eva Hesse, 1969

Eva Hesse died at thirty-four but not before she had come face to face with the liberating principle: anything is possible in art. Everything is permitted, if you have the guts to try it and the imagination to try what is fruitful. This section will deal with sculpture as container and as lamp, as space divider and as furniture,

[19] Cf. Alex Katz, illustrated in Nicolas and Elena Calas, *Icons and Images of the Sixties* (New York: Dutton Paperbacks, 1971), pp. 152–155; and Rosemarie Castoro, *A. An.m/m,* illustrated in Kenneth Baker, "Rosemarie Castoro . . . ," *Artforum,* X, No. 9 (May 1972), p. 88.

[20] See *Piero Manzoni* (Rome: Galleria Nazionale d'Arte Moderna, 1971), Figs. 12–17, 22, 24–27, 30, etc.

as causeway and as man-made landscape. All these new forms of sculpture have foraged ideas from architecture and its offshoots, interior decoration and landscaping. They are next on our list of cross-fertilizations in art. As for engineering, the synthesis of sculpture with that facet of architecture has been dealt with above in Kenneth Snelson's Structures (chap. 4, sec. 4, Fig. 20, p. 156).

First the synthesis of sculpture and building, which is effected by Environments. How do we separate these from sculpture on the one hand, architecture on the other? One of the founders of Environmentalism, Allan Kaprow, has given the answers by specifying that "Environments must be walked into," thus differentiating them from sculpture, and by stating that they are "in every practical sense 'useless' and uninhabitable," [21] thus differentiating them from architecture. Moreover, they purposely introduce ambiguities in regard to motifs and space, rendering them architecturally nonfunctional. Kaprow's definition makes explicit only that Environments are a combination of architecture and sculpture. It leaves loopholes open. Is the hollow Statue of Liberty an Environment? Is the solid *Merzbau* of Schwitters a sculpture? Are altarpieces not art because they serve a religious purpose? And so on. Several restrictive clauses would have to be inserted in Kaprow's definition to circumscribe the concept of Environments accurately.

Environments are structured in two ways. Some come with their own casing, which may be a platform, walls, or a building. Like a snail, they carry their own house. Others use the room as setting. George Segal's *The Gas Station* (1963) in the National Gallery of Ottawa and Lucas Samaras' *Corridor* (1970) in the Pace Gallery, New York, are encased structures. These may be called autonomous Environments.

The casing of *The Gas Station* (Fig. 31) consists of three walls, painted in different shades of blue, and a platform, perhaps added by the museum. The work embraces a good deal of empty space, because only the indispensable attributes of gas stations are shown.

[21] Allan Kaprow, *Assemblage, Environments and Happenings* (New York: Harry N. Abrams, 1966), pp. 159, 160.

The building stands at left with a tire as an advertisement in front of its two large picture windows; red Saphire Gulf cans are stacked behind them, while a series of blue Gulflube cans is sitting upon a shelf in the rear of the room, below a series of black tires on a rack overhead. An attendant is striding purposefully toward the right, holding a blue Gulflube can in his hand. He is headed toward a weary man seated upon an empty crate next to the right corner, between a rack with three bottle crates and a Coca-Cola machine. A white clock, marking time, hangs on the wall in the center. The figures are life size and the dimensions of the work are about eight feet by twenty-four feet, by four and a half feet.

As has been pointed out, plaster figures are not exclusive to Segal. For instance, Yves Klein made plaster portraits of his friends in 1962. The powerful impact of Segal's work, however, resides not in the plaster figures, but in the combination of these with the natural objects. The plaster beings and the Readymades in a setting, each by themselves, would be interesting as develop-

31. George Segal: *The Gas Station*. 1963. Plaster and mixed media. 8′6″ x 24′ x 4′8″. The National Gallery of Canada, Ottawa, Ontario.

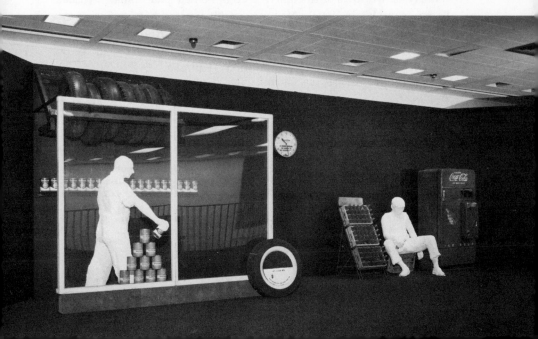

ments of old formulas. Together they form a new departure in art without the hint of the déjà vu that the two components have in isolation. This is why Segal's work is unique among the plaster-figure artists.

Segal considers it crucial that his models "accurately empathize with a situation." [22] It is because the purposefulness of one figure and the weariness of the other are taken from life that they are so convincing. The fleshy bodies of the plaster figures already look real, but for their color. When they are injected with human drives and failings, their aura of reality is heightened. On the other hand, Segal has shorn away all the trimmings that would be found in a real service station: "There was a ruthless quality of pruning away the inessential," [23] he wrote on this subject in 1964. As a result, the unreal setting diminishes the reality level of the manufactured objects. A situation is offered in which the ghostlike pulls toward reality and the natural pulls away from it to create a feeling of uncertainty in what is seen. As noted by Kaprow, ambiguity is a mark differentiating Environments from architecture.

"When I use mirror I . . . create a space, an environment, a fantasy, a world of artificiality, a complicated panorama," [24] Lucas Samaras wrote in 1969. No one could express better the essence of Samaras' mirror Environments. *Mirrored Room No. 1* was conceived in 1965; the idea had been developed by the artist two years earlier in a short story entitled "Killman." [25]

Mirror rooms abound in the rococo palaces and mansions of Europe so that the mirrored room is not a discovery made by Samaras. Yet none of those European examples is quite like Samaras' mirrored Environments. What is new in his use of a

[22] Phyllis Tuchman, "An Interview with George Segal," unpublished manuscript, 1972. I gratefully acknowledge receipt of permission to use it.

[23] Henry Geldzahler, "An Interview with George Segal," *Artforum*, III, No. 2 (November 1964), p. 29.

[24] "Letters from 31 Artists to the Albright-Knox Art Gallery," *Gallery Notes*, XXXI, No. 2 (Spring 1970), p. 39.

[25] *Ibid.*, p. 37.

mirrored room is the scale of the structure—it is not the room of a palace but of a hut—and the total commitment to mirror— all the walls are covered with mirror, inside and outside, plus the floor and ceiling. Consequently, he has not made a ballroom even larger than it is, but has caused a cubicle to comprise infinite space. Also his mirrored Environments present the viewer with two different faces: outside and inside.

Corridor (Fig. 32a), conceived in 1966, was executed in 1970 for "The Mind's Eye" exhibition at the Philadelphia Museum of Art.[26] A second, differently built version had been seen in 1967 in the exhibition, "American Sculpture of the Sixties," sponsored by the Los Angeles County Museum of Art. Both Corridors are misnamed; since they are autonomous structures, they are more correctly described as covered passageways. Note, however, that the title *Mirrored Room,* although ambiguous, is not incorrect; this title is accurate because the mirror-plated façade reflects the room in which it stands. The 1970 *Corridor* was a long, narrow, low passageway, approximately fifty feet in length and about seven and a half feet high, but only about three feet wide. Even so, it was half a foot wider than originally planned. The visitor entered *Corridor* at the left end of one long side and exited at the right end of the other long side, so that the route through the *Corridor* formed a letter *Z,* starting from its foot and terminating at its head. This plan assured the continuity of the mirror sheathing facing him, and thus an unbroken flow of reflections. Furthermore, it punctuated the beginning and the end of the visual experience by forcing the viewer to execute sharp turns, one toward the right on entering the corridor and one toward the left on leaving it.

Unlike the Mirrored Rooms series, in which pieces of furniture are placed in the interiors, *Corridor* was empty (Fig. 32b; the bulbs and light explosions seen in the photograph are the reflections of the bulbs and flashlights used for taking it). One decorative element was present, however: the mirror plates, outside and inside,

[26] For details I am indebted to the artist and Mr. Arnold B. Glimcher of the Pace Gallery, New York.

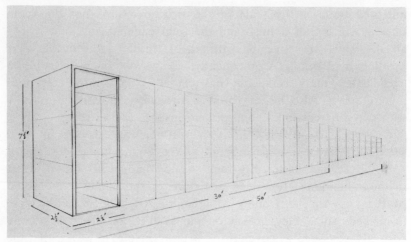

32a. Lucas Samaras: *Corridor*. Ink drawing. 1966. 14″ x 17″.

were secured by small bolts, and the reflections of these bolts in the mirrors formed a myriad of glittering dots. When the viewer entered the interior space, his reflections gave purpose to their glitter by contrasting their dynamic unrest with the large, plain shapes of his body. There are not many repetitions of the figures; I believe this may be due to the narrow width. The visitor is reflected right and left, shown as right-handed and left-handed, standing on his feet and on his head, complete and incomplete. The accent is on the fluid, the boundless, the indecipherable space, and the figure merely emphasizes this quality.

On the outside, the mirror surfaces yield a different impression. They reflect the objects in the room around them, incorporating them into the structure. The mirror walls are again dissolved, replaced by the illusion of fluid space, as in the interior. But in the outside mirrors this space is bounded because the walls of the room are reflected in them. This visual experience harks back to Brancusi's highly polished metal surfaces, mirroring the room and viewer (cf. Fig. 33, p. 218). The difference between the outer and inner reflections, the restricted space outside and the endless space

32b. Lucas Samaras: *Corridor*. 1966–1970. Inside. Installation *The Mind's Eye,* Philadelphia Museum of Art, Philadelphia, 1970. Mirror on wood frame. 7′ 9⅜″ x 50′ 3⅜″ x 3′ ¾″ (outside). Photographs: Pace Gallery, New York.

33. Constantin Brancusi: *The Newborn*. 1915. Polished bronze. $6\frac{11}{16}''$ x $9\frac{7}{8}''$ x $6\frac{11}{16}''$; with base 3' $4\frac{9}{16}''$ x 1' $7\frac{11}{16}''$ x 1' $7\frac{11}{16}''$. Musée National d'Art Moderne, Paris.

inside, is one of the main pleasures in viewing the mirror pieces of Samaras; both can be experienced simultaneously when the observer stands at an angle in front of the entrance.

Another pleasure in viewing Samaras' mirror Environments is rooted in the game they play with our senses. Space is limited, yet looks infinite; it is enclosed and yet no walls are seen. You seem to walk on water with no solid ground below, and when you look up, you apparently look down. One person has entered a tiny corridor, but a family is spaced out in the mirror universe. Touch and eye, brain and eye are at cross-purposes; one moment a gigantic fake, the other some wondrous mystery, is seen. Every impression is ambivalent.

The Environments that use the room as a setting are as diversified as the autonomous kind, as can be seen by analyzing Tony Smith's piece for "Art and Technology," the exhibition of the Los Angeles County Museum of Art in 1971, which focuses on shaping space; and Larry Bell's vacuum-coated glass panels of 1972, which center on generating optical phenomena.

Smith was not the first to think of shaping the space of a room. In *Assemblage, Environments and Happenings,* Kaprow noted:

> The mood is growing among some younger architects . . . to question the sacrosanct rectangle and arc which, with their variations, have dominated the shape of the art almost since its origins. Instead of a compass-and-ruler style, they are seeking one whose forms would emerge more from the feel of nature. . . .[27]

The text for this book was written mainly in 1959 and revised in 1961. It may well have served as midwife at the birth of Environments that shape the room to defy the rectangle. In 1961 Morris came to New York, and his first sculpture after settling in this

[27] Kaprow, *Assemblage, Environments and Happenings,* pp. 151–152. The architect and sculptor Frederick J. Kiesler had worked on that idea as far back as 1924, producing an egg-shaped structure he called "The Endless House"; see "Notes on Architecture as Sculpture, I," *Art in America,* LIV (May–June 1966), pp. 61, 67, illustrated pp. 60, 66.

city, *Passageway* of the same year, gave concrete form to such an Environment. It consisted of a curving corridor in painted plywood, about fifty feet long and eight feet high. Entered from a doorway at one end, it moved out of sight toward the right; moreover the walls converged until advance was impossible and only the eye could follow the path further.[28] In walking down such a curving, horizontal funnel, the viewer is struck concomitantly by the unreasonableness of the structure as a duct and by his own ability to penetrate into sculpture. He reacts to the restrictions imposed upon him by the funnel: the route is prescribed and blocked at its end. He also imbibes the specific atmosphere of a womb.

Sculpturesque architecture found many aficionados. In the same year, André Bloc, an Algerian engineer and artist living at Paris, president of the group Espace ("Space"), started his sculpture habitacle ("dwelling-place sculpture") at Meudon, whose plaster maquette was included next year in the exhibition "Antagonismes 2: l'objet" at the Musée des Arts Décoratifs, Paris. As explained by the artist, he wanted to create a nonobject sculpture:

> The majority of contemporary sculptors have oriented their researches toward the sculpture-object. Even when they work on a large scale for a commemorative monument, for a fountain, they still make an object. I have tried to get away from this order of researches by working on an unusual scale, but in specifying clearly that it still is a case of sculpture and not of architecture. In other words, I have tried to create a kind of monumental dwelling place with the sole means of sculpture. I could thus create a vast shelter which, in modifying the scale, might be able to become a place of cult, a palace, a game room, etc. I have let air and light penetrate by simple and complex routes. The dwelling-place sculpture is, to a certain degree, characterized by a continuity of the external and internal plasticity with a system of interpenetration and occupation of the space multiplying the relationships, the contrasts, and the plays of volume.
>
> This sculpture should be considered a simple gesture destined to

[28] Michael Compton and David Sylvester, *Robert Morris* (London: The Tate Gallery, 1971), p. 25; illustrated pp. 26, 27.

draw the attention upon the unexploited possibilities of contemporary art.[29]

Bloc turned sculpture into architecture. Tony Smith, who came to sculpture from architecture, turned architecture into sculpture. He did this by introducing the organic, irregular shapes of nature into his work in the semblance of the cave (Fig. 34e, p. 225). Why he chose this form, what its essence is artistically, Smith revealed in a statement in which he explained that he wished "to make a piece of sculpture which emphasized the negative space rather than the positive form." [30] Smith's explanation points up the difference between a funnel and a cave: both envelop man like a womb, but a funnel closes him in and threatens him, provoking fear; a cave shelters him, bringing warmth and instigating well-being. These opposite sides of the two works are underscored by the narrowing width in Morris' *Passageway* and the use of light in Smith's Los Angeles Environment.

This Environment, *Untitled* (Figs. 34a-34e), grew out of Smith's contract with the Container Corporation of America in connection with the project of cooperation between art and industry, mentioned above, that had been conceived by Maurice Tuchman, senior curator at the Los Angeles County Museum of Art. As usual, Smith assembled his walls from the interlocking of octahedrons and tetrahedrons, here provided by the Container Corporation in corrugated cardboard measuring nineteen and eleven-sixteenths inches (50 cm.). The work, approximately forty-five feet, by fifty feet, by twenty feet in size, was executed in two versions: one was shown in the United States pavilion at "Expo '70," Osaka, in Japan, and the other in the Frances and Armand Hammer wing at the "Art and Technology" exhibition, Los Angeles, the following year.[31]

[29] Quoted from *Antagonismes 2: l'objet* (Paris: Musée des Arts Décoratifs, 1962), p. 12; No. 55.

[30] *A Report on the Art and Technology Program 1967–1971*, ed. Maurice Tuchman (Los Angeles, Calif.: The Los Angeles County Museum of Art, 1971), p. 310.

[31] Information on the Osaka version, *ibid.*, pp. 306–319. The details of the Los Angeles version were communicated to me by the artist, whose help I acknowledge with deep gratitude.

34a. & 34b. Tony Smith: *Untitled*. 1969–1970. Models for *Expo '70*, Osaka, Japan. Photographs courtesy the artist.

34c. & 34d. Tony Smith: *Untitled*. Models for "Art & Technology" exhibition, Los Angeles County Museum of Art, 1971. Photographs courtesy the artist.

The two versions are very different from one another, because each had to meet different conditions in the exhibition for which it was planned. It so happens that each also exemplifies one of the dual sources of Smith's art.

The Osaka room was smaller and had a dome, but expected attendance was larger. Smith conceived this version as a building, its vertical walls decorated outside with a pretty tooth ornament. The Los Angeles room was larger, flat ceilinged, and expected attendance was smaller; Smith conceived this version as a piece of sculpture in dynamic equilibrium, its leaning walls buttressing one another. Compare the two small-scale working models prepared by the artist (Figs. 34a, b and 34c, d). Both versions present ever varying views as one walks around them, but the potential for change is more pronounced in the Los Angeles version. Seen from one façade (Fig. 34c), the structure looks like a colossal hexapod, a three-dimensional sign stretching forth its members in all directions. In the right foreground is a steeply rising wall, looking like a ramp, which leads to a wall with its top one step lower. The "ramp" is connected by two struts resembling a hanging casemate wall with an L-shaped wall at left. Although the "ramp" leans toward the right, it seems to hold up the remainder of the structure with the two struts abutting against it. This impression seems confirmed by a view at the second façade (Fig. 34d), characterized by three L-shaped buttresses, graded in size, that all lean toward the left where the one-step lower wall behind the "ramp" can be seen, rising vertically, and the other face of the casemate, propping up the largest leaning buttress. In the angle between these two, a tooth decoration is inserted, which here runs up vertically, like a ladder. (Only the two uppermost steps are visible in the photograph.) As an overall impression, the openness and airiness of the two models strike the viewer. Smith has aimed at structures that resemble not caves as enclosures, but caves as shapers of space—and he has succeeded. In this respect, too, the Los Angeles version is more advanced, that is, more widely open. There are still wall blocks preserved in the Osaka

34e. Tony Smith: *Untitled*. Interior. Installation for "Art & Technology" exhibition, Los Angeles County Museum of Art, 1971. Corrugated board. Approx. 45′ x 50′ x 20′.

model, but in the Los Angeles one, there remain only partitions.

This is the impression one gets in looking at the small-scale models. However, once the structure is set up in a room in full scale, the picture changes radically. Figure 34e shows *Untitled* as it was seen at Los Angeles; the shot is taken from a point between the left L-shaped partition and the "ramp" in Figure 34c. The first impact is of penumbrae, of play in light and shadow. Pools of light and dark corners vie for our attention. The second trait noticed is the formation of the partition walls and ceiling. It brings to mind cliffs in Cyclopean masonry built by some pre-

historic race. The walls slope, but regularly, and many stop midway at different heights, providing a series of platforms. Internal dark openings yawn within them, next to the external windows in the ceiling admitting the shafts of light. The ceiling also is stepped, decomposed into lintellike beams. But all horizontal planes seem to run parallel to the floor. To describe the visual experience I can do no better than borrow portions of a description of the Hagia Sophia in Istanbul, substituting *ceiling* for *vault, rooms* for *niches,* etc., to adapt it to our case.

> A fight ensues between the shell and the atmospheric space below it. In opposition to the space which tries to expand in all directions, the shell checks the dynamic push of the air. A contrasting motion unfolds: the ceiling levels take hold of the space. . . . Add to this the very fine feeling for the play of light and shadow. . . . The ceiling is interrupted by a great number of openings . . . which lead directly to the outside. These upper windows form the main source of light for the interior; the contrast of light enclaves and dark sections is based upon them. A wealth of nuances in light-and-shade are born in that the shadows condense in the rooms and particularly in their corners and below the ceiling.[32]

Although the tetrahedrons and octahedrons are put together to form walls irregular and unpredictable in shape, the units are all arranged in such a way that only isosceles triangles are visible, except in the copings. The system is so complex that "to make one little change, you had to alter as many as thirty pieces. Each piece acts as a keystone. To widen one passageway took three or four hours of mathematical figuring—it had to support an overhead beam, etc." [33] In other words, Smith's design is too well integrated to permit alterations. This microform pattern of isosceles triangles is overlaid upon the complex shape of the macroform, constituting its decoration. The joints of the tetrahedron and octahedron units are fitted together to draw a geometric graph over the

[32] G. A. Andreades, "Die Sophienkirche von Konstantinopel, "*Kunstwissenschaftliche Forschungen* (Berlin), I (1931), p. 44.
[33] *A Report on the Art and Technology Program* (1971), p. 316.

walls, consisting of two sets of dark oblique lines, one directed toward the right and the other toward the left. As the eye scans the lines, different patterns jump out: one-piece triangles, six-piece hexagons, two-piece and eight-piece diamonds, etc. (The regular pattern of the triangles is disturbed, unintentionally, by the tapes that hold the units together; they are pasted on at random, their edges torn rather than cut with a precision instrument. The artist had stipulated glue as binder.)

In "Remarks on Modules," Smith has revealed the reason for his use of tetrahedrons and octahedrons as design units: they are very flexible, yet permit simplicity of line:

> While the axes normal to the surfaces of a cube are three, those perpendicular to the planes of a space-lattice made up of tetrahedra and octahedra, are seven. This allows for greater flexibility and visual continuity of surface than rectangular organizations. Something approaching the plasticity of more traditional sculpture, but within a continuous system of simple elements becomes possible.[34]

Applied to *Untitled,* it means that the walls look organic and tectonic at the same time.

Larry Bell's vacuum-plated glass panels of 1972 (Fig. 35) act functionally like the partitions in an office or museum, with the added formal interest of questioning the boundaries between themselves and space. Offices use partitions to subdivide a room without closing the sections off. Museums use partitions to guide the steps of the visitors for the best possible view of the exhibitions. Both these considerations are present in Bell's use of glass sheets. In addition, his partitions are transparent and reflecting surfaces that point an accusing finger at the problematic nature of vision.

The photograph taken of the 1972 exhibition at the Pace Gallery, New York, re-creates the visual phenomenon partially. The sharp lighting brings to the fore the spatial ambiguities based on reflections but blurs the effects of transparency in the scheme. However,

[34] *Tony Smith* (Hartford, Conn.: Wadsworth Atheneum, 1966), unpaged.

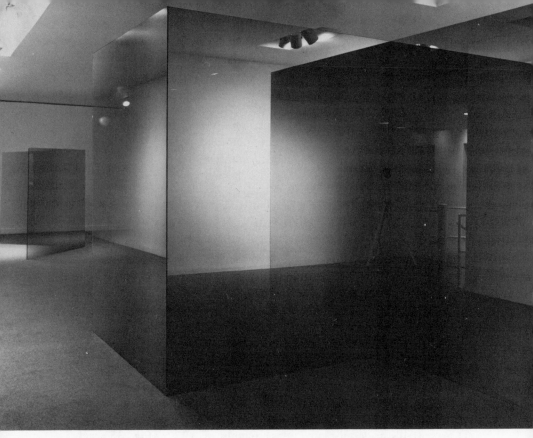

35. Larry Bell: *Untitled*. 1972. Vacuum-plated glass. Each 72" x 96" x ⅜". Installation the Pace Gallery, New York, 1973.

it serves to demonstrate the point that, with the simplest possible structure, Bell has built an incredibly sophisticated visual picture. Panels formed of one sheet, or of two sheets, set at an angle to one another, interpenetrate with the space of the room and with each other. An elusive deception is created, labile in character and mutative in appearance.

It is not a question of the reflections alone, which, because they include the spectator, change with his motion. The viewer is, first, enjoying an image visually and, second, analyzing it mentally to differentiate illusion from reality. Moreover, the quality of the image is in itself a sensual pleasure (not evident in the photograph). Images seen through glass as well as mirror reflections always have

nonillusionistic, flat, dreamlike appearances. Bell's glass panels have been rightly linked to Duchamp's *The Bride Stripped Bare by Her Bachelors, Even* (*Large Glass*) in the Arensberg Collection of the Philadelphia Museum of Art, started in 1915 and abandoned, unfinished, in 1923. According to his statement, Duchamp selected painting on glass in order to protect "the colors from oxidation," [35] and not for the aesthetic advantages of transparency. In Bell's vacuum-plated glass panels, the view through the panels is adulterated by the coating, which casts a veil or film over it, giving it a special texture and color. What is seen through the glass has a mode of appearance similar to that of the shadow thrown by the panel. The panel's shadow can be seen either beyond or through the glass. The panel in the rear of Figure 35, set at an angle to the walls of the room, gives some indication of the optical illusions referred to here. Its shadow is seen beyond and through the sheet of glass, in addition to the reflection of the foreground panel, fusing with the shadow. Add to these the vision of the wall, also seen beyond as well as through the panel, merging with the shadow and reflection.

Reflections and their purpose in Bell's work are, however, better studied in the foreground panel of Figure 35, two sheets of glass set parallel to the room's walls. The counterfeit image in this L-shaped partition re-creates the three-dimensional space of the room by mirroring the room's corner in which the camera shooting this picture is housed. Yet the viewer sees the glass in which this reflection appears as a two-dimensional surface. No doubt about that, because what lies beyond it can be seen through it (partially obscured in the photograph), in addition to the reflection. The observer is faced with a dizzying number of impressions rooted in different optical facts. The walls zigzag disconnectedly, each one different in height, like so many partitions. The authen-

[35] Calvin Tomkins, *The Bride and the Bachelors,* enl. ed. (New York: The Viking Press, 1968), p. 30. For the *Large Glass,* see Robert Lebel, *Marcel Duchamp,* new ed. (New York: Paragraphic Books, 1967), Pls. 100a, 100b, No. 155. For the connection between Bell and Duchamp, see Rose, *A New Aesthetic* (Washington, D.C.: The Corcoran Gallery of Art, 1967), p. 21.

36a. El Lissitzky: *Abstract Gallery*. 1927–1928 (destroyed). Rear corner. Formerly Niedersächsische Landesgalerie, Hanover.
36b. El Lissitzky: *Abstract Gallery*. 1927–1928 (destroyed). Side Wall.

ticity of existence in three-dimensional space of everything seen becomes suspect. First, second, and third levels of appearance have to be sorted out.

And all these optical happenings are tinted with a light film of color, the coating of the plates, that makes them seem even more unrealistic. This film has a quality of beauty that encourages us to forget about the magical tricks and indulge in the magic of color.

The creation of Environments has as its counterpart the structuring of exhibition rooms into quasi Environments (Fig. 22, p. 165). It is even possible that an exhibition room, El Lissitzky's *Abstract Gallery*, set the idea of Environments in motion. The *Abstract Gallery*, which we have already had occasion to mention, had been executed by the Russian Constructivist during his stay in Germany in two examples: one for the International Art Exhibition

at Dresden in 1926, and the other for the Landesgalerie at Hanover in 1927–28 (Figs. 36a–36c). The latter had been commissioned by the museum's director, Dr. Alexander Dorner, whose book *Beyond Art,* describing and illustrating the Hanover room, had appeared in English in 1947 and, in a second, revised edition, in 1958, just before Environments entered the art scene in the United States. Lissitzky's essay on the *Abstract Gallery,* written at the occasion of the installations, and entitled "Demonstrationsräume" (Demonstration Rooms, Exhibition Rooms) was published in 1965 in German, and in 1968 in English.[36]

Lissitzky's whole concept of an exhibition room was a radical departure from tradition: "I did not think of the four walls in the room assigned to me as supports or a shelter," he wrote in his essay, "but as optical backgrounds for the pictures. That is why I decided to dissolve the wall surface as such." Optical backgrounds draw the spectator's attention to the pictures. The surfaces were dissolved by sheathing the gray walls with strips of material a few inches thick, painted white on one side and painted black on the other (Fig. 36a). As a result, "with every movement of the viewer in the room, the effect of the walls changes: what had been white becomes black, and vice versa. Hence an optical dynamism is generated as a consequence of human striding. This play makes the spectator active." Another problem Lissitzky faced was to eliminate the traditional overcrowding; it was that that dulled the visitor's impressionability in the first place. Lissitzky was well aware of this fact: "The big international picture shows resemble a zoo in which a thousand beasts roar simultaneously at the visitors." He eliminated this defect by placing shallow traylike cases with movable glazed

[36] El Lissitzky, *Russland: Architektur für eine Weltrevolution, 1929* (Berlin: Ullstein Verlag, 1965), pp. 129–131. English translation in Sophie Lissitzky-Küppers, *El Lissitzky: Life, Letters, Texts* (Greenwich, Conn.: New York Graphic Society, 1968), pp. 362–363. For further information on these rooms, *ibid.,* pp. 73, 76, Figs. 186–188 (Dresden), and 189–194 (Hanover); *Das abstrakte Kabinett* (Hanover: Niedersächsisches Landesmuseum, 1966). I owe the last-named reference to Dr. Harald Seiler, director of the museum.

36c. El Lissitzky: *Abstract Gallery*. 1927–1928 (destroyed). Corner with Archipenko sculpture. Formerly Niedersächsische Landesgalerie, Hanover.

covers against the walls (Fig. 36b). That permitted him "to house in the room one and a half as many works as in the other rooms, yet, at the same time, one sees only half of them." What is more, the spectator is actively engaged in the show: "The visitor pushes the cover plates aside or down, discovers new pictures or hides what does not interest him. He is physically compelled to come to terms with the exhibited objects." [37] In one corner, a mirror permitted the observer to grasp with one glance, that is, simul-

[37] Lissitzky, *Russland: Architektur für eine Weltrevolution, 1929,* pp. 129–131.

taneously from front and back, a sculpture by Archipenko (Fig. 36c).

Lissitzky's comments are complemented and clarified by Sigfried Giedion's description of the Hanover room in "Live Museum," published in *Der Cicerone* in 1929. According to Giedion, the strips were of metal in Hanover, but of wood in Dresden. He compares these strips with pictures of saints composed of glass strips, as they are used in Catholic regions, in which the images flicker when the viewer passes them by. He believes Lissitzky may have unconsciously revived this baroque tradition, translating it into abstract language.[38]

As can be seen from the description, Lissitzky's *Abstract Gallery* pioneered three ideas later developed in contemporary art: the room was transformed into a quasi Environment to engage the spectator's attention; this was achieved by means of optical dynamics and a mirror; then the visitor was solicited to participate by the presence of the movable glazed covers, which offered him an opportunity to transform the exhibition. Environments, optical dynamics, and active spectator participation were sponsored.

Lissitzky's exhibition room at Hanover was destroyed by the Nazis in 1936. It was reconstructed in 1966 in accordance with the evidence, but with metal strips and the addition of electricity, as specified by Lissitzky in his project. (There were no electric cables in that room in 1936.)

Situations, the name given by the Groupe de Recherche d'Art Visuel to their exhibitions involving active spectator participation (chap. 2, sec. 1; Figs. 3a, 3b, pp. 49, 51), is given by Dan Flavin to Environments created by his Light Sculpture, the third step in the history of the use of light in art. In step one, simulated light was portrayed in painting and real light was employed in the displays of art objects—in museums as well as churches, where flickering

[38] Sigfried Giedion, "Lebendiges Museum," *Der Cicerone*, XXI, No. 4 (1929), pp. 103–106. English translation in Lissitzky-Küppers, *El Lissitzky*, pp. 378–379.

candlelight revealed glimpses of altarpieces and the sun brought stained glass to life. In step two, emitted light was used within the work of art itself, either as a movie projection of colors changing into other colors, or as part of other visual phenomena, integrated into a spectacle (Fig. 47, p. 300). The application of this use of light in contemporary art will be discussed in connection with Tech. art. In step three, light was molded as sculpture. This development is closely allied to the discovery of fluorescent tubing in the twentieth century. Bulbs with their incandescent filament construction radiating one type of light presented the artist with little scope in structuring a light art. Neon tubes offered him the possibility of shaping light into a varicolored sculpture of his own device.

However, this sculpture has a body but no boundaries. Light art is part sculpture, part painting. It is a tangible three-dimensional object like sculpture, but this object is not self-contained. Instead, it overflows into the environment, creating spatial effects as color does in painting. Also, the tubes function like lines in graphic art. Thus Light art draws upon sculpture, painting, and drawing for its composition. The manipulation of shape is borrowed from sculpture. The manipulation of color (monochrome or polychrome, uniform or variform in strength) is borrowed from painting. And the manipulation of lines (straight or curved, single or multiple, parallel or crossed, etc.) is borrowed from graphic art. The hand of the artist is recognizable in the way he proceeds. For instance, one artist deemphasizes linearity (Fig. 37, p. 238), while another uses it as a formal element in the design.[39]

The first to create Light art in the sense here discussed was, I believe, Lucio Fontana. He called these works Spatial Ambiances. He did, however, not differentiate, as I do here, between Light sculpture and sculpture picked out by searchlight. His first Spatial Ambiance, *Spatial Forms & Black Light,* done in 1949 for the Galleria del Naviglio at Milan, Italy, was of the earlier kind. Guido Ballo describes it as follows: "One entered into a kind of grotto

[39] Chryssa is an instance in point. See Calas, *Icons and Images of the Sixties,* pp. 306, 307.

full of a spectral violet light among suspended presences and forms that seemed almost to be prehistoric beings or elements from beneath the sea. It was as though we had entered into a darkly lit ceramic sculpture of his." [40] The effect was obtained by coating the sculptures suspended from the ceiling with reflective paint, which was struck by ultraviolet searchlights.

The later Spatial Ambiances by Fontana were true Light art, that is, Light Situations or Light Environments. The first of these were done in 1951, one for the entrance hall and principal stairwell of the Ninth Milan Triennial and the other for the Veronelli apartment in that city. The *Luminous Spatial Decoration* of the Triennial used nine hundred feet (200 m.) of tubing, which was bent into an enormous gestural graphic sign. The Veronelli decoration had a simpler light trajectory. Two years later, in 1953, Fontana executed a Spatial Ambiance for the ceiling of a movie theatre. Here point and counterpoint were used in the design, the artist contrasting dots of light with angular lines by piercing the soffit of the ceiling with holes under which the tubing was suspended. In 1961, ten years after the Milan work, color became the foundation of his *Fountains of Energy,* a most ambitious Spatial Ambiance, created for the pavilion Italia '61 in a commercial exhibition at Turin; in it, six thousand feet of green tubing were used to span the upper fifty feet of a seventy-five-foot-high stairwell with horizontal lines of green-colored light. Yet another Spatial Ambiance was done for the 1964 Milan Triennial, "Tempo libero" ("Leisure"). This one is an autonomous Spatial Ambiance. It is described as follows by Nan R. Piene: "For the 1964 Triennale he designed a cigar-shaped room within a room, roughly 40 × 15 feet. One entered and stepped down onto a soft, yielding rug; the light was dim; the floor, ceiling and walls were burgundy red. Red light shone through breast-level perforations all around the room." [41] These are a few of Fontana's

[40] Ballo, *Fontana,* pp. 131, 133.
[41] Nan R. Piene, "Light Art," *Art in America,* LV (May–June 1967), p. 40; see also "Tempo libero" ("Leisure"), *Tredicesima Triennale di Milano* (Milan 1964), p. 18, ill., p. 25, Figs. 14, 15.

Spatial Ambiances. They provided the foundation upon which the graphic-sign Light sculpture as well as the color Light sculpture could develop.

Light art is not obliging. It does not want to fit into any of the pigeonholes we have established in this chapter. Flavin acknowledged this difficulty by calling his assemblage a Situation instead of an Environment. Likewise, Light art is only a quasi mixture of sculpture, painting, and drawing, and quasi-Tech. art. What is the difference between a Light Situation and an Environment? The Light Situation (*To Jane and Brydon Smith*) (1969) was presented at the National Gallery of Canada, Ottawa, as part of a Flavin exhibition (Fig. 37). It is not a permanent arrangement; a different Light Situation can be created with all or some of the same elements. But this is true also of some Environments. Much more important is the fact that Light Situations are generated by light. The difference in quality between seeing objects that *shape* space and seeing objects that *color* space is expressed in this word.

How the use of fluorescent light affects the room coloristically, and what might be accomplished by it plastically, was described as follows by Flavin, the exponent par excellence of design in light:

> Now the entire interior spatial container and its components—wall, floor and ceiling, could support a strip of light but would not restrict its act of light except to enfold it. Regard the light and you are fascinated—practically inhibited from grasping its limits at each end. While the tube itself has an actual length of eight feet, its shadow, cast from the supporting pan, has but illusively dissolving ends. This waning cannot really be measured without resisting consummate visual effects.
>
> Realizing this, I knew that the actual space of a room could be disrupted and played with by careful thorough composition of the illuminating equipment. For example, if an eight-foot fluorescent lamp be pressed into a vertical corner, it can completely eliminate that definite juncture by physical structure glare and doubled shadow. A section of wall can be visually disintegrated into a separate triangle by placing a diagonal of light from edge to edge on the wall; that is, side to floor for instance.

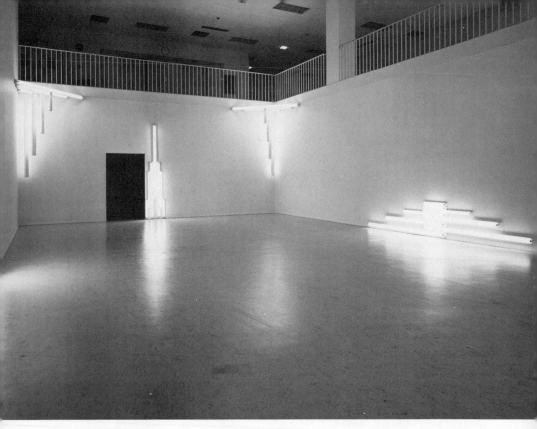

37. Dan Flavin: Untitled (*To Jane and Brydon Smith*). 1969. Cool white, daylight, and blue fluorescent light. Installation The National Gallery of Canada, Ottawa, Ontario. Room size: 162″ x 331″ x 573″. Photograph: Brydon Smith.

Besides transforming "the structure that bounded a room," light can also influence "the volume of space which is so much more extensive than the room's box. . . . through bringing the lamp as image back in balance with it as object. . . ." [42]

Figure 37, the Light Situation Flavin named after the curator who arranged his exhibition at Ottawa and the curator's wife (*To Jane and Brydon Smith*), consisted of eight works flooding a room of thirteen and a half feet, by twenty-seven and a half feet, by

[42] Dan Flavin, ". . . in daylight or cool white," *Dan Flavin,* ed. Brydon Smith (Ottawa, Ontario: National Gallery of Canada, 1969), p. 19.

forty-seven and three-quarters feet with white and blue fluorescent light. Four variants from the series Monuments for V. Tatlin, named in honor of the famous Russian forerunner of motion art, were placed on the ground at the center of each wall, spreading white fluorescent light. Three variants, compact in design, were standing upright like statues, the fourth was a horizontally extending work (Fig. 37, right wall). This series had been designed between 1964 and 1969. The three variants seen in the photograph, one a ten-foot-high object (near the door), were done for the Ottawa exhibition; the fourth, Monument 7 for V. Tatlin (not seen in the photograph), had been shown previously in Philadelphia in 1965. The four Monuments for V. Tatlin were complemented by four corner pieces suspended obliquely from the walls, just under the gallery, obviously yet another deference to Tatlin who first suspended Constructions in the angle of a room between the converging walls [43]—a practice that "corners" the object and is found in the pictorial space of painting at the turn of the fifteenth century.[44] Flavin's four corner pieces were identical, structured loosely in horizontals and verticals. The horizontals, spreading white light, consisted of tubes eight, six, four, and two feet long, set in decreasing sizes from front to back. The verticals used the same four tube lengths, but were set in increasing sizes from front to back and shed blue fluorescent light.[45]

The most precious quality of Flavin's Light art is the mellifluous and liquid glow of the light. It suffuses the space and is difficult to describe. In the Ottawa Light Situation, blurred mirror images of the Monuments for V. Tatlin appear on the floor next to them, and a triangle of light connects the verticals with the horizontals

[43] Illustrated in George Rickey, Constructivism: Origins and Evolution (New York: George Braziller, 1967), Fig. 18.

[44] For example, in Petrus Christus, Portrait of a Young Man (National Gallery, London), illustrated in Max J. Friedländer, Die altniederländische Malerei (Berlin: P. Cassirer, 1924–1937), I, Pl. 67.

[45] Dan Flavin and Brydon Smith, "Fluorescent Light, etc. from Dan Flavin: A Supplement," Artscanada, CXXXVI/CXXXVII (October 1969), p. 14; Dan Flavin (1969), Nos. 102, 112–114.

in the corner pieces, visually disintegrating a section of wall into a separate triangle, as Flavin had analyzed this phenomenon. Reflections that are dimmer in intensity are thrown from the sculptures onto the middle of the floor. The room is transformed. Flavin's art is conditioned by its location. The play of light and shadow and reflection would be impeded in a room with daylight or on a street. Flavin's Light sculpture would lose in strength if it were outside a windowless room. This is the reason that Light art, even one-piece Light art, belongs with Environments. Like Morris' *Corner Piece,* Light art cannot fully exist without a specific container.

Environments showed the practicability of making sculpture hollow. Two artists, Judd and Morris, understood that a new vision of plastic art was feasible by applying this principle to plastic works that cannot be entered. Among other things, this discovery meant that the work acquired an additional viewpoint, one upon which the spectator comes unawares so that he is taken by surprise. Traditional sculpture is savored by walking around it; as this is done new formal aspects become visible. In solid Specific Objects this mode of exploration is superfluous, because the simple geometry of their shapes makes the visualization of what is screened instantaneously available to the mind. But with sculpture that is shaped into a container, the view of the exterior is different from the view into the bowels of the object.

The view into the bowels of an object can be a downward view and a frontal view—a view effected through a skylight or through a window. The *downward view* as a special feature of Specific Objects appeared in Judd's work in 1964, when he equipped several pieces with it, among them the rectangular object in the collection of the Canadian artist Michael Snow, which has a recessed top consisting of six zigzags.[46] Another downward view surfaced in 1965 in Morris' fiber-glass cylinder section in two pieces, each piece composed of two segments with the cracks between the unjoined

[46] *Don Judd,* ed. William C. Agee (New York: Whitney Museum of American Art, 1968), illustrated on p. 22.

joints equipped with fluorescent light.[47] However, here the fact that the sculpture is hollow, and that the changes in color are between outside and top-inside, are the extent of the spectator's surprises when he looks down at the work. Although the view of the outside is different from that of the inside, it is merely a complement of it, and thus available to the mind without work by the eye. Furthermore, a glimpse through the interior can also be caught through the lighted cracks, thereby revitalizing the principle of circling the work of art for a fuller view as in traditional sculpture. Another more complex, downward view was used by Morris for his transformable objects of 1967, composed of wedge-shaped segments.[48] This downward view changes with, and according to, the organization of the segments; on the whole it is a trough-shaped hole. Here, as in Judd's piece in the Snow collection, new formal aspects are discovered when the work is looked at from above, as is done in traditional sculpture by moving around it.

In the formation of the *frontal view,* the motif of the gate served as a forerunner. It was taken over by the Minimalists from other artists and developed from a two-dimensional portal into a three-dimensional tunnel composed of segments. Morris did several single-unit gates in 1961, and was followed by Judd, who made multiple-unit frames in 1966 and 1967.[49] The next action was to broaden the gate, or to link the frames into one body, a container, transforming the gate and frames into passageways. This action was taken by Judd in 1968 with his box-shaped pieces in alloys or metals, which have two sides opposite each other open as entrances/exits (see Fig. 38, p. 243). Like Morris' cylinder section, they do not hold surprises regarding the shape of the interior space, even when not looked at from an angle that displays the interior. They revolutionize hollow sculpture from a different point of view. For Judd in 1965 "three dimensions are mostly a space to move into," [50]

[47] Compton and Sylvester, *Robert Morris,* illustrated on p. 49.

[48] *Ibid.,* illustrated on pp. 68, 70–72, 74–77, etc.

[49] Cf. *ibid.,* illustration on p. 30. Photographs of the Judd pieces at the Leo Castelli Gallery, New York.

[50] *Don Judd* (1968), p. 12.

and *space sculpture* is the answer for applying this principle to sculpture. Judd had discovered a type of sculpture in which the space is more important than the container. What is more, unlike the interbellum two-dimensional, space-drawing sculpture and the gate motif, the space in his open-sided boxes is three-dimensional, a space architecture rather than a space drawing.

First, a few words on the difference between passageway sculpture and box-type sculpture. Both solve the problem of the support in the manner of Specific Objects by equating the work with it: they create the object in the form of the base. However, the base, and a Minimal object in the form of a base, relate to their environment, that is, order everything around them, without introducing the notion of direction, which notion dominates in the statue; there is neither a front nor a back, neither right nor left. To the contrary, each unit by itself, as well as the series of units, in Judd's *Untitled* (Fig. 38) establishes direction in a way similar to traditional sculpture—although without indicating which is front, which rear, which right, and which left: there are two interchangeable solid sides and two interchangeable open sides, presenting two blocked views and two through views. Symmetry in four planes is abandoned for two opposed symmetries.

Having created an object with two opposed symmetries as his basis of operation, Judd started work on reflection. By using anodized aluminum for the exterior and blue Plexiglas for the interior, he focused the attention upon the space in the hollow interior. The matte silvery surface of the outside mirrors poorly. The image becomes a blur; reflections of light rather than of form are caught. The blue Plexiglas in the inside mirrors crystal sharp and clear. Transferring Brancusi's formal discovery from the outside to the inside of the work of art, Judd draws the roving eye into this negative shape. But, at the same time, the reflections dissolve the walls, making the interior space infinite and contrasting it with the space of the mirrors outside, as in Samaras' mirror pieces, yet each artist is exploiting a different contradiction (cf. Fig. 38 with Figs. 32b, 33, pp. 243, 217, 218).

There is a perpetual fight in the ambiguity between the simple, clean-cut, timeless, unchanging shape and the complex, changing impressions, between the visible walls outside and the invisible walls inside, which are coordinated with them visually into one image. The impressions vary not only according to the setting in which the work is viewed, but also according to whether the viewer approaches with the light in front of him or at his back. From one side the interior looks blue, from the other black. The breast-high elevation of the work also influences the prospect. From a distance and seated in front of the piece, a tunnel that can be looked through is seen. But at a distance of one foot and standing, it is no longer possible to perceive the end of the tunnel; the walls, blue as seen from one end,

38. Donald Judd: *Untitled*. 1969. Anodized aluminum with blue Plexiglas. 48" x 60" x 60". City Art Museum of Saint Louis, Missouri. Photograph: Leo Castelli Gallery, New York.

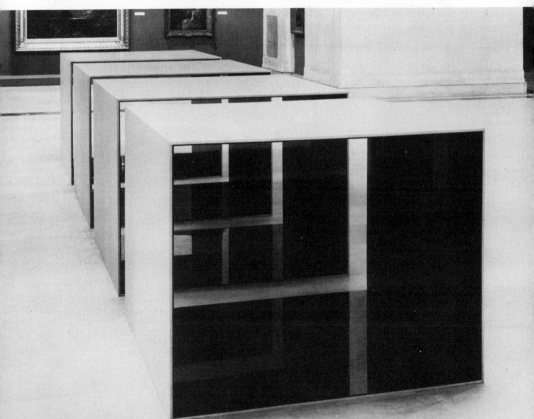

and black as seen from the other end, close, shutting out the light. When that happens, the mirror surface transforms into a pool.

Kaprow is quite right in pointing out that contemporary architecture questions the sacrosanctity of rectangle and arc. André Bloc's dwelling-place sculpture and Tony Smith's organic cave are two variants used in disposing of the interior rectangularity; Bloc and Smith re-formed interior space by enclosing it with sculptural shapes. On the other hand, Minimalist sculpture proves that man is not yet bored by the compass-and-ruler style. He is merely bored by sameness, by repetition, by the expectable that he can foretell. Transferring the discarded architectural box structure to sculpture, Judd has made it respectable again. Using the post-and-lintel motif and interior space in his open-sided boxes, he has employed architecture to re-form sculpture.

Many modern architects consider the designing of the furniture for their buildings part of their jobs. On this ground the synthesis of art and interior design can be discussed together with that of art and architecture. As a matter of fact, Environments and Light Situations are to some extent interior design because they modify the interior space and fill it by the addition of objects. Other interior design motifs taken over into art are the chandelier, that is, the work suspended from the ceiling (adopted at a time when light fixtures are recessed into the ceiling), and the rug, that is, the work placed on the floor. If such works are given monumental size, they structure the room just like any Environment.

As has been mentioned, Morris seems to be the originator of sculpture hanging from the ceiling. His *Cloud* (1962) in plywood (repeated in painted steel in 1968) has found several followers, some transforming the slab into a prism, others keeping the siab shape but decorating it with an image that the astonished viewer discovers if he looks up.[51]

[51] E.g., James Rosenquist, *Doorstep* (1973; Scull Collection, New York), illustrated in Marcia Tucker, *James Rosenquist* (New York: Whitney Museum of American Art, 1972), Fig. 78.

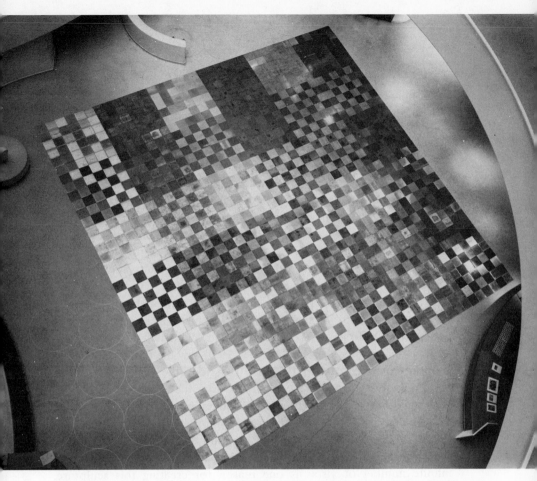

39. Carl Andre: *37 Pieces of Work*. 1970. Aluminum, copper, lead, magnesium, steel, zinc. 432″ x 432″ x ⅜″. Installation The Solomon R. Guggenheim Museum, New York. Photograph: John Weber Gallery, New York.

The carpet/rug type of sculpture I find more appealing and often successful, particularly in the work of Carl Andre, its discoverer. Both types appeared together in 1967, two years after he started to hug the floor with "runners." The carpet type was discontinued after the initial work, a monochrome wall-to-wall covering made from bricks, but with longitudinal gashes created by the omission of

several rows in the structure.[52] I have to agree with Andre that the solid rug type is more attractive. Those pieces done in 1967 consisted of monochrome metal tiles that were assembled in a square. Variants in lead, magnesium, and copper were completed in 1969. In the same year, Andre also made a checkerboard rug.

Andre's most ambitious design is the carpet created for his exhibition at the Guggenheim Museum, New York, also in 1969, *37 Pieces of Work* (Fig. 39). It consisted of 1,296 units that formed a square of thirty-six feet, which was placed on the floor of the entrance hall. It contained monochrome, two-tone, polychrome, and piebald checkerboards in a mixture of materials—aluminum, copper, lead, steel, and zinc. Each of these had its own distinctive quality: one was matte and the other shiny, one remained blank and the other reflected, one was neutral and the other colorful. The barbaric pattern and the square shape asserted themselves competently in Frank Lloyd Wright's interior space. Usually the rugs can be placed on any floor, but *37 Pieces of Work* is designed to challenge the Guggenheim's sophisticated curves. The year 1970 saw the birth of rectangular floor coverings and in 1972 the rugs took the shape of a frame, but these innovations are an anticlimax after the Guggenheim piece.[53]

When interviewed by Phyllis Tuchman in 1970, Andre offered three points for the attraction works lying flat upon the ground exercise upon him. First, "they're . . . not fixed point vistas." The rejection of a single or even a multiple point of view in favor of an infinite number of vistas is one reason for creating this sculpture. Second, "so you can be in the middle of a sculpture and not see it at all—which is perfectly all right." To have the work become one with its setting is another reason. Third, "there are a number of properties which materials have which are conveyed by walking on them: there are things like the sound of a piece of work and its sense of friction, you might say." [54] To introduce sensations of sound and friction by

[52] Diane Waldman, *Carl Andre* (New York: The Solomon R. Guggenheim Foundation, 1970), illustrated on p. 16.

[53] Photographs in the John Weber Gallery, New York.

[54] Phyllis Tuchman, "An Interview with Carl Andre," *Artforum,* VIII, No. 10 (June 1970), p. 57.

walking upon the pieces is a third reason. Oldenburg translates the eye into the fingers; Andre translates the fingers into the toes. "My idea of a piece of sculpture is a road," he told Tuchman.

Andre's rugs have also found their imitators, some artists decorating them with an image and/or inscriptions.[55]

The three reasons given by Andre to explain the purpose of his sculpture upon which the viewer walks as upon a road, either in response to the piece's attraction or by accident, apply also to his runner carpets—*Lever* (1966), a row of 137 firebricks set up horizontally on their narrow sides one next to the other, and its successor, *Prospect 68,* consisting of thirty-five wood units in the collection of Karl Ströher, Darmstadt.[56] They form a narrow walk slightly raised above the ground. Andre explained in 1969 that what he did was to place Brancusi's *Endless Column* down flat, thus voiding it of its active and aggressive character: "Most sculpture is priapic with the male organ in the air. In my work Priapus is down to the floor. The engaged position is to run along the earth." [57]

In spite of its different proportioning and height, *Lever* has many traits in common with the rugs. Both are demountable and can be stored away. They are composed of numerous but not numberless identical prefabricated units, set up to touch one another but not bound together except by gravity. Andre speaks of this type of work as *segmented works.* He saw the segments as "sort of cuts across the mass spectrum in what I call *clastic* way (*plastic* is flowing of form and *clastic* means broken or preexisting parts which can be put together or taken apart without joining or cementing)." He avoids artificial binders, combining the segments "according to laws which are particular to each particle, rather than a law which is applied to the whole set, like glue or riveting or welding." [58]

[55] E.g., Bruce Nauman, *First Poem Piece* (1969); shown in the exhibition "Bruce Nauman" (1973) at the Whitney Museum of American Art, New York (No. 53, not illustrated in the catalogue).

[56] Waldman, *Carl Andre* (1970), p. 19, ill. p. 19 and Fig. 16.

[57] *Ibid.,* p. 19.

[58] Tuchman, "An Interview with Carl Andre," pp. 57, 55.

Another common denominator of *Lever* and the rugs is their relationship to the place in which they are shown. The work can either be integrated with its setting or jar against it. In both cases, the place dictates what form the work should take—this is one of Andre's guiding principles, as has been pointed out. *Lever* disrupts the flow of the traffic in the room in which it is set up. It forces the viewer to decide which lane to take: turn right or veer to the left, or perhaps balance upon the narrow divider—the last a choice for the adventurous. Like *Lever,* the Guggenheim rug is assertive, other rugs are discreetly neutral.

The difference between *Lever* and the rugs resides in the length of the first, which initiates a drive into depth, punctuated by the rhythmical repetition of the joins; the rugs are nondirectional. Due to the length of *Lever* and due to the similarity of the joins to the ties of railroad tracks, the object seems endless. However, this particularity is less important than the common features between *Lever* and the rugs: the acknowledgment of the horizontal floor as a site for sculpture, which sculpture is made codirectional with it; the acknowledgment of the site as font and origin for the design of the sculpture; the segmentation and concomitant ease of storage.

Land art (Earthworks, Earth art) marries art to landscape architecture. It is as nonfunctional in character as Environments because its life-span is of a brief duration. Yet it may not belong in a discussion of art forms. This problem has not arisen before, but a synthesis between two branches of art poses the question in which branch does the resultant artistic expression belong. The synthesis between art and landscaping shows a tendency to accentuate landscaping rather than art, in the sense that the work beautifies nature rather than giving form to the formless.[59] However, some Land art makes *an addition* to nature by constructing a work to be set up in the landscape. Such additions belong in the realm of art as monu-

[59] For illustrations, see *Art Povera,* ed. Germano Celant (New York: Praeger Publishers, 1969); Grégoire Müller, *The New Avant-garde: Issues for the Art of the Seventies* (New York: Praeger Publishers, 1972).

ments. They focus on a new creation, not on embellishment. Christo's *Valley Curtain* at Grand Hogback, Rifle, Colorado, is of this kind (Figs. 40a, 40b, pp. 251, 252).

Valley Curtain grew out of Christo's wrappings of public monuments and mountain ranges, which, in turn, are monumentalized editions of his Packages, with the building or nature substituted for the manufactured object. The Packages were started in 1958 and consist of cloth, paper, plastic material, etc., wrapped around objects that range from spoons, bottles, furniture, and magazines to cameras, perambulators, cars, monuments, and girls. The wrappings are secured by cords or clotheslines.[60] In the Packages several ideas converge, all equally important. First, the use of manufactured objects whose shapes father the shapes of the Packages; the all but neat disposition of the wrappings, crushed and crumpled, bunched and bulging; and the graphic arrangement of the ties terminating in knots, like road arteries meeting at a concourse. Since the shape of the object is instrumental for the success of the work, the artist's choice of the right "found object" is a vital point in the creative process. Second, the realization of a work of art through the use of a commonplace object. The meaning of this device and its connection with contemporary thought is evident. Third, the hint at a surprise, the mystery of the unknown, and the pleasure of unraveling, of uncovering this surprise and mystery. Here a reference to the concept of gift may be detected, couched in Surrealist terms: the artist is the bearer of a gift.

When Christo transfers these notions to the wrapping of public monuments or nature, he again takes advantage of shapes. His latest projects, however, develop on somewhat different lines. Instead of the veiling of a three-dimensional object, a two-dimensional partition is erected—a curtain at Rifle, Colorado, a fence in the California project of 1972, *Running Fence,* which is in process fifty-four miles north of San Francisco. The idea of hiding from view is preserved, but instead of the veil surrounding the object, it is the object that

[60] David Bourdon, *Christo* (New York: Harry N. Abrams, 1971), Fig. 2.

shelters the veil. Through this inversion, the artwork is even more closely linked to the environment, which becomes part of it. The wrappings isolated a segment in the land- or cityscape; the *Valley Curtain* is embedded into nature and absorbed into it (Fig. 40a). The "art" work extends limitlessly as far as the eye reaches.

The project *Valley Curtain* was conceived in New York in March 1970.[61] During July and August, eleven possible sites in the Colorado mountains were inspected by the artist. The final choice fell on the gap of the Rifle Creek next to the Rifle Creek golf course, in the Grand Hogback (elevation 6,000 feet), 216 miles west of Denver and 7 miles north of Rifle. The gorge is traversed on its west side by Highway 325 leading to the Rifle Creek Reservoir and on its east side by the creek (Fig. 40a). Facing the Rifle Gap on the side opposite the reservoir is Grand Mesa National Forest (elevation 10,500 feet). The span between the two sides of the gap where the cables for the *Valley Curtain* were anchored measures 1,250 feet. The curtain itself comprised 250,000 square feet of nylon polyamide, a tightly woven glistening, semitranslucent material, which had to be sewn into a band of about 1,500 feet, an enormous cocoon weighing 8,000 pounds. These gigantic proportions called for several technical feats in the execution of the project. Fieldwork started in April 1971. While the construction workers anchored the cables, the artist followed the progress with sketches and models, adjusting theory to practice. All was ready for the hanging of the curtain by October. On October 9, as it was being raised to the upper cables, it opened up by itself, unfurling prematurely at mid-height, and was ripped into shreds. The technicians had proven themselves incapable of translating the artist's vision into fact. The work had to be done all over again the next season.

As completed on August 10, 1972, with the revisions learned from the mishap of the previous year, the curtain, now "only" 200,000 square feet long, was suspended across the Rifle Gap from four

[61] The project is described from press releases, a film, and oral communications from Mr. and Mrs. Christo, to whom I am much indebted for their assistance.

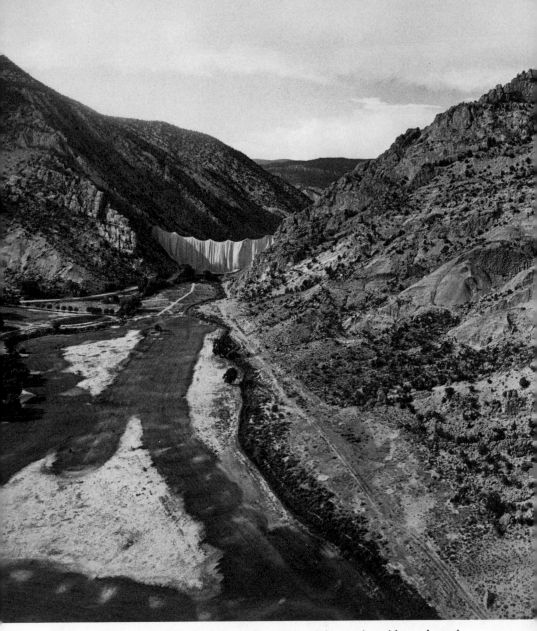

40a. Christo: *Valley Curtain*. 1971–1972. Nylon polyamide and steel cables. 185′ to 365′ x 1250′ to 1368′. Grand Hogback, Rifle, Colorado. Looking north. Photograph: Shunk-Kender.

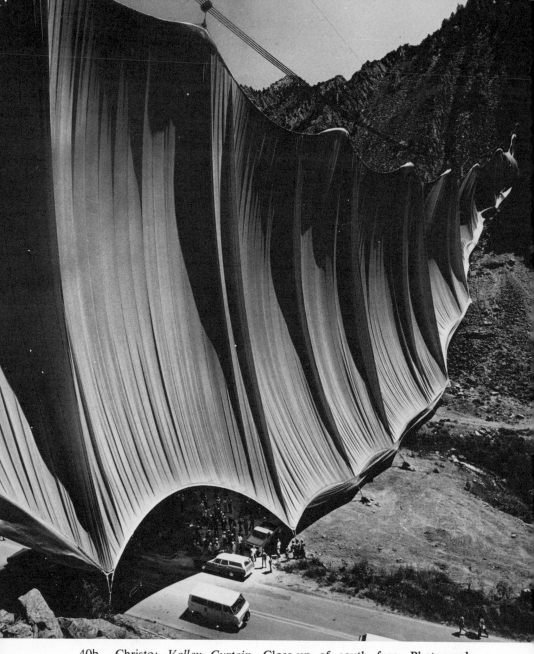

40b. Christo: *Valley Curtain*. Close-up of south face. Photograph: Shunk-Kender.

loosely stretched cables, two and three-quarter inches in diameter, over 1,300 feet long, anchored to the two mountain slopes, to which cables it was linked at eleven points. Each anchor was built to withstand a wind force of two and one-half million pounds of pull. Below, the curtain was held in place by twenty-seven moorings, rigged out with control and tie-down cables three eighths, one half, and three fourths inches in diameter. The top was also laced to a cable and the bottom to a Dacron rope through four thousand grommets. In shape, the curtain resembled a half ellipse, running straight above and describing a convex curve below. Colored a vivid orange to minimize the destructive influence of the sun's rays, its curving bottom cleared the valley at a height of 180 feet in the center, while its two ends were attached to the mountain slopes at right and left at a height of 365 feet. It was about the size of the center arch of the Brooklyn Bridge. Over the highway a large arched opening was provided, one hundred feet wide and twenty feet high (Fig. 40b). The curtain's fabric was tied slackly to the cables so that it could billow with the gusts of the wind up to thirty-five feet in each direction. Also, it touched neither the mountain slopes nor the valley bottom, leaving escape hatches for the air. To cover these spaces between the moorings so that the curtain would be visually complete, but the wind would still be able to blow through the gap, a ten-foot skirt was attached to the curtain's bottom, screening the scalloped openings. The securing of the curtain, once it was unfurled, had to be done quickly before the wind caught it. To man twenty-seven stations of moorings required an extra force in addition to the thirty-five construction workers. Sixty-four art students and college students, faculty and amateurs, enrolled as an additional labor force during the last five days of work.

The prognosis had been: "It cannot be done." So, when the curtain opened as programmed, there was great joy. Carried on the shoulders of the hardhats, the artist was dunked into Rifle Creek, while a Denver skydiving group descended upon the gap with colored parachutes.

It had been done, and yet it was not to be. Twenty-eight hours later

a gale estimated to have been blowing in excess of the maximum, that is, over sixty miles per hour, necessitated the removal of the work in advance of schedule. It should have been dismantled at the beginning of September. The project provided for the obliteration of all traces of alteration, so that no harm would be done to the ecology of the region.

I have gone into the technical side of the work in detail for a good reason. A monument like *Valley Curtain* has two sides. First, there is the deep satisfaction of human achievement. This satisfaction depends on a knowledge of the labor and difficulties incurred. It is clearly seen that *Valley Curtain* glorifies man's ability to wrestle with nature. Once this has been grasped, the violent reactions to Christo's work— praise and abuse—become understandable. Second, there are the aesthetic properties of the work. The vivid orange blends with the green vegetation and brown soil, the blue sky and white clouds, into a tonal symphony; the regular repetition of vertical seams and the crescendo of the billows toward the center add rhythm; as the cloth catches the wind, it becomes transformed into a colossal sail, rigged to the ship of nature; the giant shadows thrown by the mountains on the great expanse of cloth, and by the cloth on the landscape, lie heavily on curtain and valley, molding the two into an entity; and last but not least, the changing view—hidden, framed, and suddenly revealed when the curtain is passed (Fig. 40b). All these can be enjoyed. Yet they take second place to pride in the sheer achievement of the project.

3. *Lettrism, Happenings* et Alia

If I could use words as objects, that
would be something.

—Shusaku Arakawa, 1969

The collage-assemblage method of juxta-
posing events to each other prevails in most of them.

—Allan Kaprow, c. 1960

As long as art is married to its own kind, art or architecture, whatever element is taken over from the sister art is an artistic device. When mixed marriages are celebrated, this situation changes: it becomes necessary to define the borrowed element in terms of the discipline from which it has been borrowed. This chapter will deal with two mixed marriages: the synthesis of art and literature and that of art and the theatre.

It is a matter of individual choice which discipline comes nearest to art. Literature and art share in that both address themselves to the mind as well as to the senses, both tell stories as well as delight the eye, and both draw lines to create conventional signs. But the intellectual-sensual, narrative-decorative, and graphic-significative contents of art are part of its constitution, not later additions. What art borrowed from literature in extraneous matter is twofold: the use of explanatory text, a practice that harks back to prehistory (runes) and is traceable from ancient art (Egypt), through the Middle Ages (banderoles) into the twentieth century (Picabia, Fig. 10, p. 106); and the use of words as a formal element, a practice found sporadically throughout the ages (illuminated initials in manuscripts),[62] but developed systematically starting with the newspaper collages of the Cubists and the Merz works of Schwitters, in both of which the words have a double function of sign and form. Schwitters' collages, for instance, become food still lifes, pictures of breakfast tables, according to what his labels spell.[63] The dual use of words as signs and as formal elements continues to this day (Rauschenberg, Fig. 30, p. 205).

[62] On the relationship of art and literature, see Dietrich Mahlow, *Schrift und Bild I* (Baden-Baden: Staatliche Kunsthalle, 1962); Richard Kostelanetz, *Imaged Words and Worded Imagery* (New York: Outerbridge and Dienstfrey, c. 1970). Massin, *Letter and Image* (New York: Van Nostrand Reinhold, c. 1970); *Sound Texts. Concrete Poetry. Visual Texts* (Amsterdam: Stedelijk Museum, 1971); Klaus Peter Dencker, *Text-Bilder. Visuelle Poésie international. Von der Antike bis zur Gegenwart* (Cologne: M. DuMont Schauberg, 1972).

[63] E.g., *Kynast-Fest* (1919; Smith College) is a modernized breakfast table; the references are to an egg, cocoa with sugar, chocolate, tea, tobacco, imported goods, etc.; illustrated in Werner Schmalenbach, *Kurt Schwitters* (New York: Harry N. Abrams, c. 1967), catalogue Fig. 34.

Literature, in its turn, borrowed matter extraneous to itself from art. Namely, the practice of arranging words with attention to shapes and space. The earliest examples of this marriage, known as figured verse or rhopalic (mace) verse or pyramid verse, date back to the Greek epigrammist Simias of Rhodes (fourth century B.C.), who left three such works: "Wings," "Egg," and "Ax," which form the *Crown of Meleager*. However, figured verse was considered more or less a game and looked down upon until Guillaume Apollinaire, the Cubist poet, raised it to the status of serious poetry in 1918 by using it for the collection of poems he called *Calligrammes*. In the calligram "Il Pleut" ("It Rains"), the poem is written in such a way that the letters resemble raindrops falling down to the ground, thus translating the title of the poem into a pictorial image.[64] Apollinaire's calligrams stood godfather to a host of such experiments.

In sum, the marriages of art and literature, literature and art, antedate contemporary art and contemporary literature by thousands of years. No spectacular breakthrough was effected in these fields. In art, Lettrism remained a very popular medium, dexterously revamping old ideas, dressing them in contemporary garb, as is done by Allan Kaprow in *Words*.

Words is a collectively done Environment, with spectator participation, that was shown at the Smolin Gallery, New York, in 1962, the same year Yayoi Kusama created her airmail sticker painting, now in the Whitney Museum of American Art, New York, another remarkable application of Lettrism in contemporary art.[65] Kaprow has described *Words* as follows:

> "Words" consists of two rooms within a room; one larger, brightly lit with colored blinking bulbs, the other, smaller, dark blue, illuminated by a single weak bulb. In the first room the walls are covered with words chosen by myself and friends from a variety of sources,

[64] *The Egg* is reproduced in Janis and Blesh, *Collage,* Fig. 149; "Il pleut," in Guillaume Apollinaire, *Oeuvres poétiques,* ed. Marcel Adéma and Michel Décaudin (Paris: Éditions Gallimard, 1956), p. 203.

[65] Illustrated in Aldo Pellegrini, *New Tendencies in Art* (New York: Crown Publishers, 1966), p. 294.

such as novels, comics, and newspapers, and collectively printed by hand on strips of paper and continuous cloth rollers. Sense or non-sense may be made by reading these in any direction. The visitor is then free to alter the arrangements by stapling over the initial composition new word-strips provided for this purpose, and also by realigning the cloth rollers. Three phonographs offer recorded advertisements, lectures, soliloquies and poems, which can be played, singly or together.

In the second room, hanging from strings are many colored chalks the visitor can use to draw, write, or scribble on the blue walls whatever he wishes. Streamers torn from bed sheets dangle throughout. Visitors, helping themselves to a pad and pencil nearby, may clip onto these streamers notes written to one another. On the floor there is a recording of whispers.

Consequently, while the concept of "Words" is mine, the execution is everyone's and it never remains the same.[66]

Although Kaprow brilliantly played on the whole gamut of Lettrism in his Environment, combining words as signs and words as shapes, oral and written words, juxtaposing the lowbrow use of words in advertisements to the highbrow use of words in poems, displaying banderoles and mural inscriptions, artist- and spectator-fabricated words, etc., yet all *Words* really does is to construct an Environment on the basis of the traditional exploitations of Lettrism.

Happenings, Fluxus, and Aktionen (the last a European counterpart of the first two) are also marginal to contemporary art, but for a different reason. What is a Happening? As described by Michael Kirby in his book on the subject,[67] Happenings may be called "a form of theatre in which diverse elements, including nonmatrixed performing, are organized in a compartmented structure." Leaving aside for the moment an explanation of what is meant by nonmatrixed performing and compartmented structure, I would define Happenings as *abstract theatre,* performed by amateurs who are artists. The essence of traditional theatre is its plot. The essence of a Happening

[66] *Ibid.,* p. 243.
[67] *Happenings: An Illustrated Anthology* (New York: Dutton Paperbacks, 1966), p. 21.

is a visual spectacle in motion, often accompanied by sound, sometimes also by odor. Hence Happenings are a mixture of theatre and dance, not of theatre and art. However, the idea of making the performance abstract is borrowed from art. As nonobjective art substituted abstraction for figuration, so Happenings substituted a visual spectacle for the plot. This relationship is the reason that Happenings have a place in a discussion of art.

The two traits listed by Kirby as differentiating Happenings from traditional theatre, nonmatrixed performing and compartmented structure, are rooted in the fact that Happenings are abstract theatre. Traditional theatre is built upon establishing time, place, and characters of the play; this is termed a *matrixed performance*. The plot can be followed through every scene shown; this is termed a *noncompartmented structure*. In abstract theatre based upon a visual spectacle, time, place, and characters play no role, and three or more events can be shown concomitantly without damage, as in the circus, since it does not matter if some portion of the spectacle is not seen. In a dance performance also you cannot see every single move. Other differences between Happenings and the theatre derive from the amateur status of the performers who are artists rather than actors. Because amateurs are the actors, greater scope is given to the improvisation of lines than in true plays, and because artists are the performers, the background against which the actions are deployed is richer in artworks than it would be in the theatre.

The earliest Happenings (I am using this term to stand for Happenings *et alia* because it is acclimatized in the United States) took place at Ohara Hall, Tokyo, in 1956.[68] They were staged by the Gutai (a word meaning configuration, gestalt), a group of artists formed in 1954 who met in an old warehouse in Osaka. The Happen-

[68] Jiro Yoshihara, "On the First 'Gutai-Ten,'" *Gutai* IV (1956?), unpaged. Kaprow, *Assemblage, Environments and Happenings,* (pp. 216, 218) dates the event to 1955 in the captions for the photographs; but Udo Kultermann, *Art and Life* (New York: Praeger Publishers, 1971), p. 80, dates it to 1956. *Gutai* is written in Japanese with a short English translation. Volume IV does not give the date in the translation, but from the dates of the preceding and following volumes, I assume Kultermann's date is correct.

ings were devised as four ceremonial acts to accompany the open-
ing of their first group show. Two were planned by Kazuo Shiraga
and two by Saburo Murakami, three were performed by their authors,
and one by the chairman of the exhibition, Jiro Yoshihara. As de-
scribed by Yoshihara, the ceremonial was as follows. Shiraga had
prepared a bed of wall mud, which he had obtained from a plasterer,
outside the exhibition hall. He worked it over for several days to
stiffen its consistency. On the day of the opening he was therefore
able to shape the mud. He modeled it with his body, rolling in it
clad only in shorts. His second ritual act consisted in cutting, with a
shining ax, some red-painted poles, which were spread out like
octopus arms. For the other two Happenings, Saburo Murakami had
prepared two large paper screens, nine by twelve feet and twenty-
two by thirty feet. At the opening, Murakami broke through the
thick eightfold paper of the smaller screen, tearing it with his body
in such a way that the torn paper was given the shape of jasmine
petals. The noise was terrific and it happened with such speed that
the photographers missed the actual moment of accomplishment,
recording the event the moment after. However, the crowning event
in the ceremony was Yoshihara's tearing open the larger screen,
which was painted in gold and set up to block the entrance to the
hall. His action thus created an entranceway to the exhibition—
literally opening it to the audience.

The second indoor Gutai exhibition sponsoring Happenings was
entitled "Gutai Art on the Stage" and held at Sankei Hall, Tokyo.[69]
It opened on July 17, 1957, and consisted of twelve "works." Like
the first Happenings, they anticipated the much-heralded and much-
decried things that happened in the United States and Europe later:
destruction of objects; play with light; creation of works by means of
throwing projectiles; noise-producing actions taking place with-
out accompanying noise; voices and noise sounding from an empty
stage; materials disintegrating at the moment of use, such as smoke;
etc. Presumably arranged in between these two indoor exhibitions,

[69] Jiro Yoshihara, " 'Gutai' Art on the Stage and the Third Exhibition in
Sankei Hall, Tokyo, July 17," *Gutai*, VII (July 15, 1957), unpaged.

the "Second Outdoor Exhibition of 'Gutai' Art Group," held in a pine grove in Ashiya City near Kobe in the summer of 1956, also performed Happenings.[70]

Independently of the Gutai, Kaprow planned his first Happening in 1957 for John Cage's composition class at the New School for Social Research, New York; Cage had described to his students an event he had organized at Black Mountain College in 1952, a combination of several branches of art and other disciplines. The first Kaprow Happening was staged the year after, in 1958, at Douglass College, New Brunswick, New Jersey, and the word *Happening* was coined a year later. [71] Also in 1959, Wolf Vostell organized his first Happening-type Action, *Fernseh-dé-collage* (Television-Ungluing/ Beheading) in his atelier at Cologne—and hence Happenings exploded into worldwide prominence.

Happenings have a great power of expanding in different directions. They merge with exhibitions in the Gutai Theatre Art. They verge on Environments in Kaprow, who staged his early Happenings in Environments and even maintains that the two art forms "are the passive and active sides of a single coin." [72] They coincide with pantomime in Beuys (Fig. 52, pp. 358, 359). And they fuse with the spectacle in Cage's pre-Happening.

The reasons for creating Happenings are as diversified as their elements, but what Kaprow, a brilliant mind and an artist vocal as a writer, has given as his seems relevant. In 1959, he wrote:

He [the artist] knows for certain that he is among the remaining few in a world of tired, sour souls, who is brave enough to dream away his time. . . . I have always dreamed of a new art, a really new art. I am moved to roaring laughter by talk of consolidating forces, of learning from the past; by yearnings for the great tradition, the end of upheavals and the era of peace and seriousness. Such an essen-

[70] *Idem,* "On the Second Outdoor Exhibition of 'Gutai' Art Group," *Gutai,* V (October 1956), unpaged.
[71] Allan Kaprow, "The Demiurge," *The Anthologist,* XXX, No. 4 (Winter, 1959), unpaged; *idem, Assemblage, Environments and Happenings,* p. 212.
[72] *Idem, Assemblage, Environments and Happenings,* p. 184.

tially fear-ridden view cannot know what a positive joy revolting is. It has never realized that revolutions of the spirit are the spirit's very utterance of existence. Caution against indulging the new for its own sake can be flung aside. The truly new is hard to find and when one has it, it is very real indeed.[73]

This statement is not so simple to interpret as it looks, to wit, the double sense given to the word *dreaming* as (*a*) retreating from reality and (*b*) desiring. It seems as though Happenings are, to Kaprow, an escape hatch into the world of fantasy that obliterates the present. To withdraw into such a world carries its own reward in enabling him to create a new art form. Kaprow's revolt is a retreat from life into art, not an attempt to come to terms with life. Why should escape into aestheticism be better than escape into archaeological time? Both are dictated by the desire to escape from the present, indicative of a lack of the courage to face life.

4. *Design in Movement*

Such artists design with "movement itself."

—George Rickey, 1965

It would be difficult to name an artist or a book on modern art that does not make free with the words *space, time,* and *motion;* the word *light* is less frequently introduced into the discussion, but it is also found regularly. Yet only in contemporary art have these components reached new dimensions, equaling those discovered in premodern times. For space, these novel artistic ways have been analyzed in Fontana and Stella, and for light, in Flavin (Figs., 29, 15, 37, pp. 201, 129, 238). Now the revolution in the use of motion will be presented, and, linked to motion, a new experience in time.

Motion makes an object more noticeable. Barbers have capitalized

[73] *Idem,* "The Demiurge," unpaged.

upon this fact in the advertisements for their shops by using spiral bands of color on revolving columns. That was long before motion became a building block in contemporary art, and it combined virtual motion and actual motion. When speaking of movement in art, one must distinguish between these two. Simulated motion goes back to the paintings in prehistoric caves, but real motion, antedating the twentieth century, can be found only in automatons or clocks, that is, with a mechanistic and not an aesthetic function.

Movement has been simulated in art either representationally, through the flying gallop and through fluttering drapery, or formally, through obliques and through asymmetry. A combination of representational and formal means was used by Rodin in portraying several successive moments of motion used together. Duchamp and Futurist artists, on the other hand, showed the successive motions cinematically and failed to have them merge into one image.[74] Contemporary art is not concerned with the simulation of motion, but with the *experience* of motion, which can be of two kinds: an optical illusion or a perceptual reality. The solutions for the first, virtual movement, are offered by Optical art; the solutions for the second, actual movement, by Kinetic art. Optical art marries art and film; the viewer sees motion where none exists. Kinetic art marries art and dance; the viewer sees physical displacements in space that actually take place.

A. OPTICAL ART

> It undergoes a transformation, a meta-morphosis.

> —Jesús-Rafaël Soto

Is it the charisma of science that created an urge in both the artist and his public for a science-oriented experience in art? Or is it the charisma of change that led modern man to favor solutions link-

[74] Carla Gottlieb, "Movement in Painting," *Journal of Aesthetics and Art Criticism,* XVII (September 1958), pp. 22–33.

ing this ideology to art? Both viewpoints have been put forward. But, if the cause of the phenomenon remains undecided, its presence is undisputed: the drama of motion/change is the passionate love affair of contemporary art.

The scientific solution for generating virtual motion in art is the use of unstable patterns: *periodic structures*, that is, a repetition of anonymous elements such as lines, squares, circles, etc. (Figs. 42, 43, pp. 266, 271); *moiré effects* produced by doubling a pattern in near alignment (such as can be found in ordinary window screens); *after-images* or *simultaneous contrast,* that is, the aftereffects of certain stimulations that interact with the stimulation to form a new pattern (a phenomenon known from Impressionist art in its virtual form, and simulated in Louis and Poons (Figs. 17, 16, pp. 143, 131); *optical color mixture* (as in Richard Anuszkiewicz, Fig. 15, p. 129 left of Stella); and their likes. The mode of appearance of unstable patterns was described by Jack Burnham as follows: "The *textural gradient* or consistency of the field alters itself automatically. This brings about changes in configuration, orientation, shadow and light, color, and, most subtly, in texture." [75] A year before, Bridget Riley had dealt with the aesthetic function of this visual phenomenon. "I want a fluctuating surface—an active space . . . now, sometimes, I can bring this about by two-dimensional interactions, but sometimes it operates like the action of a whip that you can crack." The space takes on the character of "electrically charged fields" loaded by the graphic lines that function like wires to carry "energies." [76]

Line and color as instruments to express motion are not new in art. But to express is not the same as to see. The outstretched arm of a figure may direct the eye, a red or a blue garment may establish a specific level in depth, a network of lines or tangle of colors may spell turmoil; but in our encounter with these images, the only actual motion would be that of our eyes, which follow the arm, adjust to regression and advance, travel around on the graphic network, or

[75] *Beyond Modern Sculpture* (New York: George Braziller, 1968), p. 258.
[76] Maurice de Sansmarez, "Bridget Riley: A Conversation," *Art International,* IX, No. 4 (April 1967), pp. 40, 37.

jump with the color waves. The image is motionless. In contemporary art the image moves. The difference can be seen in comparing Josef Albers' Homages with Riley's *Arrest III* (Figs. 41, 42, pp. 265, 266).

In Albers' Homages each color shape lies in its own plane, but the smaller ones can be seen in front of, or behind, the larger ones. Although each shape seems to occupy not much more space in depth than a sheet of paper, it detaches itself readily from the one beyond. It seems easier to see the shapes in front of their neighbors so that the screened portions are completed by the viewer as squares. It needs more effort to see the innermost square behind its neighbor, which then becomes a frame transmitting this metamorphosis to the next color shape. But the square and frames transform into ambiance, not into holes. That is my experience of Albers' Homages. But it may not be that of every viewer. I have a very strong constancy factor and encounter difficulties in seeing railroad tracks converge.

Albers' lithograph *White Line Square XIII* (1966; Fig. 41) uses three shades of blue, graded from light to dark toward the center. The largest square has the most saturated color, the middle square looks grayed, and the smallest square is a very heavy green-blue. But, although there are only three blue colors, there are four square shapes. This wizardry is achieved by the insertion of a white line that subdivides the intermediate color square into two shapes. This type of color construction facilitates the recession of the inner-most square. Another lithograph of the same series, *White Line Square VIII* (1966), is executed in grays and again graded from lighter periphery to darker center. Here the white line divides the innermost square, however, and the color construction of this version hinders recession.[77]

Since color in art had always had a labile construction, what is new in Albers? The fact that the optical effects are all that count in his image. In traditional works optical effects were incidental; in contemporary works they are the framework within which these

[77] Eugen Gomringer, *Josef Albers: His Work as Contribution to Visual Articulation in the Twentieth Century* (New York: George Wittenborn, c. 1968), Pl. 152.

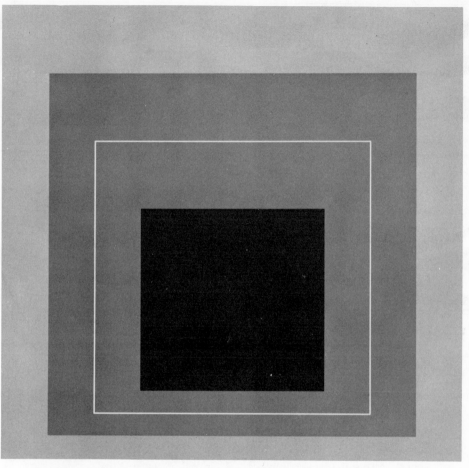

41. Josef Albers: *White Line Square XIII*. 1966. Lithograph. 21″ x 21″.
Photograph: Gemini G.E.L., Los Angeles, California.

works function artistically, forming, so to say, their theme. Thus
Albers' Homages belong to Op art, but not to movement in art.
There is no fluctuation of the surface, which effect has been stipu-
lated by Bridget Riley as her desideratum. Albers' shapes occupy
a position, then stay in that position until the viewer intervenes and,
by fixating them, makes them jump into a new position, in which they
again remain stable until he again interferes.

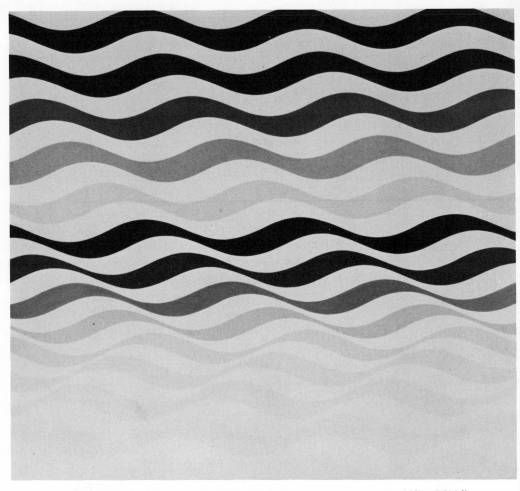

42. Bridget Riley: *Arrest III*. 1965. Emulsion on canvas. 69″ x 75½″.
Photograph: Rowan Gallery, London.

In Bridget Riley's *Arrest III* (1965; Fig. 42) the whole surface
seems to move in ripples: the canvas has become the surface of the
sea. An almost irresistible impulse to stretch out your hand and
verify by touch the ambiguous message delivered by your vision is
generated. It takes a good deal of self-control to defy this urge. The
elements that create this optical illusion look quite simple. Wavy

bands of black, off-black, dark gray, gray, light gray, very light gray, etc., traverse the field horizontally. They are graded from dark to light, and again from dark to light, starting at the top, one zone comprising five bands, the other nine. The widths of the bands are, however, unequal. They expand and contract, with the constrictions more violent near the horizontal axis of the field, where they create deeper valleys between the crests of the waves. Nor is the swell uniformly oriented. Five crests and valleys in the lower portion run from lower left to upper right, and the nine above them run from lower right to upper left.

However, the illusionistic image of ocean waves is immediately canceled by an arrangement that blurs the region nearer to us and sharpens the portion farther away, contradicting the laws of optics, and by the lack of coherence between the structure of color (nine graded bands below, five above) and the structure of shape (five oblique crests below, nine above). A light that devours the image at our feet and weakens it in the middle distance, while permitting it to regain body next to this weakening and on the horizon, is not meant to be an illusion of reality.

This deliberate flaunting of illusionism within the framework of an illusionistic structure is the hallmark of Riley's painting. The laws of optics are easily learned and as easily applied. This facility has seduced all kinds of commercial enterprises to try their hands at them—once they had been discovered for these imitators by the artists. But the results of such use are not necessarily art or even handicraft. The other day a "Poons" was flaunted by an innocent victim of the manufacturers in midtown Manhattan. It took the form of a white summer coat on which tiny colored oval shapes were strewn around. Another example of such non-art is the pavement in front of the Time and Life Building on the Avenue of the Americas. To avoid any possible disagreement, I shall discuss only the functional qualities of this pavement, leaving aesthetic considerations aside. The pavement is not arranged in the conventional monochrome manner. Broad undulating bands, alternately dark and light, cross the sidewalk between the curb and the façade, distending and shrinking. As a result, the

pavement seems to heave. It so happens that the steps of the Propylaia at Athens, the entrance gates to the city, also were not monochrome. The uppermost were in black Eleusinian stone, the others in white Parian marble. Scholars have interpreted this arrangement as a safety measure (in addition to being decorative). The black color caught the eye of the visitor as he moved from the shadows of the sanctuary into the blinding sunlight, and the presence of a step is noticed. It guided him in adjusting to the difference in levels.[78] The undulations of the pavement in front of the Time and Life Building also catch the eye, but they misguide the passerby. He is deluded into thinking that the pavement is uneven, and thus adjusts his tread falsely.

Obviously the scheme of the Time and Life pavement is based on the use of optical laws, borrowed from science, that are left uncontrolled by the laws of art. Riley's road takes the opposite direction. She employs optical laws borrowed from art that are left uncontrolled by the laws of science. The geometric structure and serialization in her work show such acumen that critics have been misled into thinking that her art derives from a study of science. But the artist categorically denies this interpretation. She insists that she has never studied optics, that her use of mathematics is rudimentary, and that she is guided entirely by empirical analyses and syntheses, by experimentation and intuition. She starts with a hunch in selecting the unit she wishes to use. Next, she studies this unit in drawings on paper: how much deformation it will bear, and what kind of deformation is necessary to bring it to the pitch of intensity that she desires. She calls this research "pacing" the unit. Then, the various possibilities to which the use of the deformed unit lends itself are studied and a choice among them is made. Finally, the scale in which the specific structure will operate visually in the most effective manner is chosen. In its apparent motion, each painting expresses a particular state of

[78] Lucy T. Shoe, "Dark Stone in Greek Architecture," *Commemorative Studies in Honor of Theodore Leslie Shear, Hesperia Supplement,* VIII (1949), pp. 343–347.

mind.[79] Op art can operate without science, but not with science alone.

Moreover, although modern science has permitted the artist to transform entities in many different ways, to wit the laser, the effects obtained by artists without technological razzle-dazzle are as interesting, and perhaps more so. Jesús-Rafaël Soto's dematerialization of matter is an excellent example of such an artistic achievement. Dissolving into scintillations of light, his works translate matter into energy (Fig. 43, p. 271). "I wanted to incorporate the *process of transformation* in the work itself. Thus, as you watch, the pure *line* is transformed by optical illusion into pure *vibration*, the *material* into *energy*," Soto explained in 1965.[80]

The dematerialization of matter is, like the liberation from gravity, a concept much courted by artists of all centuries. However, under the word *dematerialization* a number of meanings can hide. It can stand for spiritualization of a figure, obliteration of a shape, liberation from gravity, and transformation of one substance into a different substance. The use of the first two meanings can be traced back to traditional art. Spiritualization of figures is employed to indicate a superhuman status; it appears, for instance, in the portrayal of the wide-open eyes of Sumerian figures (c. 3000–2340 B.C.) that look beyond the phenomenal world.[81] Obliteration of shape can be found in the attempt to represent motion; it appears in the blurring of the wheel's spokes in Diego Velázquez's *Spinners*. These two types of dematerialization were carried to an ultimate solution in contemporary art—with Yves Klein who spiritualized his image into nonvisibility, and with the work composed of standardized units that, by filling a field evenly with multiples of one single shape, obliterates the shapes of the units (Fig. 25, p. 181), a fact noted by Soto in 1965: "By means of the endless repetition of the

[79] Sansmarez, "Bridget Riley: A Conversation," pp. 37–41.

[80] Guy Brett, "Dialogue: J.-R.Soto and Guy Brett," *Signals*, I, No. 10 (November–December 1965), p. 13.

[81] Henri Frankfort, *The Art and Architecture of the Ancient Orient*, (Baltimore, Md.: Penguin Books, 1954), Pls. 13–17.

square, the square itself disappears and produces pure "movement." [82] Liberation from gravity and transformation of substance, on the other hand, are additions to man's visual experiences made, respectively, by modern art and by contemporary art. Both are connected with advances in technology, and the second presupposes some knowledge of scientific data. The liberation from gravity, in its nineteenth- and twentieth-century aspects, has been discussed above. There remains the study of the transformation of substance.

Soto generates the optical illusion of decomposing matter by interference patterns. One of these is the moiré effect, of whose application to art he is the discoverer. The meaning of moiré is known from its use in the garment industry. Technically, a moiré or watery effect is obtained by superimposing a periodic structure of solid and open regions upon another such structure. This fact explains how Soto could discover moiré by way of Cubism: he interpreted the Cubist juxtaposition of profile and full faces as a superimposition of two views. When he saw Duchamp's *Rotatory Demi-Sphere* in 1955, the superimposition started to move and Soto as an Op artist was born. His first successful moiré effect, *Vibrations' Structure* (1955), was obtained by superimposing a white serigraph of spirals on Plexiglas upon a black serigraph of spirals on white wood at a distance of five inches. This work is now in Museum Haus Lange at Krefeld, Germany.[83] Following Mondrian's example, Soto substituted squares and verticals for spirals and curves in later works. He liked Mondrian because "one must work for the greatest simplicity, restraint." His ambition was "to make the work of Mondrian move." [84] He wanted motion because he felt that an artist whose work does not reflect his own time is a plagiarist. Motion was for him the essence of his time.

Straight lines, in particular verticals, are favored in Soto's art.

[82] Brett, "Dialogue: J.-R.Soto and Guy Brett," p. 13.
[83] Paul Wember, *Bewegte Bereiche der Kunst* (Krefeld: Scherpe Verlag, 1963), p. 46, illustrated on p. 47.
[84] Jean Clay, "Soto," *Signals*, I, No. 10 (November–December 1965), p. 9; Brett, "Dialogue: J.-R. Soto and Guy Brett," p. 13.

First he suspended them from wires in front of a striped background. If the observer moves ever so slightly, the verticals transform into vibrations of lines in a moiré effect. A luminous scintillating curtain is created from anonymous, impersonal elements of composition. An unplastic image, made from plastic elements, rises before our eyes. In later works Soto dispensed with the background and left only the verticals. He composed vibrating walls of these, which he called *Extensions* if they were isocephalous, and *Progressions* if they were graded in height. He assembled them into Environments, which he called *Penetrables*. It is the latter that epitomize his achievement in dematerializing matter.[85]

[85] Philippe Comte, "Soto dans le labyrinthe," *Opus International,* XII (June 1969), pp. 27–28; Jean Clay, "Soto's Penetrables," *Studio International,* CLXXVIII, No. 914 (September 1969), pp. 75–77; *Soto* (Bogotá: Museo de Arte Moderna, 1972), unpaged.

43. Jesús-Rafaël Soto: *Penetrable.* 1969. Plastic tubing. Installation outside Musée Municipal d'Art Moderne de la Ville de Paris. Photograph: Guy Brett, London.

The fully developed Penetrables appeared in connection with Soto's retrospectives at Amsterdam, Brussels, and Paris, in 1969. Figure 43 is the version shown at the Musée Municipal d'Art Moderne de la Ville de Paris in June, where it was set up in the space between this museum and the Musée National d'Art Moderne. Sixty miles of plastic tubing, about twice the height of a human being, were hung from a framework, forming a dense growth that filled the air with milky, stiffly vertical lianas. When the wind stirred them slightly, and when the visitors pushed them aside more brusquely, optical currents were created, metamorphosing the lianas into a solidified rain of milk. The visitors were caught up within the shower. As Soto has pointed out, the new experience in his Penetrables is that you are inside the work of art (a desideratum going back to the Futurists, and posed also by Pollock, Andre, and others):

> Even in the middle of a cyclorama, whether it be kinetic or static, we are always in front of the work. We remain observers. My Penetrables are very different. Composed of metal rods or nylon threads suspended from the ceiling, like a rain of metal, they invade the whole space. They permit no disengagement. We are no longer in front of, we are within.[86]

Not only the work itself trembles and decomposes into glittering shredded lines, but the spectator himself is dematerialized into a shimmering phenomenon of light: whether he is within the work looking at those without, or without looking at those within, he turns into a seductive glimmer for the others. Man and matter lose their weight; transformed into a spectacle of trembling, colored lines and shapes, they perpetually elude our efforts to see them as objects. With parallel vertical lines—the simplest possible elements—Soto creates a spectacle of breathtaking beauty. Note, however, how very different Soto's venture into Environmentalism is

[86] Jean Clay, "Soto itinéraire 1950–1968," *Soto* (Amsterdam: Stedelijk Museum, 1969), unpaged. Since writing the above in 1970, a Penetrable could be seen in Soto's retrospective at the Guggenheim Museum, New York (1974), installed in the center of the ground floor hall; *Soto* (New York: The Solomon R. Guggenheim Foundation, 1974), p. 125, No. 82.

from the American version. Instead of shaping space, his Penetrables are invaded by it.

Soto's works are often in black and white; chromatic hues, if present, tend to be darkened. Color as color is thus played down. But that may change in the future. In the last years, more color is used in his works, particularly for the background panels. The reason Soto gave for his initial abstention is that he wished to be more rigorous.[87] In a color-oriented country, like ours, this aspect of his art diminishes its value—quite arbitrarily, it should be noted. Moreover, there is a lyrical quality in his work, again out of step with American taste. Lyricism is more in harmony with the smiling French countryside, than with either the violent nature of Soto's native town of Ciudad Bolivar, Venezuela, or the grandeur and extremes experienced in North America. Even the purpose of his art integrates Soto into French art, often accused by its detractors of being "merely decorative." "I try to make something that will spare other people anguish" is Soto's explanation of his aim.[88] Soto's statement brings to mind Matisse's statement. Soto merely updated it to the 1960s by introducing the word *anguish*.

Instability can be rooted in shape (Vasarely, Fig. 27, p. 188), line (Riley, Soto, Figs. 42, 43, pp. 266, 271), and color (Olitski, Fig. 18, p. 145). Change can be low-keyed or intense (cf. the above). Motion can be slow or rapid, sluggish or violent, smooth or jerky; Riley's lines ripple, Soto's fluctuate. To round off the picture of motion through unstable pattern in Op art, an example of fluctuation produced by color will be given. Actually it is the *reflection* of color, that is, a light effect, that destabilizes the image.

The Argentinian artist, living in Paris, Luis R. Tomasello fills his white, square panels with regularly spaced cubes at measured intervals, which are attached to the background at different angles, like Camargo's cylinders (see Fig. 26, p. 184). These cubes are painted white on their external faces, visible to the spectator, whereas their internal faces, hidden from his view, are painted

[87] Brett, "Dialogue: J.-R. Soto and Guy Brett," p. 13.
[88] Clay, "Soto," p. 9.

a variety of colors. The colors are mirrored by the white background, where they mingle with the light reflections and cast shadows of the cubes into a coat of delicate chromatic shimmer that hovers in front of the field, enveloping the cubes and tinting the space. The coloristic effect is almost imperceptible at first glance, but as the eye adjusts to the low level of intensity, the color strengthens. Then it fluctuates: the tints that have emerged first are submerged by other tints that, in their turn, are devoured by yet another set. The chromatic waves arise because colors reach us optically at different rates of speed, since one's retina is not equally sensitive to every hue: blues appear fast, greens are slow in their motion.[89]

In addition to unstable patterns, virtual motion can be generated by composing an image in such a way that a change in its appearance occurs every time it is viewed from a different standpoint or with a different point as focus. This type of virtual motion is known from two examples in traditional painting: first, the motion of the eyes that follows the spectator in some Renaissance pictures; and, second, the change from obtuse to acute angles, and vice versa, in geometric patterns, occurring when certain lines are fixated by the viewer.[90] However, none of the authors of such pictures thought that "the composition of each painting can be modified infinitely." The artist who wrote these lines and who set out "producing a foreseeable infinity of plastic situations flowing out of one another, whose successive apparitions and disappearance provide ever-renewed revelations," has been ecountered before as an innovator: the statements were made by Agam.[91] He is the discoverer of two types of what may be termed *metamorphical pictures:* one, the *transformable paintings,* in which the spectator's hand changes the structure of the image, are not motion art; they have been studied above in connection with active spectator participation. The other, Agam's preferred

[89] Cyril Barrett, S.J., *Op Art* (New York: The Viking Press, 1970), p. 153.

[90] For example, Albers, *The Impossibles* (1931) and *Structural Constellations* (1954/55), illustrated in Gomringer, *Josef Albers,* Figs. 45, 125–135.

[91] *Yaacov Agam,* ed. Marcel Joray (Neuchâtel: Éditions du Griffon, 1962), pp. 9, 5.

experiment in metamorphical painting, is to compose works whose patterns change through the motion of the viewer. According to the nature of their images, he distinguishes two types: *contrapuntal paintings* were introduced to the world of art in 1953, and *polygonal paintings* in 1955. Both kinds of "musical" compositions are formed of a field covered with colored shapes to which have been attached upright prismatic bars or other screening units, painted in patches of color on their left and right sides. As the viewer walks in front of this parti-colored, corrugated surface, the kaleidoscope arranges itself into a succession of organic compositions. Formal unity is assured in each newly formed picture, because only such configurations will result as have been foreseen by the artist who has studied the relations of colors to forms separately in each possible combination.

Agam's method of producing unstable patterns, by using projecting units colored in different ways on different sides, and attached to a surface, had been anticipated in El Lissitzky's *Abstract Gallery* (Fig. 36, pp. 230, 231), which also tried to capture the viewer's attention by such optical dynamics. But the experience of virtual motion in Lissitzky's strips was confined to neutral color and reflection. Agam added shape and polychromy, enriching the variety of effects considerably.

A second way in which Agam divides his metamorphical paintings is based on the visual experience of the spectator. The artist again sees two types: *polymorphic works* permit the isolation of several clearly defined images; *metapolymorphic works* have too many images to isolate any particular one, each image fusing with the next.

Once upon a Time (1972) is a graphic polymorph comprising ninety-nine different colors. Yet, when viewed from the extreme right along the width of the panel, only black and white are seen, patterned into an orderly assemblage of eighteen different rectangular motifs that are set at regular intervals in three tiers of six. However, as the spectator starts to move in front of the work, color emerges, penetrating the structure of the motifs and the ground; it spreads

warmth over the image. Moving on to stand directly in front of the work, the observer sees the motifs disappear within a dynamic melee of color dots without rhyme or reason. Continuing to move toward the left, he now sees brightness infuse itself into the image. Finally, when he reaches the extreme left and looks across the width of the work from there, the confusion has resolved itself into a luminous spectral field traversed in orderly fashion by seventeen colored bands that alternate with sixteen monochrome black ones. Thus there is a movement from order to confusion and back to order, a progression from achromatism to color and to color inundated by light. Agam's *Once upon a Time* must be read from right to left; only so can the birth, growth, and flowering of color be experienced.[92]

The reason for selecting a metamorphical mode of composition has been given by Agam as follows: "My intention has been to introduce into the work a life of its own, so that the work should acquire an autonomous existence, parallel to that of the viewer."[93]

Agam's metamorphical painting has found fewer disciples than other Op methods. But among them is the Venezuelan Carlos Cruz-Diaz. His Physichromies, started in 1959,[94] use relief strips with a rectangular cross section, fuse their patterns, and their hues appear as film colors, that is, they resist spatial localization. His method —painted relief strips—places him with Agam; his effects—spatially undefined patterns—with Soto.

B. KINETIC ART

Everything came to life most emphatically via motion.
—Len Lye

[92] Whether or not there is a connection between this direction and Agam's training to read and write Hebrew from right to left, I cannot say.
[93] *Yaacov Agam,* p. 5.
[94] On Cruz-Diaz, see "Cruz-Diaz," *Signals,* I, No. 9 (September–October 1965); Frank Popper, *Origins and Development of Kinetic Art* (Greenwich, Conn.: New York Graphic Society, 1968), pp. 113–114; Barrett, *Op Art,* pp. 76, 93, 162–163.

Kinetic art faces problems from which Op art is safe. Breakdown and resupply of parts are two major issues in it, hampering the sale of kinetic objects. As phrased by Jack Burnham, who has noted these difficulties: "Purchasers bring back broken machines expecting the artist to fulfill a lifetime guarantee. While post-sale services and stocked parts remain an indispensable aspect of the commercial appliance business, neither artists nor customers have adapted themselves to the realities of machines as art." Burnham prefaced his remarks with the assumption that "when numbers of artists move into an area where tremendous technical and aesthetic difficulties remain, it indicates that a sense of manifest destiny may, in the long run, be more important to art than technical limitations." [95]

The art historian encounters his own obstacles in his dealings with Kinetic art, which will become obvious as soon as the preliminaries are out of the way: the definition of what Kinetic art is and the story of its forerunners.

Kinetic art is set in motion by a motor: wind, human hand, electricity, magnetic field, electronic device, etc. Here again a distinction must be drawn between whether "movement is a dominant theme" or an "incidental quality" in the work of art, as noted by the sculptor George Rickey.[96] He uses this aspect of the work to distinguish between the works of Gabo, Moholy, Duchamp, Man Ray, and Calder, and the development of Kineticism after 1945. To "design with movement itself" means that the work of art is built upon movement, that movement "becomes, for the artist, what a color or a shape is to the painter," [97] yet another element of composition. For the gamut of motions corresponds to the scale of colors and the range of shapes that the artist can use creatively in the same manifold manners that he employs for the other compositional elements. Objects can pitch, rock, roll, yaw, sheer, vibrate; move

[95] *Beyond Modern Sculpture,* pp. 262–263.
[96] "Origins of Kinetic Art," *Studio International,* CLXXIII, No. 886 (February 1967), p. 65.
[97] *Idem,* "The Morphology of Movement: A Study of Kinetic Art," *The Nature and Art of Motion,* ed. Gyorgy Kepes (New York: George Braziller, c. 1965), p. 106.

forward, backward, up, down, sideways (Figs. 23, 44–47, 50, pp. 169, 280, 285, 296, 298, 300, 325). There are piston, pendulum, and rocket motions. By playing off one type of motion against another, one velocity against another, periodic against accelerated-decelerated motions, regular against sporadic, continuous against interrupted rhythmic sequences, and so on, movement is "composed" into a formal entity, and thus into a work of art. Before studying such works, let me cite an example in which motion is an incidental quality: Agam's *Moods* with their regular deceleration of rocking (Fig. 23, p. 169).

Obviously, a work of art based on motion cannot be reproduced in a static photograph, not even in a series of them. A discussion of design in movement must, therefore, fall back on descriptive comparisons and diagrams. When Moholy worked on his *Light-Space Modulator* (1922–30), now in the Busch-Reisinger Museum at Harvard, he described the construction of the apparatus in terms of motion and also diagrammed it. One of the diagrams is reproduced in Figure 46a, page 296. Three types of movements were performed by the machine, corresponding to the sectors into which it was divided by three walls made of transparent zellon and vertical metal poles. The first sector used three rods, to which various materials were attached like flags, to create an irregular, wavy motion. The second sector used a solid, immovable, metal disk, in front of which a second, perforated, metal disk moved up and down; this piston motion, in turn, released a little ball on the top that flashed across the spatial cell from right to left and back. The third sector had a revolving glass spiral whose motion described a virtual cone.[98]

Moholy's machine isolates for us the three main types of motions: irregular, geometric-linear, and rolling-curvaceous. The kind of

[98] László Moholy-Nagy, "Lichtrequisit einer elektrischen Bühne," *Die Form: Zeitschrift für gestaltende Arbeit*, V, Nos. 11/12 (June 7, 1930), pp. 297–298; the article contains another diagram of the work's motion. See also Hannah Weitermeier, *Licht-Visionen: Ein Experiment von Moholy-Nagy* (Berlin: Bauhaus-Archiv, 1972), pp. 5–6; I owe the reference to this book to Dr. Peter Hahn of the Bauhaus-Archiv, Berlin, whose help is herewith gratefully acknowledged.

motion used in a work of art establishes what may be called its mood. By using three types of motions Moholy's machine expresses three different moods in alternation. It should, however, be noted that, for Moholy, the motion of his *Light-Space Modulator* was inseparable from light effects, and as a "light display machine," "light prop," it belongs to photokinetic art (for which see below, sec. 6).

Singly, the three forms of movement can be studied in Len Lye, George Rickey, and Julio Le Parc, who are all Kinetic artists.[99] Len Lye's design in motion is irregular, built upon pyrotechnics and violence. Movement is fast and spasmodic: it irrupts, follows an erratic course, and dies suddenly. The human eye cannot follow the development or predict the course, and registers only a frenzy or explosion. Elementary forces seem to be captured which, unlike machines, cannot be controlled, and, hence also cannot be organized. George Rickey's design in motion, on the other hand, has a linear quality, comparable to a geometric ballet. A group, or groups, of elements execute individual movements that the human eye can follow in their flow from one position to the other, and which the human mind can predict. As for the rolling-curvaceous form of motion, it is used by Le Parc, for instance, in his *Double Form in Contortion* (1968; Fig. 44) in the Sonja Henie-Niels Onstad Foundations, Høvikodden, Norway. In it, two metal bands are displayed vertically in an upright box, touching one another at both ends and at five points where they are held together by metal ribbons, while, in between the joints, the bodies of the bands form large loops. The ribbons are connected to axles, and when an electric motor causes the axles to rotate, the bands start to move up and down in a wavy fashion, advancing to swell their convex curves and collapsing to hollow the concave ones. The gliding movement of a serpent or, if you wish, the gyrations of a belly dancer imitating a serpent, is captured.

[99] Len Lye's work is reproduced in Calas, *Icons and Images of the Sixties,* pp. 285, 287; examples of George Rickey's work can be found in *George Rickey: Sixteen Years of Kinetic Sculpture* (Washington, D.C.: The Corcoran Gallery of Art, 1966) and in the catalogues of the Staempfli Gallery, New York; for Julio Le Parc, see *Julio Le Parc: Recherches: 1959–1971* (Düsseldorf: Städtische Kunsthalle, 1972).

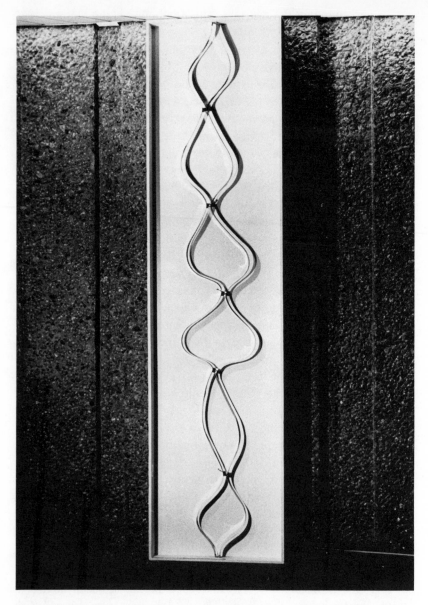

44. Julio Le Parc: *Double Form in Contortion*. 1968. Steel bands on wood and electric motor. 121⅛″ x 27½″ x 8″. Sonja Henie and Niels Onstad Samlingen, Høvikodden, Norway.

This design in motion can be followed and is predictable like Rickey's ballet, but it contrasts with the geometric side of his work. To inorganic motion, it opposes organic motion; to the pendulum and piston, it opposes the undulations of the body.

The three designs discussed all take place without displacement of the object. Other Kinetic works base their design on this aspect of motion. Robert Breer's objects in synthetic materials, for instance, move slowly over the floor, reversing direction when an obstacle is encountered, a device also used in children's toys. Like these, the Breer objects are self-propelling, driven by a hidden motor.[100] For Haacke's wind-driven objects promenading through space, see section 6, Figure 49, pages 310, 311.

Like non-Kinetic art, the materials used and the shapes that are combined offer further individualization to Kinetic works. Rickey, Lye, and Le Parc all work in metal: Rickey employs groups of serial units, Lye individualizes his pieces by combining sheets with springs and wire, whereas Le Parc uses standardized units whose motion is reflected as a play of light and shadow on the background by the addition of artificial sources of light. (This is a different type of work from the one illustrated in Fig. 44.) [101]

Another way to vary Kinetic art is the artist's approach to the machine; it gives content to the work. Rickey's and Le Parc's works are a tribute to the machine. Tinguely's works, however, appear to ridicule it. They show the machine's "human" side by exposing the vulnerability of its motor: the motor breaks down, squeaks, and behaves erratically—it seems more like a maniac than a mechanical object. Combined with this crazy, temperamental behavior, Tinguely's machines also perform like automatons, mechanically repeating the same motions, albeit protestingly. Thus Tinguely robs the machine of its terror for man. In his words, he exposes its "poetry," which

[100] Breer's work is illustrated in Calas, *Icons and Images of the Sixties*, p. 296; Burnham, *Beyond Modern Sculpture*, Fig. 129.
[101] *Julio Le Parc* (1972), Fig. 34.

aspect he substitutes for that of efficiency. The demented machine turns into a comedian (see Fig. 50, p. 325).

With so many ways in which elements can be selected and composed, design in movement has good potentialities. So far, however, these have been realized only fractionally: few Kinetic works can stand up as major art. One of the handicaps that stands in the way of this is the unmasked presence of the mechanics of motion. The motor, like the support, has to be integrated into the work and the programming veiled, before that work can be accepted as a fully satisfactory object aesthetically. Tinguely's machines have solved this problem.

All those modern and contemporary artists who proudly announce that they make use of time in their art do not seem to know that this is in no way revolutionary. Time sequences are also used in traditional art: the Dacian Wars of Trajan, the Roman emperor, are depicted on his column in Rome, and the life of Christ is represented in the Arena Chapel, Padua. Moreover, no work of art can be experienced outside time: a spectator looks at it, and a moment of time is involved in this action. A contemporary spectacle that presents a cycle of images merely needs a longer period of time in order to be seen, but this is true also of sculpture as compared to painting, or of architecture as compared to sculpture and painting. *Duration* would then be a better word to distinguish this experience from the momentary look at a painting. What actually differentiates the contemporary work from the traditional work is the *change* in the image—the aspect of spectacle, transformation, or metamorphosis—and time is a necessary but subservient element in these.

Contrariwise, new ground is broken in experiencing time in art through its dilation in Pol Bury's work. Bury's balls and other units do not move in accordance with the laws of gravity—another case when these laws are flaunted. As a result, a tension is created between the expected rate of motion and the one actually seen, the latter drawing time out of its natural proportions. Bury described the

experience in "Time Dilates" in 1964: "Between the immobile and mobility, a certain quality of slowness reveals to us a field of 'actions' in which the eye is no longer able to trace an object's journeys."[102]

Bury's slow motion falls into two categories. In the early works, done in the first half of the sixties, he focused on making balls climb up steep inclines. These works consist of dark wooden stands, each tier housing dark wooden balls in many sizes. The tiers are open except at their rears and, although the floors slope down, the ceilings slant up, both at various degrees. Wedge-shaped divisions are formed, alternating with wedges cut in half. The image of gaping mouths swallowing balls is created. This image assumes significance when the work is set in motion by its electric motor. In these early pieces the motion is programmed as a regular rolling down the inclined surfaces and, reversing direction, climbing back up. The balls are attached to thin nylon threads that unwind and rewind, lengthening and shortening. This permits the units to crawl down and, when the end of the thread is reached, be pulled back up. The mechanism is not evident to a casual glance, however. The balls are seen to move down slowly, very slowly, until some are perilously near to the steep drop into nothingness. At that instant, time stands still. In 1961 Bury spoke of the pregnant moment in the flow of motion in these evocative words:

. . . This moment of the imperceptible between the moving and the immobile this moment of the imperceptible when what moves is already at a standstill . . . when the end begins, when the beginning ends . . because all ends . all has a beginning, and what begins again is not what has been . . as was what will come back situated between the expectation of what is about to come and the present which is already getting distant . this imperceptible immobile moment . . .[103]

[102] Quoted from the English translation published in *Studio International*, CLXIX, No. 886 (June 1965), p. 234.

[103] *"La Boule et le trou* (Brussels: Éditions Stella Smith, 1961), unpaged.

In it, in this imperceptible immobile moment, the miracle happens. The viewer is fascinated, particularly if he has ever stumbled on a mountain and, rolling down, tried to break the momentum of his fall. Without a bush, tree, or boulder in evidence to halt their advance, the balls stop and redirect themselves, commencing to crawl up the incline, slowly, very slowly. It is an endless performance of peril and last-minute rescue. We seem transported back in time on a magic carpet, back to our childhood and the belief in goblins busy at night in incomprehensible deeds. Or we wonder at the likewise incomprehensible activities of ants scurrying around in a slow-motion picture. The black color and anonymous shapes encourage this transposition into a world of fantasies. But its root lies in dilated time, as exposed by Bury himself in 1964: "Thus, we can see that slowness not only multiplies duration but also permits the eye following the globe to escape from its own observer's imagination and let itself be led by the imagination of the traveling globe itself. The imagined voyage becomes imaginative." [104]

In the second half of the sixties Bury introduced magnetic fields to direct the motion of his spheres, now made of metal, and with this, the focus was shifted to irregularity in movement. Each unit moves in its own good time, at its own speed, on its own route, accelerating and decelerating apparently at will. Some roll faster than others but without a visible reason. Some move in a straight line, others circle, but without apparent cause. The director of their motion is, of course, the magnet. The magnets are put in motion by an electric motor and circle beneath the surface on which the metal balls lie, singly or in groups. The single balls are free to follow the beckoning of the magnets; balls in a group are inhibited in their motion by the elements around them unaffected by the magnetic attraction, which hold the magnetized ones in check. When the magnet approaches, the uncrowded balls on the periphery of the magnetic field start to move slowly, but as the magnet comes closer to them, they suddenly race at great speed over the field until diverted, or stopped,

[104] "Time Dilates," p. 234.

by bumping into another ball, or groups of balls. One dislocation of an element will influence the motion of the balls in developing on different lines: as a result it is ever-varied. The spectator can participate in provoking changes by moving a ball. Further complications in motion were introduced by Bury when he made his units egg-shaped and allocated different weights to them. The heavy elements resist the magnetic attraction, being proportionately less easily moved around than the light ones.

Sometimes only one unit rolls around in a Bury work, as in

45. Pol Bury: *Sphere upon a Cube*. 1971. Stainless steel. 7⅞" x 7⅞"; with base 15¾". Photograph: Lefebre Gallery, New York.

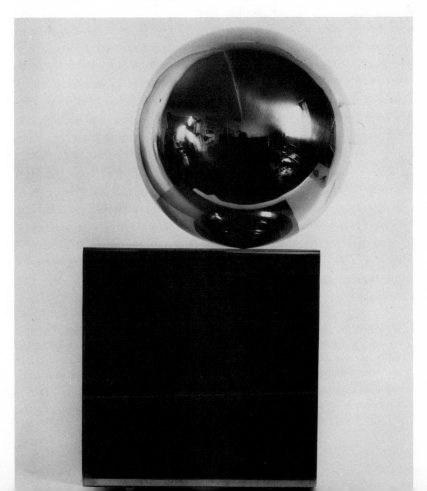

Sphere upon a Cube (1971; Fig. 45), a small sculpture in stainless steel, not even fifteen and three-quarters inches high by seven and seven-eighths inches long and deep (40 cm. by 20 cm. by 20 cm.). A sphere with a weight hidden in its body rests upon a cube in which the electromagnet has been placed. This electromagnet attracts the weight differently from the sphere. As a result the weight shifts around in the sphere's body, affecting its motion. Somehow the magical rites of the balls that climb up on the furniture pieces and the unpredictable happenings of the spheres rolling around on plane surfaces are combined in *Sphere upon a Cube,* exercising a doubly strong attraction upon the viewer. The invisible force that holds the sphere captive upon the cube is as astonishing as the movements in the other works. Because there is only one sphere, it is better able to convey the precariousness of a round object's position upon a plane surface than the agglomerate of small spheres and boccie balls described above. In contact at a single point with a support not much larger than its diameter, the giant ball revolves slowly around and around the surface of the cube, reflecting the environment. It brings into play a new element in Bury's art: ethereal beauty. This time the viewer is reminded of a heavenly body slowly following its course in the cosmos. From night we have moved to day, from chthonic happenings to celestial motions. But this heavenly motion is spiced for us by the possibility of a mishap.

Like many other artists before him, Bury was intrigued by the sphere (*boule*) and the cube as two basic forms. In an essay, written in January 1966, and edited and published by the Françoise Mayer Gallery, Brussels, in 1967 at the occasion of the artist's exhibition at that gallery, Bury revealed what he saw in the two shapes:

> *It would appear that one is equivalent to our soul—its aspirations, its eddies, its rolling around in the depth of the torrents. The other, with its ridges and its angles, would be the image of our knowledge, at least that degree of knowledge which, grosso modo, we have established for ourselves.*

But it is also less and more than that: a posterior on a chair, an apple on a table. . . .[105]

Traditionally, the sphere was connected to Fortune and the cube to Virtue, in other words, the insecure and the secure values of the world.[106] Bury is no different in linking the sphere with the torments of the soul and the cube with knowledge. But, from the serious he turns to the joke, from metaphysical to sexual symbols.

He continues the comparison by spinning yarns about sphere and cube that point up the difference in their natures. Whereas the roundness of the sphere invites man to put it in his pocket, to put it in his mouth, under his armpit and elsewhere, the edges and points of the cube prevent any spontaneous, intimate contact. As contraries, the two attract each other and complement each other. They also appropriate each other's traits: "The ball caresses . . . The caressed cube takes on roundness (one can almost hear it purr) . . . The ball, better supported than in the hollow of the hand, tastes the savor of the flat surfaces . . ."

The word *caresses* leads to a quality of Kinetic art, mentioned incidentally in the discussion of Andre, which is of specific interest for sculpture: it plays upon the sense of touch not only through the tactile presence of shapes, but also through *friction,* a by-product of motion. In Bury that side effect is exploited to great advantage. The artist actually composes in friction, presenting to the viewer's eye and ear a series of actions involving touch. Some units in Bury's works graze others, some hit others, some rub gently against each other, and others collide. In the *Sphere upon a Cube,* the sphere caresses the cube during its revolutions. Bury said in 1964: "We dare henceforward speak of the activity no longer in terms of geometry, but also in the language of the boudoir." [107]

[105] *La Boule et le cube* (Brussels: Galerie Françoise Mayer, 1967), unpaged.
[106] Guy de Tervarent, *Attributs et symboles dans l'art profane 1450–1600: Dictionnaire d'un langage perdu* (Geneva: Librairie E. Droz, 1958), pp. 136–137, *s.v. cube.*
[107] "Time Dilates," p. 234.

5. *The Use of Sound*

> Sound interests me enormously; it
> is another kind of material to me.

—Jean Tinguely

Many contemporary artists are sound conscious. Sound is part of Kaprow's Environment *Words* and of walking upon Andre's floor pieces. Yet the marriage of sound and art has not been consummated so far; the two parties have merely allied themselves into an uneasy partnership. In other words no sound art was born of the union; but for one or two artists, the use of sound in the visual arts merely modified or added to established art forms. The reason for this failure is not clear.

There are many types of sounds, both agreeable and disagreeable. Sound has pitch, timbre, a level of loudness, a degree of intensity, duration. It can be composed into melodies, harmonies, traditional tunes, jazz, or otherwise. Design in sound should therefore be as possible as design in movement. But, with few notable exceptions (Bury, Tinguely), sound in the visual arts is more or less an ornament. Starting as a nonaesthetic by-product of motion, it has remained a nonessential part of the aesthetic experience when it is accented in contemporary art. Its main purpose is to attract attention, like ornament. Because it is an unexpected element in the visual arts, sound serves this end. This contemporary substitute for ornament appears in three forms in the plastic arts: as accompaniment to the motion produced by an object, as accompaniment to the motion produced by machinery, and as part of an audiovisual show.

A few words on forerunners of sound in the plastic arts will help in understanding contemporary aims, achievements, and failures. Sound divides into tone and noise, and not every sound connected with a work of art is introduced with intent to enhance the visual experience. This makes it difficult to trace the early history of our medium. Examples of musical sound in the plastic arts are the chimes of Chinese bells and the carillons of clocks in cathedrals

and town halls. These have a musical-aesthetic function that is not integrated with the visual-aesthetic experience of the work. Examples of nonmusical sound used in works of art are the ghost voices of West Indian rattles that scare off evil spirits. Here the function of sound is utilitarian, not aesthetic. Examples of unintentional noises in works of art are the whirring of the motors in Gabo's *Virtual Kinetic Volume* (1920)[108] and Moholy's *Light-Space Modulator* (1922–30; Fig. 46, pp. 296, 298). Their sounds are neither utilitarian nor aesthetic in scope and thus lie outside the aesthetic experience. Perhaps the first instance of a sound integrated with plastic art is Duchamp's assisted Readymade *With Hidden Noise* (1916). It consists of a ball of twine set between two brass plates that are joined by four long screws. In the twine, Walter Arensberg hid an unknown object that rattles faintly when the Readymade is shaken. Sentences that make no sense, jumbling French and English words, are inscribed on this piece.[109] However, the experience of sound in it was an exclusive pleasure reserved for those "in the know." No visitor in that bygone age would think of touching a work of art, and much less dare to do so. Today, enshrined in the museum at Philadelphia, it is still out-of-bounds.

Duchamp's idea of integrating sound with plastic art was made available to the general public through Rauschenberg. His *Broadcast* (1959) contained three radios playing simultaneously, yet not harmoniously: fragments of rock and roll, commercials, and news were mixed with the sounds produced by truck ignition, neon static, and dirty controls in the radios.[110] Even nearer to Duchamp's work is Morris' *Box with the Sound of Its Own Making* (1961), currently in the C. Bagley Wright collection, Seattle. The *Box* is a nine-foot walnut cube that contains a tape recorder with a tape taken during the three-hour making of the cube. When tuned in, the sawing,

[108] Reproduced in repose and motion in Rickey, *Constructivism*, p. 192, Figs. 1, 2.
[109] Lebel, *Marcel Duchamp*, p. 39; Pls. 77, 77a; No. 129.
[110] Alan R. Solomon, *Robert Rauschenberg* (New York: The Jewish Museum, 1963), unpaged, Fig. 24.

hammering, and other noises produced during the cube's construction are heard, faithfully reproduced for the public's benefit.[111]

In a way these two works are representative of the main varieties in Sound art. Sound art vacillates between the overly simplicistic mono-tone meal and the overrich diet of a cacophony. This is its trouble, or at least one of them. It leaves us hungry or with indigestion. Sound art must be studied in the light of this unresolved dilemma. The use of sounds produced by collision is among the commendable experiments in Sound art. They are usually well adjusted to the visual image and suffer only from want of development. As long as they remain a subconscious accompaniment to the motion, the monotonous repetition of the sound is pleasant without turning into excitement. That is so in Bury's spheres and in Andre's metallic rugs.

Instead of producing sounds, the objects can be the carriers of sound-producing devices. This permits the transformation of the work of art into a musical instrument with a commensurable increase in the gamut of tones, which are released by the human hand; such works are designed for tactile spectator participation. The viewer is the catalyst for the audiovisual experience. The sound devices waiting to be brought to life are often hidden behind the units of the work of art, which units are set out like a keyboard. The musical life of these units is discovered, knowingly or by accident, when the spectator sets these keys in motion. As in a keyboard, each unit possesses a different voice: some tinkle, others whine, some emit a piercing shriek, others speak in deep basses, some are faint, others boom. But what keyboard would set a boom next to a tinkle in abrupt transitionless disarray? Here the surprise element enters the picture. The spectator-musician composes with unknown quantities. If he is gifted, then a whole melody, or even a harmonic composition, can be played with his two hands, improvised or composed after he has acquainted himself with the keyboard. Ac-

[111] Compton and Sylvester, *Robert Morris,* pp. 10–11; ill. p. 29.

cording to the power with which the units are struck, and their resilience, the accompanying gyrations are more or less violent, turning some units into blurred blobs, while others retain their identity. The crazy dances accompanied by the sound of queer music offer an infinite number of possible variations in which the spectator acts as the choreographer as well as the composer.[112]

Besides nature and man, mechanical devices can move the object, in which case the sound of the motor can be heard. In the early Bury, the soft buzzing of the motor does not rise to the surface of consciousness for everyone; for those who hear it, the low humming sound conjures up visions of burrowing animals and scurrying insects. In the later Bury, the sound of the motor is overlaid by the sharp explosive noises of his collisions. The spheres produce a crackling sound, like burning firewod; the eggs clang.

In Bury, the motor's sound is still a whispered monotone. In other artists, it whirs but still as a monotone. This stage in design with sound was overcome by Tinguely (Fig. 50, p. 325), with whom composition in sound starts. For he listens to the sounds of his motors and weighs them as a painter observes and weighs his colors: "Once I spent all day trying to make a machine," he tells us,

> bending, soldering, struggling with the material. I forgot to eat. I finished about eight in the evening. It was dark and cold, and I started the thing going to see what sort of sound it made. Sound interests me enormously; it is another kind of material to me. I studied the sound, regulated it, changed it. I changed the motor and replaced it with one that was more powerful, but that didn't satisfy me either, so I took the whole machine apart and changed its shape.[113]

Tinguely actually scrapped a full day's work because he was discontented with the sound it produced. Sound is thus an integral part of the aesthetic experience for him. He tried to adjust the sound to

[112] See *Yaacov Agam,* Figs. 41, 42.
[113] Tomkins, *The Bride and the Bachelors,* pp. 186–187.

accord with the form of the machine but, failing, destroyed the work and recomposed it to produce the sound he needed.

Design in motor sound is most possible in connection with malfunction. Tinguely mastered Sound art because his machines are cripples, giving him a range of sounds as an operational basis: they screech irritably and also purr smoothly, follow unpredictable syncopated rhythms and also form orderly runs and, from time to time, irrupt in protesting screams. Their noise is the epitome of the visual experience, conveying the impotence of the monster that dominates our life. It makes us see this monster in a changed light, demythologizing it for us. The release from fear resolves itself in laughter.

The use of phonographs, radios, and television sets to inject sound into the plastic arts also permits the transcending of monotone, but it is not successful as Sound art. It is successful neither when the sound is a "representational" element such as noise pollution shown together with littering as the American way of life, nor when the sound is an abstract element in a scrambled tonal ensemble.[114] This does not mean that such mechanized instrumentation is inadequate as an art form. Merely that it is inadequate as Sound art. If it is good, it becomes music, leaving the domain of the plastic arts. In one case only does it remain art: when mixed with a series of different media to form a spectatcle. This art form is, however, no longer design in sound, but the alliance of art and science. It will be discussed in the following section.

Another use of sound in the plastic arts also falls into that section. Sound entered the visual arts under two guises: in artistic dress, as part of the work, and in technological dress, as catalyst for the work's coming into being. The second form belongs, again, under the heading *art and science*.

[114] As in Tomiyo Sasaki, *The Great American Pastime* (1970; National Gallery of Canada, Ottawa, Ontario). Or as in Keith Sonnier, *Untitled* (1970), reproduced in *Sculpture Annual* (New York: Whitney Museum of American Art, 1970), No. 83, ill. p. 37; in Les Levine, and in Nam June Paik, illustrated in Calas, *Icons and Images of the Sixties* on pp. 313, 314.

6. Physics as Tool

His tools are the laws of nature.

—Hans Haacke, 1965

The alliance of art and science is the most difficult to describe as well as to analyze. The cinematographic nature of the spectacle in sound and light necessitates reviewing it repeatedly for a revision of one's impressions, but its technological side makes the spectacle arduous to reenact in storage rooms. The critic has to fall back on descriptions and these are frequently vague. Moreover, few reliable studies of the relationship of art to science exist. The two fields are widely disparate and not many people are conversant with both. To make one point—for many years writers have discussed the similarities in construction between abstract art and scientific illustrations. A good many books have appeared on this subject.[115] But the assumption of one and all seems to be that science is the source for this similarity; it is only later that art may have served to influence science in a kind of cross-fertilization between the two domains. I am not sure this evaluation is correct, because the persons who made the drawings and those who invented the machines that made the diagrams were familiar with the drawings of artists. Hence their designs had this material available as precedent.

Technology is overprized today, and that development has not spared artists. They have entered into a love affair with science. Without proper perspective, it is difficult to decide in which instances this trend is a true love affair, in which a case of victim fascinated by a snake—in which instances the initiative comes from the artist, in which he follows the dictates of the audience. Whatever the source for this situation be, the result is the same: art plays second fiddle in this concert. As has been pointed out by Nicolas and Elena

[115] E.g., Herbert W. Franke, *Sinnbild der Chemie* (Basel: Basilius Press, 1966) and Harold G. Cassidy, *The Sciences and the Arts: A New Alliance* (New York: Harper Brothers, c. 1962).

Calas,[116] the prizes in the competition of works of art made in collaboration with engineers, organized by Experiments in Art and Technology in 1967, went to engineers. The accessibility of technology to art may prove to be an ambiguous gain. As the Calases have clearly seen, the flaw in the use of technology lies in that it leads artists to disregard the distinction between illustration and sublimation. Art should give us a new vision, not a new type of presentation. Often the achievements of art based on technology tend to become illusionistic and tricky. In an age of rapid technological advances, these technological surprise effects become shopworn quickly. If that is all there is to art, then there is precious little.

Another problem of marrying art to technology is the necessity of having a sponsor; sponsors are indispensable when large art-and-technology works are executed. The situation is not different from medieval and Renaissance times when all public art and most private art was commissioned. The last one hundred and fifty years had seen the attempt to emancipate art from patronage, but this ideal has proven unfeasible. Sponsorship of art is here to stay. Let us, therefore, accept the inevitable. If history is any guide, artists whose creativity is not inhibited by patronage will coexist with artists who function well only under complete freedom.

Artists variously legitimize their use of technology. Rauschenberg, for instance, claimed in 1967 that he had to "create within the technological world in order to satisfy the traditional involvement of the artist with relevant forces shaping society." [117] Such a viewpoint is excellent, but the artist's involvement in art cannot stop with the use of a medium. He must first judge this medium on its merits and demerits for his art and, having established this point, then decide how best to use the medium.

A valiant attempt to foster the relationship between artist and patron was made by the Los Angeles County Museum of Art. The results of this pioneering experiment developed between 1966 and 1971—one of which, Tony Smith's Environment *Untitled* (Fig. 34.

[116] *Icons and Images of the Sixties,* p. 335.
[117] *Ibid.,* p. 310.

pp. 222, 223, 225), we have had occasion to discuss—were fully pub-
lished. The failures outweigh the achievements, but this is to be
expected in pioneer work. The value of the attempt made by the Los
Angeles County Museum resides primarily in having brought the issues
out into the open, so that steps for the resolution of the difficulties
can be pondered. On both sides there were groups that did not
wish to cooperate, and on both sides these groups divided into two:
those who declined and those who pooh-poohed the project—the
artists by proposing bizarre schemes and the sponsors' delegates by
taking hostile attitudes. Another group of artists asked for exaggerated
sums of money. Then there were some who wanted to cooperate
but did not succeed in finding parties interested in their projects,
and some who failed to take advantage of the opportunity, producing
works that could have been done without the facilities offered through
the corporations. Only a few artists fully vindicated the experiment
through their works. However, when temperaments are compatible
and interest reciprocal, the cooperation between artist and govern-
ment or industry can be successfully realized. Schoeffer's *Spatio-
dynamic and Cybernetic Light Tower* at Liège and the one planned
for Paris (Fig. 47, p. 300) have been mentioned above.

The form that the cooperation of art with technology often takes
is the spectacle. Spectacles may be based on sound, light and fire,
water, magnetism and gravity, or on combinations of these, as well
as on other elements and properties of elements used in the
construction of the work. Due to the interaction between the com-
ponents, it is difficult to survey these works systematically. I have
classified them according to their main components, and shall discuss
photo- and audiokinetic art; the four elements; and airborne, hydrau-
lic, biotic works.

A. PHOTO- AND AUDIOKINETIC ART

And not I paint but the light.

—Otto Piene, 1961

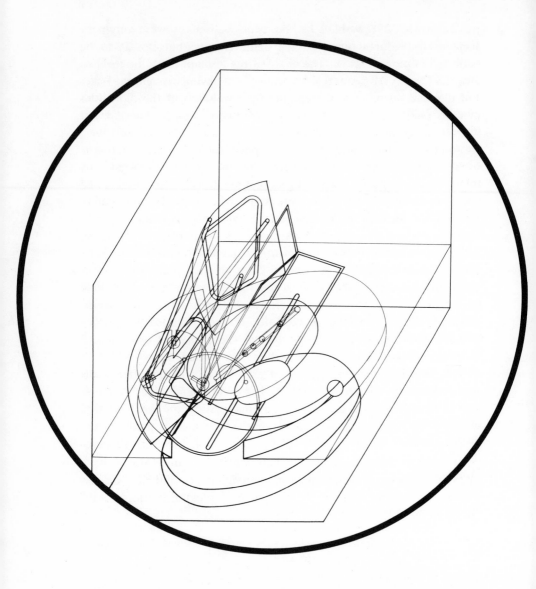

46a. László Moholy-Nagy: *Light-Space Modulator*. 1922? Construction scheme diagraming the motion. Ink [?]. Whereabouts unknown.

The projections of color on a screen have three forerunners in premodern and modern art.[118] The first is the *color organ* (*clavecin oculaire*), shown to an audience of friends by the Jesuit philosopher and mathematician Louis-Bertrand Castel in his Paris apartment in 1734, which connected color to music. The second is the *Clavilux,* invented by the Danish-American Thomas Wilfred, who started his experiments in 1905 at the age of sixteen. He built his first instrument for lumia compositions, the Clavilux, in 1921. It was a silent keyboard that created colored abstract light patterns without reference to music. The third consists of *searchlights* trained on sculpture, probably first tried out by László Moholy-Nagy in his *Light-Space Modulator.* Photokinetic art proceeded from the last-named.

The *Light-Space Modulator* (Fig. 46b) was conceived as a light stage prop (*Lichtrequisit*). Built with the help of a mechanic, it is a six-foot-high mechanized construction, which is set in motion by an electric motor that activates chain belts, while one hundred and forty differently colored electric bulbs, turned on by a drum switch, alternately spotlight the optical effects produced by the motion of the members. The motion scheme (Fig. 46a) has been outlined above. As for the design in light, in 1930 the artist and his future wife Sybil made a film of the work in action: *Light Display: Black and White and Gray.* The film's rhythm was to come from the light, and Moholy has described the light effects he planned for it: "Light beams overlap as they cross through dense air; they're blocked, diffracted, condensed. The different angles of the entering light indicate time. The rotation of light from east to west modulates the visible world. Shadows and reflexes register a constantly changing relationship of solids and perforations." [119] Sybil found the spectacle as

[118] On Light art, Piene, "Light Art," pp. 24–47; Willoughby Sharp, "Luminism and Kineticism," *Minimal Art,* pp. 317–358; Popper, *Origins and Development of Kinetic Art,* chap. 2, sec. 7 ("Light and Movement"); Burnham, *Beyond Modern Sculpture,* part 2, sec. 7 ("Light as Sculpture Medium").
[119] Sybil Moholy-Nagy, *Moholy-Nagy. Experiment in Totality* (New York: Harper and Brothers, 1950), p. 69. See also, László Moholy-Nagy, "Lichtrequisit," pp. 297–298; *idem, Telehor* (Brno), I, No. 1 (October–November

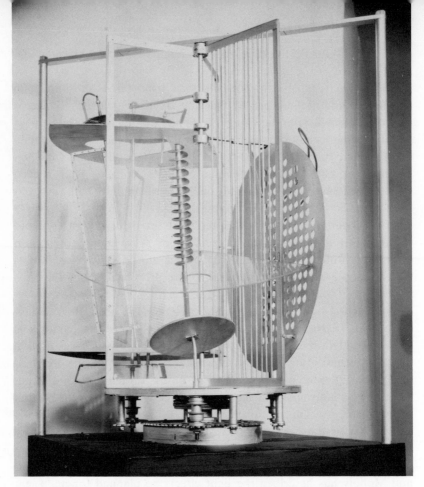

46b. László Moholy-Nagy: *Light-Space Modulator.* 1922–1930. Machine inactive. Originally chromeplate, aluminum, glass, wood. Restored in 1966. Presently chromeplate, plastic, wood. 42″ x 37″; with base 59½″ x 37″. Busch-Reisinger Museum, Harvard University, Cambridge, Massachusetts.

1936), *passim; idem, The New Vision and Abstract of an Artist,* 3rd rev. ed. (New York: Wittenborn and Co., 1946), pp. 74–75; *idem, Vision in Motion* (Chicago: P. Theobald, 1947), pp. 238, 288, Fig. 324; Burnham, *Beyond Modern Sculpture,* pp. 290–292; *Moholy-Nagy,* ed. Richard Kostelanetz (New York: Praeger Publishers, 1970), pp. 11–13, 39, 147–150; Weitermeier, *Licht-Visionen.* I owe the reference to *Telehor* to Bernard Karpel of The Museum of Modern Art, New York, whose assistance I gratefully acknowledge. Originally of aluminum, the large perforated disk was made from chrome plate in the restoration of 1966, the glass of the spiral was replaced by metal, and the glass arc by a plastic arc.

projected in the film more powerful than the direct experience, and Moholy was pleased with this reaction. In other words, the *Light-Space Modulator,* conceived as a light stage prop, became a film stage prop: film was its final medium of expression for Moholy. In Light art, light is the medium of expression. Nonetheless, the *Light-Space Modulator* is a step in the direction of contemporary photokinetic art.

An early instance of the use of light itself as the work of art is Fontana's first Spatial Ambiance, *Spatial Forms & Black Light* (1949), discussed above. However, it was not a spectacle, that is, a kinetic Light-art show.

Photokinetic art came into its own about 1960. Its varieties depend mainly on two factors: the plotting of the colors and shapes in temporal succession, and the staging. The plotting of colors and shapes is familiar to us from its analogy in painting, and the temporal succession from its analogy in film. Even the expressive range used by photokinetic art can be paralleled in painting. It reaches from the mobilization of all man's faculties to a trancelike state (cf. for painting pp. 141–142). In the first instance the spectator is bombarded with firework effects produced by blinding searchlights, radiantly white or colored; the light goes on and off, expands and contracts, swivels, blinks, regularly or irregularly, in programmed sequences. In the second instance, a quiet flow of spectral color images is presented.[120] As for the staging, it operates with reflections, refractions, mirrors, etc.

It was difficult to decide how to illustrate kinetic Light art. Imagine that you have to exemplify the art of painting by means of one, or even five, works: what would you select? In kinetic Light art, there is the additional problem that not every work is photogenic. Moreover, if only one moment of the spectacle is illustrated, it tends to blur the differences between works. I have settled on Schoeffer's unrealized *Cybernetic Light Tower* for Paris, (Fig. 47, p. 238) because, as noted by the artist, "it is at the same time a work of art and a [scientific]

[120] Cf. the effects of Chryssa's *Clytemnestra* (1967; The Corcoran Gallery of Art, Washington, D.C.), illustrated in *Chryssa* (New York: Galerie Denise René, 1973), unpaged, with those of Flavin's Monuments for V. Tatlin (Fig. 37).

47. Nicholas Schoeffer: *Cybernetic Light Tower*. 1963. Approx. 1150'. Project for the Defense Complex, near Paris. Photograph courtesy the artist.

instrument," [121] thus illustrating the cooperation of art and science. The clean, precise lines of the construction in gleaming metal bring out the fata morgana-like quality of the light beams emitted by it. The structure is, however, also the shell for housing various public conveniences, and the light beams are purveyors of information.

As planned, the tower would be about 1,150 feet high (347 m.), and include well over 3,000 multicolored projectors, 2,000 electronic flashlights, and 330 reflectors. Conceived as an open skeleton that circumscribes space, to which the elements are attached, it would illustrate all three stages in Schoeffer's development of dynamism in art: spatiodynamism, started at the beginning of the fifties, lumino-dynamism and chronodynamism, both started in the second half of the fifties. It would produce audiovisual spectacles consisting of sound and projections. In addition, the tower would comprise seven platforms, accessible to the public by elevators and stairways, on which would be located a popular and a rotating deluxe restaurant, a conference hall, a boutique, an organ, a drugstore, a post-and-telegraph office, a television room, a signal room, etc. Thus the tower would be simultaneously a symbol of light at night, which would guide airplanes and human traffic, a vantage point for seeing the environment, a producer of audiovisual spectacles, a work of art, and a fun center. Moreover, it could serve to relay useful information about the weather, the traffic, and the stock exchange. Details on these points received from hygrometers, thermometers, traffic watch-ers, and the ticker tape would be fed to computers that would come up with the information to be communicated to the public. For instance, an emphasis on blue light would indicate fair weather, whereas if red light were accented, it would mean rain and storm. Acceleration of the program at 1:00 P.M., the moment when the Bourse closes, would suggest that the French Dow Jones is up, whereas deceleration would mean it is down. Loud emissions would tell of traffic conges-tions and soft ones of light traffic; conventional signs could direct the traffic on alternate roads.

[121] "Tour lumière cybernétique: projet pour le quartier de la défense à Paris," *Art International,* XII, No. 1 (January 1968), p. 26. For the tower, see also chap. 2, sec. 3, n. 29.

Spectacles can be of short or long duration, ranging from an instant to daylong continuous productions. Spectacles of short duration have a special flavor. Agam's *Fiat Lux* (1967) and Rauschenberg's *Soundings* (1968) are both such photo- and audiokinetic spectacles. Both exploit amazement at a technical feat: sound produced by the spectator is translated into energy in the form of light.

Agam's *Fiat Lux* was shown at the exhibition "Light and Movement," held at the Musée Municipal d'Art Moderne de la Ville de Paris in 1967.[122] At the sound of a voice, a bulb would light up in a blasphemous parody of the Bible, where the words God spoke according to Genesis 1:3, "Let there be light," provided the just-created earth with daylight. Rauschenberg's *Soundings* are now in the Ludwig Collection, Aachen and Cologne.[123] At the sound of footsteps, darkness is dispelled to reveal a vision of chairs. Note that the spectator himself sets both works in motion—not by hand, but by mouth and by foot; it is he who, like a stage manager or magician, produces the shock waves that bring about the appearance of the spectacles. Note also that these miracles do not happen to those who speak or tread softly. All they see is a dead bulb and a row of "shop windows" that reflect their image. Only those who raise their voices and weight their steps activate the hidden microphones that turn on the light switches, so that the bulb bursts into light, and the photographs of chairs printed on the back of the Plexiglas plates become visible.

B. THE FOUR ELEMENTS

Ultimately this is the old dream of
mankind and of the imagination to
play with the elements of nature.

—Yves Klein and Werner Ruhnau, 1959

[122] See *Lumière et mouvement: L'Art cinétique à Paris* (Paris: Musée Municipal d'Art Moderne de la Ville de Paris, 1967), unpaged.
[123] Gert von der Osten, *Kunst der sechziger Jahre (Sammlung Ludwig). Hundertfünfzig Werke im Wallraf-Richartz-Museum,* 2d enl. ed. (Cologne: Wallraf-Richartz Museum, 1970), p. 28.

Fire is light, yet a work of fire stands apart from Light sculpture, and even more from kinetic Light art. Rather it aligns itself with works using the other three primal elements—air, water, and earth—perhaps because these four have for too long been an entity for man and for artists. Going back to Greek philosophy, these four elements became, in due time, symbols in art to be personified in the Middle Ages, the Renaissance, and the Baroque. Some of this content survives in contemporary art, where the motif intertwines physics with metaphysics.

Yves Klein's interest in the Four Elements is connected with his dream of restoring the Garden of Eden for mankind; he hoped to achieve this by means of pneumatic architecture. The word *pneumatic* carried for him its original Greek meaning of spiritual, as well as that of air. Like the void, air architecture was for Klein a symbol of the immaterial—but not of dematerialization. Yves's project, conceived, in 1951, called for the cleansing of the earth of all superstructures; the machinery necessary for man's survival was to be stored underground (Fig. 48a, p. 304). In a conference held at the Sorbonne in 1959, Yves outlined the four stages leading toward an architecture of the immaterial:

> (*1*) the *climatisation* [that is, creation of specific climates] of the great geographic spaces by the use of elementary energies in synthesis or in contrast (water, air, fire); (*2*) the change of the basic meteorological, geophysical, or marine conditions (regimen of the winds and oceanic currents); (*3*) the urban integration system to be effected through the unified application of general energy principles (water and fire fountains, smoke curtains, colored vapor clouds); and (*4*) the individual spatial conditioning through treatment of pulsating air (the air bed and its physical and psychic consequences upon the behavior of the user).[124] [Fig. 48b]

This project of a Garden of Eden where people in a state of innocence would live nude as before the Fall in a Land of Cockaigne

[124] Quoted from Pierre Restany, "Yves Klein: Les conceptions," *Antagonismes 2: l'objet* (1962), pp. 76–77.

48a. Yves Klein: Pneumatic Architecture. *Climatisation de l'espace*. 1951. Drawing by Claude Parent. From catalogue of Musée des Arts Décoratifs, Paris, 1962.

without toil, disease, or death was proposed first for a city quarter, then for a settlement, then for a town, and finally for whole countries. The different quarters were to be separated by walls of fire and water, and given roofs of air. Fire would yield warmth, and water, struck by cold gusts of air, coolness; the air roofs would hold off the rain (Fig. 48b, p. 306). The fire for the walls, fountains, and colonnades could be obtained from gas. The elements should be mixed at random so that regimentation would be avoided. Klein believed that this new type of life in a different climate would change man's spiritual makeup.

Figure 48a shows a drawing of the *climatisation* of space. At left, two nude people sit in the shadow of trees. Another nude person can be seen walking in the center, and two other oases with trees appear in the background, one sheltering an animal. Behind them is a range of mountains. The earth has been cleared of all structures. These are placed below the surface of the ground in the form of a system of tubes and units. Only their ends project above the earth. Figure 48b shows a drawing of an airborne room. In the rear the air roof can be seen. It shelters two air floats, an air bed, and an air chair, upon which nudes sit or recline in groups or alone. Behind the chair and bed is a colonnade of fire, one end struck by a jet of water.

To the layman, the technical aspect of Klein's plan for a new type of life on earth seems utopian. Yet, a few of his ideas were realized, or almost realized, even during his lifetime. Two Fire Fountains and a Fire Wall (Fig. 48c) were installed, in full-size models, at Museum Haus Lange, Krefeld, Germany, for the artist's 1961 exhibition; one fountain faced the museum's street façade the other fountain and the Fire Wall faced its garden façade. And the plan to construct pneumatic architecture on the square in front of the theatre in Gelsen-kirchen, Germany, was completed but for the actual realization.[125] The French architects Claude Parent and Sargologo, the German

[125] Paul Wember, *Yves Klein* (Cologne: M. DuMont Schauberg, 1969), p. 24, and letter of August 17, 1973, to the author. I take this opportunity to express my gratitude to Dr. Wember for sharing his intimate knowledge of Yves Klein with me.

Toit d'air (collaboration Ruhnau-Klein).

Lit d'air, 1958.

**Fontaines d'eau et de feu
" Le choc permanent ", 1958.**

48b. Yves Klein: Pneumatic Architecture. *Airborne Room*. 1958.
Drawing by Claude Parent. From catalogue of Musée des Arts Décor-
atifs, Paris, 1962.

48c. Yves Klein; Pneumatic Architecture. *Fire Wall*. 1961. Installation
in Museum Haus Lange, Krefeld.

architect Werner Ruhnau, and the German sculptor Norbert Kricke helped Yves in the technical formulation of his projects.

The motif of the Four Elements is still a vivid presence in a contemporary artist's mind, even in the 1970s. That is proven by Jean Dupuy's forging a work of this type from a Diesel engine in cooperation with the Cummins Engine Company of Columbus, Indiana, in the "Art and Technology" experiments. He called it *Fewafuel*. Jean Dupuy is a Frenchman now living in New York. As coauthor with Ralph Martel of *Heart Beats Dust,* wherein a pile of dust was enclosed in a glass container and activated by acoustic vibrations that were produced by the beating of the heart, his work had won the first prize at the "Experiments in Art and Technology" competition in 1967/68. His proposal to Cummins for *Fewafuel* outlines the work's composition and states his aims, as follows:

> A Cummins diesel machine will be shown in working condition. The public participates by sitting in a driver's seat and operating certain controls, such as pedal and clutch. The four natural elements FIRE, EARTH, WATER, AIR, which, either as sources of energy or as wastes, are part of the functioning engine, will be made visible with minimal elaboration.
> 1. To respect the form of the engine.
> 2. To indicate the basis in Nature of the engine's system.
> 3. To sense the power of the engine by sound.[126]

As executed, the fuel combustion, visible through a window, represented fire; the fan system, air; the cooling system, visible through a glass pipe, water; and the carbon debris, collected in an inverted bell jar, earth. The spectator's participation had to be limited to operating a throttle with which the turnover of the engine could be accelerated or decelerated. Dupuy's greatest technical problem was to make a window in the combustion chamber of a live engine. A Swiss engineer employed by Cummins, Willy Henny, helped to accomplish this technical feat.

[126] *A Report on the Art and Technology Program 1967–1971,* ed. Maurice Tuchman, p. 98.

As noted by Jane Livingston of the Los Angeles County Museum, Dupuy perfected the "most literal esthetic embodiment of a particular industrial product or technology produced under A&T." [127] Yet, his purpose is apparented to that of Yves. The artist defined it in the following words: "I destroyed the function of the engine, and transformed the fuel, taken from the earth, into earth again. Earth to earth—that's too Biblical—but that's what I did." [128] Klein battled with civilization by wiping all cities off the crust of the earth as if they were accretions of dirt; Dupuy battled with technology by deflecting the Diesel engine, that "primary image of the capitalist economy," from its function. Both artists saw themselves as tools of God. Klein was rebuilding the Temple: he referred to his air-and-fire fountains and colonnades as the "molten sea" (I Kings 7:23; II Chron. 4:2). Dupuy was meting out punishment for wrongdoing: he condemned the evil machine to death, as our evil Parents had been thus condemned "dust thou art, and unto dust shalt thou return" (Gen. 3:19).

C. AIRBORNE, HYDRAULIC, BIOTIC WORKS

This revived old dreams.
—Hans Haacke, 1968

Airborne, hydraulic, and biotic sculpture are no longer pipe dreams in the age of jets, rockets, and satellites, submarines and amphibians, artificial insemination and organ transplants. In fact, many varieties have been created, durable and transient, man-, nature-, or motor-propelled. For predecessors, airborne and hydraulic sculpture can look back to fire- and waterworks, or, nearer to home, to the Gutai, for instance, Sadamasa Motonaga's Work No. 12 at the "Gutai Art on the Stage" exhibition of 1957, where smoke was used to create rings that, as they drifted across the stage, were successively shot to pieces.[129] Biotic sculpture can look back to performances of animals

[127] *Ibid.*, p. 98.
[128] *Ibid.*, p. 100.
[129] Jiro Yoshihara, " 'Gutai' Art on the Stage," unpaged.

49a. Hans Haacke: *Sky Line*. 1967. Central Park, New York. Photograph courtesy the artist.
49b. Hans Haacke: *Sky Line*. 1967. Central Park, New York. Photograph courtesy the artist.

at fairs and circuses, and to pressed flowers mounted under glass. Now to the varieties.

Some airborne sculpture hovers just above the support, repelled by electromagnetic fields and thus suspended at a short distance from them.[130] Other airborne sculpture floats high up in the air. Best known among these later manifestations are the works of Group Zero, whose balloons were set adrift on air columns in the night sky and then illuminated with searchlights in Düsseldorf in 1960.[131] Another balloon spectacle, *Sky Line,* was shown by Hans Haacke at the Conservatory Pond in Central Park (Fifth Avenue at Seventy-third Street) at noontime on June 23, 1967 (repeated in the fall).[132] Haacke, a German who has moved from Cologne to New York City, released a series of balloons, filled with helium and strung together on nylon

[130] For example, Alberto Collie's *Floatiles,* illustrated in Burnham, *Beyond Modern Sculpture,* Fig. 21.
[131] *Ibid.,* p. 47.
[132] Communicated to me by the artist, whose help I gratefully acknowledge.

cord. This formation moved about in the air in accordance with the wind drifts. Figures 49a and 49b offer two views that may help to visualize the spectacle. In Figure 49a, the balloons rise steeply into the air, first in a vertical column, then bending slightly to one side, like a young sapling. In fact, the column is a chain made up of irregularly spaced beads—the balloons. Over one hundred balloons of equal size were used. (The effect of increase in size toward the top is a perspective distortion.) The buildings seen in the background, on the south side of the park, give an idea of the tremendous height to which this open chapelet rose. The pull on the string was enormous. In Figure 49b the line has slackened and decomposed into loops and twists that are carried horizontally by the wind. The spectacle was ended around five or six o'clock when a thunderstorm and rain grounded the balloons.

Airborne sculpture can also be suspended above an oblique air draft. Haacke, who had started experimenting with balloons in 1961, succeeded in balancing a balloon on a column of forced air, not only at a distance but also at an oblique point in space from the source of air in the same year in which he floated *Sky Line*.[133] Airborne sculpture can also move because it consumes itself. Andy Warhol's silver-colored, gas-filled pillows, which he showed at the Castelli Gallery in 1966, were floating at different heights as they slowly discharged their gas.[134]

Haacke as well as Alberto Collie, an artist working with airborne sculpture in Boston, have analyzed the aesthetic side of floating sculpture. "It is like describing an egg," Collie commented in 1964. "No matter how much of an egg a person can see, there is still a tiny place at the base where it cannot be seen. Now I have been able to take the art form and place it so that it can be viewed in its entirety."[135] Although correct, this asset of airborne sculpture seems less significant

[133] Edward F. Fry, *Hans Haacke: Werkmonographie* (Cologne: M. DuMont Schauberg, 1972), Fig. 28.

[134] John Coplans *et al., Andy Warhol* (Greenwich, Conn.: New York Graphic Society, 1970), illustrated on p. 138.

[135] Quoted from Burnham, *Beyond Modern Sculpture*, p. 47.

than that noted by Haacke in a lecture to the Annual Convention of the Intersocietal Color Council in 1968: "The lack of a supporting structure that visually seems to absorb most of the weight of its load makes floor sculpture look all the more weighty, inert, ponderous, chained to the ground and somewhat pathetic. Lifting it off the ground by means of air-support is like taking off its chains, and liberating it." [136] Our mind is quite capable of correctly imagining the tiny missing portion of the egg; nothing is added by seeing it except the material fact. The invisible pedestal of air keeping the object up (Figs. 49a, 49b), on the other hand, is a new aesthetic contribution to art. Thus something has been added to our enjoyment of it.

Hydraulic works are as numerous as those that are airborne. Since they are another specialty of Haacke's, the varieties may be exemplified through his work. They consist of studies in the behavior of liquids and meteorological works, each of these again subdivided. Common to all is the active participation of the spectator who sets the process in motion—a must for Haacke, in order to get away from the mystification attached to the words *creator* and *art object*. However, before turning to Haacke, the hydraulic works of Piero Manzoni should be mentioned. Manzoni, who will be discussed in the next chapter, experimented with hydrophilic material in 1960. He used phosphorescent colors, and colors drenched in cobalt chloride, which fluctuate in coloration under the influence of the weather.[137]

Haacke's hydraulic works were inaugurated with his Drippers or Waterdrop Boxes in 1962. These have rain as their prototype and function on the principle of the hourglass. They consist of Plexiglas containers that are hermetically sealed and subdivided into compartments by partitions perforated with small holes, sometimes many and sometimes only one or two. As the spectator turns the box over, the water starts coursing down through the holes from the upper regions to the lower regions. The glistening drops glide down the transparent

[136] From a paper read at the Annual Convention of the Intersocietal Color Council in 1968; German translation in Fry, *Hans Haacke,* p. 43.
[137] *Piero Manzoni* (1971), p. 124.

walls, converge and merge, break and divide, flow and form whirl-pools. In other containers, Haacke showed together Mixed or Multiple Liquids. These do not mingle, hence one liquid would circle around the other in an effort to bypass it. In a horizontal, narrow Plexiglas container hanging from the ceiling, Haacke emprisoned his *Wave*. Put in motion by the spectator, a liquid passes through the narrow corridor and breaks at both ends.[138]

Haacke's meteorological works started in 1963 with Weather Boxes. These operate with the condensation and evaporation of moisture through the use of heat. The second half of the sixties saw the Ice Works, in which ice was formed by an electrically activated cooling system and regulated in its performance by the humidity and temperature of the work. In other words the artist created the conditions under which freezing and defrosting then took place according to natural laws. In 1968 steam and fog were harnessed to Haacke's hydraulic works. For instance, his *Water in Wind* was an experiment in which water was produced on the roof of the building in lower Manhattan in which his studio was located, and then that water was left to fight with the wind and weather. Or, at the University of Washington in Seattle, the fog was used in the context of the marshy and eroded ground, characteristic of Seattle climate.[139]

The third type, biotic art, is less common than airborne or hydraulic art. The earliest instance of living plants in a work of art seems to have occurred in a Rauschenberg. In 1953 he was experimenting with *dirt pictures*. He packed earth tightly into shallow boxes that functioned like frames. One day some birdseed accidentally fell into one of these boxes and sprouted. This gave Rauschenberg the idea of having a *living picture*. He exhibited it at the Stable Gallery, New York, that year.[140] Another example of seeded earth was exhibited as a work of art in Paris in 1967 by the Polish expatriate sculptor Piotr Kowalski. His grass-seeded cone of earth was slowly

[138] Fry, *Hans Haacke,* Figs. 6–11, 12–15, 16.

[139] *Ibid.,* Figs. 35–39, 56.

[140] Calas, *Icons and Images of the Sixties,* pp. 171–172; Fry, *Hans Haacke,* p. 15.

rotated by a motor so that the direction of the vegetation's growth would be affected by the centrifugal motion.[141] The protagonist of such art is once again Haacke who demonstrates by it the process of life. He made in 1967 his *Grass Cube,* a Plexiglas container with soil on its top in which grass seeds were planted. Later, eliminating the container as superfluous, he made a *Grass Mound.* In 1969 a *Grass Cone* was done; it showed an uneven growth due to the uneven exposure of the cone's surface to the sun and weather. In another experiment at Toronto, Canada, repeated the following year at Saint-Paul de Vence, France, Haacke shaped growth by the use of humidity.

Haacke's studies of plant life were followed by studies of bird and animal life. A 1965 project for a show at Scheveningen, Holland, involving sea gulls was executed in 1966 at Coney Island: *Living Sculpture* showed the birds diving for crumbs of bread. However, the best known of Haacke's animal studies are his Chicken Hatchings in incubators, started in 1969. When shown in the context of an exhibition, the hatching and growth of the chickens form part of the work. Other animal experiments involved a cooperative venture of ants in an artificial environment (1969), a record of the reactions of tortoises (1970), and a study of the behavior of a goat grazing in a forest (1970).

Haacke's reasons for making these works are philosophical and artistic. Philosophically, Haacke is concerned with systems: starting from physical systems he turned to biological ones and finally to social ones. Artistically, Haacke wished to make the spectator aware of the passage of time through confrontation with change and growth.

Haacke's biotic art is characterized by his application of the laws of physics. He influences his living organisms by subjecting them to heat (hatching), humidity (growth), etc. The Filipino artist David Medalla, who lives in London, is interested in the performances of living organisms as substitutes for man. In his biotic art the animals are left to themselves.[142]

[141] Fry, *Hans Haacke,* pp. 15–16.
[142] Burnham, *Beyond Modern Sculpture,* pp. 345–346.

The earliest instance of a living animal used in a spectacle in contemporary art seems to be Tinguely's dove, which was supposed to soar upward from a machine that was destroying itself in the Copenhagen demonstration of 1961, the dove's flight being a symbol of the prisoner's liberation. But the dove did not succeed in escaping; it was found dead among the debris of the machine, causing unfavorable comment by the Danish SPCA.[143] Who can say whether or not the failure was part of the program?

Medalla is a counterpart of Haacke in many respects. He also works with foam, wave formations (formed by him from sand dunes), mist, and frost. His experiments with live animals show snails making sounds by moving over touch-sensitive plates, shrimps executing underwater ballets, and ants marching in regimented patterns in sealed containers.

It is important to note that the artist's contribution to works demonstrating growth, or to spectacles performed by animals, is limited to the selection of the material and setting. The artist does not control the motion of the work.

Many other airborne, hydraulic, and biotic works could be mentioned, but few of them create more than a fleeting aesthetic experience. Once seen, such works have exhausted their charm. As stated by Elena Calas, "aesthetic pleasure and curiosity are not to be confused." [144] Moreover, the artistic effect is usually a copy of a natural effect instead of a retranslation of nature into artistic terms. Originals are always more stimulating than copies.

The reason for the limited number of interesting airborne, hydraulic, and biotic sculptures may be that the technological problems inhibit the creative vision. Haacke, who has covered in his pioneering work nearly all aerodynamic solutions found in other artists, commented on this aspect in his address to the Intersocietal Color Council in 1968, as follows:

[143] Tomkins, *The Bride and the Bachelors,* pp. 183–184.
[144] Calas, *Icons and Images of the Sixties,* p. 300.

Aerodynamics proved to be an extremely inaccessible field for lay-men. It was hard to get advice and to develop an intuitive under-standing for the important factors. The difficulties were great in harnessing the movement of air and to predict its effect on light-weight bodies and fabrics, so as to arrive at aerodynamically viable designs. Even engineers seem still to rely a lot on trial and error when tackling this delicate and elusive medium.

He went on to outline the dangers an artist faces when venturing into this field.

Since floating sculptures, figuratively speaking, don't stand with both feet on the ground, they are extremely sensitive, easily injured, and susceptible to react to the slightest changes in their environment. If the source of air-motion, an electric fan, for example, does not supply a consistently even flow of air and is not directed at all times into exactly the same direction, the floating body or fabric immediately reacts and, depending on its aerodynamic stability, regains a new equilibrium. Also, outside drafts can influence the system. The be-havior of air-buoyant objects resembles that of a thermostatically controlled set up. In their attempt to adjust to prevailing environ-mental conditions, they alternatingly overshoot and aim too low, thus being caught in an interminable state of oscillation. If conditions change abruptly and to an excessive degree, floating objects crash and will not recover, similar to living organisms.[145]

[145] From an unpublished manuscript; German translation in Fry, *Hans Haacke,* pp. 42, 43.

VI

The Desanctification of the Artist and the Desacralization of the Art Object

At the same time, the over-estimated role of the artist-creator is being questioned.

—Groupe de Recherche d'Art Visuel, 1966

I am tired of monuments, these tokens to eternity.

—Allan Kaprow, 1959

The origins of the power to create are still a mystery, in art as well as in life. Consequently, throughout the ages, the artist has been considered something special: if not divinely inspired, at least better endowed than the average man. Such a view informs Clyfford Still's statement of 1966: "Art is the only aristocracy left where a man takes full responsibility." [1] Concomitantly with the artist, his creation—the art object—was sacralized, but on its own terms. The emotive power of the work and its durability, reaching so far beyond the life-span of the individual, formed the bases on which art was accorded this privilege.

[1] *Clyfford Still: Thirty-Three Paintings in the Albright-Knox Art Gallery* (Buffalo: The Buffalo Fine Arts Academy, 1966), p. 18.

318

The concepts of the artist's priesthood and mystical properties of the art object have been discredited by contemporary artists. The rejection of these particular traditions cuts a deeper swath than the insurrections against the codified traditions in content and form and species. To start new developments in content, to bring about an uproar in form, to transgress the barriers between the arts were well within the realm of avant-garde thinking. No sooner is a formula exposed by the critic than it becomes exhausted for the artist, and he will search for a new, contradictory solution to prove that art cannot be delimited by rules. He succeeds because the resources of art and the resourcefulness of the human brain seem to be inexhaustible. But the demythification of the artist and demystification of art stepped beyond the confines of avant-garde thinking since the beliefs in the artist as the "anointed one" and in creation as a magic act can be traced through the fathers of modern art. Cézanne brought the first point up in posing a rhetorical question to his dealer, Ambroise Vollard, in a letter written in 1903: "Is Art, indeed, a priesthood (*sacerdoce*) which demands pure servants, wholly dedicated to it?," he pondered.[2] What else but belief in the immortal power of their hands made Picasso and Pollock imprint them on their works?[3] Any medicine man can tell you that they thus transmitted the power of the hand to the object touched.

Curiously, the desanctification of the artist and the desacralization of the art object are due not so much to the efforts of the Groupe de Recherche d'Art Visuel, which set itself the task "to demystify creation as being a magic, exceptional act, to question the myth of the artist, unique and a genius, creator of immortal

[2] Paul Cézanne, *Correspondance,* ed. John Rewald (Paris: Bernard Grasset Éditeur, 1937), p. 252. If Rewald's transcription is accurate, then Cézanne spelled art with a capital letter.

[3] Picasso, in illustrations to Paul Éluard's *La Barre d'appui,* illustrated in Alfred H. Barr, Jr., *Picasso. Fifty Years of His Art* (New York: The Museum of Modern Art, 1946), p. 194; and Pollock, in *Number One* (1948; The Museum of Modern Art, New York), illustrated in Bryan Robertson, *Jackson Pollock* (New York: Harry N. Abrams, 1960), Fig. 136.

works," [4] as to creeds that declared the insane and the machine equal to the artist in power to create; that declared junk, nonsense, and foul objects equal to the art object in power to move us.

1. *The Insane as Artist*

Madness lightens its man and gives
him wings and helps to have vision.
—Jean Dubuffet, 1949

The possible relationship between insanity and genius, suggested by Cesare Lombroso in 1877, is a problem as tantalizing as procreation and creativity. "Only the physically unfit among men compose poems, pluck the lyre or swing the paintbrush," Jean Arp wrote in 1932.[5] Although Arp refers to abnormality and not to insanity, although he considers this state desirable, his words could not have been written before Lombroso. Perhaps it is the specter of ab- or subnormality that makes contemporary artists deny that they are different from the average man and posit that any person can be a creator. "But I am afraid of the word 'creation,'" Duchamp told Pierre Cabanne in their conversations in 1966, ". . . fundamentally, I do not believe in the creative function of the artist. He is a man like any other man, that is all." [6]

There have been many cases of artists who became insane, but the percentage is probably not higher than in nonartists; Hugo van der Goes, Franz Xaver Messerschmidt, and Vincent van Gogh are among the better-known ones. Many other artists have exhibited curious or even psychopathic traits, but once again the percentage is probably not any higher than that of nonartists; Leonardo's fear of spies, Michelangelo's custom of sleeping in his boots, and Cézanne's aversion to physical contact come to mind. The works of

[4] *Yvaral* (Paris: Galerie Denise René, 1969), unpaged.

[5] *The Dada Painters and Poets: An Anthology,* ed. Robert Motherwell (New York: Wittenborn, Schultz, 1951), p. 222.

[6] Pierre Cabanne, *Éntretiens avec Marcel Duchamp* ([Paris]: Éditions Pierre Belfond, 1967), p. 19.

such artists have to be differentiated from the works of the insane nonartists, as well as from their own works done during fits of madness. The works of the mentally ill have been studied by Hans Prinzhorn, Ernst Kris, and Francis Reitman, but as psychoanalytical revelations rather than as art. Reitman has pointed out that their doodles are not tied together compositionally; without structuring, they cannot be considered art.[7]

Such considerations are quite foreign to Jean Dubuffet who feels that the unconscious is an excellent guide to vision (see epigraph). He said in 1951 in "Honneur aux valeurs sauvages" that "it is the *raison d'être* of art to be the road of expression for the underlying strata, for the levels in depth." According to him, reason, thinking cannot produce art. "Which country does not have its little section of cultural art, its brigade of career intellectuals? . . . This activity, does it have anything to do with art?" he asked in 1949 in "L'Art brut préféré aux arts culturels." As is evident from the article written in 1951, what Dubuffet appreciates in a work of art is "that its author has uncovered in it, has invented through it, ways to pierce his surface strata and to open a passage to the voices of his underlying strata—and, through that, also concomitantly to ours [i.e., to open a passage to the voices of our underlying strata], from the moment this work is before our eyes."[8] Since the unconscious is freer to operate in abnormal people than in normal people, it follows that the painting and sculpture of the mentally sick represent art at its highest peak.

Starting from this premise, Dubuffet collected the precious art produced by

those strange and inspired spirits, those IRREGULARS of art, innocent and mostly devoid of culture, seers and clairvoyants, rich in presentiments and visions, sensitive to all sorts of correspondences, nonprofessionals who use art as a means of exorcism. These beings,

[7] Francis Reitman, *Insanity, Art and Culture* (Bristol: J. Wright, 1954), p. 14.
[8] *Prospectus et tous écrits suivants,* I, ed. Hubert Damisch (Paris: Éditions Gallimard, 1967), pp. 198, 207.

often reduced by their exclusive preoccupations to an extreme help-
lessness (*denuement*), ignorant of all technique, obsessed and mania-
cal, lacking relationships—except sometimes medical ones—are scat-
tered throughout the most distant provinces. Some live in the psy-
chiatric asylums.

This is a description by Dubuffet's lifelong friend, the poet Georges
Limbour.[9] The *irregulars,* who step out of line, were contrasted by
Dubuffet with the *homologizers,* those who follow the outworn ruts
of the Beaux-Arts. The first create valuable *brut art,* the second,
cultural art, that is, academic art.

How Dubuffet became involved with, and interested in, these
people has also been told us by Limbour. It happened about 1923,
before the flood of articles on children's art and the art of the insane
was launched. Dubuffet was discharging his military obligation at
the meteorological observatory in the Eiffel Tower. One day the
National Meteorological Office distributed a questionnaire among
the public, requesting a report on the sky as it looked at a given
date and time. In response, a sketchbook by a lady, containing
drawings of a sky filled with corteges, carriages, and all kinds of
apparitions, was received at the Eiffel Tower station. Dubuffet hap-
pened to see it and was enchanted. He visited this visionary and
collected other sketchbooks by her with similar curious and pas-
sionate visions. Then he got in touch with other seers, correspond-
ing with them regularly—sometimes, when the visionary was unable
to hold a pen, through the mediation of the doctor. Later, during
his travels in Switzerland, France, and other countries after World
War II, Dubuffet was able to collect an abundant documentation on
the art of the irregulars. His favorites were two inmates of Swiss
asylums: Heinrich Anton and Jeanne the Medium. About 1947 the
Society for Brut Art was founded to organize exhibitions and to
publish articles, such as Dubuffet's "Brut Art Preferred to the Cul-
tural Arts." Both *brut art* and the article can be studied in the

[9] Georges Limbour, *L'Art brut de Jean Dubuffet: Tableau bon levain à
vous de cuire la pâte* (New York: Pierre Matisse; Paris: René Drouin,
1953), p. 57.

catalogue of the show held at the Galerie René Drouin, Paris, in October 1949.

Dubuffet's own art picked up traits of his protégés, a fact also noted by Limbour, who is, however, quick to emphasize that "it seems impossible to place on the same level their works and those of their admirer."[10] He is quite right, of course, but that did not prevent Dubuffet's enemies from being given a handle with which to disparage his works. What is more, a bridge had been constructed between structured and nonstructured art, confusing further the already confused mind of the average man. He reacted by labeling modern art the effusions of madmen.

Another outcome of Dubuffet's theories is as damaging to art. If the artist needs only instinct and no brain power to create, then his cousin, the ape, can create art as well. The artistic abilities of chimpanzees were widely advertised in 1957 and 1958 through newspaper reports, a book on the London chimpanzee Congo, and the exhibition at the Institute of Contemporary Arts in London.[11] This exhibition featured the hand-painted pictures of the ape Betsy from Baltimore, and the crayon-on-paper and brush-painted pictures of the ape Congo from London. Of course, the argument can be presented in reverse, and it can be claimed that Betsy and Congo did better pictures than other chimpanzees just because their thinking power was better developed. But the man on the street would only see the similarities between the pictures of the chimpanzees and those of the abstractionists, both of which made "no sense" to him. The relationship confirmed his adverse judgment of modern art.

2. *The Machine as Artist*

> It proves that anyone can make an
> abstract picture, even a machine.
>
> —Jean Tinguely

[10] *Ibid.,* p. 60.
[11] Julius Huxley, "Aping the Artist," *The New York Times Magazine* (October 6, 1957), p. 94; "Chimpanzee's Daubs," *Newsweek,* (November 10, 1958), p. 94.

The idea of making a machine perform an artistic act occurred to Tinguely in 1959; this *Meta-matic* is a variety of the artist's *meta-machines* invented in 1953, after he moved to Paris.

The first meta-machine, a meta-mechanism, consisted of wire constructions and reliefs in which some units were mounted on axles and put in motion through "meta-mechanisms" behind the images. In 1955 Tinguely improved upon this idea by shaping the units in his meta-machines as imitation Herbins, Kandinskys, and Malevichs, and the Meta-Herbin, Meta-Kandinsky, and Meta-Malevich series were born; they presented images similar to those of the three artists —but in motion. The *Meta-matic* is another improvement on the meta-machines; it presented a robot, an idea going back to antiquity. About A.D. 100 Hero of Alexandria had instructed the readers of his treatise on mechanics on how to make automatons, among which dancing figures were also listed. The earliest instance, known today, of such robots having actually been constructed occurs, however, only in a sixth-century description of a mechanical clock in the tower of Gaza, Israel, each hour being marked by a statue of Herakles performing one of his twelve labors.[12] Tinguely's robots, the meta-matics and sonorous-metarobot-painting machines (*métarobots-sonores-machines à peindre*), consisted of old car parts, activated by electric motors or pedals, and they performed the labors of the Tachists and Action painters. They walked around, made noises, and drew abstractions (see Fig. 50). Each drawing was unique in form since the robot used a system of asynchronous gears, which made its movement unstable and thus nonrepetitive.

Tinguely's biographer, Calvin Tomkins, has described these machines, as follows:

They are handsome pieces made up of black metal plates and rods welded together. Each one has a complicated mechanical arm operated by a small motor and fitted with one or more clamps, in which can be placed crayons or inking devices. When the meta-matic is put

[12] K. G. Pontus Hultén, *The Machine* (New York: The Museum of Modern Art, 1968), p. 7.

50. Jean Tinguely: *Meta-matic No. 17*. 1959. Iron. 118″. Installation Ière Biennale de Paris. Collection of Moderna Museet, Stockholm. Photograph: Galerie Iolas, Paris.

into operation by the spectator, the arm moves erratically over a clip board holding a sheet of paper. The spectator can stop or start the machine at will, change the colors, and exert some control over the speed at which the arm moves. Some initiates claim that the personality of the operator gets into the painting, and it is certainly true that no two paintings made by the same machine are ever quite alike. Few people can resist trying their luck, and the results, as often as not, are not only distinctly pleasing but uncomfortably close to certain contemporary paintings produced by the unaided human hand.[13]

In July 1959 an exhibition of the Meta-matic series opened at the Iris Clert Gallery in Paris. It drew flocks of people to the small gallery, which had to stay open until midnight to permit the flow of some three hundred daily visitors. For the Clert show Tinguely devised a competition for the best picture made on one of his machines. He also insured for himself the following of the anti-Tachists and other anti-abstractionists by telling a reporter that his machine was "an anti-abstract machine, because it proves that anyone can make an abstract picture, even a machine."[14] This barb directed against abstract painting resulted in the banding together of those ridiculed in order to keep Tinguely out of the Paris Biennial. They succeeded in having his machine banned from the Musée Municipal d'Art Moderne, where the Biennial was scheduled to be shown in October, on the basis that his gasoline-operated *Meta-matic* would be a fire hazard, endangering the visitors and the works of art. Tinguely was not fazed. He merely placed his eight-foot machine outside the entrance to the building. There, according to Tomkins,

it so fascinated visitors that some of them never got into the museum at all. The meta-matic walked, danced, broke down, was repaired (Tinguely, as usual, was on hand to fix it), mesmerized children, created some thirty-eight thousand abstract paintings during the two weeks of the Biennale, and was praised as "a good machine" by

[13] *The Bride and the Bachelors,* enl. ed. (New York: The Viking Press, 1968), p. 163.
[14] *Ibid.,* p. 164.

André Malraux, the Minister of Culture. Malraux had the misfortune to be standing in front of the meta-matic when a balloon attached to the exhaust pipe exploded in his face.[15]

Another event sponsoring the Meta-matic series soon followed. For his show at the Kaplan Gallery, London, Tinguely scheduled a lecture at the Institute of Contemporary Arts. The lecture's text was drawn from the famous manifesto *For Statics,* which the artist had distributed from an airplane over Düsseldorf in 1959, on the occasion of another exhibition. It advocated: "Be static—with movement. . . . Stop insisting on 'values' which can only break down. Be free, live. Stop painting time. Stop evoking movement and gesture." [16] The London lecture was delivered by means of a record Tinguely had made beforehand in English; while it played, he sat mute on the stage, illuminated by a spotlight. The tape contained not only the speech but also the corrections in English pronunciation and grammar that had been made by somebody else. Moreover, a duplicate tape was played simultaneously, slightly out of sync, like a Bach fugue. Thus words could be heard, but the sentences could not be followed. The *Meta-matic* appeared first in the intermission, in which a French girl walked up and down the aisles, producing abstract drawings on a hand-operated *Meta-matic* to the tune of Paul Anka's "I'm Just a Lonely Boy." The *Meta-matic* also filled the second portion of the evening. In it, the program sponsored a contest between two cyclists mounted on a *cyclo-graveur* (bicycle-engraver) *Meta-matic.* Two young men competed to see who could turn out more drawings by pedaling the machines around. Their furious activity released a stream of paper with yards of drawings that, shooting beyond the stage, buried the audience in a reversed ticker-tape parade.[17]

Whether or not Tinguely's meta-matic demonstrations were dictated by his sense of humor or by serious thinking, by objection to

[15] *Ibid.*
[16] *Ibid.,* p. 162.
[17] *Ibid.,* pp. 164–166.

abstract art or by love of playing games with machines—or all of these—is irrelevant to the effect they had on the general public, which would not be aware of the overtones: they demoted art, and not only that of the abstractionists. The conclusion that a machine can do what the Tachist or Action painter does could easily be extended to embrace all of modern art. The emotive character of art was deflated: tragedy had been shown to be comedy.

3. From Found to Discard Object, from Form to Function: The Battle Against the Essentials of Art

> You're getting rid of the things that people
> used to think were essential to art.

—Donald Judd, 1966

In November 1963 Robert Morris accompanied one of his works, a relief of a series of keys on a key ring entitled *Litanies* (The Museum of Modern Art, New York), with the following statement, which he had authenticated by a notary public: "The undersigned, ROBERT MORRIS, being the maker of the metal construction entitled LITANIES described in the annexed Exhibit A, hereby withdraws from said construction all esthetic quality and content and declares that from the date hereof said construction has no such quality and content." [18] Morris' voiding his work of aesthetic quality is related to Duchamp's 1966 statement: "One must arrive at something of such an indifference that you have no aesthetic emotion. The choice of Ready-mades is always based upon visual indifference at the same time as upon the total absence of good or bad taste." [19] Applied to a work of art, such a position questions its nature, as it is defined traditionally. According to Morris and a score of other contemporary artists, form and content are unessential in art.

[18] *Art Povera,* ed. Germano Celant (New York: Praeger Publishers, 1969), p. 192.
[19] Cabanne, *Éntretiens avec Marcel Duchamp,* p. 84.

This attitude of hostility toward everything sanctioned by tradition has deep roots in the thought of the twentieth century (compare Tinguely's Düsseldorf manifesto), and stretches back into the nineteenth century. The assault on content in art was initiated, I believe, by the Impressionists, who stressed the importance of technical method over that of subject matter. Based upon the continuing weight placed on the formal element in art, abstraction could do away with subject matter altogether—that is, subject matter as it is defined in traditional terms. I have shown above how this term was restructured by contemporary art, and it is against this extended meaning of the word *content* in the form of nonobjective symbolism that Morris reacted.

As for the fight against form as a basic tenet of art, it is a century younger than that against content. I believe it was begun by the Dadaists and carried on by the Surrealists who sponsored chance, accidents, and automatism as the true foundations of art. Works produced by these methods and works subject to the vagaries of the wind or the push of a hand may lack aesthetic quality. Although it is possible to eliminate what would prove unsatisfactory in static art and programmed Kinetic art, mobiles cannot be organized to form predictable visual images. Therefore, Rudolf Arnheim, the Gestalt psychologist, rejects them as art, comparing them to the "playful, accidental pattern that we observe with pleasure but without admiration in kaleidoscopes." [20] The Minimalists, who base themselves on the Gestalt theory, accept form as a given premise of the simple geometric shapes they use, but they do not seek to enrich the formal vocabulary of art: "In recent object-type art the invention of new forms is not an issue. A morphology of geometric, predominantly rectangular forms has been accepted as a given premise." [21] This statement is again by Morris, who is one of the most vocal of these artists. The breach made in the defenses of art as

[20] Rudolf Arnheim, *Art and Visual Perception: A Psychology of the Creative Eye* (Berkeley, Calif.: University of California Press, 1954), p. 333.
[21] "Anti Form," *Artforum,* VI, No. 8 (April 1968), p. 333. By anti-form, Morris and the Minimalists really mean antitraditional composition as it was, and is, practiced, namely, a relationship of part to part.

form has not been plugged by the Minimalist position of indifference to it.

Content and aesthetic quality are not the only traditional essentials discarded by contemporary art, yet there was no need for Morris to mention others because these other sacred cows had already been disposed of. To wit, Morris anathematizes neither the concept of art as something eternal nor the use by artists of precious materials. The fight against these had been started by Edgar Degas when he clothed his bronze *Young Dancer* with a perishable tutu in 1880; it was carried on by Picasso, who introduced paper that yellowed into his ink drawing *The Bathers* (1908; see chap. 5, n. 4); and it was terminated by Kurt Schwitters who composed his collages, Constructions, and *Merzbau* mainly of throwaways after World War I. Concomitantly with Schwitters, André Breton formulated the principle of the perishable art object in its most trenchant manner when he wrote in *Two Dada Manifestoes* (before 1924): "It is inadmissible that a man should leave any trace of his passage on earth." [22] By 1931 the idea that a work of art should have a life cycle had been accepted, and Duchamp, who sixteen years earlier had chosen glass as a medium to protect the paint from change, would forbid the repairing of the cracks his *Large Glass* had acquired accidentally.

Another traditional "must" not mentioned by Morris, because it was already dead, is the notion that a work of art needs to be fashioned by the hand of the artist. Degas' tutu, Cubist newspapers, Schwitters' Merz ingredients—all manufactured objects—challenged this concept, and it was administered the coup de grace when Duchamp's Readymades were accepted as works of art, proving that the artist's eye alone, without his hand, was capable of doing the job. Morris also does not mention originality as dispensable. It was left to Harold Rosenberg to proclaim that trait as unessential in a work of art. The critic advanced as believable the theory that Arshile Gorky deliberately rejected originality.[23] Even though only

[22] Motherwell, *The Dada Painters and Poets: An Anthology*, p. 203.

an interpretation and not proven, it is significant that such a thought could be entertained.

To sum up the present-day situation, most of the best work is intentionally made in commonplace and perishable material so that it will end up in a garbage can within a predictable period of time. Its fate is unredeemable. Kaprow, who noted this fact, motivates the choice with the words: "The spirit does not require the proofs of the embalmer. If one cannot pass this work on to his children in the form of a piece of 'property,' the attitudes and values it embodied surely can be transmitted." [24] We see here a formulation of the principle that the concept or ideation of a work of art outweighs its manufacture, a principle that will be explored in detail below. According to Kaprow, the choice of making artworks nondurable reflects the importance of change, which governs both reality and art. Reality has to be understood as a constant metamorphosis.

But why has it all at once become so important to reflect change in art? After all, change has always governed our life. Yet for thousands of years the belief that art is something unchangeable had been the counterweight to change in life: it has been man's refuge from the ravages of reality. Why should art all at once become the ally of death, who constantly defeats us? Why should it now become his ally, instead of helping us to contend for victory against him? Why should art all at once become the floodgate instead of the dam? Kaprow has not explained that.

Before change could become a formal desideratum of art, immobility as a forming principle had to become obsolete. Immobility is a quality inherent in the nature of the art object. However, when the Industrial Revolution and the growth of cities had forced man to reevaluate stasis as stagnation, art followed suit in trying to cap-

[23] William Rubin, "Arshile Gorky, Surrealism, and the New American Painting," *New York Painting and Sculpture: 1940–1970*, ed. Henry Geldzahler (New York: E. P. Dutton and Co., 1969), p. 377.

[24] *Assemblage, Environments and Happenings* (New York: Harry N. Abrams, 1966), p. 168.

ture a world in flux, instead of a moment arrested in time. This presents quite a problem in painting and sculpture, a problem that was solved in various ways by the Impressionists, Cézanne (whose greatness lies in having found a means to combine the image of flux, demanded by his time, with the image of permanency, given by the nature of art), the Cubists, and the gestural artists.

With the image of flux as a basis, the acceptance of change as a forming principle in contemporary art, manifested through the intentional choice of perishable material, became possible. Its rapid spread may be rooted in today's quick turnover of goods: the monthly replacement of toys for the young and gadgets for the young in mind, the seasonal choice of new clothing, the yearly investment in a new refrigerator and radio, the biennial purchase of a new car, the quadrennial moving from apartment to apartment and job to job, and the decennial acquisition of a new house. Once you grow up in this atmosphere, you become conditioned to the expendability of things. Likewise, if you grow up on prepared and canned food, they will taste better than food made at home.

How about the patron who invests large sums of money in nondurable goods? Well, he also is conditioned to the concept of expendability. Furthermore, to invest capital in objects perhaps to be thrown away proves the sincerity of his interest in art. Untainted by the idea of financial gain, he buys for fame and pleasure alone. He makes a gift to the artist, not a purchase from him, when he acquires his work.

Thus Change spelled with a capital letter could become a forming principle for art. As noted by Kaprow, it manifests itself through works that are never finished, whose parts are detachable, alterable, and rearrangeable. It also manifests itself through making the creation, growth, and decay of an art object part of the work's experience.[25] The decay is a function of nature; thus nature joins the artist in fathering the work.

[25] *Ibid.*, pp. 168–169.

4. The Remythification of the Artist and the Remystification of the Art Object

Myths die hard, even if they are completely fictional, which, in my opinion, is not the case with the myth of the artist. Although I do not concur with Cézanne, Picasso, and Pollock in seeing him as a magician, I consider him better endowed than the average man and differently endowed than the scientist. Since, for a vanguardist, Cézanne, Picasso, and Pollock are formidable allies to draw upon as precedents, it is not surprising that a remythification of the artist and remystification of the art object took place concomitantly with the demythification and demystification.

The case for the artist as a magician was furthermore strengthened by the misunderstanding of Duchamp's Readymades. When, in 1913, he made us believe that a bicycle wheel could be converted from a manufactured object into a work of art by a sacramental act, similar to the conversion of a commoner into a king, his aim was to ridicule the pompousness of art. Duchamp as the priest sanctified the wheel by the laying on of hands (carrying it home) and, in a later version, by anointing (placing his signature on version No. 3 of 1951). Probing further into the subject of sanctification in 1919, the artist-priest now delegated the sacerdotal power to his sister. From South America he bade Suzanne Crotti to expose a geometry book to the accidents of the weather in France, which she did, thus creating the *Unhappy Ready-made,* a "naturally corrected" Ready-made.[26] But it so happened that Duchamp's poisoned arrows were either ignored or misinterpreted. When artists, critics, and art historians took note of the Readymades, they did not see beyond the surface. They accepted the dispensation of Grace by the Divine Master as genuine; ennobled through it, the objects had become works of art. No wonder the self-ordained high pontiff of art was disgusted with man's incorrigible denseness.

[26] Robert Lebel, *Marcel Duchamp,* new ed. (New York: Paragraphic Books, 1967), p. 45.

A. INTERLUDE: THE TRAILBLAZERS

He exists, in a state of profound illumi-
nation.
—Yves Klein, before 1962

In January 1961, I constructed the first
"magic base."
—Piero Manzoni, 1962

The remythification of the artist and remystification of the art
object was spearheaded by two artists: Yves Klein and his follower
Piero Manzoni.

Yves candidly believed in the metaphysical power of the artist.
Leading like Ariadne's thread through the metaphysical depths of
Yves's thought, the words *illumination* and *live* appear again and
again in his writing: the painter exists in a profound state of illumina-
tion, and paintings are live presences. But the canvas is an inert
piece of material! How then to transform it into a living substance?
Yves borrowed from a realm within the comprehension of all view-
ers: religion. More specifically, he utilized transmission by contact,
a ritual act well documented in religion in the healing powers at-
tributed to relics. In his attempt at the remythification of art, Yves
used human beings and the elements as his tools for creating art
objects, and then consecrated these by ritual acts. This is clear from
Yves's actions and statements. His art has been named New Realism.

The Blue Anthropometries were first shown in 1960 at the Galerie
Internationale d'Art Contemporain in Paris, and later recorded in
the film *Mondo Cane* (1962). The idea of utilizing human bodies
for recording their activities had come to Yves in Tokyo in 1953,
when he saw the imprints formed of sweat and dust that the bodies
of judo wrestlers left upon the white rugs. He suggested to a film
producer that the marks of bodies in beach sand, or their sweaty
outlines on sheets, be shot as signs of amorous struggles. When the
presence of human shadow imprints at Hiroshima became known,
representing the immaterial remains of human bodies consumed in

the holocaust, Klein remembered his idea. One day in Paris in 1960, when looking at the models in his studio, he conceived the plan of immaterializing the body by recording its imprint in paint. Nude models would cover themselves with blue color and, under Yves's direction in immaculate formal dress, to the sound of music, they would stamp themselves on a canvas or paper, which had been tacked to the wall or laid on the floor. First, these imprints were made by bodies in repose, later by bodies in motion.

In another type of Anthropometries, much fewer in number, Yves's friends or models would cover their bodies with blue paint and then wrap thin linen sheets around themselves. Or, again, the body was placed in front of the sheet and paint sprayed around its outlines, forming negative imprints. In principle, the whole body was imprinted on the regular Anthropometries, forming a kind of full statement; only portions of the body appear here, more hinting at its existence than stating it. These special Anthropometries, Klein called *Sudaria* (*Suaires*). One of these Sudaria (Ant. Su. 11), shown in the Palais des Expositions de la Porte de Versailles in 1960, is a group portrait of the New Realists. It forms a counterpart to the panel copied from a Masaccio or Paolo Uccello that depicts *The Founders of Florentine Art*—Giotto, Uccello, Donatello, Manetti, and Brunelleschi, now in the Louvre, Paris.[27] Another Sudarium, entitled *Scroll-Poem* (*Store-Poème*), executed on March 1, 1962, in Klein's apartment (Ant. Su. 15), mixes the poetry of Yves Klein, Arman, Claude Pascal, and Pierre Restany with their body imprints. Obviously, the Sudaria had a more intimate meaning for Klein than the "normal" Anthropometries. What was it?

Suaire is the French title of the pictures called in English, *The Veil of Saint Veronica*.[28] But Klein linked his Sudaria to the sweaty

[27] John Pope-Hennessy, *The Portrait in the Renaissance* (New York: Bollingen Foundation, 1966), Fig. 21.

[28] See Louis Réau, *Iconographie de l'art chrétien*, Vol. II, part 2, (Paris: Presses Universitaires de France, 1957), p. 19: *Le Suaire de Véronique*. The term *anthropometry*, on the other hand, is used by the Sûreté (the French FBI) to denote the measurements of a criminal. It can be found in a Matisse statement published by Raymond Escholier, *Matisse ce vivant* (Paris: A. Fayard, 1956), p. 189.

traces of judo wrestling, not to the face of Christ. Yet, the *vera icon* mysteriously imprinted upon the cloth offered by the saint to Christ on the road to Calvary, for wiping the sweat off his face, could have served to prove Klein's contention that human bodies have an immaterial existence outside themselves, an existence demonstrated to him by the shadow images of Hiroshima.

Long before Haacke composed his meteorological works, Duchamp's *Unhappy Ready-made,* created by proxy, was a work formed by atmospheric conditions. Yves Klein's Cosmogonies of 1960 also antedate Haacke in utilizing nature to create art objects. Like Duchamp, Yves exposed a work to the weather. But Duchamp had used a geometry textbook, whereas Yves used a monochrome blue painting by his own hand. He would strap such a canvas onto the roof of his white Citroën in which he traveled on Route Nationale No. 7 from Paris to Nice at a speed of 100 km. (62 miles) per hour—the round figure obviously chosen for its implications of magic power—offering the canvas to the heat and the cold, the light, wind, and rain. In one day the painting aged thirty to forty years.[29] Yves also made special Rain Cosmogonies. He would place a canvas on the ground on a rainy day, and then throw powdered blue color into the air. As the rain encountered the pigment, it carried it along, depositing it upon the canvas as a sediment. The hand of God or nature? Predestination or chance? Which of these powers helped in forming Klein's art?

Following the exposition of his Fire Fountains and Fire Wall at Krefeld (Fig. 48c, p. 307), Yves turned to the creation of Fire Paintings. That was in 1961. Asbestos panels painted in blue and red colors were scorched with jets of burning gas. In later examples the panels were dampened so that they showed the traces of fire without being consumed, like archaeological remains that have undergone a conflagration. Two other series combined fire painting with body and/or plant imprints, sometimes in a coloristic trilogy of blue, red, and gold. Yves's spurting living death with the blowtorch to create these

[29] Yves Klein, *Le Dépassement de la problématique de l'art* (La Louvière, Belgium: Éditions de Montbliart, 1959), p. 38.

Fire Paintings inevitably brings to mind Zeus Kataibates (Jupiter Fulgur) and the lightning's kiss of love-death, which transforms the thing it touches into an *enelýsia,* that is, a consecrated ground.

Klein's selling of zones of immaterial pictorial sensitivity for ten-gram ingots of gold has already been mentioned (chap. 3, sec. 2). Yves acknowledged receipt by issuing a check for the respective amount, authenticated by a seal of guarantee. Five checkbooks and nine receipts are preserved, one a sale to Edward Kienholz, the West Coast Pop artist. The text read: "Received . . . Grams of Fine Gold against one Zone of Immaterial Pictorial Sensitivity," and it contained the name of the locality where the transaction was concluded, the date of the transaction, and Klein's signature. In addition the following annotation was put in boxed type: "This transferable zone cannot be ceded by its owner but for double the value of the initial purchase (signatures and dates of the transfers on the verso). The transgressor exposes himself to the total annihilation of his own sensibility." That was the normal type of transaction. But it was possible to make a more valuable purchase in which the buyer became one with the immaterial value of the zone he acquired. To qualify, he had to burn his receipt ceremoniously and then repurchase the zone a second time for the amount that had been specified on the receipt. In return, Yves le Monochrome was obliged to throw half of the gold into a place where it could not be retrieved in the presence of the purchaser, a notary public, and witnesses who were paid their fee in the form of one ten-gram ingot.[30]

In analyzing the meaning of this ceremony, as well as of other acts by Yves, you must conclude that these are rituals of consecration. What else could the following be? Yves offering a painting as a holocaust for the "triumph of blue" at the Colette Allendy exhibition of 1957; Yves dispensing the tithe to the witnesses of his sale of immaterial pictorial sensitivity and offering a libation of gold

[30] Pierre Descargues, "Yves Klein," *Yves Klein,* ed. Kynaston McShine (New York: The Jewish Museum, 1967), p. 24; Paul Wember, *Yves Klein* (Cologne: M. DuMont Schauberg, 1969), pp. 39–40.

to the river-god Seine after the buyer had burned the receipt of the transaction and scattered the ashes to the wind; Yves in tails presiding over an audience at the creation of Anthropometries to the sound of music; Yves marrying fire and water in the offices of the French Gas Company. All these deeds resemble religious rites. Jack Burnham has noted that the sight of Yves Klein rolling the naked female models over the surfaces of his canvases to create his Anthropometries, and wielding his torch to burn the paint on his canvases for creating his Fire Paintings, was infinitely more effective than the finished product. It is not so much Klein's capacity as an actor in a Happening that makes this true, as it is the artist's conviction that his work had a religious overtone, and as it is the nature of his materials.

Piero Manzoni was born in Milan in 1933 and died there at the age of thirty. His imaginative productivity and meteoric life are comparable to those of Yves Klein, by whom he was greatly influenced; in fact, he was launched by seeing, at the Galleria Apollinaire in Milan in 1957, what their French maker called "Blue Worlds," "chanting the immaterial," eleven identical pictures—yet each priced differently, because each portrayed "a different poetic moment." [31] The same year Manzoni created his beautiful Achromatics. They replace Klein's heavenly color with a virginal white. However, this is not the only important difference between Klein and Manzoni in their attempts at a remythification of the artist and remystification of the art object.

Like Klein, Manzoni used the human being as a tool for creating his work. But, unlike Klein who relied upon the violence of the elements, Manzoni relied upon the physical laws of nature. Also, anything connected to the process of life, physical and mythical in origin, was welcomed by Manzoni as material for his art. He has described what he considered his main achievements in a text written in 1962, just before his untimely death, *Some Realizations, Some*

[31] "The Monochrome Adventure," ed. Marcelin Pleynet, *Yves Klein* (1967), p. 30.

Experiments, Some Projects.[32] The following are excerpts from this text.

In 1959 Manzoni made pneumatic sculptures; forty-five Air Bodies (*corpi d'aria*), balloons with a maximum diameter of two feet, seven and one half inches (80 cm.) and standing to a height of three feet, eleven inches (120 cm.), including the base. He also designed a group of larger Air Bodies with a diameter of eight feet, two inches (2.50 m.) for a park, which moved individually, in a slow rhythm of inhalation and exhalation, upon a stream of compressed air. In his text the artist has the following comment on the small-sized Air Bodies: "In addition to the involucrum and base (enclosed in a small suitable case), the buyer could acquire also, if he wished, my breath to store in the same involucrum." We are reminded of the biblical passage that tells of God breathing the breath of life into Adam so that he became a living soul (Gen. 2:7). Also in 1959 Manzoni started on his Lines, strips of paper on which a line was drawn. These were then stored in sealed, colored cardboard tubes with the length of the line noted on them. It varies from sixty-three feet (19.11 m.) to about four and a half miles (7.200 km.). The lines remind us of the line of Life, studied by palmists, and of the thread of life spun by the Fates in mythology. Still in the same year and going into 1960 Manzoni turned to the idea of making a robot. He describes this attempt as follows:

For use outdoors I studied (1959–60) a sculpture with autonomous motions. This mechanical animal will be independent, for it will draw its nourishment from nature (solar energy). At night, it will close and withdraw into the self; during the day, it will ramble around, emitting sounds, rays, and [stretching forth] feelers in order to seek energy and avoid obstacles; besides, if possible, it will be given the faculty to reproduce.

It is not clear how this robot could reproduce itself. Be that as it may, here is a project for a new Adam-cum-Eve.

[32] *Piero Manzoni* (Rome: Galleria Nazionale d'Arte Moderna, 1971), p. 124.

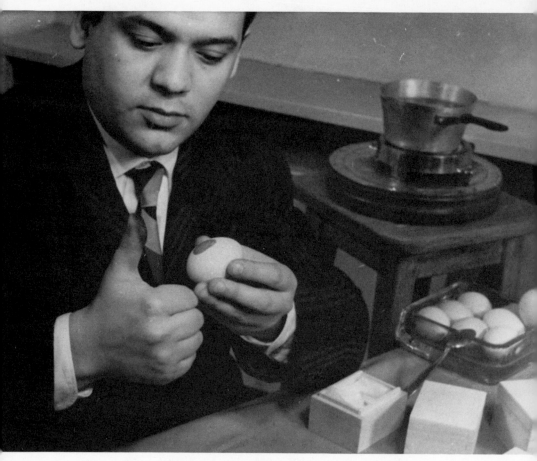

51a. Piero Manzoni thumbprinting eggs. 1960. Photograph: Henk Peeters, Leusveld/Hall, Holland.

In July 1960 Manzoni produced his one hundred and fifty eggs about which he has again written: "In 1960, during the two manifestations (Copenhagen and Milan), I converted hard-boiled eggs into art by putting my fingerprint on them. The public could enter directly into contact with these works by swallowing a whole exhibition in 70 minutes." From earliest times the egg has been considered potent with magic, an embodiment of life and fertility. This belief was inherited by Christianity. Decorated, hard-boiled eggs are

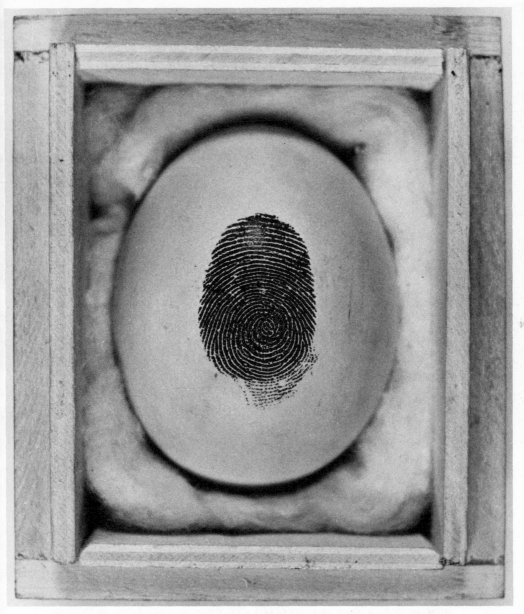

51b. Piero Manzoni: *Egg.* 1962. Collection Henk Peeters, Leusveld/ Hall, Holland.

eaten at Easter, the time of Christ's death and resurrection. The fingerprint served as a signature, authenticating the eggs as assisted Readymades that had been knighted by the artist's accolade (Figs. 51a, 51b). As for the meaning of the fingerprint, in it the laying on of hands as a magical act is combined with anthropometry in which the image is a magical sign: the body in Klein; the palm in prehistoric man, Picasso, and Pollock; and the fingerprint in Manzoni and Fontana (cf. Figs. 51, 29, pp. 340, 341, 201). The thumbprint is the most personal of these identification marks. Manzoni started to sell his right and left thumbprints as works of art in the year of the egg communion.

Then, in May 1961 the artist produced ninety containers of Artist's Shit (*merda d'artista*), each preserving one ounce (30 gr.), hermetically sealed and marked: "Produced by" with the signature "Piero Manzoni" following. Another, nonexecuted, project called for phials of Artist's Blood (*sangue d'artista*). The ritual significance of excrement as a fertilizer of the soil and the ritual significance of blood as a lien between brothers is obvious.

In these last months before his death Manzoni's activity and ideas reached a feverish pitch. Also in 1961 he began to sign his name on the bodies of girls and men, which he then exhibited as works of art. With each signed body went a certificate of authenticity. The Dutch Nul artist, Henk Peeters, is one of these indigestible variants of the thumbprinted eggs. These human Readymades seem to represent the ultimate art object in that genre, surpassing Duchamp in bizarreness.

Manzoni also outdid Duchamp in another respect, namely in the delegation of power to create. Duchamp had ordained his sister, another though lesser artist, which is quite in keeping with the rules of priesthood. Manzoni delegated the power to create art to a lifeless object. In 1959 the artist had already thought of exhibiting living sculptures. Now this project was brought to fruition. In 1961 he created the first *Magic Base* (*base magica*), affirming that "whichever person, whatever object, is to be upon it would be, as long as they remained there, a work of art." Manzoni created a second such

magic base in Copenhagen, while a third, made of iron, was placed, upside down, in a park at Herning, Denmark, so that this *Basis of the World* (*Socle du monde*) carried the earth. Just as the Titan Atlas, brother of Prometheus and grandchild of Heaven and Earth, carried heaven on his shoulders, so the base at Herning, child of Manzoni's brain and hand, " 'held up' the world."

The last works try to combine the three sides of Manzoni's genius: his impeccable feeling for form, documented by the Achromatics, his faculty of sensing the potential of new material for art, such as cotton wool, straw coated with kaolin, or luminous paint, and his power to invent mental games, documented by the experiments described above. At the turn of the year 1961/1962 Manzoni created his Bread Works, in which round rolls shaped in five sections were covered with plaster and set out in a grid pattern on a panel. Bread brings to mind the Eucharist as well as the rites of hospitality in which the guest is offered bread and salt—both joyous communal meals.

Was Manzoni committed to metaphysics, like Klein, or was he satirizing the stupidity of the world, like Duchamp? I leave this question open for the reader to decide through visual confrontation with Manzoni's work. Such a direct contact is necessary because Manzoni could be discussed here only from a specific viewpoint, unjustly favoring only the one unattractive aspect of his work and distorting his image as an artist.

With that we must leave the worlds of Klein and Manzoni, two artists who provided a short but lively countercurrent in the general trend toward demythification of the artist and demystification of the art object in contemporary art.

B. AFTERMATH: THE ARTISTIC IMPERATIVE

This is a portrait of Iris Clert if I say so.

—Robert Rauschenberg, 1961

The offspring of Klein and Manzoni can be found in an unsus-pected quarter. It is quite common today for an artist to present something disputable as indisputable truth, based solely on his "if I say so." As far as I know, the connection of this attitude with Klein and Manzoni has not been pointed out. Yet, Klein's sales receipts and Manzoni's authentications of living sculpture provide examples of this type—modeled after Duchamp's Readymades. This attitude may be called the *artistic imperative*.

The first if-I-say-so artist is Robert Rauschenberg. In 1961 he received a commission to do her portrait from the art dealer Iris Clert. In response he cabled her: "This is a portrait of Iris Clert if I say so." We are not told whether the telegram arrived COD, or what the charge for the portrait was. As is usual with Rauschenberg, his action is ambiguous. The cable can be interpreted not only as being an act of overbearance, but also as being a reference to Clert's sheltering *The Void:* for both Klein's pictures and Rauschenberg's portrait in the form of a cablegram presuppose the viewer has suf-ficient imagination to see what the artist sees. Whatever the meaning of Rauschenberg's gesture, one thing is certain. With him the artistic imperative comprises an ironical flavor, such as can also be found in his other actions. (For example, he used two works by other artists, which had been rejected from a planned exhibition, in one of his Combines that had been accepted for the same exhibition, a gesture of defiance ridiculing the initial decision.[33])

Morris' affidavit regarding *Litanies* is another case in point of the if-I-say-so art object. Morris is, however, as deadly serious as Klein in his use of the artistic imperative. What is more, for him it is a tool of warfare. Following Morris' example, the New York Con-ceptualist artist (for this term, see next chapter) Joseph Kosuth lands himself in trouble when he applies the if-I-say-so maxim to other artists' work. In an article written in 1969, "Art After Philos-ophy," [34] Kosuth asserted that art becomes art through the artist's

[33] Andrew Forge, *Rauschenberg* (New York: Harry N. Abrams, 1972), p. 15.
[34] Reprinted in Ursula Meyer, *Conceptual Art* (New York: Dutton Paper-backs, 1972), pp. 155–170.

intention of making art. He quotes Judd as saying: "If somebody calls it art, it's art." But Judd used the word *somebody,* not the word *artist.* What he asserts, in fact, is: art is recognized as art by somebody's [logical] evaluation of the qualities of a work. Working from his premise, Kosuth applies the artistic imperative to several artists, extolling some as sheep and branding others as goats. Even when he offers an explanation for his judgment, the explanation limps. To Kosuth, Pollock's sole importance resides in having "painted on loose canvas horizontally to the floor." Pollock's aim at self-expression is of no consequence in the picture "because those *kinds* of subjective meanings are useless to anyone other than those involved with him personally. And their 'specific' quality puts them outside of art's context." We may well ask, what has a method to do with quality? If we did not know how Pollock produced his works, would they be less valuable? Is a painting precious because it was painted with the brush placed in the behind? To my mind it is the effect of a method, not the method itself, that counts. As for self-expression being inconsequential in evaluating Pollock's art, here Kosuth contradicts his own position. Self-expression was an *intention* of Pollock's. If we follow Kosuth's reasoning, it should make his work art.

The artistic imperative as a joke is a valuable tool to make people think. The artistic imperative as a "religious" truth leads to ego-centricity and fanaticism, transplanted into the domain of art. Explanations are superfluous; you should believe by faith alone, faith in the pronouncements of the Prophet.

5. *Sense in Nonsense: Dada* Rediviva

Art is Nonsense and—as all—not senseless.
—Jean Tinguely, 1967

One very important aspect of twentieth-century art is what may be called its Dadaist attitude—poking fun at established rules, exalting absurdities, and promoting anti-art. There are various reasons

behind this approach to art. One of them is revulsion at a given situation and the wish to change it. This was the reason of the Dadaists: "Dada wanted to replace the logical non-sense of the men of today by the illogically senseless," Arp explained in 1948 in *I Became More and More Removed from Aesthetics.*[35] Such an attitude has a moral significance, but the artist does not necessarily produce works of aesthetic value. When, on the other hand, the artist strikes this posture merely for the love of pranks, as entertainment, then his behavior has no ethical value, but it does not follow that his art cannot have beauty of form. Behavior and art must be kept separate, and each judged on its own. Furthermore, a work of art is neither better nor worse if it is humorous. These clarifications are necessary to evaluate the Neo-Dadaist events and works in contemporary art.

As can be seen in the course of the discussions, the greatest single influence on contemporary thought is Marcel Duchamp. He put his mark on the emergence of the screwball artist and nonsense object through a number of actions, which he classified as *A-Art,* that is, anti-art or non-art activities.[36] As I hope I have made obvious, I believe that anti-art as practiced by the Dadaists and A-Art as practiced by Duchamp differ only in their objectives: the Dadaists were concerned with criticizing life, Duchamp, with criticizing art. Anti-art sacrificed art to purge the world of evil; A-Art sacrificed art to purge art of evil. Both were only apparently against art, and both sacrificed themselves together with art.

Among Duchamp's A-Art, the Readymades play a major role. Unfortunately, they are not easily deciphered, not even on the first level of meaning. For they are bound to familiarity with life in France as well as in America, French as well as English vocabularies, and a store of common as well as specialized knowledge. Furthermore, they are many-layered. Thus, without a knowledge of French,

[35] *Arp on Arp: Poems, Essays, Memories,* ed. Marcel Jean (New York: The Viking Press, 1972), p. 238.

[36] Hans Richter, "In Memory of a Friend," *Art in America,* LVII (July–August 1969), p. 40.

the name *L.H.O.O.Q.* is an enigma (Fig. 9, p. 104). Yet such diverse images as homosexuality and the sphinx of Queen Hatshepsut (who was bearded like male sphinxes depicting a Pharaoh, although Hatshepsut was a woman) arise in one's mind: homosexuality because of the androgynous nature of *L.H.O.O.Q.* and the gay personas attributed to Leonardo and Marcel; the sphinx because the famous smile of the Mona Lisa is always described as enigmatic and sphinxlike, and because of the sphinxlike characters of both Leonardo and Marcel. These are only two thoughts that come to mind in looking at Duchamp's saucy barbering of the Mona Lisa print. Many more are possible.

The difficulty of interpreting Duchamp even on a superficial level can be measured by comparing his Readymade to a Picabia symbol. In spite of calling them symbols, a reference to the esoteric nature of Christian symbols, Picabia's mechanical symbols are readily understood, provided the viewer is familiar with the object the artist has portrayed. The mechanical symbols are based upon a store of everyday knowledge, or knowledge accessible by checking a reference book; contrary to that, Christian symbols are based upon patristic writings and material buried under the dust of centuries. Consider, for example, the self-portrait with the legend CANTER that depicts an automobile horn labeled "Le Saint des saints" (Fig. 10, p. 106). It presents Picabia as the voice of the artistic movement, leader of the contemporary saints, the artists. Moreover, as the title "Le Saint des saints" is obviously a blasphemous borrowing of Jesus' title of *Sanctus sanctorum,*[37] it designates Picabia as the voice of Christ. Likewise, Picabia's name *Daughter Born Without Mother* for the twentieth-century god, the machine, is a blasphemous transference of the mystery that made Christ a Son born of an uncorrupted Mother. But let us return to Duchamp.

If the iconography of Duchamp's Readymades, that is, the read-

[37] Saint Bernard, "Super missus est, II," *Patrologiae cursus completus . . . ,* Latin series, Vol. CLXXXIII, ed. Jacques Paul Migne (Paris: Migne, 1844–1865), col. 62A.

ing of his motifs, presents obstacles, it can be expected that their iconology, that is, the artist's philosophical approach to life as expressed in the Readymades—their meaning and the reason that Duchamp made them—is even harder to establish. Luckily we have verbal evidence from Duchamp on this subject: "I threw the urinoir into their faces and now they come and admire it for its beauty," he wrote to his friend, the German Dadaist Hans Richter, in 1962.[38] He said the following to Cabanne in 1966: "Note: I did not want to make a work [of art]. . . . when I placed the bicycle wheel upon a stool . . . there was no thought of a ready-made, not even of anything else, it was simply a distraction. I had no specific reason for making it, no intention of exhibiting or describing." The expression "ready-made" was adopted in 1915 in the United States because "it seemed to suit very well these things which were *not works of art,* which were not sketches, which did not correspond to any of the terms accepted in the world of art" [39] (italics mine). However, by the time these statements became available, the meaning of the Readymades had already been misinterpreted by artists, critics, and art historians.

To judge by the road contemporary art took under the stimulus of the Readymades, it seems to have been assumed that they question concepts hallowed by tradition: the validity of aesthetics as a frame of reference and the concept of divine inspiration as a prerequisite for the creation of art. Yet the Readymades did not contribute directly to the elimination of these concepts. On the one hand, the critic was quick to see that the frame of reference for judging the aesthetically significant had merely been transferred by Duchamp but not destroyed: the vista had been widened to enclose the manufactured object. The discovery that a manufactured object could be aesthetically satisfactory did not preclude a created object claiming the same status. As for the demotion of genius, it could be argued that a specially gifted person was still needed to discover

[38] Richter, "In Memory of a Friend," p. 40.
[39] Cabanne, *Entretiens avec Marcel Duchamp,* pp. 82, 83.

the beautiful—whether it was seen by the mind's eye of the tradi-
tional artist within unformed material, or with the supersensitive
eye of Duchamp in natural forms and manufactured goods. What
Duchamp had achieved was to transfer the artist's intervention
from the hand to the eye. Creation was superseded by adoption
the worker by the manager. Genius now consisted of merely point-
ing at a thing, instead of painting a thing. It will be remembered
that Leonardo considered the superiority of painting over sculpture
to be that a sculptor had to exercise physical effort "causing much
perspiration, which, mingling with the grit, turns into mud." He
looks like a baker covered with minute chips of marble and his
dwelling is dirty, filled with dust and chips of stone.[40] Leonardo and
his home may have been spotless, but not every painter is fasti-
dious. By graduating from the role of laborer to that of supervisor,
the problem of staying immaculate was solved for the artist. Morris
was quite right in stating in 1970 that Duchamp "attacked the Marx-
ist notion that labor was an index of value . . ."[41]

To this achievement with regard to the devaluation of manual
work—if achievement it can be called—the Readymades added a
second achievement with regard to the audience—again an achieve-
ment of very questionable nature: to disorient further a public
already badly in need of orientation. Instead of training our sensi-
tivity to art, and thus helping us to enjoy art properly, Duchamp
obliterated the line between art, craft, and nature, between master-
piece, ornament, and curiosity. This is why Kaprow could compare
art to "fine cooking or the seasonal changes." [42] This is why Haacke
could tell Burnham in his 1966 interview: "I did think of signing
the rain, the ocean, fog, etc., like Duchamp signed a bottle rack or
Yves Klein declared November 27, 1960 as a world-wide Théâtre
du Vide." For Haacke in 1968, "letting the natural laws in is

[40] *Artists on Art: From the XIV to the XX Century,* ed. Robert Goldwater
and Marco Treves (New York: Pantheon Books, 1947), p. 46.
[41] *Conceptual Art and Conceptual Aspects* (New York: The New York
Cultural Center, 1970), unpaged.
[42] *Assemblage, Environments and Happenings,* p. 169.

tantamount to the adoption of something which, in the art-jargon, is known as ready-made." [43]

Duchamp's statements reveal what the Readymades are not; on what they are, he kept silent. Yet this information would be more precious. Since he was secretive and had a superior intellect, it is difficult to guess his real intent. It does not seem impossible, however, that he may have created the *Bicycle Wheel* to deride the pretensions of industrial design masquerading as art. He may have wanted to illustrate the difference between masterpiece and artifact, work of art and work of craft. If so, then, as the public failed to grasp his intention, arriving at the opposite result, he would have had good reason to be annoyed at man's imbecility. Thinking him incurable in his inept appreciation of art, Duchamp had his revenge by mystifying him. Mystification bred mysticism, however. The Readymades teach us something by words and images; hence they carry expressive values as allegorical works. Confusing the domain of ethics with that of aesthetics, critics, connoisseurs, artists, and art historians declared the Readymades to be masterpieces of art. As the Christian believes that the Holy Ghost has descended upon the Apostles, so the Duchamp admirers believe that the spirit of Duchamp has breathed art into a bottle rack or a urinal.

The weaknesses of this position and the absurdities to which it leads can be illustrated by an analysis of a believer, Terry Atkinson, an English Conceptualist (for which art form, see below). He reasoned:

> Hence if a bottle rack can be asserted as a member of the class "art-object" then why not the department store that the bottle rack was displayed in, and if the department store then why not the town in which the department store is situated, and if the town then why not the country. . . . and so on up to universe scale (and further if you like!).

[43] Jack W. Burnham, "Hans Haacke: Wind and Water," *Tri-Quarterly,* Suppl. I (Spring 1967), p. 24. Hans Haacke, unpublished manuscript, German translation in Edward F. Fry, *Hans Haacke: Werkmonographie* (Cologne: M. DuMont Schauberg, 1972), p. 4.

In analogy to Duchamp's manufactured "art object," Atkinson and Michael Baldwin, another Conceptualist, declared Oxfordshire an "art ambience" in 1969. "If then Oxfordshire is declared to be an art ambience," they asked, "how are the objects within Oxfordshire to count? Do then Magdalen College, Christchurch Meadow, a Volkswagen in Banbury High Street, etc., etc., count as art-objects?" [44] Do they count as art objects? Atkinson states that he does not get "hung up" on his questions. Shouldn't he?

Although the aesthetic value of the Readymades is a figment of overcredulous brains and nonperceptive eyes, their ethical value cannot be exaggerated. The closer one looks at these modern allegories, the more one finds to think about. There is great sense in their nonsense. The same is true, to a lesser degree, of some of their following.

The Neo-Dadaist activities of contemporary artists can be separated into jokes, destructive acts, and a retreat from art; combinations of these reactions also occur, as in Tinguely where laughter mingles with destruction. The behavioral motivations for these activities embrace as widely disparate emotions as the idealist's desperation at the world's state of affairs, the anarchist's revolt against rules, the romanticist's emotional involvement with the disadvantaged (a reason given by Schwitters in 1920 for his love of nonsense [45]), and the prankster's amusement at childish play. But viewers are often not aware of overtones because the evidence is published only in specialist journals, and it is spotty. Imitating their idol, Duchamp, these epigones disdain to explain their curious activities to the "squares" (*pompiers* in France), the contemporary designation for the bourgeois of yesteryear. They consider themselves an elite above such idiots. For similar reasons critics write in a jargon of uncommon and long words, which they consider a sign of erudition—the more foreign-sounding and the longer, the better—so that even a specialist cannot disentangle the meaning of

[44] Meyer *Conceptual Art,* pp. 19, 20.
[45] "Merz," *The Dada Painters and Poets,* p. 60.

their sentences without a special effort. Duchamp witnessed the results of his youthful overbearance and tried later to correct his mistake by offering explanations to interviewers. As far as I know, he has not been imitated in that respect.

Under these circumstances, what are the effects of Neo-Dadaist activities upon the average man who is left without a means to decode them? Bystanders who do not wish to get involved in art frequently reject them out of hand. Those interested in art who wish to analyze them, but have no clue as to their meaning, are bewildered. They puzzle, but cannot find the key to unlock this art.[46] The average man sees no logical reason for a goat feeding in a forest to be classified as art (Haacke). Even less does he understand why somebody should want to paint with his foot (a feat accomplished by Shiraga who exhibited two canvases executed in this way at the "First Gutai Group Show" in Ohara Hall, Tokyo, in 1956) if he has two good, serviceable, trained hands. And what should he think of a project that involves the moving of the British Isles to the Mediterranean, as was proposed by George Brecht, an Oregon artist now residing in Düsseldorf, to the Rand Corporation in the "Art and Technology" project? He is quite within his rights to question the good sense of such artists, not to say their sanity. Such art is acceptable only when considered as a *manifesto*.

There is no need to clarify this point for the viewer if the activities of the artists are accompanied by rites, or the works carry mythic overtones. Such is the case in Klein and Manzoni, in Akira Kanayama's 109 1/3 yards (100 m., again the round number invested with magic power) long strip of vinyl imprinted with footmarks, exhibited at the "Second Outdoor Exhibition of 'Gutai' Art Group" at Ashiya City near Kobe in October 1956, and in the English Pop artist William Green's ceremonial disposition of his work, which he immolated by first riding a bicycle over it and then

[46] Cf. Rauschenberg's conversation with a middle-aged lady who was attending the opening of his exhibition at The Jewish Museum, New York, in 1963; told in Tomkins, *The Bride and the Bachelors,* pp. 190–191.

burning the painting in 1957.[47] The manifesto character is obvious, and the viewer either approves or disapproves of the demonstration. Considering the other Neo-Dadaist activities also as manifestos, and not as pranks of spoiled children, they can be interpreted in the following manner.

Haacke retreated from art into the study of nature. He needed to externalize his compassion for his fellowmen and that was not possible using the discredited ways of tradition. An art that carried only aesthetic values was empty for him; consequently he turned to the study of physical, biological, and social laws.

To paint with your foot instead of your hand (Shiraga) can have two meanings: you want to prove that you are more dexterous in your profession than your fellow craftsmen; or you want to prove that sometimes a less qualified instrument is misused to do a job, the choice justified solely by a personal whim. Seeing how many people without proper qualifications are nominated to their positions on the basis of nepotism and simony, Shiraga's act can be read in this manner also.

The transference of the fog-ridden British Isles to the sunny Mediterranean shores can also have two meanings: ridiculing utopian projects, such as Klein's air architecture, and exposing the criminal waste of funds on nonessential projects.

Provided that these Neo-Dadaist activities are manifestos and not mischievous acts, and the first alternative must first be proven, does that make them art? No, it does not. However, sometimes what is nonsense as art today can become art, and it can even spawn art. Curving walls in architecture and spike-heeled or platform-soled shoes seemed as nonsensical as the above Neo-Dadaist activities when they appeared in our lives. Curving walls could not accommodate furniture properly at that time. Spike-heeled and platform-soled shoes tire the foot instead of helping it carry the body. However, under the pressure of the new architectural outlook, a new type of furniture that fitted into curves was invented.

[47] Lucy R. Lippard *et al., Pop Art* (New York: Praeger Publishers, 1966), p. 50.

From that moment on, curved rooms acquired the right to live as art. The same is not true of spike-heeled or platform-soled shoes, for which the only sensible use so far is: not to walk in them.

If these Neo-Dadaist activities are not art, what are they? They are moral warnings and, even if they were not intended as ethical manifestations in the first place, but as mischievous acts, even then they would become moral warnings if somebody interpreted them in such a way. As moralities, they should be more valuable for human society than for art. Unfortunately, that is not the case because our spirit is willing but our flesh is weak.

6. *The Foul Object: Sculpture from Fat*

But fat affects other centers in the observer.

—Joseph Beuys, 1968

Foul is defined in Webster's Dictionary as "offensive to the senses." Offending the senses is nothing new in art; complaints about the artist painting ugliness and nastiness are legion, as are also their refutations. But contemporary usage of fat is of a somewhat different caliber. Auguste Rodin's realistic portrait of François Villon's disabused old prostitute, *La Belle Heaulmière,* in the nineteenth century, and Picasso's fantastic deformations and distortions of the female body in modern art, shock one sense merely, the eyes; sculpture from fat is objectionable to several senses at once: it is repugnant to the eyes, tastes rancid, smells fetid, and is slimy to the touch; by synesthesia, it may provoke the auditory sensation of sizzling, a hissing sound. It brings to mind the unhealthiness of overfat bodies and the difficulties of cleaning spots caused by grease. Fat carries a beneficial connotation only as a lubricant, and even here there is an undertone: oily and greasy are nasty-sounding attributes for the ability to make things run smoothly. Sculpture from fat is ugly, unsavory, malodorant, and repulsive—in actuality as well as by association. Why select it as a material for art?

Joseph Beuys, the discoverer of this medium, is interested in fat because it can be made to flow, and flux permits the transformation of the chaotic into the formed. Warmth and coldness are, for him, plastic principles corresponding to life and death —supraspatial to be sure: "I recognized that warmth (coldness) were supraspatial principles which, in shapes, correspond to expansion and contraction, the amorphous and the crystalline, chaos and form," [48] he said in an interview in 1964. By passing from a solid to a liquid state, fat symbolizes the possibility of change from rigid form, a dead thing, to form in flux, a live one. In a later interview in 1968, given to Armin Halstenberg, the Cologne journalist, the artist explained why this metamorphosis is of consequence to him:

> I wish to split wide open the conventional notion of "plastic art." With fat as material, I show the chaotic flowing that I mold into a shape— even into hard shapes, to wit, my "fat corners." But fat touches other centers in the observer. It is not merely a question of forming. The potential for being formed (*das Plastische*) is also a biological element in man himself. That fact I wish to clarify.[49]

Felt, Beuys's other untraditional material, can likewise be used to illustrate the transformation from chaos to form. It represents isolation; the haptic quality is unimportant. Also, it is not necessarily a sign of decay, grayness, and dust.[50] Asked what message his art conveys, Beuys replied: "Information on political, philosophical, theological relationships, which cannot be worded in a rational way, but can be produced in a rational way." [51] Beuys's

[48] "Krawall in Aachen," *Kunst: Magazin für moderne Malerei—Grafik— Plastik* (Mainz), IV (October 1964). Reprinted in *Joseph Beuys: Werke aus der Sammlung Karl Ströher* (Basel: Kunstmuseum, 1969/70), p. 11.

[49] "Joseph Beuys," *Kölner Stadt-Anzeiger,* June 14/15, 1968; reprinted in *Joseph Beuys: Werke* (1969/70), p. 36.

[50] Hanno Reuther, "Werkstattgespräch," shown by the Westdeutscher Rundfunk, III. program, July 1, 1969; Georg Jappe, "Fond III von Joseph Beuys: die 100. Ausstellung bei Schmela in Düsseldorf," *Frankfurter Allgemeine Zeitung,* No. 35, February 11, 1969, p. 2; reprinted in *Joseph Beuys: Werke* (1969/70), pp. 38, 37.

[51] Halstenberg, "Joseph Beuys"; reprinted in *Joseph Beuys: Werke* (1969/70), p. 36.

statements can be better understood by knowing something about the man and his art.

Beuys is the Warhol of Germany, by which I mean he is that country's symbol for the art movement: to some all that is admirable in art, to others all that is vexing in it, is embodied in his person. Both Warhol and Beuys provoke excessive reactions in supporters and enemies alike. Warhol was shot in 1963; Beuys was struck down in 1964. It happened during an Action, Beuys's version of our Happenings, which was scheduled at the Technische Hochschule (Technical College) of Aachen on July 20.

The event, billed as ACTIONS, AGIT-POP, DE-COLL/AGE HAPPENINGS, EVENTS, L'AUTRISME, ART TOTAL, RE-FLUXUS, was introduced by Bazon Brock who, in the second part of his speech, stood on his head to demonstrate Hegel's idea that "philosophy is the world [standing] on its head." In one of the Actions following Brock's talk, Beuys threw some geometric bodies mixed with candies, dried oak leaves, marjoram, a postcard of the cathedral of Aachen, and washing powder into an old, disused piano, into which he had poured hydrochloric acid, a liquid present in gastric juices, during a previous number. This stew would affect the sound of the piano when it was played. His purpose: "The salutary chaos, the salutary transformation into amorphous matter in a certain (bewusste) direction which, through dissolution, consciously spreads warmth to social convention, a past form that has become cold and rigid, therefore making possible a future form." [52]

By the time one-third of the program had been completed, the audience was ready to explode. There had been a good deal of adverse criticism in the newspapers; moreover, July 20 was commemorated in Germany as the day of the unsuccessful attempt on Hitler's life in 1944 by the military leaders, who paid for it with their lives. Beuys was suspected of having intentionally chosen this day for his demonstration as a sign of disrespect. Therefore feelings

[52] "Krawall in Aachen," *Joseph Beuys: Werke* (1969/70), p. 11.

ran high in the town of Charlemagne: half of the public had come with the intention of staging a protest. Beuys has denied having had anything to do with the choice of the date; it was an oversight on the part of the organizers, but he and the Actions were the victims. A right uppercut landed upon his nose—blood spurted. Beuys's reaction of picking up a cross intended for use in the program and raising it aloft, as though he were exorcising the devil, further inflamed the gang. There followed a free-for-all, known in the story of art as the "riot at Aachen."

Joseph Beuys was born and grew up in the small Prussian town of Cleve near the Dutch border on the Rhine, today known chiefly as the home of Anne of Cleves, fourth wife of Henry VIII, king of England, both of whom have been immortalized by Hans Holbein the Younger. To art historians, Cleve is also known as the home of the Mannerist painter Joos van Cleve, and to musicians as the home of Lohengrin, who lived in its castle Schwanenburg. Only the last-named landmark is important in Beuys's art. Shot down over Russia during World War II, Beuys fell sick in the fifties and for four years, two of which he passed in bed, did not want to do anything. He came out of this depression in 1959. In 1961, he was called to teach sculpture at the State Academy of Art in Düsseldorf.[53]

However, his preoccupation with fat antedates his move to Düsseldorf, and even his illness. The 1968 catalogue of the Ströher Collection in Darmstadt lists five works from fat: *Fat Sculpture* (1952), *Fat Vessel* (1953), *Fat Box* (1960), *U-Shaped Twin-Lamp with Hare's Fat* (Scroll) (1961), and *Fat Figure with Filter* (1961; Nos. B.22, 36, 80, 87, 96)—besides a host of later fat objects, among which are the *20th of July Fat Case,* the *Fat Corner,* salvaged from the ill-starred Aachen program (Nos. B.150, 151),[54] and the *Chair Covered With Fat* (1964), which is in the

[53] Ernst Günter Engelhard, "Ein grausames Wintermärchen," *Christ und Welt* (Stuttgart), XXXI, No. 1, January 3, 1969; reprinted in *Joseph Beuys: Werke* (1969/70), p. 34.

[54] *Joseph Beuys: Werke* (1969/70), at end of catalogue, unpaged.

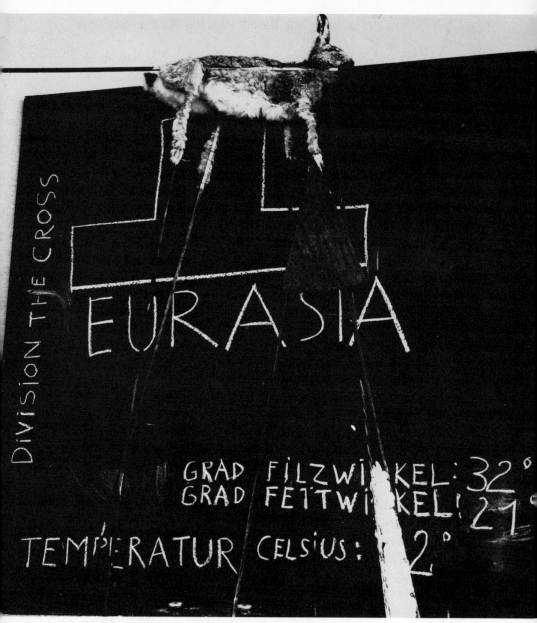

52a. Joseph Beuys: *Eurasia* (from the *Siberian Symphony*). 1966.
Fluxus Action. Galerie René Block, Berlin.

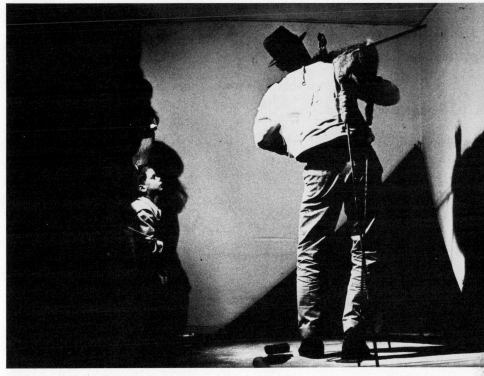

52b. Joseph Beuys: *Eurasia* (from the *Siberian Symphony*). 1966. Fluxus Concert. Galerie René Block, Berlin.

Stella Baum collection, Wuppertal, Germany, and which was mentioned in the introduction.

As he himself has admitted, and as recognized by critics,[55] Beuys's imagery is archetypal. In this respect he harks back to the Cobra Group (Karel Appel, Asger Jorn, Corneille), and beyond them to Paul Klee. Beuys's use of fat in an art context has to be read in view of this fact. Beuys's symbols are either traditional: animals—living (the horse) or dead (the swan of Schwanenburg, the antlered deer, the fast-running hare)—skeletons, the cross, the staff of office; or newcomers: fat and felt. In his Actions, he dem-

[55] "Plastik und Zeichnung," *Kunst: Magazin für moderne Malerei—Grafik—Plastik* (Mainz), V (December 1964); reprinted in *Joseph Beuys: Werke* (1969/70), p. 13.

onstrates a point with such symbols. For instance, the dead hare, a symbol of the quick passage of time and of the flight of life, and the Cross, a symbol of suffering and victory, were used in an Action of one and a half hours duration, shown on two evenings, October 14 and 15, 1966, in Copenhagen, repeated without the introductory motif of "The Division of the Cross" on October 31, 1966, at the Galerie René Block, Berlin. It was called *Eurasia* and was part 32 of the *Siberian Symphony* (1963) (Figs. 52a, 52b).

As described by an eyewitness, the Danish writer Troels Andersen, the main events were as follows:

Kneeling, Beuys slowly pushed two small crosses, which were lying on the ground, toward a board. Upon each cross was placed a clock with the alarm system set. On the board he drew a cross, that he then half effaced, writing under it "EURASIA."

The remainder of the piece consisted in Beuys's maneuvering a dead hare whose legs and ears were prolonged with long, thin, black, wooden rods along a marked line. As the hare lay upon his shoulders, the rods touched the floor. Beuys went from the wall to the board, where he deposited the hare [leaning it against the board on its stilts]. On the return trip, three things happened. He strewed white powder between the legs of the hare, placed a thermometer in its mouth, blew into a tube. After that he turned toward the board with the half-cross and made the hare smell the weather (*wittern*) with its ears, while he himself held one leg, to which an iron plate was bound, above an identical plate lying on the floor. From time to time he stepped hard upon that plate.

This is the main content of the Action. The symbols are all entirely clear and can all be translated. The division of the cross: the separation of East and West, Rome and Byzantium. The half-cross: the reunited Europe and Asia, where the hare is heading. The iron plate on the ground is a metaphor: it is difficult to walk and the earth is frozen. The three interruptions on the return trip signify the elements: snow, cold, and wind. All this can be understood only when the keyword "Siberian" is given. But, of course, it is a fact that the interpretation of the symbols is of subordinate importance.[56]

[56] Written in 1966; published in *Blockade '69* (Berlin: Galerie René Block, 1969), unpaged.

If the interpretation of the symbols is subordinate in importance, the absorption by the viewer of their meaning is of prime consequence. This is the reason that timeworn symbols are used by Beuys. In Kaprow's Happenings, symbolism carries little weight, and his objects are not specific in this respect. The word *Happening* as opposed to the word *Action* again suggests a difference in the character of the event, while the word *demonstration,* used by Beuys, points up the difference further.

To my mind, "The Division of the Cross" is more than a reference to the division between Catholicism and Orthodoxy, part of the flotsam of history. "The Division of the Cross" is a *typus* for the division of Berlin, a fact much on Beuys's mind. A few days after the Aachen riot he drafted his "Beuys Recommends a Raising of the Berlin Wall by 5 cm. [2 inches] (Better Proportion!)." Since the recommendation reveals Beuys's approach to life, and hence also to the use of fat, I quote here from the text. It starts with the following three sentences: "This is a picture and should be looked at as a picture. Only in an emergency or for pedagogic reasons should you fall back on interpretation.

'I do not understand why you do not grasp the manifest sense without an interpretation.' " Then further on:

> The observation of the Berlin Wall from a point of view which takes into account only the proportion of the structure may well be permissible. It immediately defuses (*entschärft*) the Wall. Through internal laughter. Destroys the Wall. You no longer get hung up on the physical wall. One is directed toward the spiritual wall and, to overcome that one, is after all the goal.[57]

The erection of the Wall is a gesture. As such, it has become a symbol of hate. Try to be indifferent to gestures, seeing their funny sides. Then hate will be blunted. The question is: to overcome the

[57] Beuys empfiehlt Erhöhung der Berliner Mauer um 5 cm. (bessere Proportion!), an Aktenvermerk, sent to the Innenministerium on August 7, 1964; reprinted in *Joseph Beuys: Werke* (1969/70), pp. 14–15.

spiritual attitude that led to the erection of the Wall rather than the material presence of the Wall as an eyesore.

Fat was also used in the Aachen Actions. It functioned as a counterpoint to the traditional symbols. Its ordinariness pointed up their distinction, and vice versa. That banality makes fat so effective as a symbol Beuys is well aware. "There does not exist anything more banal than margarine, this shocks people," he stated in the 1968 interview.[58] Malleable fat symbolizes the malleability of human consciousness. To develop human consciousness is the purpose of art for Beuys. Thus fat serves to demonstrate that man can be educated.

[58] Halstenberg, "Joseph Beuys"; reprinted in *Joseph Beuys: Werke* (1969/70), p. 36.

VII

The Disavowal of the Art Object

The world is full of objects, more or less interesting; I do not wish to add any more.

—Douglas Huebler, 1968

Recently the execution of a work of art, and even the work itself, have become inconsequential for the artist whose interest has focused instead upon the problem he faces and upon how to solve it, a mental process replacing both the act of creation and the object. In traditional art, only the finished product counted. Modern art placed the creative process on a par with it, or even above it, hence the interest in artists' drawings and sketches. Clyfford Still expressed this position when he stated in 1959: "I held it imperative to evolve an instrument of thought . . . so that . . . an idea be revealed with clarity. . . . And the act, intrinsic and absolute, was its meaning and the bearer of its passion." [1] The

[1] *Paintings by Clyfford Still* (Buffalo: The Buffalo Fine Arts Academy, 1959), unpaged.

promotion of the creative process was the first step in the unseating of the art object, although that was not apparent at the time. The development was greatly helped along by the importance accorded to research in contemporary art, through which the urge to experiment came to dominate the urge to make an art object. As a result, the execution of the work could be dispensed with. "I don't make the ETERNAL work of ART," stated Jan Dibbets, "I only give visual information. I'm more involved with the process than the finished work of art. . . . I'm not really interested any longer to make an object." For Marinus Boezem, "creativity is not only expressed by an art object but [also, and] not least, in a mental attitude on the strength of which communication and research are made possible." While Douglas Huebler, who does not wish to add more objects to a world already overflowing with them, declared in 1968 that he prefers "simply, to state the existence of things in terms of time and/or place." [2]

In this chapter, the origins of this attitude, its principles, and specific examples demonstrating it will be studied.

1. *Demise: Erased and Burnt Offerings*

Will a Phoenix arise from the ashes?

—John Baldessari, 1969

The notion of the dispensability of the art object could probably not have arisen without the idea first taking root that the destruction of art objects is a permissible, nay, a praiseworthy, action. Two categories of destruction of works of art have to be differentiated here: necessary and unnecessary. To the first class belongs the artist's destruction of works with which he is discontented, a frequent occurrence. Sometimes a whole series may be sacrificed, usually early works. The disposal may take place immediately, or

[2] *Art Povera,* ed. Germano Celant (New York: Praeger Publishers, 1969), pp. 103, 198, 43.

later, when the artist has turned to a different style. He may then not be able to lay his hands on all the works he disavows, as is, fortunately, the case with Chaim Soutine's Ceret paintings, done between 1920 and 1922 under the impact of Amedeo Modigliani's death, which are much more exciting than the rather dull production turned out afterward—proving once again the fallibility of the artist's judgment. (Or is it here the artist's objection to voyeurism?) A second type of destruction, also in the necessary class, is that for convenience's sake. The disposal of *Hon* (Fig. 4, p. 63) is of this kind. Rauschenberg's disposal of his Thought Boxes (a name given by the Galleria dell' Obelisco, Rome, to works Rauschenberg made in North Africa) in 1953 may be due to the same reason: the financial obstacle of transportation costs. Following the advice of an unsympathetic Florentine critic, the artist threw the bulk of the Thought Boxes into the Arno.[3]

Contrary to these necessary sacrifices are the unnecessary ones going back to the Dadaists. It is from these that the contemporary erased and burnt offerings are descended, sacrifices in which destruction is a manifesto by the artist in the form of a Happening. The gestural type of destruction was inaugurated at the First Friday Matinée organized on January 23, 1919, in the Palais des Fêtes, Paris, by the periodical *Littérature,* edited by André Breton. It involved the erasure of a Picabia work by Breton, with Picabia as author of the scenario.[4]

An enormous crowd attended the Matinée—the introduction of Paris to Dada. An advertisement placed in the *Intransigéant* the day before had announced a lecture by the poet André Salmon on "The Change Crisis," and this was interpreted by the business community as a discussion of the devaluation of the franc, whereas it actually dealt with the reversal of literary values following the Symbolist movement. Consequently, many innocent victims were lured to the manifestation, together with those in the know and

[3] Calvin Tomkins, *The Bride and the Bachelors,* enl. ed. (New York: The Viking Press, 1968), pp. 207–208.

[4] Michel Sanouillet, *Dada à Paris* ([Paris]: J.J. Pauvert, 1965), pp. 144–147.

the journalists. The program listed six items: 1. The introductory lecture by Salmon. 2. Poems by the Great Ancestors (the Cubist poets), recited by their admirers. 3. Presentation of works by avant-garde artists, Cubist and Dadaist (for example Juan Gris, Jacques Lipchitz, Francis Picabia). 4. Poems by the new generation, recited by their admirers. 5. Avant-garde music. 6. More poems by the new generation.

The destruction of Picabia's painting was part of item 3. First his picture *Le Double Monde* ("The Double World") was shown. It consisted of some black lines in enamel paint on a light ground and was covered with nonsense inscriptions such as *Haut* ("Top"), placed at the bottom, *Bas* ("Bottom"), placed at the top, *Fragile, À domicile* ("At home"), *M'amenez-y* ("Bring me there"), which was the projected name of a Dadaist review, etc. In addition there were five enormous red letters, reading from top to bottom: L.H.O.O.Q. It took a few minutes for the audience to absorb the meaning of Duchamp's verbal puzzle; then a vociferous protest engulfed the room. At that moment, a second work by Picabia was rolled on the scene, a "black painting," called *Riz au nez* ("Rice at the Nose"), a pun on *Raisonnez* ("Think"). It again consisted of a few lines, here in chalk, and hermetic inscriptions. The tumult doubled. Then, synchronized with its climax, Breton took a sponge and with one swipe effaced the painting. Had Tristan Tzara not declared in the *Dada Manifesto* of 1918: "All pictorial or plastic work is useless"?[5] But the audience was not yet mentally geared to such an attitude. Quickly, item 4 of the program was started, the musical interlude, to appease the fury of the spectators.

The item matching the Picabia scenario in the second portion of the program is also relevant to our subject. It was Tzara's interpretation of one of his poems and followed the recital of his "Lepreux du paysage" ("Leper of the Landscape") by Louis Aragon. Tzara started to read—and the spectators realized dumbfounded that his poem was nothing other than the latest discourse

[5] *Lampisteries, précédés de sept manifestes Dada* ([Paris]: J.J. Pauvert, 1963), p. 25.

of the rightist academician Léon Daudet in the Chamber. It was not easy to identify what was read, however, because Tzara's recital was accompanied by the sound of two bells that were brandished by Breton and Aragon in the wings. The enraged spectators reacted with invective; even the Great Ancestors, Salmon and Gris, were dismayed. Imperturbably, Tzara continued his reading. As he has explained in his *Memoirs of Dadaism,* "all that I wanted to convey was simply that my presence on the stage, the sight of my face and my movements, ought to satisfy people's curiosity, and that anything I might have said really had no importance." [6] The concept of the dispensability of poetry antedates that of art by half a century.

Robert Rauschenberg's erasure of a Willem de Kooning drawing in 1953 is more shadowy in its implications than Breton's erasure of the Picabia, for it involved the work of an artist not committed to this program. Breton merely carried out Picabia's instructions. Rauschenberg wished to destroy another artist's work, and needed de Kooning's consent. Rauschenberg's explanation for his act is that he wanted to create a work of art by the method of erasing. He has left an account of the event [7] that only thickens the fog surrounding his motivations. He selected de Kooning for his experiment because "it had to be something by someone who everybody agreed was great. . . ." Thus creating a ghost work, a new artistic form, was only half the reason for his act; the other half was to destroy something valuable. Was the memory of the Thought Boxes that had just been dumped into the Arno to be laid to rest by this sacrifice? Rauschenberg already possessed a de Kooning drawing that he had stolen from the artist, but "that wouldn't do—the act required the artist's participation." That means de Kooning himself had to select the offering in order to make the sacrifice effectual. Yet, why should Rauschenberg bring in the episode of the stolen

[6] Quoted in Edmund Wilson, *Axel's Castle: a Study in the Imaginative Literature of 1870–1930,* Appendix 2 (New York: Scribner's, 1948), p. 304.

[7] Tomkins, *The Bride and the Bachelors,* pp. 210–211.

drawing, thereby marking himself a kleptomaniac? To exonerate compulsive drives? To accentuate the value he himself placed on a de Kooning work, and hence to associate himself with the loss? One prefers the second possibility, and it is also more plausible since the whole affair reeks of primitive rites. The only redeeming feature in this transaction is de Kooning's behavior. He did not like the idea but entered into the spirit of the thing by selecting a drawing for which he cared: "something I'd miss." Rauschenberg concludes with the observation that "I liked the result. I felt it was a legitimate work of art, created by the technique of erasing. So the problem was solved and I didn't have to do it again." But, if this experiment led into a dead-end street, was it worthwhile doing at all? Perhaps Nicolas Calas is right, and the erasure implies "that not to imitate an older artist whom he admired was the goal that he had set himself." [8] If so, it could have been reached by a less devious way.

The Californian John Baldessari's act of destruction, *Cremation Piece* (June 1969), is transparent in its nature, by comparison with Rauschenberg's. He described it as follows: "One of several proposals to rid my life of accumulated art. With this project I will have all of my accumulated paintings cremated by a mortuary. The container of ashes will be interred inside a wall of the Jewish Museum [New York]. For the length of the show ["Software," 1970], there will be a commemorative plaque on the wall behind which the ashes are located. It is a reductive, recycling piece." [9] Unlike Rauschenberg, there is some sense in this destruction. Rightly or wrongly, it disputes the validity of art objects, museums, and shows. It stipulates that only the creation of art, not its existence, has value, which means that art should concern only the artist; the audience should have no part in it. Museums are morgues,

[8] Nicolas Calas, *Art in the Age of Risk and Other Essays* (New York: Dutton Paperbacks, 1968), p. 182.

[9] *Software: An Exhibition Sponsored by American Motors Corporation* (New York: The Jewish Museum, 1970), p. 31; Ursula Meyer, *Conceptual Art* (New York: Dutton Paperbacks, 1972), p. 32.

and shows are macabre revivals of what is dead and done with. Furthermore, the *Cremation Piece* pokes fun at the reduction and recycling processes, one vaunted in current art and the other in current life. The description terminates with: "Will I save my life by losing it? Will a Phoenix arise from the ashes? Will the paintings having become dust become art material again? I don't know, but I feel better." Here the Christian faith is questioned. But, under the guise of its teachings, an artistic creed is voiced: the artist should not stand still; he should try to renew himself even at the cost of extinction.

We do not tend to think of art as built upon destruction. Yet Picasso thought of it in this way: "A picture used to be a sum of additions. In my case a picture is a sum of destructions," he told Christian Zervos in 1935. Piet Mondrian told James Sweeney in one of his last letters (1942–1943?): "I think the destructive element is too much neglected in art." And Ad Reinhardt wrote in "The Next Revolution in Art" in 1964: "Art-as-Art is a creation that revolutionizes creation and judges itself by its destruction. Artists-as-Artists value themselves for what they have gotten rid of and for what they refuse to do." [10]

I am not sure whether this aspect of art has always existed and has merely been uncovered at the present time, or whether it is a new side. At any rate, it led to the possibility of destructive acts. These were performed for different reasons. To the two mentioned, necessity (*Hon,* Thought Boxes) and manifesto (Green, Rauschenberg, Baldessari), a third reason can be added: destructions to counter the fear of the holocaust by ridiculing it, as seen in Tinguely's Homages and Niki de Saint-Phalle's Carbine works. The latter succeed in taking the horror out of shooting. They consist of reliefs of scrap iron among which plastic tubes containing paint

[10] Alfred H. Barr, Jr., *Picasso: Fifty Years of His Art* (New York: The Museum of Modern Art, 1946), p. 272. *The Dada Painters and Poets: An Anthology,* ed. Robert Motherwell (New York: Wittenborn, Schultz, 1951), p. XII. Ad Reinhardt, "The Next Revolution in Art: Art-as-Art Dogma II," *Art News,* LXII, No. 10 (February 1964), p. 49.

are placed. At the opening of the exhibition, the artist shoots at the relief, releasing the paint and giving birth to the picture. The idea behind these acts is exposed in Oldenburg's *Thrown Can of Paint* (1969), a project, which was not executed, for the garden of The Museum of Modern Art in New York. It proposed that paint be hurled against the museum's wall, so that "the act of hostility is transformed into a work of art, an example of the thing being attacked." [11] Tinguely, Saint-Phalle, and Oldenburg construct with destruction. If destruction there must be, let it be of this positive type.

2. *Demotion: From End Product to By-Product in Conceptual Art*

The making of the work has no more
than a relative interest.

—Daniel Buren, 1970

It may seem peculiar to continue a discussion of art after having dealt with the demise of the art object. Yet, as is known from psychoanalysis, violent hate (destruction) is often bound up with love (creation). Indifference (neglect), on the other hand, is beyond both; in a way, it is a greater danger to the continued existence of the art object. This is the situation prevailing today. The art object has passed from being the end product to being a by-product of artistic endeavor . Once again Duchamp is the source of this attitude. In the 1955 interview for the National Broadcasting Corporation, conducted by Sweeney, Duchamp stated: "I considered painting as a means of expression, not an aim." Sweeney: *"One* means of expression?" Duchamp: "One means of expression instead of a complete aim for life." [12]

With doubt cast upon the essentials of art, with ridicule showered upon the art object, with artistic imperatives and sacrificial dis-

[11] *Object into Monument,* ed. Barbara Haskell (Pasadena, Calif.; Pasadena Art Museum, 1971), p. 112.

[12] *Wisdom. Conversations with the Elder Wise Men of Our Day,* ed. James Nelson (New York: W. W. Norton & Co., 1958), p. 97.

posals as a foundation, a completely different type of "art" could take over. It has been variously named Conceptual (Concept, Idea) art, Beyond-the-Object art, Attitude art, etc., but I believe Think art (Art in the Mind), or para-art, other names for this art form, or meta-art, would constitute a better designation.[13] First, they get around the difficulty that the presence of concepts, indicated as the basis of Conceptual art in the title, is a necessary part of any work of art. Second, they emphasize, respectively, that this new type of art is a joint venture with thought and that it is something beyond normal art. Third, either as Art in the Mind, as para-art, or as meta-art, they dispose of the criticism levied against Conceptual art as an art form: that art presupposes an object with physical existence. In fact, many artists protest being called Conceptualists. However, since this expression has become accepted here and abroad, and is no more a misnomer than other names for art movements, I shall use it as a convenience (capitalized as a title), alternating with the expression para-art (in lower case as an art form), which latter indicates that we deal with a new kind of human expression that has joined literature, dance, music, and the visual or plastic arts as a sister art form. Para-art is as different from *formalist* art (the Conceptualist designation for prior art forms) as dance is from opera.

Conceptual art originated in 1966. Following up some ideas expressed by Andre, LeWitt, and Morris, the Englishmen Terry Atkinson and David Bainbridge, the American Joseph Kosuth, and other artists took as their objective a study of the pattern of the thought going into the creation of a work of art. To make an object became superfluous. Their shows went unnoticed, however, until the publication of their periodical *Art-Language* in London in May 1969 (joined by Kosuth in July 1969). Soon after this, several group shows were staged by interested museums and galleries, of which I mention "Konzeption-conception: Dokumentation einer

[13] Cf. the journal *Art-Language* (Coventry, England); Meyer, *Conceptual Art;* Klaus Honnef, "Konzept einer 'Konzept'-Kunst," *'Konzept'-Kunst* (Basel: Kunstmuseum, 1972).

heutigen Kunstrichtung" at the Städtisches Museum in Leverkusen (Germany; 1969) and " 'Konzept'-Kunst" at the Kunstmuseum in Basel (1972), in Europe; the exhibitions "557.087" in Seattle (1969), "Art in the Mind" at Oberlin College in Ohio (1970), "995.000" in Vancouver (1970), and "Conceptual Art and Conceptual Aspects" at The New York Cultural Center (1970), in America. What is para-art? Here are some of the ideas culled from the writings of artists and critics.

Para-art is the liberation from thingness, as it is externalized by the production of art objects. This production has to be stopped, Victor Burgin said in 1969, because "aesthetic commodity hardware continues to pile up," while "each day we face the intractability of materials that have outstayed their welcome." [14] Art hardware is, at any rate, superfluous since art is not vested in the object but in the artist's discovery of the process of how to form it. The process can be documented through plans, sketches, drawings, titles, descriptions, photographs, maps, films, video- and audiotapes, books, etc. That information is transmitted to the spectator and forms the *artwork* or *proposition*. By presenting him with raw material instead of a finished product, the artist invites him to construct the work mentally and to become engaged himself in the *production* of art. Audience cooperation is an objective of this art form, so much so that the critic Klaus Honnef could claim Conceptual art is not a new style but a stratagem to bring the audience into direct contact with creation.[15]

Para-art not only discards the Minimalist maxim of reification as the goal of art, it also contradicts Picasso, the thorn in the flesh of the Minimalists, who said to Marius de Zayas in 1923: "What one does is what counts and not what one had the intention of doing." [16] To the Conceptual artist, the value and effect of an

[14] "Situational Aesthetics," in Meyer, *Conceptual Art,* p. 81.
[15] Honnef, "Konzept einer 'Konzept'-Kunst," *'Konzept'-Kunst* (1972), unpaged.
[16] Barr, *Picasso: Fifty Years of His Art,* p. 270.

artist's endeavor is not measurable through the physical existence of an object, but through the artist's ideas.

Together with the traditional fixation on the fashioning of art objects, Conceptual art rejects aesthetic quality as a necessary component of artwork or propositions, because it defines art solely in morphological terms. "The concern with 'quality' in art can only be another form of consumer research . . . ," Morris stated in 1970.[17] Morphology should be replaced by methodology. Hardware art is comparable to the work of a lexicographer who is interested in structure; Software art to that of a grammarian who is interested in function, according to Ian Burn and Mel Ramsden (1970).[18] As noted by Honnef, the framework of traditional art leading to an aesthetic of form had been the question "how": how is it painted, how is it composed, how are the problems solved? For the "how," Conceptual art has substituted the "what": what is the nature of art? For a decorative aesthetic, it substituted a functional aesthetic. In Conceptual art, the form of a proposition is merely a reflection of its context, and aesthetic quality serves merely to facilitate the perception of the intimated relationships.[19] Formalist art is no more than an ornament and almost valueless as art, according to Kosuth. "Formalist art (painting and sculpture) is the vanguard of decoration, and, strictly speaking, one could reasonably assert that its art condition is so minimal that for all functional purposes it is not art at all, but pure exercises in aesthetics" (1969).[20] Conceptual art is an instrument of the mind.

On the whole, all this is true. There are, however, other sides to Conceptual art, I believe, not discussed by the Conceptualists. The value of a proposition resides in stimulating the thinking process, a most commendable aim. Consequently difficult propositions will

[17] *Conceptual Art and Conceptual Aspects* (New York: The New York Cultural Center, 1970), unpaged.

[18] "Excerpts from 'The Grammarian (1970),' " in Meyer, *Conceptual Art,* pp. 100–101.

[19] Honnef, "Konzept einer 'Konzept'-Kunst," *'Konzept'-Kunst* (1972), unpaged.

[20] "Art After Philosophy," in Meyer, *Conceptual Art,* p. 159.

be more valuable, although that alone does not guarantee their worth; here the artist's power to formulate the proposition clearly, and with just the right amount of clues, comes into play. Unluckily, our capabilities for abstraction have atrophied due to the "check-off yes-or-no" system used in schools, in colleges, and on intelligence tests. As a result, enjoyment of good Conceptual art will be restricted to the few who still can think, and also have the a priori knowledge, as well as the gift for abstraction needed for solving the specific problems posed by the propositions. Moreover, since even artists have difficulty in visualizing a work they plan before it is executed, how can the public hope to succeed? The following statement comes from an interview of Donald Judd (and Frank Stella) by Bruce Glaser in 1964. Judd: "Even if you can plan the thing completely ahead of time, you still don't know what it looks like until it's right there." [21] The functional approach makes art even more esoteric than the aesthetic approach, which is based upon sensitivity to form.

Also, para-art forces the observer to spend much time on what may prove to have been a waste of effort. After all, Software art has as many worthless objects to offer the public as any other art form—probably more, if the failure arising from the artist's difficulty in visualizing a physically nonexisting work is added. "You may turn out to be totally wrong once you have gone to all the trouble of building this thing," Judd told Glaser in the above-mentioned interview, to which Stella added: "Yes."

Furthermore, the advantages of assisting at the creation of the artwork are balanced by the disadvantages. During material execution, the original concept undergoes changes. These are now eliminated. This is not a gain. The original concept is rarely better than the final product in art. Therefore many valueless propositions are formed, deceiving a naïve audience into accepting them as artwork. The product of Conceptual art is a documentary, but an

[21] Bruce Glaser, "Questions to Stella and Judd," *Minimal Art: A Critical Anthology,* ed. Gregory Battcock (New York: Dutton Paperbacks, 1968), p. 162.

unselective one. Moreover, creation is an act of intimacy. Not every observer enjoys the status of voyeur, even though the artist does not mind playing the role of exhibitionist.

The principles of Conceptual art have been formulated in thirty-five theses by Sol LeWitt, which he called "Sentences on Conceptual Art, 1968." [22] The references to metaphysics in them give these "Sentences" the tenor of articles of faith. For example, the opening Sentence is: "Conceptual Artists are mystics rather than rationalists. They leap to conclusions that logic cannot reach." And Sentence No. 28 states: "Once the idea of the piece is established in the artist's mind and the final form is decided, the process is carried out blindly." The first thesis, I see as a reference to the irrational element in art, the other, as an attempt to verbalize the irresistible force driving an artist to bring a concept to completion. Oversimplification of the problems mars many of LeWitt's Sentences when they deal with Conceptual art. For instance, the statements in Sentences Nos. 1, 22, 28, 29, 34 are too sweeping and should be qualified by the addition of the word *some*. Other statements are half-truths. Sentence No. 4, "Formal art is essentially rational," I would qualify as follows: "All good art is, among other things, a product of reason." Sometimes these half-truths are not expressed clearly, as in Sentences Nos. 2 and 3: "(2) Rational judgments repeat rational judgments. (3) Illogical judgments lead to new experience." What LeWitt wanted to express is: "Rational judgments do not lead to worthwhile experiences, whereas illogical judgments do." This statement is a matter of personal opinion. Contrariwise, when LeWitt discusses art in general, he has many astute observations (Sentences Nos. 9, 18–21, 23–27, 32, 35). But all the Sentences show remarkable insight into the problems of art, illuminating them from new sides. To wit, Sentence No. 13: "A work of art may be understood as a conductor from the artist's mind to the viewer's," which tries to formulate the kinetic aspect of empathy. Sentence No. 17: "All ideas are art if they are con-

[22] Reprinted in *Sol LeWitt* (The Hague: Gemeentemuseum, 1970), p. 60.

cerned with art and fall within the conventions of art" is the basic
tenet of Conceptual art. Its acceptance depends on the definition
of the word *art*. We may note that LeWitt's doctrinal declaration
intentionally omits the qualifying attribute *conceptual*.

However, some statements I believe to be incorrect. Although
it is true that ideas do not proceed in logical order, they must *not*
necessarily be completed in the mind before the next one is formed,
as asserted by Sentence No. 11. Perhaps the artist meant "before the
next one should be worked out." Although it is true that the words
of one artist can induce a chain of ideas in another artist's mind,
the two artists must *not* share the same concept, nor need the party
be an artist, as asserted by Sentence No. 14. It is not true that words
proceeding from ideas about art are art or literature, as asserted by
Sentence No. 16; they are references to art, which can be art crit-
icism, art theory, descriptions of art objects, etc. Many of the in-
correct statements can do little harm. But two are dangerous if the
advice they give is followed. I refer to Sentences Nos. 5 and 6.
Number 5 advises: "Irrational thoughts should be followed abso-
lutely and logically." I could not disagree more violently with any
statement than with this. Irrational thoughts, if followed absolutely
and logically, give birth to myths, which, in turn, lead, at the best,
to asocial behavior, and at the worst, to mass hysteria. Number 6
advises: "If the artist changes his mind midway through the execu-
tion of the piece he compromises the results and repeats past
results." Discounting that the conclusions do not follow logically
from the premise, the advice to stick to your project even if you
consider it to be wrong is unsound. Surely, time spent on a project
judged a failure is time lost.

It so happens that the French Conceptualist Daniel Buren has
issued a "Warning" (1969, revised 1970) against bad art going
under the name of Conceptual art, which is worthwhile studying.[23]
He classifies it into four categories:

[23] "Beware, I: Warning," in Meyer, *Conceptual Art,* pp. 61–63.

(1) *Concept = Project*. . . . That which was only a means becomes an end through the miraculous use of one word. There is absolutely no question of just any sort of concept, but quite simply of an object that cannot be made life-size through lack of technical or financial means. (2) *Concept = Mannerism*. Under the pretext of concept the anecdotal is going to flourish again and with it, academic art. It will no longer of course be a question of representing to the nearest one a number of gilt buttons on a soldier's tunic, nor of picturing the rustling of the undergrowth, but of discoursing upon the number of feet in a kilometer, upon Mr. X's vacation on Popocatepetl or the temperature read at such and such a place. . . . [*In order, no doubt, to get closer to "reality," the "conceptual" artist becomes gardener, scientist, sociologist, philosopher, storyteller, chemist, sportsman.*] It is a way—still another—for the artist to display his talents as conjurer. . . . [2a] *Concept = Verbiage. To lend support to their pseudo-cultural references and to their bluffing games, with a complacent display of questionable scholarship, certain artists attempt to explain to us what a conceptual art would be, could be, or should be—thus making a conceptual work.* . . .] (3) *Concept = Idea = Art*. Lastly, more than one person will be tempted to take any sort of an "idea," to make art of it and to call it a "concept." It is this procedure which seems to us to be the most dangerous, because it is more difficult to dislodge, because it is very attractive, because it raises a problem that really does exist: how to dispose of the object?

Buren's objections are well taken. For good order's sake, I note that my discussions of the Conceptualists' writings—Atkinson's "spatial ambience," LeWitt's "Sentences," Kosuth's "Art After Philosophy," Buren's "Beware"—have to be seen as the equivalent in that art form of the traditional discussions of works of art.

3. *Repression: The Neutered Object*

What the work of art looks like isn't too important.

—Sol LeWitt, 1967

Conceptual art can be subdivided into branches from two points of view: the nature of the proposition (execution of scientific experiments, analysis of theories, interpretation of metaphors) and the nature of the material (verbal arguments, scientific data, pictorial operations with verbal clues, presentation of realities, divulgence of personal facts). This leaves the critic with a wide range of choices for illustrating the aims of Conceptual art. My selections are based on the artist's power to structure his thought through words and works; the aesthetic quality of the work played no role, only the quality of thought that went into its making and the clarity of the presentation to illustrate the thought. However, it is undeniable that a proposition presented in aesthetically valid terms, as image and as language, has a greater chance to succeed with the audience than an indifferent presentation. Several propositions in different realms give a better insight into the objectives of Conceptual art than several propositions in one realm, even if some of these realms are less important. This fact has also guided my presentation of examples.

The four propositions to be studied now are Daniel Buren's anonymous art, Robert Barry's invisible art, Lawrence Weiner's indifferent objects, and Hans Haacke's invitations to think.

A. ANONYMOUS ART

The absence from it of considerations of style forces us to acknowledge a certain anonymity.

— Daniel Buren, 1969

Daniel Buren objects to having the word *concept* signify art or equate with object. He still uses hardware for his message to the spectator but it is voided effectively of aesthetic content. Here is his "path of no return upon which thought must embark." [24] Since

[24] "Beware, III: Preamble," *ibid.,* p. 76.

1966, "without any evolution or way out," his work has consisted of vertically striped sheets of paper or cloth, the bands three and a half inches wide (8.7 cm.), and alternately white and colored. These are pasted over the internal and the external surfaces of walls, fences, display windows, supports whose ends are covered with dull white paint. Through these "sandwiches" he wishes to achieve the following goals.

Create something that is real yet nonillusionistic and therefore neither an art object, as in traditional art, nor an ideal object, as in false Conceptual art. Eliminate emotionality and composition by using only verticals and by repeating the same width so that the painting becomes neutral. Avoid uniqueness, which leads to the creation of a quasi-religious archetype, by leaving the external form —material, support, size—mutable. Pass from the mythical to the historical, from the illusion to the real, by abandoning the search for a new form. Destroy the anecdotal by using all the colors simultaneously, without any order of preference. Fight retinal (that is, aesthetic) shock by utilizing banality which, in art, soon becomes extraordinary. Use multiple locations because a single viewpoint or single location manacles art. Efface the artist behind the work that he makes or that *makes him*. Be no longer the *owner of his work,* which should not be *his* work but *a* work of which he is not the *author/creator* but the *producer/person responsible*. In sum, make the work anonymous.[25]

Buren's argument is clear, although not every point is equally well founded. In addition, his theory can be attacked and refuted —but this is true of any theory or philosophy. Be that as it may, his *produce* does "signal the existence of certain problems,"[26] as he correctly noted. The problem signaled by Buren's art is that a wrong turning has been taken somewhere, leading us into disaster. We have pursued the false road for so long that the point where we have gone astray is no longer recognizable. His remedy is: a tabula rasa. Every notion has to be challenged and reevaluated.

[25] "Beware, II: What Is This Work," *ibid.,* pp. 63–75.
[26] "Beware, III: Preamble," *ibid.,* p. 76.

B. THE INVISIBLE OBJECT

> I went to things that could be neither
> seen nor perceived.
>
> —Robert Barry, 1969

Whereas Daniel Buren's anonymous art criticizes a solution and tries to answer a question, Robert Barry's invisible art aims at solving a problem. First, his problem was to involve art with "the entire space" and "get away from the concern with color." In searching for a material, Barry, the son of an electrical engineer, turned to his father's field. He described his route to a fellow artist, Ursula Meyer, in an interview in 1969.[27] He started by making works from wires, so thin and stretched so high above the ground that it was virtually impossible to see them—or to photograph them. From wires, the carriers of energy, he went on to construct works from energy itself, such as carrier waves, the specialty of his father, who helped him in his work. These were imperceptible to human eyes. Yet, curiously, Barry did not explore this aspect of his material; rather he reobjectified it. Instead of treating it as a source of information, he treated it as an object that can be measured, has a specific duration in time, and is limited by existing conditions. For instance, one carrier wave between New York and Luxembourg could be used only in January; in other months different locations had to be utilized for this work. As a result, Barry could maintain: "We are not really destroying the object, but expanding the definition, that's all." Since he does not reject the object, he can also affirm that there is no real difference between the new art and the traditional art of the object. "We are looking at objects from another point of view, so that it seems that art is changing, but I personally do not see a real difference between the new art and the 'traditional' art of the object."

Barry can say things with his material that are impossible to say

[27] Meyer, *Conceptual Art*, pp. 35–41; the quotations will be found on pp. 36, 41, 40, 39, 39–40, and 36.

with traditional objects. Thus he can prove that carrier waves follow different rules from objects: two can occupy the same space at the same time, if one is an AM type and the other an FM type.

Besides carrier waves, Barry used ultrasonic sound waves. Unlike normal sound waves, these cannot be heard, but they can be directed like a beam and they bounce back from a wall. Invisible patterns can be made with them, which can be diagramed and measured.

Another material Barry used was barium 133, a small radioactive isotope that emits radiation, which he buried in Central Park in 1969. A radioactive isotope is an artificial material that constantly loses half of its energy within a specific period. The period can be ten years or fifteen seconds. But the radiation never goes out of existence, although it is so small it cannot be measured in our terms. The zero time, that is the moment when this process starts, is printed on the label of the plastic phial in which the isotope is contained. A radiation wave cannot be tampered with by man. You can only know what it does. Here is another object that follows laws different from those we are accustomed to.

Carrier waves are not seen but they cannot be produced without objects, which are visible. The presence of these became unacceptable to Barry. Hence he turned to work with inert gas. An inert gas does not combine with any other element and is imperceptible. When released, it changes from a measured quantity to an unmeasurable one, from a definite volume to an indefinite expansion. It expands forever, constantly changing, although nobody is able to see it. One has to trust the manufacturers that it is there. Barry released neon and xenon in the Mojave Desert. When a tank of gas was opened, they heard a whistling sound, proving it was there.

Still in 1969, Barry turned from gas to telepathy, or mental energy, in his work for Seth Siegelaub's exhibition at Simon Fraser University, Vancouver. Then, at his December 1969 exhibition for the Art & Project Gallery, Amsterdam, he showed invisibly for the duration of the show—two weeks. He asked the owners to "lock the door and nail my announcement to it, reading: 'For the exhibition the gallery will be closed.'" It is the logical conclusion

to work "involved with things intangible and immeasurable, physical, yet metaphysical in their effect."

Asked how he felt about the loss of an aesthetic aspect in his art, Barry replied: "Making art is not really important. Living is. In my mind art and living are so closely interlocked. Trying to be involved in living and in the world around me makes this satisfactory." His work is satisfactory because something can be learned from it: "I am using art to draw attention to something. The function of what is made is important—not the making or the made."

Operating with scientific data, Barry has solved the apparently insoluble problem of showing an object made from invisible material. He did not make such objects; he proved their existence: "I have not *produced* objects; maybe I found objects," he said. Through mixing science with art he has revealed the existence of unsuspected realms, expanding man's vision of the world and linking physics to metaphysics.

C. THE INDIFFERENT OBJECT

> An amount of paint poured directly upon
> the floor and allowed to dry.
> —Lawrence Weiner, 1969

"I do not mind objects, but I do not care to make them.

"The object—by virtue of being a unique commodity—becomes something that might make it impossible for people to see the art for the forest." Here is Weiner's attitude to the object in a nutshell, expressed in conversation with Ursula Meyer in 1969.[28] Art of high aesthetic quality would detour the viewer from the true function of art; bewitching his senses, it would put his thought processes to sleep. Consequently works of indifferent character should be created. The titles of Weiner's works illustrate that he means formally indifferent. Such works as *Removal to the Lathing or Support of Plaster or Wallboard from a Wall* (1967), *An Amount of Bleach Poured upon a Rug and Allowed to Bleach* (1968), *Two Minutes of Paint*

[28] *Ibid.*, pp. 217–218.

Sprayed Directly upon the Floor from a Standard Aerosol Spray Can (1968) can best be defined as actions, valuable as manifestos, but they are without aesthetic significance.

If the work has no aesthetic validity, then an exhibition of it has, likewise, no such validity. One may as well exhibit nothing, which would again be a manifestation. This is just what Weiner did in 1972. For a day, on February 12, the Leo Castelli Gallery in New York had a Weiner show in two empty rooms. According to the invitation, four items were exhibited: 1. LOUDLY MADE NOISE (forte) AND/OR MODERATELY LOUDLY (mezzoforte)

2. SOFTLY MADE NOISE (piano) AND/OR MODERATELY SOFTLY (mezzopiano)

3. NOISE MADE VERY LOUDLY (fortissimo) AND/OR MODERATELY LOUDLY (mezzoforte)

4. NOISE MADE VERY SOFTLY (pianissimo) AND/OR MODERATELY SOFTLY (mezzopiano).

Not only is the object of indifferent character, Weiner considers its history also to be of no consequence. He is unconcerned whether or not his proposition is or is not executed, is or is not bought, is or is not an autograph. From his point of view, all these solutions are equal, and it is sufficient if the viewer remembers his work, or has it fabricated.

Unlike many other Conceptualists, Weiner does not have an artist's-privilege syndrome. Dictatorship in art is condemned in strong words. "Art that imposes conditions—human or otherwise—on the receiver for its appreciation in my eyes constitutes aesthetic fascism." Weiner never gives directions regarding the present or future of his work. The decision about that "rests with the receiver upon the/occasion of receivership." The work can be taken anywhere the receiver chooses, rebuilt, or kept as is.

Weiner also denounces the evil of self-centeredness as leading to harming other people:

For art being made by artists for other human beings should never be utilized against human beings, unless the artist is willing to renounce

his position as an artist and take on the position of a god. Being an artist means doing a minimum of harm to other human beings.

Big egocentric expensive works become very imposing. You can't put twenty-four tons of steel in the closet.

Most artists are blinded by prejudices when it comes to trends opposed to their own approach to art. This may lead to art dictatorship, as exposed by Weiner.

D. TO THINK OR NOT TO THINK

I don't know what this is, "Art."

—Hans Haacke, 1966

Haacke has sharp eyes and a good mind; like Kaprow and Morris, he has contributed excellent observations to the understanding of art. His analysis of the current art situation is likewise to the point. Asked by Burnham in a 1966 interview whether he considered his work art, he rightly admitted the question to be unanswerable. For what is art? Where does the boundary line lie between art and architecture in Land art, where between fine art and literature in Lettrism, where between fine art and the theatre in Happenings, where between fine art and the film and music in spectacles, where between fine art and science in airborne and biotic art? The unions were too successful for asserting this is fine art, that, another discipline. The aesthetics of the merger have triumphed.

As noted, Haacke prefers to classify his work as *systems,* a word he utilizes in a different way from the one adopted in art history by Alloway (cf. chap. 1, sec. 6 and chap. 4, sec. 6). He found this word through his contact with Burnham (who was to use it in his book *Beyond Modern Sculpture,* published in 1968). Haacke's Physical and Biological Systems have been outlined above. The best known of his Social Systems is probably his investigation of *Sol Goldman & Alex Dilorenzo Manhattan Real Estate Holdings: A*

Real-Time Social System, as of May 1, 1971, which the Guggenheim Museum refused to include in the artist's one-man show scheduled for that year, with the result that the exhibition was canceled.[29] Brought up to date, the status of the holdings *As of May 1, 1972,* was shown in " 'Konzept'-Kunst" at Basel. The presentation, based on public records, consisted of three portions: (*a*) A list of fourteen corporations. (*b*) Thirty photographs mounted vertically on one sheet in six rows of five, some displayed sideways. They show some of the buildings in question. (*c*) A map of Manhattan between Forty-second and Forty-fourth streets, Second and Ninth avenues, with about eighty properties, mainly office buildings, isolated by circles. The list of corporations was preceded by the following explanation: "The marked properties are operated under the corporate names of . . . The information contained here has been culled from public records at the New York City Registrar's office, 31 Chambers Street. According to FORBES (a business magazine) of June 1, 1971, the total market value of the properties is estimated at 666.7 millions." [30]

Haacke's latest information pieces, *Visitors' Profile* numbers 1 and 2, deal with art, and are the analyses of questionnaires. In No. 2, twenty-one questions were asked of the visitors to the John Weber Gallery, New York, during April and May 1973. The questions treated background material (vital statistics, social position, artistic affiliation) and responses involving judgments. The first could be answered spontaneously, the second necessitated passing a judgment.

The results of the poll and the artist's analysis were posted in the gallery during September and October 1973. Haacke focused on the question: *Do you think the preferences of those who financially back the art world influence the kind of work artists produce?,* relating it to six other questions from the questionnaire. He picked the following. *Do you have a professional interest in art? How much*

[29] Edward F. Fry, *Hans Haacke: Werkmonographie* (Cologne: M. DuMont Schauberg, 1972), pp. 56–69.

[30] Honnef, "Konzept einer 'Konzept'-Kunst," *'Konzept'-Kunst* (1972), unpaged.

money have you spent on buying art (total)? Would your standard of living be affected if no more art of living artists were bought? Do you think the collectors who buy the kind of art you like share your political/ideological opinions? How would you characterize the socio-economic status of your parents? It has been charged that the present U.S. government is catering to business interests. Do you think this is the case? The answers to these questions, as compiled from the questionnaire, were tabulated on each sheet under five progressive grades (yes, a lot; somewhat; slightly; not at all; don't know) and illustrated by graphs showing the percentage.[31]

Through the questions, Haacke hopes to provoke people to think: to analyze what shapes their lives, to evaluate the effects of these influences, and, if the effects are unhealthy, to search for remedies.

From the examples discussed, it is obvious that the merger of art with other disciplines has taken most Conceptual works out of the domain of art and into a different domain. That fact is, indeed, recognized by the Art-Language group, in the name given to their periodical, and by Haacke.

[31] *Visitors' Profile,* Xerox copy in the John Weber Gallery, New York.

Attempt at a Trial Balance

> There isn't a rule. I don't want to keep any
> rules. That's why my art might be so good,
> because I have no fear. I could take risks.

—Eva Hesse, 1970

In which direction is art heading? Why in that direction? What is the nature of its achievements? To what extent do previous achievements color that nature? These were the questions we set out to answer. By now we have found that art has gone off at a tangent during the last twenty-five years and is heading for no-art's-land. The art scene has been shaken by radical changes that seem to have left nothing vital untouched: a complete revision of basic ideas has taken place. It affects content: nonobjective symbols, the promotion of thingness, the enthronement of the Idea. It affects form: soft sculpture, anti-form, solutions to the pedestal. It affects the essence of art: airborne, hydraulic, biotic, kinetic works, mergers. It affects the relationship of artist to spectator: proposals for active participation. It affects the relationship of artist to art: the devaluation of uniqueness, the demythification of art, the disavowal of the art object. The list of innovations is long and the items on it are refreshingly different from the has-beens. However, these novel ideas are by now no longer novel, having been absorbed into the tradi-

tion—except for the disavowal of form, which seems the most radical departure of all. It is also the latest. Not enough time has passed for the readjustment to this issue to take hold of us.

In spite of appearances to the contrary, this radical departure from tradition did not appear fully grown out of nowhere. Rather, it fed upon strange side issues in art, which were slowly gathering momentum in these less-noticed regions, until it was ready to spring upon the world and deflect the course of art. The new art can be traced back through Moholy, Lissitzky, Schwitters, the Dadaists, Man Ray, and Duchamp to Brancusi and Picasso; and through Brancusi and Picasso to the mainstream of art. In other words, it is rooted in art, but not in art tradition. That is what I meant when I wrote art went off at a tangent and is headed for no-art's-land. This new art has explored the dead ends, which seemed closed to further developments. Against "better" judgment, against all odds, it succeeded in opening them up for art. Who, before contemporary art, would have thought a musical relief or an autodestructive sculpture would be something he could enjoy as much as a painting by Andrea Mantegna or a sculpture of an archaic Greek maiden? What must be borne in mind, however, when speaking of the filiation of the new art from the mainstream is that the interpretation put by contemporary artists on the deeds of their forerunners does not tally with what these forerunners had in mind themselves. They would have taken a different course—provided they could have found the way out of these dead ends—and would not have ended up butting their heads against a brick wall.

All new developments, by being new, are controversial as well as revolutionary. Contemporary art is no different in this respect but for the intensity level of the changes. There is an abundance of roads. For the disabused pedestal in sculpture alone, three substitute solutions were found: a sculptured mirror image, the work of art itself, and air. There is the denunciation in toto of rules and restrictions: admission of fat, nails, and rope as materials for art; sculpture that flows or produces sound; invisible works as a form for art. There is the extension from visual and tactile sensations

to all sensations as artistic media, with preference given to untapped sources such as friction. No artist, before contemporary art, thought of using his sculpture as a rug. If history can be trusted, such a violent upheaval in art presages a violent upheaval in life. Thus, a similarly violent sweeping away of art canons heralded the Middle Ages. To judge then from the state of art, we are at the beginning of a new historical period, that is, the conditions of life will undergo a complete change in the near future.

At this point it is necessary to note that visual art is not alone in showing signs of drastic reforms. Similar developments have taken place also in the other arts. For instance, mergers can be noted in them. In the music of the Italian composer Sylvano Bussotti (b. 1931), gesticulation is as much part of the composition as playing it is; graphism and sound are wedded. In the choreography of the American dancer Dan Wagoner (b. c. 1935), the spoken word replaces music, or silence ousts both, while props become an integral part of the performance, synthesizing dance and theatre. Film projections complement the acting in many theatrical and operatic performances. These are only a few instances of the phenomenon of radical departures from tradition in the arts.

It is more difficult to estimate why the arts (and music and the dance and the theatre) are headed toward a breaking point. In the introduction I posed four questions that are still unanswered. I did not take them up within the context of the chapters in which they belong because my evaluation of the situations seemed too conjectural for that. That evaluation may find its place in the conclusion, which is, by its nature, suitable for conjectures. Three of these questions relate to the reason that art has taken this specific direction.

One question is how the urge to live creatively is connected with other problems of our time. I believe this urge is a refuge from the boredom of fractional, repetitive work. There is a compulsion in us to create things, and to create them whole. This drive is thwarted by repeating yourself and being a cog on a wheel. To *do* rather than to create makes man aimless: he works for money,

not to produce, and after the newness of that experience has worn off, he feels that the possession of money is not enough to fill his life—as can be seen in the dispute over forced overtime in the car industry. As long as man could build his horse-drawn carriage all by himself, seeing it take shape from the trunk of the living tree to the finished product, he felt at peace with himself. But he is not at peace if his sole function day in and day out is to put a screw in a car on the assembly line. Art becomes a handy escape route for his frustration. But, for many people it is not so much the wish to create *art,* as it is *to create* a thing, any thing. The pleasure of making a beautiful object may follow only later, as a secondary, subsidiary, consequence of the primary choice.

The second question left open is why the tempo of change has accelerated so much since the 1960s. This phenomenon may be related to the first one, in that the passion for change seems based on the giant steps that the uniformizing of the world has taken since World War II. Since then the same goods have been displayed, the same pleasures have been offered, in Singapore, in Stockholm, and in Los Angeles. Through this leveling of all differences, a blanket of conformity is spread over every side of human life, smothering it. As a reaction, the appetite for the different is whetted. "Something else" becomes the battle cry of the suffocating crowd.

The third question—What advantages does such a rapid and radical transformation have for art?—is contingent upon the second. If the artist as artist in creative ferment does not provoke the changes, but the artist as man in revolt against benumbing sameness, then there is no causative link between art and change. Without it, the question has to be reframed to read: What advantages does such a rapid and radical transformation in art have for man?—a question that has been answered.

As to the fourth and last question—Why do the statements of the artists not touch upon the problem of change in style?—the omission may well be due to reticence on the part of the interviewers who may not want to touch upon an embattled issue,

whereas the artists who oppose sudden changes in style may not wish to talk on a sore point and the artists who favor them may find it superfluous to comment on something natural to them.[1] In other words, it is too intimate and personal a problem to be exposed to the harsh light of day.

Living art is hard to assess. Like quicksilver it eludes the grasp, because perspective is wanting for those who live in its midst. To them, the art scene looks confused, resembling an intricate road system that is puzzling to the traveler. On roads help is given by signs and maps. On the roads of art the signs are provided by the artists who inform the public of their purpose through their statements, and the maps are furnished by the art historians who interpret the overall situation and the specific points through their writings. Here is the reason that the material for this discussion was gathered by analyzing the statements of the artists.

Since the statements are the basis for my deductions, a few words on the relevance of one artist's belief to the beliefs of other artists seem in place. How far is his belief representative of theirs? I found that the attitude of one artist in a group, particularly the group's leader, is not an isolated case; on the whole, it is shared by other leading artists of the same group, although shades in meaning particularize each individual statement, revealing its personal bent. But not all artists of the same group need automatically share *all* the ideas of that group; for example, Willem de Kooning values tradition: "It is because of Western civilization that we can travel now all over the world"; whereas Clyfford Still rejects it: "I felt it necessary to evolve entirely new concepts." [2] On the other hand, the goals postulated by the artists and their viewpoints will vary from generation to generation, but they will also be affected by cultural backgrounds. "Change is what makes art," James Rosenquist asserted

[1] Soto is one of the few artists who have touched upon this problem; see Jean Clay, "Soto," *Signals,* I, No. 10 (November–December 1965), p. 9.

[2] Willem de Kooning, "The Renaissance and Order," *Transformations . . . ,* I, No. 2 (1951), p. 86. Ti-Grace Sharpless, *Clyfford Still,* (Philadelphia: Institute of Contemporary Art, University of Pennsylvania, 1963), unpaged.

in 1965; to which Martial Raysse countered in 1967: "Change changes nothing."[3] However, even contemporaries who live in the same country can pursue opposite aims. Thus when Larry Poons stated: "The making is the whole idea of art," and when Frank Stella wrote in 1969: "To me, the thrill or the meat of the thing is the actual painting. I don't get anything out of laying it out," these opinions are diametrically opposed to Andy Warhol's "I think somebody should be able to do all my paintings for me" (see p. 54). When Claes Oldenburg declared in 1967: "I am for an art that is political-erotical-mystical, that does something other than sit on its ass in a museum," this is diametrically opposed to Warhol, who said, in the same year, "there was no profound reason for doing a death series, no 'victims of their time'; there was no reason for doing it at all, just a surface reason."[4] When Ronald Bladen affirmed in 1970 that: "One of the characteristics I think of all my pieces is that they have a front and they have a back. They seem very human to me—they always do,"[5] he reveals that he pursues an aim foreign to the Minimalists. Contrariwise, men as far apart as Claes Oldenburg and Yaacov Agam may share in connecting the transformation of structure in a work of art with the notion of life: "The possibility of movement of the soft sculpture, its resistance to any one position, its 'life' relate it to the idea of time and change,"[6] Oldenburg noted in 1966. Four years earlier Agam had connected his reason for selecting a metamorphical mode of composition with his wish to endow his works with a life of their own (see chap. 5, sec. 4).

[3] Lucy R. Lippard, "James Rosenquist: Aspects of a Multiple Art," *Artforum*, IV, No. 4 (December 1965), p. 41. "Writings by Martial Raysse, Dan Flavin, Robert Smithson," *Minimal Art: A Critical Anthology*, ed. Gregory Battcock (New York: Dutton Paperbacks, 1968), p. 401.

[4] Lucy R. Lippard, "Larry Poons: The Illusion of Disorder," *Art International*, IX, No. 4 (April 1967), p. 22. William S. Rubin, *Frank Stella* (New York: The Museum of Modern Art, 1970), p. 37. Barbara Rose, *Claes Oldenburg* (New York: The Museum of Modern Art, 1970), p. 190. Andy Warhol, *Cahiers du Cinéma* (English ed.), X (May 1967), p. 40.

[5] *Ronald Bladen/Robert Murray*, ed. Doris Shadbolt (Vancouver: The Vancouver Art Gallery, 1970), unpaged.

[6] Rose, *Claes Oldenburg*, p. 194.

It is the task of the critic to find his way in this maze of roads and crossroads, and to decide what is a highway, what a byway, what group opinion, what the influence of environment, and what personal inclination.

To be "anti" occupies a fairly large place in today's world. Hence attacks on personalities or groups occur from time to time, particularly if two artists belong to different generations, or if one is European and the other American. The former is the case when Robert Indiana labels Jackson Pollock's impasto a "visual indigestion,"[7] or when the Conceptualists substitute intention for the execution of a work of art, rejecting Frank Stella's and the Minimalists' positions (see above, and chap. 7, sec. 2). The latter is the case when Roy Lichtenstein declared himself "anti-experimental," thus rejecting the credos of Jean-Pierre Yvaral, Julio Le Parc, etc. (see chap. 1); when Andy Warhol stated in 1967: "I am not trying to educate people to see things or feel things in my paintings; there's no form of education in them at all," thus opposing Josef Albers as well as Yvaral; or when Claes Oldenburg represents a series of consecutive moments simultaneously in his *Shattering Milk Bottle* (1969/71)—the bottle hurtling through the air, the moment of impact, and the moments after impact—thus ridiculing Kinetic art.[8]

The list of disagreements and rejections is fairly long, but to multiply instances serves no useful purpose. In the choice between discussing our artists' positive actions or their negative reactions, I have cast my vote for the former. The reader can take it for granted that someone somewhere has taken the opposite position.

However, one significant fact connected with the conflicting viewpoints of the artists should be mentioned: when the basic principle of a group is violently opposed by a member of a different group,

[7] Gene R. Swenson, "What Is Pop Art?, I," *Art News,* LXII (November 1963), p. 27.
[8] Warhol, *Cahiers du Cinéma,* p. 40; *Object into Monument,* ed. Barbara Haskell (Pasadena, Calif.: Pasadena Art Museum, 1971), p. 112.

the same principle can reappear as the formative element of a third group. Thus de Kooning, in 1949, read a paper that contained the following statement: "One is utterly lost in space forever. You can float in it, fly in it, suspend in it and today, it seems, to tremble in it is maybe the best or anyhow very fashionable. The idea of being integrated with it is a desperate idea." [9] Since Lucio Fontana's "White Manifesto" dates from 1946, and his pierced canvases from 1949, de Kooning's diatribe may be directed against the *spazialismo* of the Argentinian artist. Yet, the integration of the work of art with space is also the basis for Environmental art, coming to the fore in 1961 with the exhibition "Environments, Situations, Spaces" at the Martha Jackson Gallery, New York. De Kooning thus appears as the accidental link between Fontana and the Environmentalists.

On the other hand, when de Kooning, in 1951, pronounced himself, in a much-advertised symposium at The Museum of Modern Art, New York, "What Abstract Art Means to Me" (published in the museum's *Bulletin*), against the reductive trend in art by saying: "Art meant everything that was in it—not what you could take out of it," [10] this was probably an attack on the painting of Barnett Newman who had had exhibitions at the Betty Parsons Gallery, New York, in 1950 and 1951. If so, de Kooning is a link between Newman and Minimal art, with which the reductive principle resurfaced in the 1960s. It would be only human if a new generation of artists, involved in the rejection of the leader of their predecessors, should select as the foundation of their work a principle that this leader has specifically disavowed.

Thus the road of art usually contains many switchbacks, one group picking up where its predecessors diverged.

This is the moment to mention another peril for the unwary in exploiting statements. It concerns the meaning of words, or rather

[9] Thomas B. Hess, *Willem de Kooning* (New York: The Museum of Modern Art, 1968), p. 15.

[10] "What Abstract Art Means to Me," *The Museum of Modern Art/Bulletin,* XVIII, No. 3 (Spring 1951), p. 5.

their ambiguity. Each generation has the tendency to coin new expressions and to endow old ones with special meaning. The new words then find their way from one discipline into another, art borrowing from philosophy and science, or vice versa. In the beginning of the century such a new art term was *volume;* a contemporary example would be *presence.* William Rubin has aptly defined the latter as "the ability of a configuration to command its own space." [11] Unfortunately, the meaning of new terms is not always pinned down, or it is pinned down too late. Therefore the same word may not always mean the same thing to different artists. This happened with the expression *system,* and the havoc wrought by a nonconformist attitude in the use of words is obvious. Another word much liked by contemporary man is *attitude.* Conceptualist art has been called an art of attitude. Yet, already in 1966, the year Conceptual art was born, and several years before the public appearance of the Conceptualists on the art scene, the critic Aldo Pellegrini had defined the New Realists of Yves Klein's group: "It is more reasonable to speak of an art of behavior or of attitude when referring to these artists. For it is precisely in this that the importance of all of them lies: they are men who hierarchize the attitude in the artist. . . ." [12] But what about the expression *New Realism* for this trend, an expression quite inadequate to conjure up the style of the group? Yayoi Kusama's use of the words *self-destruction* and *self-obliteration* also conveys the wrong idea of what she does, which is to cover the nude body with paint instead of with a dress. By using such loose terminology, quite unconnected artistic trends are linked together, particularly in exhibitions that wish to focus on a certain theme, but need a number of works to fill the rooms.[13] No harm is done as long as an analytical survey points out the differences.

[11] Rubin, *Frank Stella,* p. 37.

[12] Aldo Pellegrini, *New Tendencies in Art* (New York: Crown Publishers, 1966), p. 248.

[13] E.g., John Coplans, *Serial Imagery* (Pasadena, Calif.: Pasadena Art Museum, 1968) and *Destructive Art: Destroy to Create* (New York: Finch College, 1968).

Even if a word carries an identical meaning for two artists, subtle inflections may shade it differently in each. Also, similarities in the phrasing of a thought can sometimes be found in two artists who seem to have little in common, and whether or not there is a connection between them is not clear. Thus Jean Dubuffet refers to the art that he considers boring and "homologous" as *art culturel*, that is, cultural art (see chap. 6, sec. 1), and Clyfford Still speaks of the Establishment in art, whose ideology he rejects, as the "Culture State." [14] Does this mean that Still, like Dubuffet, rejects culture totally?

There is great risk in taking words at their face value, without searching out what actually lies behind them. Thoughtless acceptance of phrasing is a source of the confusion that reigns in writing on art. Each term must be interpreted within the context in which it appears.

The art in the midst of which you live is hard to assess. One moment you seem to have grasped its shape, and the very next moment it changes, re-forming differently under dismayed, yet pleased, eyes. Despite the lack of psychological distance, however, some traits have emerged in the discussions. Such is this art's great vitality. Also its many-sidedness in one art center coexisting with its uniformization on the global level. It is as though, in a curious reversal of history, regionalism has been wiped out and catholicism substituted: the same tolerance for cohabitation of manifold vanguard types pervades the art scene everywhere in the world. This development started when Abstract Expressionism in the United States and Tachism in Europe were able to live in harmony with Constructivist art. By the 1970s the trend has spread to encompass the Far East and South America, so that the types living together in good neighborliness have grown in number and diversity.

These are general traits. More specifically, one solution encountered again and again in the survey is the use of reflecting and

[14] *Clyfford Still: Thirty-Three Paintings in the Albright-Knox Art Gallery* (Buffalo: The Buffalo Fine Arts Academy, 1966), p. 18.

transparent surfaces (Figs. 32b, 35, 38, 45, pp. 217, 228, 243, 285), the discoveries of Brancusi (Fig. 33, p. 218), and of Duchamp (*Large Glass,* discussed in connection with Larry Bell). The reason that this path is much frequented by contemporary art is given in a statement, not quoted so far, which charts this road as a signpost.

Hans Haacke, in discussing his aluminum foil, stainless steel, and plastic works of 1961 and 1962, had the following to say about them to the Intersocietal Color Council in 1968:

> The room in which these reflecting objects (they are not really paintings any more) were displayed became part of them simply by being reflected in them. In fact, the objects could not be seen isolated at all. Their appearance was constantly at the mercy of their environment. Actual, not illusionistic, changes were taking place, changes that could be recorded by a camera. Stretching beyond the space it materially occupied by integrating the area of display, an optical dialogue was established between the reflector and its surroundings. The viewer, being part of the surroundings, participated in this dialogue.[15]

This comment of the artist reveals that the use of reflecting (and transparent) surfaces in contemporary art is part and parcel of two drives: one for constant, unpredictable changes, and the other for integration of art, environment, and spectator. These two notions, change and integration, are formative influences in contemporary art, as is evident from their offshoots, the philosophies of the *something else* and of *the merger*. Yet it is impossible to establish whether the effects of reflecting and transparent surfaces led to the desiderata of change and integration, or the call for change and integration led to the utilization of reflecting and transparent surfaces.

Much can be learned from a study of the artists' statements about their goals, but much also remains untold.

Some of the roads traveled by contemporary art are of the kind found in any period, for instance, the search for new types of com-

[15] From a paper read at the Annual Convention of the Intersocietal Color Council in 1968. German translation in Edward F. Fry, *Hans Haacke: Werkmonographie* (Cologne: M. DuMont Schauberg, 1972), p. 39.

position. Here then one has to go one step farther and ask: what types of composition? Anchored to the notion of regularity seems to be the answer: regularly disposed assemblages of dots and stripes, grid systems, and systems of curves prevail, in nonobjective art, over dramatic and lyrical effusions. They are evident as a support below the surface even where the surface is an irregular crust, as in Jasper Johns (Fig. 12, p. 110). Coolness dominates in contemporary works through these geometrically inspired and regularized motifs. In figurative art the age-old visual symbols, which are effective because they concurrently stimulate the imagination and satisfy the eye,[16] are used: doors, seats, curtains, spheres, towers, etc. (Figs. 4, 25, 40, 45, 47, pp. 63, 181, 251, 252, 285, 300). Added to them are symbols relevant to topical questions, like Lichtenstein's imitations of Greek temples,[17] which make fun of the trend toward escaping from the present into archaeological time; Haacke's *Strand Pollution* (1970),[18] a monument constructed at Carboneras, Spain, from garbage left by people, which castigates selfish unconcern; and Beuys's references to the Berlin Wall, etc.

Other roads are new, and they have been specifically built by contemporary art. Two cases in point are the exploitation of new materials, through which new visual experiences are added to the enjoyment of art, and the stress on self-sufficiency, the work being given a gravitational center in itself, either by disposition of shapes or by eliminating a pedestal.

In trying to appraise the character of contemporary art from 1945 to 1973, I have been struck by its negative or rejective side. Possibly I am overemphasizing this point because positive attitudes seem to me more valuable than negative ones. Why should "the responsibility of *not* knowing [be] one of the most important aspects of making art," as asserted by Poons in 1965? Why should "the

[16] This point will be discussed elsewhere by the writer.
[17] Diane Waldman, *Roy Lichtenstein* (New York: Harry N. Abrams, 1971), Figs. 99, 100.
[18] Fry, *Hans Haacke,* Fig. 70.

most beautiful thing about modern art [be] that it has built into its own potential the capacity for destroying itself," as asserted by Barry in 1969? [19] Why not, rather, the responsibility of "knowing"? The capacity for "renewing itself"? It is true that nihilistic and destructive gestures impress more strongly than positive and creative ones. Annihilation of a work will be more vividly remembered than its process of creation. But, the artist, as spiritual leader of the community, should rise above these tricks of the trade and set an example of a goal that should be reached by excellence of work rather than by shock tactics. An invitation to productivity is healthier than an invitation to destruction.

Another provocative trait of contemporary art is its "if-I-say-so" attitude. One feels that perhaps a certain amount of insecurity underlies this assertion of the self as the supreme judge. In this regard it is interesting to note that Robert Morris created a new type of self-portrait in the shape of a giant letter *I*. *I-Box* (1962) is currently in the collection of Haverford Yang, New York.[20] The *I* forms an inset in a square panel, darker in color, so that the shape stands out vividly. Two hinges on one side and a projecting knob indicate that the *I* serves as a door, which the viewer is invited to open. Inside is displayed a photograph of the artist, confronting the spectator in paradisaical nudity. His body is posed symmetrically, like the statue of a god, except for a slight deviation in the hands. There he stands with his head thrown back and laughing fullheartedly at our surprise in finding him enshrined in this sham compartment. Once the idea has taken root that the *I* stands for the artist, other possible meanings surface in the mind. The letter *I* is also the Roman equivalent for the Arabic number *1* (one). Therefore Morris identified himself with Number 1. But, pronounced phonetically, *I* is identical with *eye*. This synonymity of the artist with an eye is a common metaphor in art; Cézanne used it deroga-

[19] Lippard, "Larry Poons," p. 22. Ursula Meyer, *Conceptual Art,* (New York: Dutton Paperbacks, 1972), p. 35.

[20] Michael Compton and David Sylvester, *Robert Morris* (London: The Tate Gallery, 1971), p. 54.

torily to call Monet "only an eye, but good Lord what an eye!" [21] However, Morris may have picked up the eye image from Johns, who had portrayed the critic as defective eyes a year before.

Friction between the museum or collector as buyer and the artist as seller, between the critic as appraiser and the artist as appraised, is a normal occurrence. But, in the first portion of the contemporary art period (1945–1960), pique has turned into acerbity, surfacing in statements and retributive gestures. One of the former is Pollock's outburst to Selden Rodman in 1957: "None of the art magazines are worth anything. Nobody takes them seriously. They're a bunch of snobs. Hess is scared—scared of being wrong." [22] One of the latter is the relief *The Critic Sees* (1961) by Johns, which is in the Robert Scull collection, New York.[23] Johns has isolated the region of the eyes from a human head and modeled it on a plaster bed. The eyes look at us through glasses. Yet, instead of pupils, two toothy mouths lie behind the orbits. The right mouth sneers, the left vituperates. If Johns is to be believed, the critic uses his mouth instead of his eyes. Kurt Schwitters was more charitable in portraying *The Critic* (1921) in his rubber-stamp drawing for gallery-owner Herbarth Walden's *Der Sturm,* a vanguard publication of pre–World War I Berlin. Schwitters' critic shoots arrows from the eye as well as from the mouth, one from the former and six from the latter. But these arrows are not foul, abusive language, they are enlightenment. As rays of light emanate from the head of Christ, likewise nine lines, each reading "Der Sturm," radiate from the critic's head. The critic is identified with Walden, the publisher, because his body consists of typographical matter: stamps reading *Bezugsexemplar* (reviewer's copy); *Redaktion;* and date stamps

[21] Ambroise Vollard, *Paul Cézanne: His Life and Art* (New York: Crown Publishers, 1923), p. 74.

[22] Selden Rodman, *Conversations with Artists* (New York: Devin-Adair, 1957), p. 85. Sol LeWitt's attack on the critic in 1967, "Paragraphs on Conceptual Art"; reprinted in *Sol LeWitt* (The Hague, Gemeentemuseum, 1970), p. 56, is milder.

[23] Max Kozloff, *Jasper Johns* (New York: Harry N. Abrams, 1969?), Pl. I.

alternate with printed repetitions of the name *Herbarth Walden,* and with blocks of abstract lines.[24]

Both Morris' *I-Box* and Johns's *The Critic Sees* are distinguished by the wittiness of the invention, and wittiness is a third pervasive trait to be noticed in contemporary art, but it is mainly confined to its American branch. Johns, Rauschenberg, Morris, and Oldenburg are the leaders in this respect, but the irony displayed in Pop art also bears mentioning. Johns's and Rauschenberg's manipulations of art and the object, Oldenburg's attack on Kineticism, Morris' impassable *Passageway,* and Lichtenstein's *Greek Temple* exemplify this side of American contemporary art.

As stated in the introduction, the years 1945 to 1973 divide into two portions: the stable rule of Abstract Expressionism and the quick take-overs by one "usurper" after the other. It now becomes evident that another circumscription of these two periods is possible: the domination of painting by the appreciation of retinal effects; and the domination of sculpture by the appreciation of haptic sensations. Sculpture, for centuries the stepchild of art, has finally caught up with painting. It may even have taken the lead again, as it had for most of the course of art history. To catch up with painting sculpture had to cover a great deal of ground, and it is possible that that fact accounts for the hectic atmosphere in the second phase of contemporary art. With the rise of sculpture new tactile effects have joined the ranks of the old ones, such as yielding to the touch, shaping with the touch, being caressed by the object (friction), and sticking to the touch (fat). Color, the mainstay of painting, was demoted to being an adjunct, to serve as a toucher-up of parts. On the other hand, light, which is an adopted effect in painting as well as in sculpture, has maintained its high standing. The revival of sculpture is perhaps the most perplexing aspect of contemporary art, in that this return of the prodigal is a return to the fold of tradition.

[24] Werner Schmalenbach, *Kurt Schwitters* (New York: Harry N. Abrams, 1967?), p. 108.

These then are the gains, positive and negative, of the past quarter of the century, albeit outlined tentatively. It remains to see where we now stand. The Introduction contended that 1945 was the year when the latest corner was turned in art. That was written five years ago, when this survey was started. Today this statement no longer seems quite true. Actually, the corner was turned in the 1960s, and the years 1945 to 1960 merely led up to this last break in the history of art. During the 1960s we took off into outer space. Note that flying into no-art's-land is a much sharper separation from the past than turning a corner. Rosenquist is right: art is an activity of change, hence unpredictable. Raysse seems wrong: change *has* changed something. This new development has brought about a reversal in the life history of art.

After a century of promoting a philosophy of aestheticism, art is turning its back on that: after seeking to stimulate the senses, it now seeks to address itself again to the mind. Art has found at last that aestheticism has led man down a path toward gratification of the self with utter disregard for the weal of others. The Impressionist trailblazers were not aware of that, however. Aestheticism was born out of the disappointment suffered by the French intelligentsia and middle class when the revolution of 1848 turned out to be the stepping stone that led to the abolishment of the republic. The disillusioned fighters for the rights of the individual buried their hopes and, turning away from participation in the life of the community, dedicated themselves to providing a substitute for the unattainable dreams they had sought to make real through the revolution. The artists among them found that substitute by creating what Meyer Schapiro has called "vacation art" [25]—that is, an art form addressed mainly to the individual's enjoyment of sensations, without the accompaniment of troublesome thought; the accent was placed on seeing a lovely spectacle, and content was minimized in the work—even declared harmful at times. This type of art became dominant from the 1860s through World War I, and it was also

[25] From class lectures at Columbia University, 1952.

prominent during the 1960s. However, to maximize form at the expense of content places art on a par with drinking, playing cards, watching games, and betting—in other words, the pastimes of the thoughtless. Yes, idealism was defeated, but does it follow that man has to accept the defeat and to adopt a defeatist attitude in turning back upon himself?

Apparently bottom has been touched in this decline of humanistic values, and art wishes to work its way up again. To this end the importance of content in the work has been reasserted. But the climb uphill is a laborious process. Drastic measures are needed to get art out of the hole into which it has maneuvered itself. The drastic step art has taken is to dispense altogether with aesthetics. In addition, the art object was anathematized. Whether this para-art will continue as a viable direction on a path of no return or whether, having lanced the boil that poisoned its body, art will resume its former path, reaffirming the validity of form but not its supremacy, it is still too soon to judge.

Bibliography

Adriani, Götz; Konnertz, Winfried; and Thomas, Karin. *Joseph Beuys.* Cologne: M. DuMont-Schauberg, c. 1973.

Agam, Yaacov. *Yaacov Agam.* Neuchâtel: Éditions du Griffon, 1962.

Arnheim, Rudolf. *Art and Visual Perception: A Psychology of the Creative Eye.* Berkeley, Calif.: University of California Press, 1954.

Ars Multiplicata: Vervielfältigte Kunst. Cologne: Wallraf-Richartz Museum, 1968.

Ballo, Guido. *Fontana.* New York: Praeger Publishers, 1971.

Bann, Stephen; Gadney, Reg; Popper, Frank; and Steadman, Philip. *Four Essays on Kinetic Art.* St. Albans, Great Britain: Motion Books, 1966.

Barrett, Cyril, S.J. *Op Art.* New York: The Viking Press, 1970.

Battcock, Gregory, ed. *The New Art.* New York: Dutton Paperbacks, 1966.

––––––. *Minimal Art: A Critical Anthology.* New York: Dutton Paperbacks, 1968.

Bourdon, David. *Christo.* New York: Harry N. Abrams, 1971.

Burnham, Jack. *Beyond Modern Sculpture.* New York: George Braziller, 1968.

Calas, Nicholas. *Art in the Age of Risk and Other Essays.* New York: Dutton Paperbacks, 1968.

––––––, and Calas, Elena. *Icons and Images of the Sixties.* New York: Dutton Paperbacks, 1971.

Castleman, Riva. *Technics and Creativity: Gemini G.E.L.* New York: The Museum of Modern Art, 1971.

Celant, Germano, ed. *Art Povera.* New York: Praeger Publishers, 1969.

Compton, Michael, and Sylvester, David. *Robert Morris.* London: The Tate Gallery, 1971.

Contemporary Sculpture. New York: The Art Digest (Arts Yearbook VIII), 1965.

Coplans, John. *Serial Imagery.* Pasadena, Calif.: The Pasadena Art Museum, 1968.

————, *et al. Andy Warhol.* Greenwich, Conn.: New York Graphic Society, 1970.

Forge, Andrew. *Rauschenberg.* New York: Harry N. Abrams, 1972.

Fried, Michael. *Morris Louis.* New York: Harry N. Abrams, 1971?

Fry, Edward F. *David Smith.* New York: The Solomon R. Guggenheim Foundation, 1969.

————. *Hans Haacke: Werkmonographie.* Cologne: M. DuMont-Schauberg, 1972.

Gomringer, Eugen. *Josef Albers: His Work as Contribution to Visual Articulation in the Twentieth Century.* New York: George Wittenborn, c. 1968.

Gottlieb, Carla. "Movement in Painting." *Journal of Aesthetics and Art Criticism,* XVII (September 1958): 22–33.

Green, Eleanor. *Scale as Content.* Washington, D.C.: The Corcoran Gallery of Art, 1967/68.

Habasque, Guy, and Ménétrier, Jacques. *Nicholas Schöffer.* Neuchâtel: Éditions du Griffon, 1963.

Hess, Thomas B. *Willem de Kooning.* New York: The Museum of Modern Art, 1968.

————. *Barnett Newman.* New York: The Museum of Modern Art, 1971.

Hon—En historia. Stockholm: Moderna Museet, 1966.

Hultén, K. G. Pontus. *The Machine.* New York: The Museum of Modern Art, 1968.

Hunter, Sam. *American Art of the Twentieth Century.* New York: Harry N. Abrams, [1972].

Julio Le Parc: Recherches 1959–1971. Düsseldorf: Städtische Kunsthalle, 1972.

Kaprow, Allan. "The Demiurge." *The Anthologist,* XXX, No. 4 (Winter 1959), unpaged.

————. *Assemblage, Environments and Happenings.* New York: Harry N. Abrams, 1966.

Kirby, Michael. *Happenings: An Illustrated Anthology.* New York: Dutton Paperbacks, 1966.

————. *The Art of Time: Essays on the Avant-Garde.* New York: Dutton Paperbacks, 1969.

Kostelanetz, Richard, ed. *Moholy-Nagy.* New York: Praeger Publishers, 1970.

Kozloff, Max. *Jasper Johns.* New York: Harry N. Abrams, 1969?

Kultermann, Udo. *Art and Life.* New York: Praeger Publishers, 1971.

Lebel, Robert. *Marcel Duchamp.* New ed. New York: Paragraphic Books, 1967.

Limbour, Georges. *L'Art brut de Jean Dubuffet: Tableau bon levain à vous de cuire la pâte.* New York: Pierre Matisse, 1953.

Lippard, Lucy R. *Changing: Essays in Art Criticism.* New York: Dutton Paperbacks, 1971.

————, et al. *Pop Art.* New York: Praeger Publishers, 1966.

Lissitzky-Küppers, Sophie. *El Lissitzky: Life, Letters, Texts.* Greenwich, Conn.: New York Graphic Society, 1968.

Lumière et mouvement: L'Art cinétique à Paris. Paris: Musée Municipal d'Art Moderne de la Ville de Paris, 1967.

McShine, Kynaston, ed. *Yves Klein.* New York: The Jewish Museum, 1967.

Man Ray. *Self Portrait.* Boston: Little, Brown, 1963.

Massin. *Letter and Image.* New York: Van Nostrand Reinhold, c. 1970.

Meyer, Ursula. *Conceptual Art.* New York: Dutton Paperbacks, 1972.

Morris, Robert. "Anti Form." *Artforum,* VI, No. 8 (April 1968): 33–35.

————. "Notes on Sculpture, Part 4: Beyond Objects." *Artforum,* VII, No. 8 (April 1969): 50–54.

Motherwell, Robert, ed. *The Dada Painters and Poets: An Anthology.* New York: Wittenborn, Schultz, 1951.

Müller, Grégoire. *The New Avant-garde: Issues for the Art of the Seventies.* New York: Praeger Publishers, 1972.

O'Connor, Francis V. *Jackson Pollock.* New York: The Museum of Modern Art, 1967.

Pellegrini, Aldo. *New Tendencies in Art.* New York: Crown Publishers, 1966.

Piene, Nan R. "Light Art." *Art in America,* LV (May–June 1967): 24–47.

Piene, Otto, and Mack, Heinz. *Zero.* Cambridge, Mass.: MIT Press, 1973.

Piero Manzoni. Rome: Galleria Nazionale d'Arte Moderna, 1971.

Popper, Frank. *Origins and Development of Kinetic Art.* Greenwich, Conn.: New York Graphic Society, 1968.

Restany, Pierre. "Quand l'art descend dans la rue." *Arts et loisirs,* XXXI (April 27–May 3, 1966): 16–17.

Rickey, George. "The Morphology of Movement: A Study of Kinetic Art." In *The Nature and Art of Motion,* ed. Gyorgy Kepes, pp. 81–115. New York: George Braziller, c. 1965.

————. *Constructivism: Origins and Evolution.* New York: George Braziller, 1967.

Robertson, Bryan. *Jackson Pollock.* New York: Harry N. Abrams, 1960.

Rose, Barbara. *A New Aesthetic.* Washington, D.C.: The Corcoran Gallery of Art, 1967.

————, ed. *Readings in American Art since 1900: A Documentary Survey.* New York: Praeger Publishers, 1968.

————. *Claes Oldenburg.* New York: The Museum of Modern Art, 1970.

Rubin, William S. *Frank Stella.* New York: The Museum of Modern Art, 1970.

Russell, John, and Gablik, Suzi. *Pop Art Redefined.* New York: Praeger Publishers, 1969.

Sandler, Irving. *The Triumph of American Painting: A History of Abstract Expressionism.* New York: Praeger Publishers, 1970.

Schwarz, Arturo. *The Complete Works of Marcel Duchamp with a Catalogue Raisonné.* London: Thames and Hudson, 1969.

Seitz, William C. *The Responsive Eye.* New York: The Museum of Modern Art, 1965.

Selz, Peter. *Directions in Kinetic Sculpture.* Berkeley, Calif.: Berkeley University Art Museum, 1966.

Sharpless, Ti-Grace. *Clyfford Still.* Philadelphia: Institute of Contemporary Art, University of Pennsylvania, 1963.

Smith, Brydon, ed. *Dan Flavin.* Ottawa, Ontario: National Gallery of Canada, 1969.

Software: An Exhibition Sponsored by American Motors Corporation. New York: The Jewish Museum, 1970.

Solomon, Alan R. *Robert Rauschenberg.* New York: The Jewish Museum, 1963.

Sound Texts. Concrete Poetry. Visual Texts. Amsterdam: Stedelijk Museum, 1971.

Steinberg, Leo. *Other Criteria: Confrontations with Twentieth-Century Art.* New York: Oxford University Press, 1972.

Swenson, Gene R. "What Is Pop Art?" *Art News,* LXII (November 1963): 24–27, 60–64; (February 1964): 40–43, 66–68.

Tancock, John L. *Multiples: The First Decade.* Philadelphia: Philadelphia Museum of Art, 1971.

3 → ∞ : New Multiple Art. London: Whitechapel Art Gallery, 1970/71.

Tinguely. Hanover, Germany: Kestner-Gesellschaft, Catalogue No. 2, 1972.

Tomkins, Calvin. *The Bride and the Bachelors*. Enl. ed. New York: The Viking Press, 1968.

Tuchman, Maurice, ed. *American Sculpture of the Sixties*. Los Angeles, Calif.: Los Angeles County Museum of Art, 1967.

————. *A Report on the Art and Technology Program 1967–1971*. Los Angeles, Calif.: Los Angeles County Museum of Art, 1971.

Tzara, Tristan. *Lampisteries, précédés de sept manifestes Dada*. [Paris]: J. J. Pauvert, 1963.

Vasarely, Victor. *Vasarely*. 2 vols. Neuchâtel: Éditions du Griffon, 1965, 1970.

Waldman, Diane. *Carl Andre*. New York: The Solomon R. Guggenheim Foundation, 1970.

Weitermeier, Hanna. *Licht-Visionen: Ein Experiment von Moholy-Nagy*. Berlin: Bauhaus-Archiv, c. 1972.

Weller, Allen S. *Art USA Now*. New York: The Viking Press, 1963.

Wember, Paul. *Yves Klein*. Cologne: M. DuMont-Schauberg, 1969.

Wescher, Herta. *Collage*. New York: Harry N. Abrams, 1971?.

Index

Boldface page numbers indicate illustrations. *Italic* page numbers indicate major discussions of a subject.

A-Art, 346. *See also* Duchamp, Marcel: Readymades
abstract (nonobjective) art, 144, 152, 292, 329, 398; ambiguity of term, *96;* and symbolism, 99; and scientific illustrations, 293; colored light, *297;* done by chimpanzees, 323; done by machine, 324, 326, 328; pedestal in, 133, 167
Abstract Expressionism, 18, 70, 90, 117, 396; and Morris, 164, 166; and Poons, 131; chronology, 3, 401; defined by Greenberg, *80;* defined by Rosenberg, *97–98;* rejected as decorative, 99; rejected as too emotional, 94; scale, *137–38, 139. See also* color-field painting; Gestural art
Abstract Expressionist sculpture, 100, 101, *167*
abstract patterns, 180, 206–07, 258
absurdity, 162, 175, 345, 367
academic art, 24, 39–40, 322, 377
accident (chance), 26, 53, 107, 166, 290, *321;* and Gestalt psychology, 329; in Duchamp, 330, 336; in Morris, 163; in Pollock, 152; in Rauschenberg, 2, 6; promoted by Dada, 36, 329
Achromatics, 338
Action Painting. *See* Gestural art
active spectator participation, 139, 313, 372, 387; blockage of route, *46–50;* destruction of work, 41, 43; handling of work, *52,* 256–57, 285, *290–91;* ingestion, 342; options for display, *52–53;* Penetrables, 272,

see also reflections; rearrangement, *44–45, 232–33*
additive, 173
aesthetic experience, 12, 353, 373, 383; dispensable, 328, 378, 382, 402; indispensable, 67, 378
afterimage (simultaneous contrast), 130, 177, 263
Agam, Yaacov, 21, *44–46,* 57, 151, 166, *167–70,* 173, 198, *274–76, 290–91;* contrapuntal paintings 275; *Fiat Lux,* 302; metamorphical paintings, *45–46, 274;* metapolymorphic works, 275; *Moods, 168,* **169,** *170,* 172, 191, 278; musical relief, *290–91; Once upon a Time, 275–76;* polygonal paintings, 275; polymorphic works, 275; statements, 45, *147, 151,* 159, *168,* 274, *276,* 392; *Three Times Three Interplay,* 45; transformable paintings, *44–45, 274*
aggregation sculpture, 182
airborne art, 135, 147–48, *303–08, 309–313,* 314, 316, *339,* 384, 387
Aktionen, 34, 257, 260, *356–57, 360,* 361, 362
Albers, Josef, 4, 27, 57, 154, *172, 186,* 200, *264–65,* 393; Homages to the Square, 172, 186, 190; *Impossibles, The,* 274n; statements, 22, 126, 190, 264–65; *Structural Constellations,* 274n; *White Line Square VIII,* 174, *186,* 190, *264–65,* **265;** *White Line Square XIII,* 264
allegory, 73, 103, 114, 137, 350, 351

allover design, 131, 140, 164, 166
Alloway, Lawrence, 170–71, 384
ambiguity, 9, 27, *126–27, 130–32, 174, 195, 212,* 214, 215, 344; spatial, *see* reflections
American art, 92, 138. *See also* contemporary art in America and Europe
Amsterdam: Art and Project Gallery, Robert Barry exhibition, 381— Stedelijk Museum, Soto retrospective, 272
anaxial symmetry, 125
ancient art, 72, 108, 255
Andersen, Troels, 360
Andre, Carl, 25–26, 27, 115, *125, 245–48,* 272, 287, 288, 290, 371; *Lever,* 247, 248; *Prospect 68,* 247; statements, 25, 125, 135, *246, 247; 37 Pieces of Work,* 114, 115, 135, **245,** *245–46,* 248
Andreades, G. A., 226
animals, 44, 73n, 309, 311, 315, 316
anonymous art, *378–79*
anti-art (non-art), *345–46,* 348
anti-form, 158, *163,* 167, 329, 387
Anuszkiewicz, Richard, 21, **129,** 263
Apollinaire, Guillaume (pseud.), 97; *Calligrammes,* "Il pleut," 256
Appel, Karel, 359
Aragon, Louis, 366, 367
Arakawa, Shusaku, 254
Archipenko, Alexander, 4, *203,* **233,** 234; *Woman Combing Her Hair,* 203n
architecture, 99, 154–55, 194, 210, *211–54,* 353–54, 384
Arensberg, Walter, 56, 289
Arman, 88, 335
Armando, 88
Arnheim, Rudolf, 132n, 329
Arnhem (Holland), Park Sonsbeek, "Summer Group Exhibition," 157
Arp, Jean, 4, 40, *126,* 132, 133; *Almanach Dada,* 126; "I Became More and More Removed from Aesthetics," 126, 346; statements, 126, 320, 346
art: and behavior, 346; and problems of life, 11; background for Happenings, 258; carries a message, 99–100, 105; cerebral exercise, 194; changes man, 305; commercialized, 57, 58; defined, 1; demonstrates process of life, 315; escape hatch from present, 261; esoteric, 374; experience different from reality, 159; expression of state of mind, 268–69; fetish-object, 54; gratifies senses, 38; guided by unconscious, 321; imitates conditions of life, 369; includes its life cycle, 332; instrument of warfare, 33, 344; interdependent with object, 209; lacks causal link to change, 390; made for others not self, 383; mental process, 363; mindless, 38; misdirected through sponsorship, 67; philosophical speculation, 111; pretext for financial operations, 54, 58; reflects its time, 20, 57, 58, 270, 294; reflects concept of change, 331; relaxation, 5–6, 31; renewal through tabula rasa, 379; reserved for gentlemen, 30; source of understanding man, 60; spiritual experience, 38; strategical tool, 116; subservient to object, 28, 249; tied to idea of beauty, 28; tied to idea of joy, 78; tool to influence masses, 25, 66; tool to influence self, 18; useless, 366; visual puzzle, 174
art ambience, 351
art brut, 321–22
arte povera. *See* Land art
artifact, *38,* 56, *59, 60,* 91, *267–68,* 349, 350
artificial paints, 120, 121
artist, 3, 12, 16–17, *20,* 64, 70, *259,* 316, 376, 387; and art, 369, 376, 379, 387; and creative power, 20; and critic, 3, 138, 319, 400; and other artists, 391–94; and power to influence others, 34–35; and privilege syndrome, 319, 383; and stylistic changes, 391; admirer of technology, 293; amateur actor, 257; average man, 320; clerk, 33; conjurer, 377; critic of contemporary values, 70; crusader, 24; dec-

orator, 59; dictator, 384; different from scientist and average man, 333; dreamer, 261; equal to Christ and kings, 137; fallible in judg- ment, 333, 365; gift bearer, 249; guide, 45; *homo universalis,* 4, 198; illuminated, 334, 345; judge, 3; less important than human being, 35; magician, 319, 333; overcomes restricting rules, 319; physically unfit, 320; political be- ing, 33; prejudiced, 384; "pro- ducer" of artwork, 116; renews himself at cost of extinction, 369; revolutionary, 390; screwball, 346; something special, 318; spiritual leader, 399; tool of God, 309, 319, 345; uninvolved, 90–91, 382; vi- sionary, 59, 70, 294. *See also* Christian notes in the artists' writ- ings; spectator; sponsor; statements
artistic imperative, *343–45,* 370, 399
artistic versus aesthetic, 38
Art-Language (London), 371, 386
art/object dichotomy, *108–14,* 209, 238
Arts, Les (Paris), 87
Ashcan School, 92
Ashiya City, Japan, "Second Outdoor Exhibition of 'Gutai' Art Group," 260, 352
Atkinson, Terry, 371, 377; statement, 350–51
Attese, 200
audiovisual spectacle, *65–66,* 288, 290, *301. See also* photo- and au- diokinetic art
autobiographical art, 6, 18, 37, 345
autodestruction, 68, 316, 388, 395
autographic quality of work, 54, 330, 383, 392
automatism, 329
automatons (robots), 262, 281, 324, *339*
autonomy of artwork, *128, 148–51, 153,* 195, *276,* 334, 392. *See also* visual pattern

Baargeld, Johannes Theodor, 40
Bach, Johann Sebastian, 65, 327

Bainbridge, David, 371
Baldessari, John, *Cremation Piece, 368–69;* statements, 364, 368, 369
Baldwin, Michael, 351
Ballo, Guido, 235
Barbari, Jacopo de', *Dead Partridge, The,* 133n
Baroque art, 32, 234, 303
Barry Robert, 378, *380–82,* 399; statements, 380, 381, 382, 399
Basel, Kunstmuseum, " 'Konzept'- Kunst," 372, 385
Bauhaus, 55, 56, 91, 186
Beckmann, Max, 4
Bell, Larry, 121, 134, 197, 219, *227– 29, 231,* 397; *Untitled,* **228**
Berlin, Galerie René Block, *Eurasia: The Siberian Symphony,* Part, 32, 1963, 360
Bernini, Gianlorenzo, *Ecstasy of Saint Theresa, The,* 159
Betsy from Baltimore (chimpanzee), 323
Beuys, Joseph, 8, *34–35,* 121, 135, 163, 260, *355–62;* "ACTIONS, AGIT-POP, DE-COLL/AGE HAPPENINGS, EVENTS, L'AU- TRISME, ART TOTAL, RE- FLUXUS," 356–57; "Beuys Rec- ommends a Raising of the Berlin Wall by 5 cm. (Better Propor- tion!)," 361, 398; *Chair Covered With Fat,* 8, 357; "Division of the Cross, The," *360,* 361; *Eurasia: The Siberian Symphony,* Part 32, 1963, 197, 260, **358,** *359, 359–60; Fat Box,* 357; *Fat Corner,* 357; fat corners, 355; *Fat Figure with Fil- ter,* 357; *Fat Sculpture,* 357; *Fat Vessel,* 357; statements, 33, *35,* 354, *355,* 356, 361, 362; *Table I,* 8; *20th of July Fat Case,* 357; *U-Shaped Twin-Lamp with Hare's Fat,* 357. *See also* Aktionen
Biederman, Charles, 100n
biotic art, 309, *314–16,* 384, 387
Bladen, Ronald: statements, 392; *X, The,* 146n
Bloc, André: sculpture habitacle, 220, 244; statement *220–21*

Boccioni, Umberto, 20
Bochner, Mel, 171
Boezem, Marinus, 364
Bonnard, Pierre, 128
Bosch, Hieronymus, *Garden of Earthly Delights, The,* 65
boundary in sculpture, *132–36,* 194. *See also* extensibility; integrationism; reflections; segregationism
Brancusi, Constantin, 4, 242, 388; and reflections, 134, 202, 216, 397; and the pedestal, *133–34,* 135, 167; Birds, 73n; *Endless Column, The,* 158, 247; *Newborn, The,* 73n, 115, 202, 216, **218,** 242, 397; paints essence, 114, 115; removed overgrowth from sculpture, 159
Brecht, George, 352, 353
Breer, Robert, 281
Breton, André: First Friday Matinée, *365–67;* "First Papers of Surrealism," 163; *Littérature, La,* 365; statement, 330; *Two Dada Manifestoes,* 330
Brock, Bazon, 356
Brunelleschi, Filippo, 20, 335
Brussels, Soto retrospective, 272
Buonarroti, Michelangelo. *See* Michelangelo Buonarroti
Buren, Daniel, 378–79, 380; statements, 370, 376–77, 378, 379
Burgin, Victor, 372
Burn, Ian, 373
Burnham, Jack, 179, 263, 277, 338, 349, 384
Bury, Pol, 57, 147, *282–87,* 288, 290, *291; Sphere upon a Cube,* 147, 278, **285,** *286–87,* 397, 398; statements, *147,* 148, *283,* 284, *286–87*
Bussotti, Sylvano, 389

Cabanne, Pierre, 320, 348
Cage, John, 141, 260
Calas, Nicolas and Elena, 293–94, 316, 368
Calder, Alexander, 4, 154, 277
Camargo, Sergio de, *Relief No. 246,* 174, *183–85,* **184,** 273
Camus, Albert, 88

Caravaggio, Michelangelo Merisi da, *Narcissus,* 148n
carillons, 288
Caro, Anthony, *101–03,* 107, 114; *LXXII,* 101, **102,** *102–03;* statements, 95, 101
Castel, Louis-Bertrand, 297
Castelli, Leo, 112
Castoro, Rosemarie, *A. An.m/m,* 211n
ceiling sculpture, *135–36,* 211, 244n
Cennini, Cennino, 29
Cézanne, Paul, 20, 117, 320, 332, 333; *Self-Portrait,* 206; statements, 30, 319, 399
Chagall, Bella, 113
Chagall, Marc, 4, 5; *Birthday, The,* 112–13, chairs, 4, 5
chair: as motif, *5–9,* 64, 70, 124, 287, 302; as pedestal, *6, 9,* 103, 105, *134–35;* for Matisse, 5–6, *31*
Champfleury (pseud.), 137
chance. *See* accident
Chandler, John N., 185, 186
change, 119, 196, 273, *331–32,* 387; and experience of time, 282, 315, 332; and identity, 5; apparent not real, 380, 392, 402; formal desideratum, 331; formative principle, 332; from chaos to order, 355; in attitude toward art, 23; intensity of, 388, 390, 392, 401, 402; nature of art, 1, 391–92, 402; obsession with, 12, 263; of inert gas, 381; of perishable art, 331, 332; potential for, 166, 224. *See also* Op(tical) art; permutation; "Something else"; spectacle; transformation
Chardin, Jean-Baptiste Siméon, 53, 172
checkerboard, use of. *See* grid, use of
children, *44,* 47, 64, 164, 322, 355, 392
chimpanzees, 12, *323*
Chinese bells, 288
Christian notes in the artists' writings: ark of Noah, 64 (Tinguely); cathedral, 61 (Saint-Phalle *et al.*), 74, 75 (Nevelson), 78 (Smith,

D.); Christ as Saint of Saints, 347 (Picabia); empty throne, 5 (Samaras); *fiat lux* (Gen. 1:3), 302 (Agam); dust to dust (Gen. 3:19), 309 (Dupuy); molten sea, 309 (Klein); phoenix, 369 (Baldessari); Satan, 162 (Oldenburg); virginal motherhood, 347 (Picabia)
Christo (Javacheff), *249–54;* Packages, 249; *Running Fence,* 249; *Valley Curtain,* 249, *250,* **251, 252,** *253–54,* 398; Wrappings, 249
Christus, Petrus, *Portrait of a Young Man,* 239n
chronodynamism, 301
Chryssa, 235n, 299n; *Clytemnestra,* 299n
cityscapes, 100, 118
classifications, 25, 31
clastic, 247
Clavilux, 297
Clert, Iris, *323,* 344
Cobra Group, 359
collage, *91,* 134, 182, *199,* 203, *204, 255, 330*
collective effort. *See* teamwork
Collie, Alberto, *Floatiles,* 311n; statement, 312
Cologne: "Dada Early Spring," "Dada Wins," *40–41*—Wallraf-Richartz Museum, "Ars multiplicata: Vervielfältigte Kunst," 54, 57
color, 8, 17, 24, *144,* 187, 235, 297, 299; affects space, 237; creates levels in depth, 186; deemotionalized, 144; demoted, 280, 401; film color, 229, 276; fluctuates under influence of weather, 313; played down, 273; reflected, 211; reflects, 134; speed of, 274; symbolic, 17–18, 30; unstable, 273
color construction, *144,* 264–65
colored light, 143, 144
color-field painting, *80, 81, 85,* 140
color organ, 297
Column of Trajan (Rome), 282
Combat (Paris), 87
Combines, 200, *204,* 206, 344
compartmented structure, 257, 258
composition: courted, 397–98; rejected, 163, 379
composition, types of: airplane view, 185; armature and work coincide, 163; calculated randomness, 130, 166; climaxed, 146; continuity of color, 144; continuity of field, 220, 227; discontinuity, 144, 187, 189, 267, 283; equalization of parts, 203; fading at edges of canvas, 128, 130; fragment, 93, 128; *horror vacui,* 140; hypnotic, 128, 130, *141–42,* 150–51, 180, 182, 299; microstructure, 139, 141, 142, 226; opposed symmetries, 242; provocative, 140, *141–42;* unclimaxed, 180, 194. *See also* allover design; holistic; nondirectional; nonrelational symmetry; open-ended; reversibility; reflection; station point; inside work; structure
Compton, Michael, 166
concept: not identical with art, 378; outweighs manufacture, 331
Conceptual art, 3, *33,* 118, 193, 344, *403;* and Minimalists, 393; and New Realists, 395; art ambience, 350–51; false, 379; history and meaning, *371–78;* idea, *115–117;* types, *380–86*
Concrete art, 99
Congo of London (chimpanzeee), 323
Constructions, *199,* 204, 239, 330
Constructivism, 20, 55, 99, *100,* 101, 204, 231, 396
Container Corporation of America, 221
contemporary art, 3, 11, 12, 262, 319, 329; ancestors, 4, 388; and the commonplace, 240; and Duchamp, 346; and Lissitzky, 234; and Neo-Dadaism, 346, 351; and tradition, 5, 264–65, 388; characteristics, *388–89, 396–99, 401;* content, 34–35, 38, 70, 355; dematerialization carried to extreme, 269; experimentation, 20, 21, 364; form, 117, 118, 380; Happenings fall outside scope of, 257; Klein

contemporary art (*continued*)
links physics and metaphysics, 303; Lettrism antedates, 256; limits, 1, 3; nonvisual sensation-conscious, 354, 389; painting versus sculpture in, 401; Readymades and, 348; sound-conscious, 288; symbolism, 79; values of, rejected, 70. *See also* statements

contemporary art compared to: Dada, 43; Impressionism, 402; Middle Ages, 389; modern art, 32, 270, 297, 363; precontemporary art, 5–6, 9, 54, 69, 72–73, 79, 81, 111, 148, 194–95, 208, 214–15, 256, 263–64, 282, 288, 289, 330, 349, 354; premodern art, 2, 73–74, 261, 297, 363; Renaissance art, 32, 40, 198; Rubens, 54

contemporary art in America and Europe: active spectator participation, 52, 178; approach to art, 393; chair, 7, 11, 68; color, 273; Environments, 272–73; Happenings, 361; rope, 163; size, 138; symmetry, 125; witticism 401

content, 11, 70–71, 100, 101, 103, 387; and abstract art, 96–98; and Brancusi, 114; and Duchamp, 348; and ethics, 22–23, 24–25, 33–35, 38, 105, 354, 355, 392; and form, 117; and human being, 62; and idea, 116; and Pop art, 89; and subject matter, 69, 70, *89–95*, 98; maximized, 70, 403; minimized, 328, 402. *See also* metaphysics; symbolism

conventions. *See* rules and restrictions

Coplans, John, 171, 172, 395n

Corneille (Cornelis van Beverloo), 359

copying. *See* duplication

cosmic overtones, 86, 87, 202

cotton wool, 121, 343

Courbet, 25, 137; *Atelier, The,* 137; *Burial at Ornans, The,* 137

Couture, Thomas, 30

creation, 375; and Duchamp, 320; and survival, 368; by erasure, 367, 368; dispensed with, 364; replaced by adoption, 349; replaced by intention, 393; replaced by problem, 363; unimportant, 282

creativity: and ape, 323; and assembly line, 389; and Readymades, 349; based on subconscious, 321; expressed in mental attitude not object, 364; inhibited by spying on oneself, 26; inhibited by patronage, 25, 294–95; less important than moral character, 35; origin of 318

critic, 95, 138, 293, 351, 393; tested by Duchamp, 107, 333, 348. *See also* artist: and critic

Croce, Benedetto, 16

Crotti, Suzanne (Duchamp), 333

Cruz-Diaz, Carlos, Physichromies, 276

Cubism, 97, *117,* 175, 270, 332, 366; relational symmetry, 125; subject matter, 91; use of non-art material, *199,* 203, 204; use of shadow, *167;* use of words, 255

Cummins Engine Company of Columbus (Indiana), 308

cutouts, 211

Dadaism, 33, *40–43,* 114, 345, 348, 388; "Dada Early Spring," "Dada Wins," 40–41; First Friday Matinée, *365–67;* promotes accident for art, 36, 329; promotes nonsense, 346; "uninvolved," 90–91

Dadamax. *See* Ernst, Max

Daley, Janet, 58, 59

Dali, Salvador, *Persistence of Memory, The,* 72n

dance, 57, 61, 198, 258, 262, 311, 316, 371, 389

Daudet, Léon, 367

Daumier, Honoré, 53, 91

David, Jacques-Louis, 22, 24; *Rape of the Sabine Women, The,* 22; statement, 22

Davis Stuart, *Odol,* 91

decorative art, *55, 59,* 95, *98–100,* 199, 202, 273, 349. *See also* artifact; visual pattern

deformation. *See* distortion

Degas, Edgar, 60, 128, 199; *Young Dancer*, 330

de Kooning, Willem, 80, 98, 140, 154, 367; statements, 97, 368, 391, 394; *Women*, 97

Delacroix, Eugène, 23

dematerialization, 237, 240, *269*, 303. *See also* reflections

demountable and storable works, 247, 248

demythification, 12, *54, 292, 313, 333, 348–49*, 379, 387

Denis, Maurice, 99

destruction, 13, 259, 316, 351, *352–54, 364–70*, 395n; as gesture, 61, 309; as praiseworthy, 364, 399; discredits art, 371; gift to spectator, *40–43. See also* autodestruction

Dibbets, Jan, 21, 364

dilation of time, *282–84*

Dine, Jim, 21, 93; *Hatchet with Two Palettes No. 2*, 43

direction, 187, *242*, 248

directional drive, *173*, 174, 175, 177, 178, *248, 268. See also* towers

discord as artistic device, 136, 146–47. *See also* segregationism

dispensability, 364, 367, 368

distortion (deformation), *16*, 47, 65, *187*, 189, 267, 268, *354*

Divisionism, 20, 143

Donatello, 335, 203n

Dorner, Alexander, 10, 232

dot, use of, 117, 130, 144, 180, 187, 216, 236, 398

Dreier, Katherine, 55

Dresden, "International Art Exhibition," 231, 232

drip method, 120, 151–52

Dubuffet, Jean, *321–23*, 396; "Art brut préféré aux arts culturels, L'," 321; "Honneur aux valeurs sauvages," 321; statements, 320, 321

Duchamp, Marcel, 4, 8, 26, 56, 57, 62, 343, 352, 388; A-Art, *346;* and artistic imperative, *344;* and object, 113, 114; *Bicycle Wheel*, 6, 55, 103, 105, *134–35*, 333, 348, 350; *Bicycle Wheel No. 3*, 333; *Bottle Rack*, 349, 350; *Bride Stripped Bare by Her Bachelors, Even, The* (*Large Glass*), 229, 330, 397; chair, *6, 9, 103–05, 134–35;* "First Papers of Surrealism," 163; *Fountain* (Urinal), 91, 348, 350; imitated, 62, 342, 351, 366; *L.H.O.O.Q., 103–05*, **104**, *347;* motion, 262, 277; multiples, 55; *Nude Descending a Staircase No. 2*, 56; *Nude Descending a Staircase No. 3*, 56; Readymades, 6, 55, *103–05*, 107, 110, 135, *289*, 330, 333, *346–51; Rotatory Demi-Sphere*, 270; statements, 26, 229, 320, *328, 348*, 370; *Unhappy Ready-made*, 333, 336; "Use a Rembrandt as an Ironing Board," 103n; *With Hidden Noise*, 289

duplication (copying), 2, *53, 55*, 115, 171, 172, *338. See also* variants

Dupuy, Jean, *Fewafuel*, 308–09; *Heart Beats Dust*, 308; statements, 308, 309

duration, 248, 282, 302, 380

Dürer, Albrecht, 30, 41

earth as part of artwork, 308, 314

Earth art; Earthworks. *See* Land art

edge, *125–32*, 180, 194. *See also* extensibility

eggs, 121, *342*

Eiffel, Gustave, 155

Einstein, Albert, 72

electricity, optical effects, 124, 281, 302. *See also* photo- and audiokinetic art

electricity, use of motor, 277, 279, 281, *282*, 283, 288, 289, 291, 297, 309, 314, 315. *See also* photo- and audiokinetic art; technology

electric waves. *See* radio

electromagnetism, 148, 286, 311. *See also* laser beam

electronics, 66, 198, 277. *See also* photo- and audiokinetic art; television

Éluard, Paul, *La Barre d'appui*, 319n

emblem, 105, 114, 150

emotion: revealed, 17, 18, 31, 94, 97, 113–14; its display rejected, 94, 107–08, 345, 379

empathy, 151, 375
emptiness as artistic device, *83–84*,
140, 141, 183, 195, 212
energy, 71, 95, *97–98,* 155, 263, *269,*
280, 381
engineering and art, *148, 154-55,* 212,
270, *294, 317*
Environments, 3, 34, *212–34,* 237,
244, 260, 394; ancestors, 10, 44;
difference from quasi, 147; light,
234–236, 240, 248. *See also* Penetrable, *272; Words, 256–57,* 288
Ernst, Max (Dadamax), 4, *40–41,* 43
eroticism, 62, 93, 162, 180, 182, 247,
287, 392
escapism, *261, 389–90,* 398, 402
Espace (group), 220
essence, 73, 114, 115, 369, 383
ethics confused with aesthetics, 346,
348, 351, 354
expandability, 332
experimentation (research), 20–21,
135–36, 268, 364, 378, 393
expressionistic art, 15, 16–17; rejected,
345, 392. *See also* Abstract Expressionism; physiognomic
extensibility, 99, 129, 158, *179*
Eyck, Jan van, 141, 142

Falkenberg, Paul, 152
fat, 8, 35, 121, *354–55,* 357, 359, 361,
362, 388, 401
felt, 8, 52, 121, 163, *164–67, 355,*
359
Ferber, Herbert, 100n
figurative art, 96, 398
figured verse. *See* rhopalic verse
film, 24, 64, 152, 229, *235,* 262, 334,
372, 384, 389; effects imitated in
art, 45, 262. *See also* photo- and
audiokinetic art
fire, 121, 295, *303, 305,* 308, 309
flags, 93, 94, 100, 108, *109–11,* 114
Flavin, Dan, 234, *237–40,* 261; *Monument 7 for V. Tatlin,* 239; Monuments for V. Tatlin series, 239;
statements, 237, 238; *Untitled (To
Jane and Brydon Smith),* 121, 235,
237, **238,** *238–39,* 261, 299n
fluidity, 95, 355

Fluxus, 257
flying gallop, 262
foam rubber, 52, 121, 160
Fontana, Lucio, 4, *200–04,* 211, *235–
37,* 342, 394; *Concetto Spaziale:
Attese,* 200–02, **201,** 261, 342;
Fountains of Energy, 236; *Luminous Spatial Decoration,* 236, 263;
movie theatre ceiling, 236; Spatial
Ambiances, 235–36; *Spatial Forms
& Black Light,* 235–36, 299; statements, 100, 119, 202, 394; "Tempo
libero," 236; Veronelli apartment,
236; "White Manifesto," 394
Forbes (New York), 385
Forge, Andrew, 6
form, 5, 60, 328, 329, 373; and art,
32; and Beuys, 355; and Buren,
379; and contemporary art, *117–18,*
387; and content, 33, 402–03; and
Denis, 99; and Duchamp, 328; and
LeWitt, 375; and manufactured object, 348; and material, 134; and
Matisse, 31; and Minimalists, 329;
and Morris, 163; and pattern, 100;
and Rauschenberg, 6, 32; and Symbolists, 99; cultivated, 402; injures
art, 382; rejected, 71, 116–17, 163,
373, 379, 388, 403
found objects, 74, 207, 249, 382
Four Elements, The, *302–09*
frame, *126, 132,* 133, 144, 151, 167,
187, 195, 208, 241, 254
Frankenthaler, Helen, 120
Frankfort, Henri, 5
Frankl, Paul, 173
Freud, Sigmund, *16, 62,* 72, *162*
friction, *246–47, 287,* 316, 389, 401
Fried, Michael, *28,* 37, 103, 107, 141,
152, 209
Friedrich, Caspar David, *Monastery
Graveyard under Snow,* 73n
Fry, Roger, 16
function versus form, 382
Fuller, Buckminster, 154
Futurism, 20, 262, 272

Gabo, Naum (Pevsner), 4, 20, 277,
289; *Realistic Manifesto,* 20; *Virtual
Kinetic Volume,* 289

game, art as, 15, 16, 26, 256, 328, 329, 343, 348, 351
Garbo, Greta, 64
García Rossi, Horacio, "Day in Street, A," 67
Gauguin, Paul, 5, 10; *Where Do We Come From? What Are We? Where Are We Going?*, 10
Gelsenkirchen (Germany), 305
genre, 116, 117, 137
geometry, 209, 287, 329, 398
Gerstner, Karl, 57
gestalt, *168,* 173, 185, 202, *209,* 258, 329
Gestural art (Action Painting), *97– 98,* 332; in music, 389; rejected, 94, 101, 345; ridiculed, 324, 325, 326, 327, 328. *See also* autobiographical art
Giacometti, Alberto, 47
Giedion, Sigfried, 234
Gijsbrechts., Cornelis Norbertus, *Trompe l'oeil, 108–09;* **109**
Giotto, 335
Glaser, Bruce, 374
glass and its substitutes, 229, 234, 330; coated glass, 121, 219, 227; fiber glass, 121, 240; Plexiglas, 47, 114, 121, 178, 242, 270, 302, 313
Gleizes, Albert, 125
Goes, Hugo van der, 320
Gogh, Vincent van, 5, 8, 17, 30, 91, 320; chairs, 5, 91; shoes, 91; statement, 30
Gomringer, Eugen, 186
Gonzalez, Julio, 120
Goossen, Eugene C., 138n
Gorky, Arshile, 150, 179, 330
gravity: Agam, 151; Andre, 247; Bury, 282; drip method, 151–52; Haacke, 135, 313; levitation, 148; liberation from, 147, 269, 270; Louis, 152–53; Morris, 159, 163– 64; Snelson, 154, 158; spectacle, 295; virtual, *148, 398. See also* airborne art
Greco, El, 53
Greek: art, 128, 208, 388, 398; philosophy, 303; words, 303
Green, Theodore, 99

Green, William, *352–53,* 369
Greenberg, Clement, 80, 151
grid (checkerboard), use of, 130, 179, 187, 246, 343, *398*
Gris, Juan, 134n, 366, 367; *Lavabo, The,* 134n
Group N (Italy), 88
Group Nul (Holland), 88, 342
Group Zero (Düsseldorf), 88, *121– 22,* 311
Groupe de Recherche d'Art Visuel (GRAV), 21, *44, 55,* 139, 234, 319; "Day in the Street, A," *46– 48,* 67; *Labyrinth No. 1, 48,* **49,** *50,* 61, 234; *Labyrinth No. 3, 50,* **51,** 234; multiples, 58; statements, 40, 54, 67, 318
Grünewald, Matthias, *Crucifixion* (Isenheim), 81
Gutai Theatre Art, *258–60,* 309

Haacke, Hans, *34,* 116, 147, 281, *311–15,* 336, 352, *353,* 378, *384– 86; Chicken Hatchings,* 315; *Grass Cone,* 315; *Grass Cube,* 315; *Grass Mound,* 315; Drippers (Waterdrop Boxes), 313–14; Ice Works, 314; *Living Sculpture,* 315; Mixed or Multiple Liquids, 314; Physical and Biological Systems, 34, 385; *Sky Line,* 135, 147, 281, **310, 311,** *311– 12,* 313; Social Systems, 34, 384; *Sol Goldman & Alex Dilorenzo Manhattan Real Estate Holdings: A Real-Time Social System, as of May, 1, 1971, 384–85;* statements, 34, 293, 309, 313, 317, *349–50, 384, 397; Strand Pollution,* 398; *Visitors' Profile No. 1,* 385; *Visitors' Profile No. 2,* 385–86; Waterdrop Box (Drippers), 313–14; *Water in Wind,* 314; *Wave,* 314; Weather Boxes, 314
Hagia Sophia, 81, 226
Hals, Frans, 132
Halstenberg, Armin, 355
Hamilton, Richard, 93, 94
Hanover (Germany): Kunstverein, "Kenneth Snelson," 154—Landes-

Hanover (Germany) (*continued*)
 galerie, "Abstract Gallery, The,"
 232, 234
Happenings, 23, 197, *257–61, 259,
 338,* 384; Aktionen, 356, *361;* de-
 struction as, 365; mono-Happen-
 ings, 68; Self-Obliteration, 180
haptic art, 32, 401
hardware, 116, 372, 378
Haskell, Barbara, 162
Hatshepsut, 347
Hegel, Georg Wilhelm Friedrich, 356
Held, Al, *113,* 114, 117, 138, 177;
 statements 113, *138,* 177
Henny, Willy, 308
Herbin, Auguste, 324
Hero of Alexandria (Egypt), 324
Hess, Thomas B., 78, 84, 85, 208, 400
Hesse, Eva, 4, 31, 198, 211, 387;
 statements, 31, *198, 211, 387*
Hilliard, Nicholas, 30
historical art, 22, 24, *96,* 116, *137*
historical context, 5, 9–10, *389*
Hitler, Adolf, 75, 356
Hofmann, Hans, 120
Holbein, Hans the Younger, 357
holistic, *125,* 129, 136
hologram, 61
Honnef, Klaus, 372, 373
Hopps, Walter, 111
"Horst Wessel Song," 112, 113
Huebler, Douglas, 363, 364
Huizinga, Johan, 16
Hultén, Pontus, 61
Hunter, Sam, 120, 208
Huxley, Aldous, 99
hydraulic works, 309, *313–14,* 316,
 387

iconography, 11, 89, *91–95,* 116, *347*
illusionism versus reality. *See* reality
 versus illusionism
imagistic content, 101
Immaculates, 92
"Immaterial Blue," 86
immateriality, 88, *334–35,* 336, 338;
 and dematerialization, 269, 303
immobility versus flux, 331–32
immortality of art, 29–30, 61; re-
 jected, 318, 330, 364, 368

impregnation, 48, 50, 87
Impressionism, 20, *32, 33,* 38, 60,
 143, 148, 151, 180, 263, *329, 332,
 402*
Indian art. *See* West Indian art
Indiana, Robert, 70, *93,* 94, 150, 393;
 road signs, 93; statements, 93, 94,
 393
indifferent art objects, 382–84
Ingres, Jean-Auguste-Dominique, 23
insanity and art, 12, *26–27, 320–23*
inscape, *95, 97–98,* 100, 116
integrationism, *132–36,* 202, 227,
 235. See also reflections
interference patterns, 270
Intersocietal Color Council, Annual
 Convention of, 313, 316, 397
Intransigéant, L' (Paris), 365
invisible art: objects, 86, 116, 269,
 313, *380–82,* 388; exhibitions, *87–
 88,* 344, *381–82, 383;* pedestals,
 135, 313, 388
irony (joke, sarcasm, wit), Arp, 126;
 artistic imperative, 343–45; as
 weapon, 346, 370, *401;* Baldessari,
 396; Beuys, 361; Brecht, 353;
 Bury, 287; Dadaism, 345–48; Du-
 champ, 113, 333, 343; Lichtenstein,
 398; Manzoni, 343; Neo-Dadaism,
 351; Oldenburg, 160, 393; Rausch-
 enberg, 207, 344; Saint-Phalle, 62,
 369; Schwitters, 351; Tinguely, 62,
 281–82, 292, 327, 351
irrational versus rational, 375, 376
Islamic art, 99

Joos van Cleve, 357
Johns, Jasper, 71, 128, *150,* 153–54,
 398, *400,* 401; and serialization,
 172, 173; Ballantine ale cans, 111;
 Critic Sees, The, 400; extensible,
 reversible, and four-sided, 155,
 158, 179; flags, 39, 109, 111, 128;
 object/art dichotomy, *107–11,* 112,
 113, 114; statements, 69, 94, 107,
 108, *111; Three Flags,* 109n; tar-
 gets, 111; *White Target,* 108, **110,**
 150, 153–54, 158, 172–73, 398
joke as weapon. *See* irony as weapon

Jorn, Asger, 359
Judd, Donald, 52, 115, 174, *178–79,
240–44;* holistic, 125; not modular,
191; Specific Objects, *114;* state-
ments, *32, 103,* 241, 328, 345, *374;
Untitled* (1968), 178n; *Untitled*
(1969), *114,* 115, 125, 173, *178–
79,* 191, *241–44,* **243,** 397

Kanayama, Akira, 352
Kandinsky, Wassily, 70, *96–97,* 324;
Rückblick, 1901–1913, 97n; state-
ments, 70, 97
Kaprow, Allan, 10, 198, 214, 244,
332, *361,* 384; Environments, 10,
260; Happenings, *260, 361;* state-
ments, *212, 219, 254, 256–57,
260,* 318, *331,* 349; *Words, 256–
57,* 288
Katz, Alex, 211n
Kelly, Ellsworth, 126, 208
Kienholz, Edward, 93, 337
Kiesler, Frederick J., *Endless House,
The,* 219n
Kinetic art, Kineticism, 3, 20, 211,
276–88, 297, 324–28, 387; ances-
tors of, 239; ridiculed, 393, 401;
sponsored, 55, 57. *See also* mo-
tion; photo- and audiokinetic art
kinetic field, 179. *See also* reiteration
Kirby, Michael, 257, 258
Kitaj, Ronald, 93
Klee, Paul, 74n, 359
Klein, Yves, 50n, 80, *86–89,* 269,
302–08, 334–38, 343, 344, 352,
353, 395; Blue Anthropometries,
334–35, 338; "Blue Worlds," 338;
Cosmogonies, 336; Fire Fountains,
305, 309, 336; Fire Paintings, 336,
337, 338; Fire Wall, 121, *305,* **307,**
336; immaterial paintings, 86;
"Pictorial Material Sensibility in
the State of Prime Matter, The"
("The Void"), *87–88,* 344; plane-
tary reliefs, 146; plaster portraits,
213; pneumatic architecture, 303,
304, 305, **306,** *308;* Rain Cosmog-
onies, 336; *Scroll-Poem, 335;* state-

ments, *80, 86, 87,* 302, 303, *334,*
338, 352; Sudaria, *335–36;* Thea-
tre of the Void, The, 349; "Void,
The," *see* above; Yves Klein re-
trospective, 305
Kline, Franz, *80, 98;* statements, 100,
136, 138, *139*
Kosuth, Joseph, 344–45, 371, 373,
377; "Art After Philosophy," *344,*
377; statements, 344, *345, 373,* 377
Kowalski, Piotr, 314–15
Krebs, Rockne, 198
Kricke, Norbert, 308
Kris, Ernst, 321
Kusama, Yayoi, *8–9,* 121, 135, 174,
180–83, 256, 269, 395, 398; *Accu-
mulation I, see* below; aggregation
sculpture, 180, 182; airmail sticker
paintings, 182, 256; chair, 9; Dot
Events, 180; "Floor Show," 182;
net paintings, 8, 180; "No Show,"
182; *Phallic Sofa (Accumulation
I),* 121, 135, 174, 180, **181,** *182–
83,* 269, 398; Self-Obliteration
Happenings, 180; statements, *180,
182;* "Water Color International,"
180

Land art (arte povera, Earth art,
Earthworks), 3, 21, 70, *248–54,*
384
landscape, 60, 100, 116, 117
laser beam, 61, 269
Lebel, Robert, 103
Le Brun, Charles, 48
Leonardo da Vinci, 20, 29, 81, 147,
172, 320, 347, 349; *Madonna of
the Rocks,* 172; *Mona Lisa,* 81,
347; Notebook, 29; statements, *29,
349*
Le Parc, Julio, 21, 24, 67, *278–81,*
393; "Day in the Street, A," 67;
Form in Contortion, 278, *279,* **280,**
281; statements, *24*
Lettrism, 70, *255–57,* 384
Leutze, Emanuel, *Washington Cross-
ing the Delaware,* 96
Lévêque, Jean-Jacques, 48, 50

Leverkusen (Germany), Städtisches Museum, "Konzeption-Conception," 371–72
Levine, Les, 292n
LeWitt, Sol, 33, 116, 174, 185, *190–94*, 371; *A 2 5 8*, 115, 174, **191**, *191–94; B 2 5 8*, 193; *Sentences on Conceptual Art, 1968, 375–76; Serial Project No. 1, 1966, 192;* statements, 33, *115, 190*, 192, 193, *375–76*, 377
Lichtenstein, Roy, 17–18, 393; *Drowning Girl*, 93; Greek temples, 398, 401; statements, *89*
light, 20, 61, *141 143–44, 234–35*, 261, 303; in Agam, 302; in contemporary art, 401; in Gutai, 259; in Kaprow, 256; in Le Parc, 281; in Moholy-Nagy, 279, *297, 299;* in Morris, 241; in Rauschenberg, 302; in Wilfred, *297. See also* photo- and audiokinetic art; Situations
light and shade, *183, 185*, 221, *225–26*, 240, 254, 274
Limbour, Georges, 321–22, 323
line, use of, 180, 235, 236, 249, 263, 264, 269, 270, 272; instability rooted in, 273; wavy, 179, 266–67, 316
Lipchitz, Jacques, 366
Lippold, Richard, 100n
Lissitzky, El, 4, 10, *43–44, 231–34*, 275, 388; *Abstract Gallery*, 10, *42–44*, **230, 231**, *231–34*, **233;** "Demonstrationsräume," 232; statements, *232, 233*
Littérature, La (Paris), 365
living sculpture, 121; animal, 315; human, 249, *342–43. See also* biotic art
Livingston, Jane, 309
Lombroso, Cesare, 320
London: Institute of Contemporary Art, exhibition of work of chimpanzees, 323; Jean Tinguely lecture, 327—Kaplan Gallery, Jean Tinguely exhibition, 327—Whitechapel Art Gallery, "3 →∞: New Multiple Art," 54n, 58, 59

Los Angeles, Los Angeles County Museum of Art, "American Sculpture of the Sixties," 215; "Art and Technology," 219, 221, 224, *294–95, 308*, 352
lost-wax process, 120
Louis, Morris, 31, 120, 140, *141, 151, 152–53*, 179, 263; *Alpha Tau,* 140, *141*, **142–43**, *153*, 179, 263; Florals, 152–53; Split Veils, 152; Stripes, 153; Unfurleds, 141, 153; Veils, 152
Luffar-Petter, 64
luminodynamism, 301
Lye, Len, 276, *279, 281;* statement, 276

MacArthur, Douglas, 85
machine, 12, 93, *105*, 309, 320; and Tinguely, 62, *281–82, 291–92, 323–28*, 316
Mack, Heinz, 57, 88, 121
magnets, electromagnets, 277, 284, 295, 311
Magritte, René, 4, 5, 8
Maillol, Aristide, 133
Malevich, Kasimir, 324
malleability, 35, 355, 362
Malraux, André, 327
Manet, Édouard, 30, 60, *203*
manifesto, art as: articles, lectures, 24, 232, 329; nonsense acts, 40–43, 344–54, 365–70, 383; ritual destruction, 309, 353, 365–69; sarcasm, 61, 68, 103–05, 316, 324, 326, 346–51; symbolic language, 340, 356–57, 360–61
manipulable art. *See* transformable art
Mantegna, Andrea, 388
manufactured object, 207, 213, *214*, 247, 249, 348, 383. *See also* collage; Constructions; Duchamp: Readymades
Manzoni, Piero, 88, 121, 211, *313*, 324, *338–43*, 344, 352; Achromatics, 338, 343; Air Bodies, 339; Artist's Blood, 342; Artist's Shit,

Manzoni, Piero (*continued*)
342; *Basis of the World,* 343;
Bread Works, 343; eggs, 121, **340,
341,** *341–42;* hydrophilic works,
313, 343; Lines, 339; living sculpture, 342, 344; *Magic Base,* 334,
342; *Magic Base* (Copenhagen),
343; robot, 339; *Some Realizations. Some Experiments. Some
Projects, 338–39;* statements, 334,
338–39, 340, 342
Martel, Ralph, 308
Marx, Karl, 349
Masaccio, *Founders of Florentine
Art, The,* 335
mass media, 23, 66, 92
mass production, 58, 59
Master of Flémalle (Robert Campin), Mérode *Annunciation,* 72n
mathematics, 179, 186, 187, 190,
191, 226
Matisse, Henri, 4, 9, 133, 144, 273;
his aim, *5–6,* 31, 38; statements,
5–6, *31,* 336n; treatment of
shadow, *167*
matter, 71, *101, 102,* 107, 114
Medalla, David, *315, 316*
Messerschmidt, Franz Xaver, 320
metamorphosis. *See* transformation
metaphysics (mysticism), 71, 116,
269, 286, *343, 382,* 392; and Fontana, 202; and Klein, 80, *86–89,*
303, *334–38;* and LeWitt, 375; and
Newman, 27, 38, *81, 82–83, 140,*
202; and Rothko, 80–81. *See also*
mythical overtones
metope, 128, 208, 210
Metzinger, Jean, 125
Meyer, Ursula, 380, 382
Michelangelo Buonarroti, 24, 29–30,
81, 320; Rondanini *Pietà,* 81; sonnets, 30
Middle Ages, 112, 255, 294, 303
Milan: Galleria Apollinaire, "Blue
Worlds," 338—Galleria del Naviglio, *Spatial Forms & Black Light,*
235—Ninth Triennial Exhibition,
236—Thirteenth Triennial Exhibition, "Tempo libero," 236
Miller, Arthur, 59

Minimal art, 3, *27–29, 31–32,* 70,
241, 244, 372, 392, 393; active
spectator participation, 52; and
Brancusi, 114; and Newman, 394;
and objecthood, 32, *37–38, 103–07,
113–14;* dispenses with pedestal,
135; emphasizes form, 28, 118,
329–30; nondirectional, 177
minor arts, 6, 99, 208
mobiles, 154, 329
modern art, 11, 12, 297, 323, 354;
equalization of parts, 203; interest
in optics, 20–21; promotion of motif to theme, 108n; versus contemporary art, *5,* 32, 73, 270, 363;
versus Renaissance, 32
Modigliani, Amedeo, 365
modularity, *171,* 174, *185, 186, 190–
94*
Moholy-Nagy, László, 4, *56,* 277,
278–79, 289, *297–99,* 388; *Light
Display: Black and White and
Gray* (film), 297; Light-Space-
Modulator, *278–79,* 289, **296,** *297,*
298, *299;* statements, 56, 297;
"telephone paintings," 56
Moholy-Nagy, Sybil, 297, 299
moiré effects, 263, 270, 271
Mona Lisa. See Leonardo; Duchamp
L.H.O.O.Q.
Mondrian, Piet, 18, 114, 115, 126,
177, 270, 369; statement, 369
Monet, Claude, 117, 172, 400; Haystacks series, 172
monochrome, 86, 180, 200, 245, 338,
366
Moore, Henry, 4, 159, *203–04;* statement, 159
Morellet, François, "Day in the
Street, A," 67
Morris, Robert, 108n, 115, 133, 159,
198, 371, 384; anti-form, *163–67,
329–30;* artistic imperative, *344;*
ceiling sculpture, *135–36,* 244; rejection of traditional values, *328–
30;* self-portrait, *399;* shaping
space, *219–20,* 221; space sculpture, *240–41;* sound art, *289–90;*
statements, 1, 53, 107, *108n, 133,
159, 328, 329,* 349, 373; trans-

Morris, Robert (*continued*)
formable works, *52–53;* witticism, 401

Morris, Robert, Works of: *Box with the Sound of Its Own Making,* 289–90; *Cloud,* 135–36, 244; *Corner Piece,* 136, 147, 240; *I-Box,* 399, 401; *Litanies,* 328, 344; *Passageway,* *219–20,* 221, 401; *Untitled* (felt), 52, 115, **165;** *Untitled* (fiberglass cylinder), *240–41; Untitled* (I-beam), 177n

Morris, William, 55, 91

motion (movement), 46, 57, 95, 132, 166, 210, 265, 273; activates spectator participation, 45, 53; and experience of time, 282–86; as inhalation and exhalation, 339; history of, 261–62; ridiculed 327; simulated, 148, 262, 269; types of *277–79*

Motonaga, Sadamasa, 309

motor. *See* electricity, use of motor

movement. *See* motion

Mühely, 186

Müller, Grégoire, 154

multiples, 23, *54–59,* 68, 172. *See also* variants

multiplication, 54, *57,* 58, 174, *179–85,* 194. *See also* reiteration; repetition

Multiplication d'Art Transformable (MAT), 57

multisensory art, 61, 66, 246, 258, 290–91, 301, 389

Munari, Bruno, 57

Murakami, Saburo, 259

music, 65, 66, 130, 289, 290, 291n, 292, 297, 335, 338, 384, 389

musical relief, *290–91,* 388

mysticism. *See* metaphysics

mythical overtones, body magic, 259, 334, 336, 342; consecration by touch of hand, 203, 319, 340, 342; delegated magic, 342; foot magic, 352, 353; mystic presence, 81–82, 87, 334; number magic, 336, 352; object magic, 206, 207; of blood, 342; of bread, 343; of breath, 339; of eggs, 340, 342; of excrement, 342; of sacrificial offerings, 337–38, 352, 353, 367, 368, 369; sound magic, 289; wedding of fire and water, 338

Nabis, 144

nails, 8, 121, *122–24,* 180 199–200, 388

Namuth, Hans, 18, 152

nature, 107, 316, 332, 333, 334, 336, 338, *349,* 350, 353, 355

Nauman, Bruce, *First Poem Piece,* 247n

Navrátil, Josef, *Pie, The, 91,* **92**

Neer, Aert van der, 143

negative shape, *203–04,* 210, 221, *242*

negativism, 292, 328, 331, 349, 350, 393, *398–99.* See also A-Art; anti-art; autodestruction; autographic quality of work; demythification; destruction; form: rejected; invisible art; nonsense object; perishable art; uniqueness

Neo-Dadaism, 70, 346, *351–54*

Neoplasticism, 18

Neo-Surrealism, 70

Nevelson, Louise, *44,* 71, *74–78,* 86, 146, 172–73; "Circus, The," 44; *Homage to 6,000,000 No. I,* 75, **76–77,** 146, 172–73; *Homage to the World,* 75; *Menagerie, The. Crowd Outside, The. Clown Is the Center of His World, The,* 44; "Moon Garden + One," 74; "Queen of black black," 75; *Sky Cathedral,* 74, 75; statements, 71, 74, 75

New Brunswick, N.J., Douglass College, Allan Kaprow Happening, 260

Newman, Abraham, 85

Newman, Barnett, 27, 38, *81–86,* 88, *140,* 198; *Abraham,* 85; and Fontana 200, 201–02; attacked by de Kooning, 394; *Onement I, 84–85;* statements, 27, 80, 81, 82, 83–84; *Vir Heroicus Sublimis,* **82–83,** 83, 84, *85–86,* 140; *Wild, The,* 208. *See also* metaphysics: and Newman

New Realism, 3, 70, *334,* 335, 395
New York, "Armory Show," 56
New York: Betty Parsons Gallery, Barnett Newman exhibition, 394— Brooklyn Museum, The, "Water Color International," 180—Castellane Gallery, "Floor Show," 182— Contemporaries Gallery, "Labyrinth No. 3," 50, **51**—Cordier & Ekstrom Gallery, "For Eyes and Ears," 43—Finch College, "Art in Series," 171; "Destructive Art: Destroy to Create," 395n— Gertrude Stein Gallery, "No Show," 182— Grand Central Moderns Gallery, "Moon Garden + One," 74— Green Gallery, "Store, The," 160 —Guggenheim Museum, The, "Carl Andre," 246; "Soto," 272n; Systemic Painting," 170—Jewish Museum, The, "Robert Rauschenberg," 352n; "Software," 368— John Webster Gallery, "Hans Haacke: Visitors' Profile," 385— Leo Castelli Gallery, Andy Warhol exhibition, 312; Lawrence Weiner exhibition, 383—March Gallery, Kenneth Snelson exhibition, 154— Martha Jackson Gallery, "Environments, Situations, Places," 89, 394; "New Forms, New Media I," 89— Museum of Modern Art, The, "Art of Assemblage, The," 90; Buckminster Fuller," 154; "Experiments in Art & Technology," 294, 308; "Fantastic Art, Dada, Surrealism," 41; "Homage to New York," 68; "Technics and Creativity: Gemini G.E.L.," 54n, 57; "Twentieth Century Engineering," 154—New York Cultural Center, "Conceptual Art and Conceptual Aspects," 372— Norlyst Gallery, "Circus, The," 44 —Pace Gallery, "Chair Transformation," 7, 8; "Larry Bell," 227— Pratt Institute, Kenneth Snelson exhibition, 154—Reid Mansion, "First Papers of Surrealism," 163 —Smolin Gallery, "Words," 256— Société Anonyme, exhibition, 55—

Stable Gallery, Robert Rauschenberg "dirt pictures," 314— Whitney Museum of American Art, "Bruce Nauman," 247n
New York Tribune, 105
Nice Group, 88
nineteenth century, *20, 25,* 28–29, 30–41, 73, 91, *99,* 119, *133, 148, 329,* 354
Noland, Kenneth, 125
non-art. *See* anti-art
Nolde, Emil, 142
nondirectional, 53, *150, 151,* 155, 175, 177, 178, 242, 248, 257. *See also* open ended; reiteration; reversibility
nonmatrixed performance, 257, 258
nonobjective art. *See* abstract art
nonrelational symmetry, *125, 177–78*
nonsense object, 12, 320, 345, 346, 349, 351, 353–54
nudes, 93, 117, 399

Oberlin College (Oberlin, Ohio), "Art in the Mind," 372
Object-Portraits, 103, *105–07, 347*
Oldenburg, Claes, 9, 16–17, 93, *159– 62,* 370, *393;* compared with Andre, 247; compared with Morris, 163, 164, 166, 167; *Giant Soft Fan,* 162; *Giant Soft Fan—"Ghost Version,"* 52, 103, 121, *160,* **161,** *162; Notebooks,* 162; *Shattering Milk Bottle, 393,* 401; statements, 62, *158, 159– 60,* 370, 392; "Store, The," 160; *Thrown Can of Paint,* 370; witticism, 62, 401. *See also* soft sculpture
Olitski, Jules, 126, 142, *144–46,* 182, 273; *Green Goes Around,* 144n; *Panger, 144,* **145,** *146,* 182, 273; *Rexus,* 144n; statements, 126, 142
open-air works, 45, 65, 67
open-ended, 53, 178. *See also* composition; continuity of field; edge; extensibility; nondirectional
Op(tical) art (unstable patterns), 3, 20, 219, *232,* 234, *262–76,* 277, 397. *See also* reflections
optical color mixture, 263

optics, laws of, 20, 21, *171,* 173, 186, *267, 268–69*
options. *See* transformable art
Osaka, "Expo 70," 221, 224
Ostade, Adriaen van, 91, 94
Ottawa, National Gallery of Canada, "Dan Flavin," 237, 239
oxyacetylene torch, 120

Paik, Nam June, 292n
paint, fluorescent, luminous, reflective, 180, 236, 313, 343
painting as slab: in Johns, 108, 109, 110; in Stella, 111, 129, 208, 210. *See also* support
Parent, Claude, 305
Paris: Dada retrospective, 43; World Fair (1889), 155—Galerie Colette Allendy, Yves Klein exhibitions, 87, 337—Galerie Internationale d'Art Contemporain, Yves Klein exhibition, 334—Galerie Iris Clert, "Pictorial Material Sensibility in the State of Prime Matter, The" (The Void"), 86, 87; Jean Tinguely exhibition, 326—Galerie René Drouin, "L'Art brut," 323— Musée des Arts Décoratifs, "Antagonismes 2: l'objet," 220—Musée Municipal de l'Art Moderne de la Ville de Paris, "Light and Movement," 302; " First Biennial," 326; "Soto retrospective, 272; "Third Biennial," 48;—Palais des Expositions de la Porte de Versailles, 335—Palais des Fêtes, First Friday Matinée, 365–67
Parthenon (Athens), 81
Pasadena, Pasadena Art Museum, "Serial Imagery," 171, 395n
Pascal, Claude, *Scroll-Poem,* 335
pastel, 199, 204
patron and artist. *See* sponsor: and artist
pattern, 71, 114, 117, 129, *209,* 246. *See also* visual pattern
pedestal, *133–35,* 387, 388; as isolator, 195; eliminated, 126, 133, 135, 242, 398; in abstract art, 167; invisible, 135, 313; mirror image of

form, 167–68; not integrated in design, 167, 282; plastic form, 6, 9, 103, 134–35
Peeters, Henk, 88, 342
Pellegrini, Aldo, 395
perforation, 200, 202, 245, 394
periodic structures, 263, 270
perishable art, 277, *330,* 331, 332
permutation, 7, 174, 177, *185–90,* 192, 194. *See also* change; Op(tical) art; transformation
Pevsner, Antoine, *Realistic Manifesto,* 20
Philadelphia: Institute of Contemporary Art, University of Pennsylvania, "Current Art," 239—Philadelphia Museum of Art, "Mind's Eye, The," 216; "Multiples: The First Decade," 54n, 57
philosophy, 21, 111, 395
photo- and audiokinetic art, 11, 23, 25, 288, 293, *295–302,* 384; and light, 235; as abstract film, 24; cooperation of scientists needed, 197, 295; difference from nonkinetic spectacle, 60–61, 282; Happenings as, 257, 260; in GRAV, *45–50;* in Schoeffer, *65–68;* in Tinguely, *68*
photography, 56, 372, 385, 399
physics, 303, 315, 338, 339, 353, *380–82*
physiognomic, 164, 392
Picabia, Francis, 4, 103, *105–07,* 112, 114, *255, 347, 365–66,* 367; *Daughter Born Without Mother,* 347; *Double World, The,* 366; First Friday Matinée, *365–66;* Object-Portraits, 103, *105–07,* 112, *347;* portrait of Stieglitz, *105, 107; Riz au nez,* 366; *Self-Portrait,* 103, *105,* **106,** 255, *347;* statement, 105
Picasso, Pablo, 4, 117, 330, 333, 354, 388; artist a political being, 33; *Bathers, The,* 199n, 330; *Glass of Absinth,* 91; *Guernica,* 81; *Guitar,* 199n; hand imprint, 319, 342; has interchangeable styles, 95; illustration for Éluard, *La Barre d'appui,* 319n; on copying, 2; reversibility, 155; *Self-Portrait with Palette,*

206; statements, *2*, 15, *33*, 369, *372; Swimming Woman,* **149,** *150,* 153; what one does counts, not intention, 372
pictorial field, 101, *108–10,* 127, *128–29,* 130, *140*
Piene, Nan R., 236
Piene, Otto, 88, 121; statement, 295
Pintoricchio, Bernardino, 143
Pissarro, Camille, 119
plaster figures, 120, 213–14
pneumatic art. *See* airborne art
poetic sites, 48
Pollock, Jackson, *17–18,* **19,** 36, 37, *80,* 150, 153, 333; compared to Kandinsky, *97–98;* hand imprint, 319, 342; his paintings fade toward edges, 128, 130; judged by other artists, 345, 393; judging critic, 400; *Male and Female,* 73n; microstructure, 140, 142; *Number One,* 319n; reversibility, 150, 179; statements, 17, 95, 138, *150,* 151, 400; station point, 150, 272; use of nail, 122; working methods, 120, 151–52
Poons, Larry, 18, 180, 182, 263, 392; imitated commercially, 267; interested in optics, 20, 21; *Northeast Grave, 130,* **131,** *132,* 179, 182, 263; problem of edge, 130–32; statements, 18, 21, 130, 132, 392, 398
Pop(ular) art, 3, 70, 71, *89-95,* 114, 117, 337, *401;* and Dada, 90; and Minimal art, 103, 107; and Picasso, 95; Lichtenstein versus Oldenburg, 16–17
portrait, portraiture, 96, 117, 213, 335; abstract, 100, 118; inscape, 98; nude, 399; Object-, 107, 347; telegram as, 343, 344
potter's wheel, 120
Pousseur, Henri, 66
precious material, 330
prefabricated units. *See* standardized units
prehistory, 173, *198,* 225–26, 236, 255, *262,* 342
premodern art, 5, 261, 297. *See also*

contemporary art compared to: premodern art
Priapus, 247
primary structures (Specific Objects), *114–15,* 117, 135, 177, 240, 242
Prinzhorn, Hans, 321
Prometheus, 343
Propylaia (Athens), 268
psychoanalysis, 62, 136, 162, 321, 370
psychological survey, 35–36
psychopathic traits in artists, 320
pun: verbal, 62, 103, 347, 366; visual, 400
pyramid verse. *See* rhopalic verse

quasi Environments, 147, 197, 202, *231–34*
quasi-Tech. art, 237
questionnaires, 34, 48, 322, 385, 386

radio as part of art object, 64, 289, 292
Ramsden, Mel, 373
Rand Corporation, 352
Raphael, 172
Rauschenberg, Robert, 8, *52, 111, 134,* 154, 200, *289, 314;* and artistic imperative, *343–44;* and copying, *2;* and technology, 294; *Bed,* 111; *Black Market,* 52; *Broadcast,* 289; *Coexistence, 204,* **205,** *206–08,* 255; *Combines,* 6, *204–08,* 344; creation through destruction, *367–68,* 369; *Factum I, 2; Factum II,* 2; *Living Picture,* 314; *Pilgrim,* 6; *Portrait of Iris Clert,* 343–44; *Soundings,* 302; statements, 32, 134, 294, 343, 344, 367, 368; Thought Boxes, 365, 367, 369; use of words, 255; White Paintings, 134; witticism, 401
Ray, Man, 4, *41–43,* 55, 57, 277, 388; *Indestructible Object,* 43; *Lampshade,* 55; *Object to Be Destroyed, 41–43,* 44; *Object to Be Destroyed* (drawing), *41,* **42;** statements, 41, 43, 55
Raysse, Martial, 88; statements, 391, 402
Read, Herbert, 159, 166

Readymades. *See* Duchamp: Readymades
realism, 23
Realistic Manifesto, 20
reality versus illusion, 111, 160, 182, *199, 214, 228,* 266–67, 379. *See also* reflections
Redon, Odilon, 25; *Journal,* 23
reductive art, 369, 394
reflections, *214–215,* 299, *396–97;* in Bell, 277–79, 231; in Brancusi, 134, 202, 216, 397; in Bury, 286; in Flavin, 240; in GRAV, 47; in Gris, 134; in Judd, 178, 242–44; in Kusama, 182; in Le Parc, 281; in Lissitzky, 232–34, 275; in Moholy-Nagy, 297; in Rauschenberg, 134; in Samaras, 7, 214, 215–16, 219; in Schoeffer, 66, 301; in Tomasello, 273–74; spectators included in work as, 397
Regina, Canada, Norman MacKenzie Art Gallery, Morris Louis posthumous exhibition, 151
regionalism, 4, 92, 396
Reinhardt, Ad: "Art as Art," 32; "Next Revolution in Art, The," 369
reiteration, 7, 52, *174–79,* 192, 194, 263; obliterates shape, 269; used to neutralize, 379. *See also* duplication; multiplication; repetition
Reitman, Francis, 321
relief, *198–99,* 204
religious art, *22, 24,* 81, 116, *137,* 148, 212, 234; quasi-, 379
Rembrandt, Harmensz. van Rijn, 103n, 142
Renaissance, 40, 89, 111, 198, 199, 303; desire for fame, 28, *29–30,* 32; interest in optics, 20, 21; motion of eyes, 274; negative space, 203; sponsorship, 294
René, Denise, 55, 57
repetition, 141, *171–72,* 175, 189, 210, 343–46; as boring, 244; as mesmerizing, 128, 130, 150–51, 180, 182; of progressively graded units, 168, 267
research. *See* experimentation

Restany, Pierre, *Scroll-Poem,* 335
retinal art, 32, 379, 401
reversibility, *148–51,* 179, 398
rhopalic (figured; pyramid) verse, 256
Richter, Hans, 348
Rickey, George, 138, 261, 277, *279, 281;* statements, 138, 261, 277
Ridolfi, Carlo, *Wonders of Art, The,* 14–15
Riegl, Alois, 16
Riley, Bridget, 263, 264, 265, *266–69,* 272; *Arrest III,* 263, 264, **266,** *266–67,* 273; statements, 263
riot at Aachen, the, 356–57
ritual overtones: Baldessari, 368–69; Green, 352; Gutai, 259, 353; Klein, 334–38, 352; Manzoni, 339–43; Rauschenberg, 367–68
Rivera, Diego, 23, 24; statement, 23
Rivers, Larry, *Washington Crossing the Delaware,* 96
Robbia, Luca della, 111
Roberts, Colette, 74
robots. *See* automatons
rococo art, 214
Rodin, Auguste, *17,* 133, *148,* 151, 262, 354; *Belle Heaulmière, La,* 354; *Burghers of Calais, The,* 133
Rodman, Selden, 400
Rome, Galleria dell' Obelisco, Robert Rauschenberg exhibition, 365
rope, 52, 121, *163–64,* 388
Rose, Barbara, 108n
Rosenberg, Harold, 97–98, 330
Rosenquist, James, 93, 94, 391, 402; *Doorstep,* 244n; statements, 94, 391, 402
Roszak, Theodore, 100n
Rothko, Mark, *80–81,* 84, 138, 139, 140, 142; compared to Olitski, 144; statements, 80, 100, 138, 139; working method, *120*
Rubens, Peter Paul, 54, 137, 144; *Story of Marie de Médicis, The,* 137
Rubin, William S., 112, 139, 150, 395
Ruhnau, Werner, 305
rules and restrictions (conventions), 319, 345; denounced, 138, 139, 351,

388, 389; reformulated by Barry, 381

Saint-Phalle, Niki de, *61–65*, 365, *369–70*, 398; Carbine works, 369–70; *She—a Cathedral, 61–62,* **63,** *64–65,* 365, 369, 398

sales angle, 11, 54, 57, 58, 138, 277, 332

Salmon, André, 365, 366, 367

Samaras, Lucas, 134, 135, 182, 197, 212, *214–19,* 242, 397; *Chair Transformation,* 7, 8; *Corridor,* 134, 197, 212, *215–16,* **216, 217,** *217,* 219, 242, 397; "Killman," 214; *Mirrored Room No. 1,* 214; Mirrored Room series, 215; statement, 214

San Francisco, Arshile Gorky retrospective, 150

sarcasm as weapon. *See* irony as weapon

Sargologo, 305

Sasaki, Tomiyo, *Great American Pastime, The,* 292n

scale, 190; compared to size, 136; dictated by pattern, 268; obtained through holistic composition, 129–30; obtained through exhibition in confined space, 138–39; used as compositional motif, 155

Schapiro, Meyer, 12, 60, 402

Schiller, Friedrich von, 16

Schoeffer, Nicholas, 25, 60, *65–67,* 68, 121, 295, *299–301,* 398; collaboration with scientist advocated by, 66–67, 197; *Cybernetic Light Tower,* 25, 66, 67, 121, 197, 235, 278, 295, *299,* **300,** *301,* 398; *Spatiodynamic and Cybernetic Tower, 65–66,* 295; statements, 60, 66-67, 196, 197, 299

Schwitters, Kurt, 4, 91, 94, 212, *255,* 330, 388, *400–01; Critic, The,* 400–01; *Kynast-Fest,* 255n; Merz, 199, 255; *Merzbau,* 212, 330; statement, 199–200; use of nail, 122, 199–200

science, *35–38, 197,* 198, 262–63, 270, 292, 293, *380–82,* 384, 395

sculpture: as causeway, 212, 247; as furniture, 7, 8, 9, 124, 180, 182–83, 211; as lamp, *see* ceiling sculpture; as man-made landscape, 212, *249–53;* as open-sided box, *see* space sculpture; as partition, 52, 211, *227–29,* 231, 249; as Penetrable, 220, *271–73;* as rug, 124, 244, *245–46,* 388, 389; nonobject, 220; that flows, *354–55,* 388; that produces sound, *290, 291,* 388

Seattle, Seattle Art Museum, "557.-087," 372

Seaux, Jean, 66

Seckler, Dorothy, 84

Segal, George, *120–21,* 197, *212–14; Gas Station, The,* 120, 197, *212–14,* **213;** statements, 120–21, 214

segmented works, *52–53,* 75, 240, 241, 247

segregationism, 132, 136

self-centered system, 32, 99, 108n, 154, 155, 202, 398. *See also* segregationism; autonomy of artwork

self-obliteration, 180, 395

senses, the, 21, 82, 97, 219, 228, 388–89; hearing, 246–47, 257, 259, 287, *288–92,* 308, 354; sight, 159, 283, 287, *349,* 354, 401; smell, taste, 354; touch, 158, *159–60, 163,* 199, *246–47,* 287, 289, 354, 401. *See also* active spectator participation; multisensory art

serialization, 6–7, 33, *53–56,* 59, 91, 130, *171–74,* 179, 190–91, 192, 210; exhibitions, 171, 395n

Seurat, Georges, 117

shadow: in Agam, *see* solidified shadow; in Bell, 299; in Camargo, 183, 185; in Christo, 254; in Flavin, 237; in Nevelson, 74–75; in Poons, 130; in Stella, 111; in Uecker, 8, 122, 180

shadow box, *75,* 172

shape, 18, 24, 45, 79, *113, 114, 117,* 159, 162, 166, 202, 220, 221, *235, 237,* 249, 264, 273, 279, 291, *398;* and Brancusi, 159; and Bury, 286–87; and site, 135; and word, 256; conforms to pattern, 99, 112; conscious of, 159; exposes hidden or-

shape (continued)
der, 209; flexible, 159; obliterated, 182, 269; primacy of, 28, 107; produced by gravity, 152–53; used for permutation, 187
shaped canvas, 200, 208–11
Shiraga, Kazuo, 259, 352, 353
Siegel, Jeanne, 34
Siegelaub, Seth, 381
sign, 100, 236, 255, 257
Simias of Rhodes, Crown of Meleager, 256
simultaneity, 233–34
simultaneous contrast. See afterimages
single-image painting, 140
Sisley, Alfred, 119
site, 364, 379, 380; dictates shape of work, 135; integrated with work, 50, 240, 246, 248, 250. See also reflections
size, 215; compared to scale, 136; influences composition, 56, 220; leads to new visual experiences, 146–47; necessitates deeper stretcher, 208; rejected as egocentric, 384; used for permutation, 187
Smith, Betsy, 94
Smith, Brydon, 238
Smith, David, 14, 74n, 78–79, 120, 138; Bec-Dida Day, 79; Cathedral, 78; Cubi, 79; History of Leroy Borton, 79; statements, 14, 78, 138; Tank Totems, 78; Three Planes, 79; Timeless Clock, 79
Smith, Jane, 238
Smith, Tony, 185, 186, 191–92, 219, 221–27, 244; "Art and Technology," 219, 221, 224; "Expo 70," 221, 224; interested in object, 27–28, 32; "Remarks on Modules," 227; statements, 27, 32, 170, 221, 227; Untitled, 186, 192, 197, 221, 222, 223, 224–25, 225, 226–27, 244, 294
smoke, 259, 303, 309
Snelson, Kenneth, 153–58, 179; Easy-K, 153, 156, 157, 157–58, 179, 212; mobile, 154; statement, 147; structures, 154, 155, 212; towers, 155; wall reliefs, 158; X-Piece, 154
Snow, Michael, 240, 241

soak-and-stain method, 120
Sobrino, Francisco, "Day in the Street, A," 67
Société Anonyme, 55
soft sculpture, 52, 121, 158, 167; in Kusama, 9, 180, 182–83; in Oldenburg, 9, 159–66, 387, 392
software, 116, 372–73, 373–74
solidified shadow, 159, 167–70, 388
"Something else," 12, 119, 260–61, 390, 397
Sonnabend, Ileana, 112
Sonnier, Keith, Untitled, 292n
Soto, Jesús-Rafäel, 57, 197, 269, 270–73, 391; and Cruz-Diaz, 276; Extensions, 271; Penetrable, 197, 263, 269, 271, 272–73; Penetrables, 271; Progressions, 271; statements, 100, 170, 262, 269, 272, 273; Vibrations' Structure, 270
sound, 246–47, 288–92, 316, 380–81, 383; part of a Happening, 180, 257, 258, 259; part of a spectacle, 61, 64, 65, 66. See also photo- and audiokinetic art
Soutine, Chaim, 365
space, external: 20, 256, 261, 395; affected through magnitude, 146; and Barry, 380; and de Kooning, 394; as undecipherable, 213, 215, 217, 219, 228, 235, 242; colored and disrupted by light, 237; integrated with work, 397; invades work, 203, 273; more important than work, 242; occupied by two objects simultaneously, 381; shaped by work, 219, 224, 226; work has its own, 151
space, internal: affected through magnitude, 146; as infinite, 83, 84; emptiness as, 195; explodes, 132; in Stella, 210; stepped, 186, 190; treated as light and shade, 74–75
space drawing, 124, 192, 242
space sculpture, 52, 114, 134, 179, 211, 240–44
Spatial Ambiance, 235
spatiodynamism, 301
spazialismo, 200, 394
spectator, 67, 178, 186, 193–94, 344,

361, 373–74, 378, 382; and artist, gap between, 3, 11, 39–40, 53, 67; as composer and choreographer, 290–91; as inconsequential, 368; directed by artist, 50, 215, 270; disoriented, 346–50, 351–52, 365–69; educated by artist, 23; forced to think, 116, 373–74; guided by artist, 45; impregnated, 50; invited to form associations, 162; invited to think, 46, 385, 386; recipient of information, 372; unrestricted owner of work, 383

Spiegel, Der (Cologne), 57

Spitzweg, Karl, 91

Spoerri, Daniel, 57

sponsor (patron): and artist, 24, 25, *39–40*, 56, 67, *294–95*, 332, 385, *387, 400;* state as, 67, 295

square shape, use of, 184, 187, 209, 246, 264, 270, 273

standardized (prefabricated) units, 174, 177, *179–85*, 190, 194, *247*, 269, 281

statements, 3, 10, 11, 352, 356, *391–96;* a defective source, 27, 90, 394–95, 397; disappear by 1970 on purpose, 33; help to establish meaning of works, 96, 334; ignore some problems, 12, 37, 151, 390; on critic, 400; their contents, 15, 16, 119, 120, 125, 391. *See also* individual artists, *s.v.* statements

station point: inside work, 48, 50, 83–84, 139, 150, 246, 272, *see also* self-centered system; movable, 246; multiple, 270, 379; varied in painting same object, 160

Statue of Liberty, 65, 162, 212

Steen, Jan, 91

Stein, Joël, "Day in the Street, A," 67

Stella, Frank, 114, 117, 118, 150, 180, 374; Aluminum series, 112; and space, 261; compared to Conceptual art, 393; Black paintings (pinstripes), 112, 128, 129; *Fahne hoch, Die, 111–12,* 209n; flags, 93, 100; holistic composition, 125, 128–29; Irregular Polygons, 209; *Jill, 112, 113;* pattern and shape

of support, *111–13;* Portrait series, *112–13,* 210; Protractor series, 209; *Sabine Pass,* 209n; *Sangre de Cristo,* 100, 125, **129,** 132, 137, *138,* 191, *209–10,* 261; scale, *137, 138;* shaped canvas, 200, *208–11;* visual patterns, *98–100,* statements of: 121, 210; aim, 32, 95, 98–99; autograph, 392; nonrelational symmetry, 125; scale, 129, 130, 139; visualizing a work before execution, 374

Stieglitz, Alfred, 105

Still, Clyfford, 80, *127–28,* 132, *1951-D,* 80, **127,** *128,* 132; statements, 124, 128, 318, 363, 391, 396

still life, 116, 137, 225

Stockholm: Wassily Kandinsky exhibition, 70—Moderna Museet, "She —a Cathedral," 61

storable works. *See* demountable and storable works

structure, 267, 268, *321,* 323, *329*

Stuart, Gilbert, *Washington,* 96

Sturm, Der (Berlin), 400

subject matter, 17, 98, 100, 103, 362; banal, 91, 103; compared to content, 69–70, 89; in abstract art, 96–98, 329; in Minimal art, 103, 115; in Picasso, 117; in Pop art, 91–95; in Symbolist art, 17–18

subserviency reversed between: art and object, 28, 249; artwork and site, 135; image and blank canvas, 141; pictorial field and pattern, 100; setting and sculpture, 146

Sumerian art, 269

support, 99, 111, 129, 208, 209

supraspatial principles, 355

surprise as an artistic device: abnormality, 103, 259, 366; banality, 362; location of work, 244; sound, 288, 290; sudden change, 186; technological feats, 294, 302; unexpected additional views, 240, 241; used for spectator participation, 46, 50, 53

Surrealism, 33, 36, 72, 79, 207, 249, 329

Sweeney, James, 369, 370
Sylvester, David, 166
symbolism, *71–73,* 86, 89, 117; absent, 361; archetypal, 72, 73, 74, 79, 359; banal motifs, 121, 359–60; Christian, 72, 73, 347; color, 17, 30; contemporary, 75, 78, 79; Freudian, 62, 64, 72, 162; mechanical, 105, 114, 347; metaphysical, 81, 84, 85–86, 303, 308; nonobjective, 117, 329; Pop, 107, 114; timeworn motifs, 5, 114–15, 361, 398; topical motifs, 398. *See also* demythification; mythical overtones
Symbolist art, 17, 23, 30, 99, 365
system, 34, 179, 315, 395

Tachism, 99, 324, 326, 328, 396
tactile effects, 401. *See also* haptic art; friction; senses: touch
targets as motif, 113–14
Tatlin, Vladimir, 392
teamwork (collective effort, workshop), 48, 50, 54, 68, 197, 256–57
Tech. art, 70, 235, 237, 292
technology, *66–67,* 119, 120, 147–48, *197, 250, 254,* 269, 270, 277, 279, *292, 293–95,* 316. *See also,* Four Elements, the; photo- and audiokinetic art
television, 61, 64, 292
tensegrity, 153
theatre, 37, 198, *257–58,* 384, 389. *See also* Gutai Theatre Art; Happenings
thought, 17, 371, 378
throwaway work, 59, 207, 330, 331, 332
Tilson, Joe, 93
time, 261, 282, 364, 392; existence of things stated in terms of, 364; experience of, 61, 254, 297, 299; expression of, 20; expression of passage of, 315, 360; not to be painted, 327. *See also* dilation of time; duration
Time and Life Building, 267–68
Tinguely, Jean, 26, 57, 70, 288, 370;

Copenhagen demonstration, 316; *cyclo-graveur,* 327; *For Statics,* 327, 329; Homages, 369; *Homage to New York,* 68; Meta-Herbin, 324; Meta-Kandinsky, 324; meta-machines, 324–28; Meta-Malevich, 324; *Meta-matic No. 17,* 278, 282, 291, *324,* **325,** *326;* ridicules abstract art, *321–28;* ridicules machine, *381–82; She—a Cathedral, 61–65;* sonorous-metarobot-painting machines, 324; statements, 26, *281,* 288, 323, 326, 327, 345; use of sound, 289, 291–92
Titian, 144, 146
title: connected with image. 105; found after work is ready, 74; imaged in rhopalic verse, 256; no connection to image, 100, 111–13; reveals meaning of work, 17–18, 72, 74; use by Conceptual art, 372; use by David Smith, 73–74, 78–79; use by Duchamp, 103; use by Picabia, 105
Tokyo: Ohara Hall, "First Gutai Group Show," 352; "First 'Gutai-Ten,' The," 258—Sankei Hall, "Gutai Art on the Stage," 259, 309
Tomasello, Luis R., 211, 273–74
Tomkins, Calvin, 324, 326
Toulouse-Lautrec, Henri de, 128
towers, 155, 192, 193; and Schoeffer, 25, 65–66, 67, 68, 121, 299–301, 398; Eiffel, 155; of Babel, 64, 65; of Gaza, 324
traditional art compared to contemporary art, 11, 116, 349, 373; color effects, 264–65; content and form, 96, 328; discarding of pedestal, 240; distribution of weight, 148; experience of motion, 274; form innovates, 117; kinetic field, 194; latter can uncover unknown facts, 381; new rooted in art but not in tradition, 388; no difference, 69, 146, 257, 380; plasticity of sculpture, 227; portraiture, 107; prints versus multiples, 54; process versus finished work, 363; subject matter, 96; symbolism, 72, 79, 362; thea-

tre versus Happening, 257–58; treatment of chair, 5; use of gravity, 148; use of word *dematerialization*, 269; use of word *time*, 282; variants versus transformable paintings, 54; viewing of sculpture, 240–42. *See also* contemporary art compared to: precontemporary art

traditional values, *330–31;* battle against, 12, 61; rejected 329, 370–71

transformable art (manipulable art, options), 47, 52, 67, 237, 257, 332; by Agam, *44–45,* 274; by Morris, 52, 163, 166, 241

transformation (metamorphosis), 5, 12, 43–46, 167–70, 232–34; due to unstable patterns, 263; due to walking or fixating, 274; form in flux, 355, 356; of color, 373; unplastic image formed from plastic elements, 271. *See also* Kinetic art; motion; Op(tical) art; permutation

transparency, 121, 227, 299, 397

tribal art, 163

trompe l'oeil, *108–09,* 132–33

Truman, Harry, 85

Tuchman, Maurice, 221

Tuchman, Phyllis, 246, 247

Turin, "Italia '61," 236

twentieth century, 133, 199, 255, 262; Dadaist attitude, 345; hostility toward tradition, 329; machine its god, 347; rejects sentimentality, 107; symbolism a personal discovery of spectator, 79; technological discoveries, 120, 235. *See also* contemporary art; contemporary art compared to

291 (New York), 105

Tzara, Tristan (pseud.), 41, 98; *Dada Manifesto,* 366; "Lecture on Dada," 90; "Leper of the Landscape," 366, 367; *Memoirs of Dadaism,* 367; statements, 366, 367

Uccello, Paolo, 20; *Founders of Florentine Art, The,* 335

Uecker, Günter, *121–24,* 135, 179, 180, 182, 183, 186; chair, *8;*

Ocean, 121, *122–23,* **123,** 124, 174, 179, 182; statement, 179

Ultvedt, Per-Olof, *Broken Clavicle,* 64; *Man in a Chair,* 64; *She—a Cathedral,* 61–65

uniformization, 25, 70, 390, 396

uniqueness, 2, *54,* 379, 382, 387

unstable patterns. *See* Op(tical) art

Vaillant, Wallerand, *Trompe l'oeil: Letters,* 133n

Vancouver, "995.000," 372

variants (versions), 45, *53–54,* 56, 160–61, 172, 177, 193, 264

Vasarely, Victor, 4, 24, 55, 174, *186–90,* 198, 273; delegates work, 54; *Chessboard,* 187; *Harlequin,* 187; statements of: *23, 39, 53,* 120, 190; on collaboration, 198; on psychic needs, 66; on permutation, 170; on serialization, 54; *Supernovae,* 187n; *VP 111,* 174, *187,* **188,** *189–190,* 273; *Zebras,* 187

vegetation as artwork, 311, 314–15, 336

Velázquez, Diego de, *Spinners, The,* 269

Venus of Willendorf, 65

Vermeer, Jan, 141, 143

Veronelli apartment (Milan), 236

Veronese, Paolo, 31

versions. *See* variants

Villon, François, 354

visual pattern, 32, *99–100,* 112, 113, 114, 117, 129

visual versus scientific laws, 171, 173–74, 186, 187, 268

Vollard, Ambroise, 319

Vostell, Wolf, *Fernseh-dé-collage,* 260

Vries, Her de, 88

Wagoner, Dan, 389

Walden, Herbarth, 400–01

Walther, Franz Erhard, 37

Warhol, Andy, *6–7,* 25–26, 54, 93, 95, *174–77,* 198, 356; Borden cow, 95; Campbell soup cans, 93, 95; Disaster series, 7, 93; electric

Warhol, Andy (*continued*)
 chair, 7, 95, 173; *Elvis I and Elvis
 II,* 93, 171, *174–77,* **176;** flowers,
 95, 173; *Jackie Kennedy,* 93, 95,
 172–73; *Lavender Disaster,* 7; pil-
 lows filled with gas, 312; state-
 ments, 14, 54, 90, 170, 392, 393;
 Triple Elvis, 174–77, **175**
Washington, D.C., Corcoran Gallery
 of Art, "Scale as Content," 146n
water, fog, ice, mist, steam, 295, 309;
 Dupuy, 308; Haacke, *313–14,* 349;
 Klein, 303, 305, 336, 338; Man-
 zoni, 313; Medalla, 316
Weiner, Lawrence, 373, *382–84;
 Amount of Bleach Poured upon a
 Rug and Allowed to Bleach, An,*
 382; *Removal to the Lathing or
 Support of Plaster or Wallboard
 from a Wall,* 382; statements, 382,
 383, 383–84; *Two Minutes of
 Paint Sprayed Directly upon the
 Floor from a Standard Aerosol
 Spray Can,* 382–83
Wesselmann, Tom, 93

West Indian art, 151, 289
Wilfred, Thomas, Clavilux, 297,
 lumia compositions, 297
will to form, 11, 13, 38
will to inform, 13, 16, 38. *See also*
 Conceptual art
witticism as weapon. *See* irony as
 weapon
word in art: terminology ambiguous,
 27, 96, 107, 394–96; use of, *255–
 57,* 289, 371, 378, 383, 384. *See
 also* pun
word in music, 389
workshop. *See* teamwork
Wright, Frank Lloyd, 246

Yoshihara, Jiro, 259
Yvaral, 67, 393; "Day in the Street,
 A," 67; statements, 21, 40, 319–20

Zayas, Marius de, 372
Zen Buddhism, 180
Zervos, Christian, 2, 15, 369
Zeus Kataibates, 337
zips, 84